Fashioning
the Victorians

Dress, Body, Culture

Series Editor: **Joanne B. Eicher**, *Regents' Professor, University of Minnesota*

Advisory Board:

Djurdja Bartlett, *London College of Fashion, University of the Arts*
Pamela Church-Gibson, *London College of Fashion, University of the Arts*
James Hall, *University of Illinois at Chicago*
Vicki Karaminas, *University of Technology, Sydney*
Gwen O'Neal, *University of North Carolina at Greensboro*
Ted Polhemus, *Curator, 'Street Style' Exhibition, Victoria and Albert Museum*
Valerie Steele, *The Museum at the Fashion Institute of Technology*
Lou Taylor, *University of Brighton*
Karen Tranberg Hansen, *Northwestern University*
Ruth Barnes, *Ashmolean Museum, University of Oxford*

Books in this provocative series seek to articulate the connections between culture and dress, which is defined here in its broadest possible sense as any modification or supplement to the body. Interdisciplinary in approach, the series highlights the dialogue between identity and dress, cosmetics, coiffure and body alternations as manifested in practices as varied as plastic surgery, tattooing and ritual scarification. The series aims, in particular, to analyse the meaning of dress in relation to popular culture and gender issues and will include works grounded in anthropology, sociology, history, art history, literature and folklore.

ISSN: 1360-466X

Previously published in the series

Helen Bradley Foster, *"New Raiments of Self": African American Clothing in the Antebellum South*
Claudine Griggs, *S/he: Changing Sex and Changing Clothes*
Michaele Thurgood Haynes, *Dressing Up Debutantes: Pageantry and Glitz in Texas*
Anne Brydon and Sandra Niessen, *Consuming Fashion: Adorning the Transnational Body*
Dani Cavallaro and Alexandra Warwick, *Fashioning the Frame: Boundaries, Dress and the Body*
Judith Perani and Norma H. Wolff, *Cloth, Dress and Art Patronage in Africa*
Linda B. Arthur, *Religion, Dress and the Body*
Paul Jobling, *Fashion Spreads: Word and Image in Fashion Photography*
Fadwa El Guindi, *Veil: Modesty, Privacy and Resistance*
Thomas S. Abler, *Hinterland Warriors and Military Dress: European Empires and Exotic Uniforms*
Linda Welters, *Folk Dress in Europe and Anatolia: Beliefs about Protection and Fertility*
Kim K. P. Johnson and Sharron J. Lennon, *Appearance and Power*
Barbara Burman, *The Culture of Sewing: Gender, Consumption and Home Dressmaking*
Annette Lynch, *Dress, Gender and Cultural Change: Asian American and African American Rites of Passage*
Antonia Young, *Women Who Become Men: Albanian Sworn Virgins*

David Muggleton, *Inside Subculture: The Postmodern Meaning of Style*

Nicola White, *Reconstructing Italian Fashion: America and the Development of the Italian Fashion Industry*

Brian J. McVeigh, *Wearing Ideology: The Uniformity of Self-Presentation in Japan*

Shaun Cole, *Don We Now Our Gay Apparel: Gay Men's Dress in the Twentieth Century*

Kate Ince, *Orlan: Millennial Female*

Ali Guy, Eileen Green and Maura Banim, *Through the Wardrobe: Women's Relationships with their Clothes*

Linda B. Arthur, *Undressing Religion: Commitment and Conversion from a Cross-Cultural Perspective*

William J. F. Keenan, *Dressed to Impress: Looking the Part*

Joanne Entwistle and Elizabeth Wilson, *Body Dressing*

Leigh Summers, *Bound to Please: A History of the Victorian Corset*

Paul Hodkinson, *Goth: Identity, Style and Subculture*

Leslie W. Rabine, *The Global Circulation of African Fashion*

Michael Carter, *Fashion Classics from Carlyle to Barthes*

Sandra Niessen, Ann Marie Leshkowich and Carla Jones, *Re-Orienting Fashion: The Globalization of Asian Dress*

Kim K. P. Johnson, Susan J. Torntore and Joanne B. Eicher, *Fashion Foundations: Early Writings on Fashion and Dress*

Helen Bradley Foster and Donald Clay Johnson, *Wedding Dress Across Cultures*

Eugenia Paulicelli, *Fashion under Fascism: Beyond the Black Shirt*

Charlotte Suthrell, *Unzipping Gender: Sex, Cross-Dressing and Culture*

Irene Guenther, *Nazi Chic? Fashioning Women in the Third Reich*

Yuniya Kawamura, *The Japanese Revolution in Paris Fashion*

Patricia Calefato, *The Clothed Body*

Ruth Barcan, *Nudity: A Cultural Anatomy*

Samantha Holland, *Alternative Femininities: Body, Age and Identity*

Alexandra Palmer and Hazel Clark, *Old Clothes, New Looks: Second Hand Fashion*

Yuniya Kawamura, *Fashion-ology: An Introduction to Fashion Studies*

Regina A. Root, *The Latin American Fashion Reader*

Linda Welters and Patricia A. Cunningham, *Twentieth-Century American Fashion*

Jennifer Craik, *Uniforms Exposed: From Conformity to Transgression*

Alison L. Goodrum, *The National Fabric: Fashion, Britishness, Globalization*

Annette Lynch and Mitchell D. Strauss, *Changing Fashion: A Critical Introduction to Trend Analysis and Meaning*

Catherine M. Roach, *Stripping, Sex and Popular Culture*

Marybeth C. Stalp, *Quilting: The Fabric of Everyday Life*

Jonathan S. Marion, *Ballroom: Culture and Costume in Competitive Dance*

Dunja Brill, *Goth Culture: Gender, Sexuality and Style*

Joanne Entwistle, *The Aesthetic Economy of Fashion: Markets and Value in Clothing and Modelling*

Juanjuan Wu, *Chinese Fashion: From Mao to Now*

Annette Lynch, *Porn Chic: Exploring the Contours of Raunch Eroticism*
Brent Luvaas, *DIY Style: Fashion, Music and Global Cultures*
Jianhua Zhao, *The Chinese Fashion Industry: An Ethnographic Approach*
Eric Silverman, *A Cultural History of Jewish Dress*
Karen Hansen and D. Soyini Madison, *African Dress: Fashion, Agency, Performance*
Maria Mellins, *Vampire Culture*
Lynne Hume, *The Religious Life of Dress*
Marie Riegels Melchior and Birgitta Svensson, *Fashion and Museums: Theory and Practice*
Masafumi Monden, *Japanese Fashion Cultures: Dress and Gender in Contemporary Japan*
Alfonso McClendon, *Fashion and Jazz: Dress, Identity and Subcultural Improvisation*
Phyllis G. Tortora, *Dress, Fashion and Technology: From Prehistory to the Present*
Barbara Brownie and Danny Graydon, *The Superhero Costume: Identity and Disguise in Fact and Fiction*
Adam Geczy and Vicki Karaminas, *Fashion's Double: Representations of Fashion in Painting, Photography and Film*
Yuniya Kawamura, *Sneakers: Fashion, Gender, and Subculture*
Heike Jenss, *Fashion Studies: Research Methods, Sites and Practices*
Brent Luvaas, *Street Style: An Ethnography of Fashion Blogging*
Jenny Lantz, *The Trendmakers: Behind the Scenes of the Global Fashion Industry*
Barbara Brownie, *Acts of Undressing: Politics, Eroticism, and Discarded Clothing*
Louise Crewe, *The Geographies of Fashion: Consumption, Space, and Value*
Sheila Cliffe, *The Social Life of Kimono: Japanese Fashion Past and Present*

Dress, Body, Culture: Critical Sourcebooks

Rebecca N. Mitchell, *Fashioning the Victorians: A Critical Sourcebook*

Fashioning the Victorians

A Critical Sourcebook

Edited by
Rebecca N. Mitchell

BLOOMSBURY VISUAL ARTS
LONDON • NEW YORK • OXFORD • NEW DELHI • SYDNEY

BLOOMSBURY VISUAL ARTS
Bloomsbury Publishing Plc
50 Bedford Square, London, WC1B 3DP, UK

BLOOMSBURY, BLOOMSBURY VISUAL ARTS and the Diana logo are trademarks of
Bloomsbury Publishing Plc

First published in Great Britain 2018

Cover design by Holly Bell
Cover image: *On the Shores of Bognor Regis - Portrait Group of the Harford Couple and
their Children*, 1887, Rossi, Alexander M. (1840-1916) / Private Collection / Photo © Bonhams,
London, UK / Bridgeman Images

A catalogue record for this book is available from the British Library.

Library of Congress Cataloging-in-Publication Data
Names: Mitchell, Rebecca N. (Rebecca Nicole), 1976- editor.
Title: Fashioning the Victorians : a critical sourcebook / edited by Rebecca N. Mitchell.
Description: New York : Bloomsbury Academic, An imprint of Bloomsbury
Publishing Plc, 2018. | Includes bibliographical references and index.
Identifiers: LCCN 2017046796 | ISBN 9781350023390 (hardback : alk. paper)
Subjects: LCSH: Clothing and dress–Great Britain–History–19th century. |
Clothing and dress–Great Britain–History–Sources.
Classification: LCC GT737 .F37 2018 | DDC 391.00941/09034–dc23 LC record available at
https://lccn.loc.gov/2017046796

Series: Dress, Body, Culture, 1360-466X

HB: 978-1-3500-2339-0
PB: 978-1-3500-2340-6
ePDF: 978-1-3500-2341-3
ePub: 978-1-3500-2338-3

Typeset by Integra Software Services Pvt. Ltd.
Printed and bound in India

To find out more about our authors and books visit www.bloomsbury.com and sign up for our newsletters.

CONTENTS

LIST OF FIGURES

ACKNOWLEDGEMENTS

I am deeply grateful to the organizations and people that facilitated the completion of this volume. Virginia Woolf's 'Modes and Manners of the Nineteenth Century' appears with the permission of the Society of Authors as the Literary Representative of the Estate of Virginia Woolf. The Pasold Research Fund generously provided a research grant; I thank the Fund, and Professor Stana Nenadic for this support. The Bodleian Library's John Johnson Collection offered an extraordinary range of nineteenth-century ephemera, and Mrs Julie-Anne Lambert provided essential assistance with its use. The Jay T. Last Collection at the Huntington Library, Pasadena, California, was similarly enriching; I thank David Mihaly, Curator of Graphic Arts and Social History, and Krystle Satrum, Assistant Curator of the Last Collection, for their help and insight. The British Library's efforts to digitize public domain images were also much appreciated.

The Cadbury Research Library at the University of Birmingham was, as ever, extraordinarily helpful with sourcing nineteenth-century images. Special thanks are due to Catherine Martin, Library Support Assistant, and Martin Killeen, Rare Books Librarian, at the Cadbury.

At Bloomsbury, Hannah Crump, Joanne B. Eicher and Pari Thomson offered encouragement and guidance at every turn. I am grateful for their assistance and for the helpful insight of the anonymous readers who reviewed the manuscript.

I am indebted to my colleagues and friends for their support of this project: I owe sincerest thanks to Katherine Baxter, Joseph Bristow, Oliver Herford, Anna Maria Jones, Deborah Longworth, Kristin Mahoney, Valerie Rumbold, Anna Tillett, Erika Wright, Gillian Wright and especially Christopher Donaldson, whose early suggestions proved invaluable. Lastly, thanks go to my mother, Gloria Tobey, who taught me how to sew in my earliest years.

NOTE ON THE TEXT

The original publication has been used as copy text except where indicated; publication details are listed in the header for each piece. Silent corrections include updated punctuation marks, uniform spellings and corrections of obvious typographical errors. Authors' notes are flagged in brackets. Headnotes at the beginning of each section and each selection offer context, and footnotes explain unfamiliar terms, allusions or sources. Fashion terms that appear in the volume's glossary are not annotated but are rendered in bold.

TIMELINE

1800s

1800 Jacques Louis David begins his Portrait of Madame Récamier in neo-classical muslin gown

1804 Napoleon crowned Emperor of the French

1806 British magazine *La Belle Assemblée* (later *Court Magazine and Belle Assemblée*) founded, illustrated with fashion plates

1807 Slave Trade Act of 1807 abolishes slave trade in British colonies

1810s

1811 **Regency** begins, ending in 1820 with the death of George III

1813 Jane Austen publishes *Pride and Prejudice*

1815 Duke of Wellington defeats Napoleon at Waterloo

1816 Beau Brummell flees England for France to escape gambling debts, ending his reign as London's fashion leader

1820s

1820 Sir Walter Scott publishes *Ivanhoe*

1824 First **Mackintosh** raincoat sold

1824 National Gallery opens in London

1825 First public freight and passenger steam railway opens between Stockton and Darlington

1830s

1833 Slavery Abolition Act outlaws slavery in the British empire

1837 Victoria ascends the throne, aged eighteen

1837–9 Charles Dickens publishes *Oliver Twist*

1839 Invention of the Daguerreotype announced

1840s

1840 Penny Post introduced across the United Kingdom

1840 Queen Victoria marries Albert of Saxe-Coburg and Gotha

1841 *Punch* launches

1848 Pre-Raphaelite Brotherhood founded

1848	Revolution in France results in the election of President Louis Napoleon Bonaparte (later Emperor Napoleon III)

1850s

1851	Great Exhibition at the Crystal Palace, London
1854	Crimean War begins, ending in 1856
1855	Newspaper Stamp Act abolished, making newspapers more affordable for working-class readers
1856	William Henry Perkin accidentally discovers **mauveine**, the first synthetic aniline dye
1858	India becomes Crown Colony of England
1858	House of Worth established
1858	Empress Eugénie of France debuts cage **crinoline** in London
1859	Charles Darwin publishes *On the Origin of Species*

1860s

1861	Prince Albert dies
1861	American Civil War begins, ending in 1865
1862	Thomson Crown crinoline wins medal at the International Exhibition
1863	Ebenezer Butterick invents graded (sized) patterns for home sewing
1864	John Lewis opens store in Oxford Street, joining Whiteleys (est. 1863) as one of Britain's first department stores
1866	First Transatlantic telegraph cable laid
1867	The Singer Company opens factory in Scotland to meet British demand for sewing machines
1869	Girton College founded for women at Cambridge

1870s

1870	Franco-Prussian War begins, ending in 1871 with the defeat of Napoleon III
1871–2	George Eliot publishes *Middlemarch*
1875	Inaugural issue of *Myra's Journal of Dress, Fashion and Needlework*
1876	American Alexander Graham Bell invents the telephone
1877	Victoria crowned Empress of India
1879	Thomas Edison invents the lightbulb

1880s

1880	Mundella's Elementary Education Act extends compulsory primary school for children up to age ten
1881	Rational Dress Society founded in London
1882	Married Women's Property Act grants married women the ability to maintain control of their holdings

1883	Coco Chanel born
1885	Japanese Village exhibition proves wildly popular in Knightsbridge, London
1885	John Kemp Starley introduces the 'Rover' safety bicycle
1886	Single-volume publication of *Little Lord Fauntleroy* by Frances Hodgson Burnett sparks velvet suit craze for boys
1888	Jack the Ripper murders

1890s

1890	Oscar Wilde publishes *The Picture of Dorian Gray* in *Lippicottt's Magazine*
1891	William Morris founds the Kelmscott Press
1897	Duke of Devonshire's costume ball celebrates Victoria's diamond anniversary

1900s

| 1901 | Victoria dies; son Albert Edward crowned King Edward VII |

Introduction

In her 1910 review of *Modes and Manners of the Nineteenth Century* by Max von Boehn, Virginia Woolf reflected on the fashion that defined the century before her own (see #26). By this point, the high Victorian mode had grown dusty – it was the era of one's parents and one's grandparents – and a kind of resigned bemusement is detectable in her tone. In light of Boehn's comprehensive and sumptuously illustrated study, she acknowledges that even seemingly insignificant actions or episodes can affect the shape of women's clothes, in particular. 'The opening of a railway line, the marriage of a princess, the trapping of a skunk', Woolf writes, 'such external events tell upon them'.[1] She concludes that works of history might provide an account of the exterior trappings of a generic people of the past, but they are unable to capture a true sense of the lived experience, the 'modes and manners' that individuals would have inhabited. Studies of fashion might give a fuller impression of that experience than the driest historical works, but it is still up to the poets and the novelists, she argued, to communicate those more nebulous sensations that cannot be captured in an account of fluctuating hemlines and waistlines. Nearly a century of nuanced fashion theory and richly researched costume history has countered Woolf's conclusions, but most scholars would agree with her that events 'tell upon' fashion. And the nineteenth century, perhaps more so than any before it, brimmed with such events.

Given the length and complexity of the period, attempts to describe it – even its clothing – can only be reductive. That such an expansive era is defined by the name of a single individual is the first of many obstacles to easy summary. When the eighteen-year-old Victoria ascended to the throne in 1837, she became the first female monarch in over a century, and one who would actively use fashion to control her image. Her sixty-three-year reign would see the vast expansion of the British empire as well as extraordinary advances in technology, science, industry and communication, advances that helped to shape ever-changing fashions. The enlarged imperial reach was reflected in the introduction of new fabrics and novel styles, from the mid-century cult of the Indian **shawl** to the **kimono**-influenced designs of the fin de siècle;

[1] Virginia Woolf, 'Modes and Manners of the Nineteenth Century', *Times Literary Supplement* (24 February 1910), p. 64.

industrial innovation facilitated the development of paper dress patterns, the home sewing machine and ready-made clothes; the laboratory offered up dyes that produced fabric in colours hitherto impossible to manufacture. Woolf acknowledges the different textures of history and sociology, fiction and verse, but left out of her discussion are the more immediate descriptions, more primary documents of lives lived: the texts and images created and consumed by the Victorians themselves. They were constantly initiating and reflecting upon changes in words and in dress, as evidenced in the veritable explosion of print journalism that both documented and contributed to sartorial evolutions.

In light of the sheer volume of writing produced, it can be bewildering to identify which Victorian works were especially influential or representative of larger trends, which best detail the ways that men and women in the nineteenth century understood, purchased and wore clothes. The goal of *Fashioning the Victorians: A Critical Sourcebook* is not to present a totalizing narrative of nineteenth-century dress or to stage an argument about its evolution, but rather to map the intersection of events, fashion and commentary, by gathering together contemporary sources that speak to the myriad ways that clothing circulated in the public imaginary – and in the wardrobes – of Victorian Britain. Each of the volume's seven sections presents a sample of writings and, in most cases, images connected to one of the period's prevailing themes, which are intended to be neither exhaustive nor mutually exclusive: Fashion Theory; Dress Reform; Crinolines and Corsets; Men's Dress; Occasional Dress: Wedding, Mourning, Children's and Fancy Dress; Production and Industry; and International Influences and Echoes. This introduction will offer a brief overview of nineteenth-century fashion before turning to the techne that facilitated the publication of the works included in the collection and countless others like them. Finally, it presents examples of some of the often-unexpected connections that emerge between these primary documents.

* * * * * *

Woolf is right to caution against viewing waistlines as a barometer for meaning, but it holds true that nearly each decade of the nineteenth century can be identified by the prevailing silhouette of women's dresses. Flipping through the images in this introduction will make the shifts immediately obvious; and a brief primer will help get our bearings on sartorial ebbs and flows, evolutions and revolutions. No revolution told more upon Western fashion than the French uprisings at the end of the eighteenth century. Just as the monarch was cast off, so too were the overwrought rococo stylings of his court. In its place arose neo-classical architecture and thought, and the tightly corseted, ornate gowns of Marie Antoinette gave way to the Greek-inspired simplicity and unadorned fabric that came to typify the Empire style. Madame de Récamier, as depicted in Jacques-Louis David's unfinished portrait of 1800 (see fig. I.1), rivals the Empress Josephine as visual prototype, with her natural curls (in contrast to the powdered wigs of the *ancien regime*) and understated expression. In England, where fashions reverberate for some time after their Continental debut, the high-waisted, light, narrow muslin dresses would reign through the 1820s (see fig. I.2).

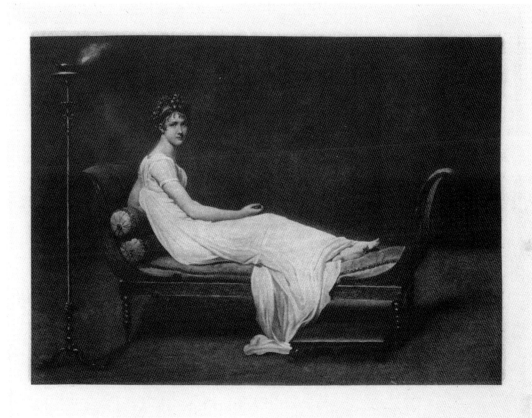

FIGURE I.1 *Photogravure of portrait of Mme Récamier by Jacques-Louis David [1800], from Hugh Noel Williams's* Madame Récamier and her Friends *(London: Harper & Bros., 1901), facing p. 32. Image courtesy of Cadbury Research Library: Special Collections, University of Birmingham.*

Then, as the waistline descended to near its natural point between the bust and the hips, skirts and sleeves began to widen. The 1830s and 1840s saw bodices with persistent dropped shoulders and only slightly elevated, sometimes pointed waists, married to full skirts (see figs. I.3–I.6). Skirts continued to balloon in circumference through the 1850s, when the introduction of the cage **crinoline** obviated the need for multiple **petticoats** and provided structure to support the widest skirts of the century (see figs. I.7–I.8).

After peaking around 1862, that circumference gradually receded; the wire structure of the crinoline allowed for variations in shape, and as the front of the skirt flattened, volume shifted to behind. The addition of the **bustle** accommodated elaborate **trains** that expanded the profile of the dress, although from the front skirts appeared to narrow considerably (see fig. I.9). By the 1870s, this narrower silhouette began to become exaggerated. Longline bodices called **cuirasses** (after the breastplate armour) extended to the hip, creating a streamlined shape that remained popular through the 1870s and 1880s (see fig. I.10). This sleekness required corseting, which became newly important after the mid-century spell when the crinoline was at its peak.

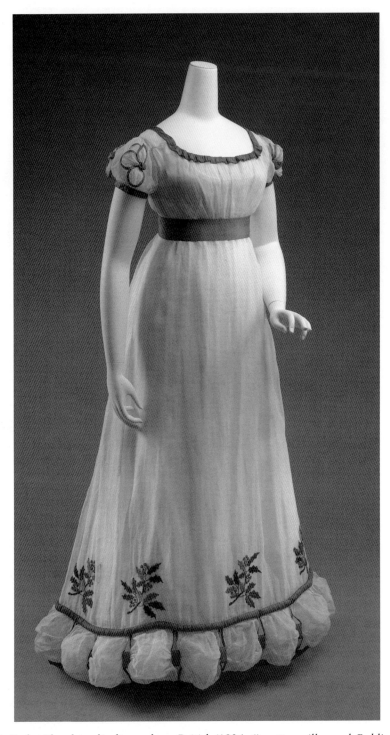

FIGURE I.2 *Embroidered muslin dinner dress, British (1824–6), cotton, silk, wool. Public domain image courtesy Metropolitan Museum of Art, Ascension number 2015.98a.*

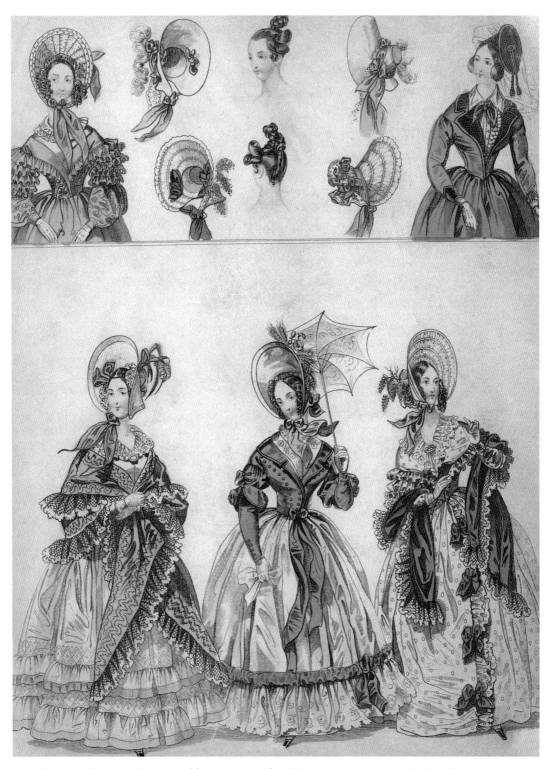

FIGURE I.3 *Women's dresses and bonnets, British (1837). © Getty Images #104591405.*

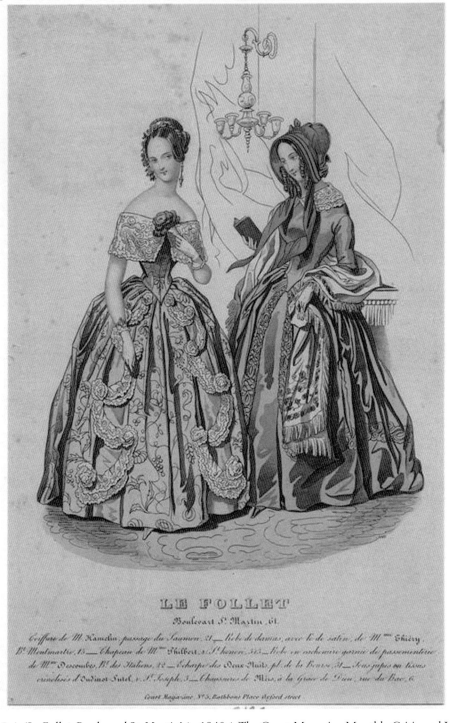

FIGURE I.4 *'Le Follet, Boulevard St. Martin' (c. 1840s)*. The Court Magazine Monthly Critic and Lady's Magazine. *Public domain image courtesy The New York Public Library, Art and Picture Collection.*

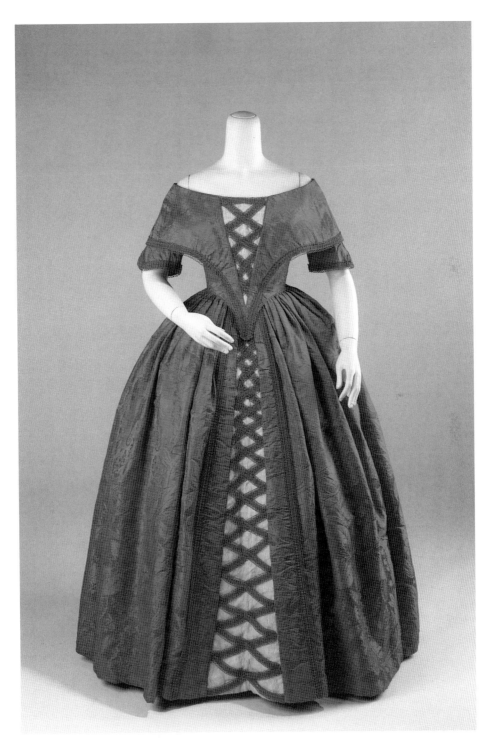

FIGURE I.5 *Ball gown, Britain (c. 1842), cotton and silk. Public domain image courtesy Metropolitan Museum of Art, Ascension number 2009.300.1007. Brooklyn Museum Costume Collection at The Metropolitan Museum of Art, Gift of the Brooklyn Museum, 2009; Designated Purchase Fund, 1984.*

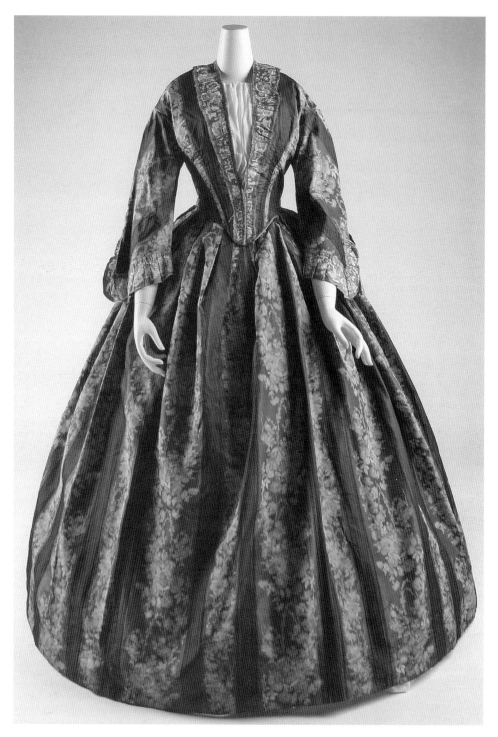

FIGURE I.6 *Afternoon dress, British (1847–50), silk. Public domain image courtesy Metropolitan Museum of Art, Ascension number 1974.194.7.*

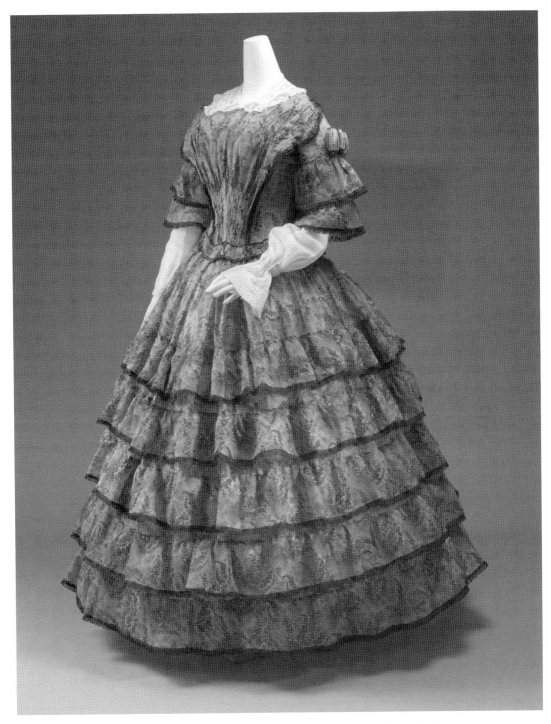

FIGURE I.7 *Day dress with flounced skirt, European (1853–6), wool, silk. Public domain image courtesy Metropolitan Museum of Art, Ascension number C.I.138.23.60a.*

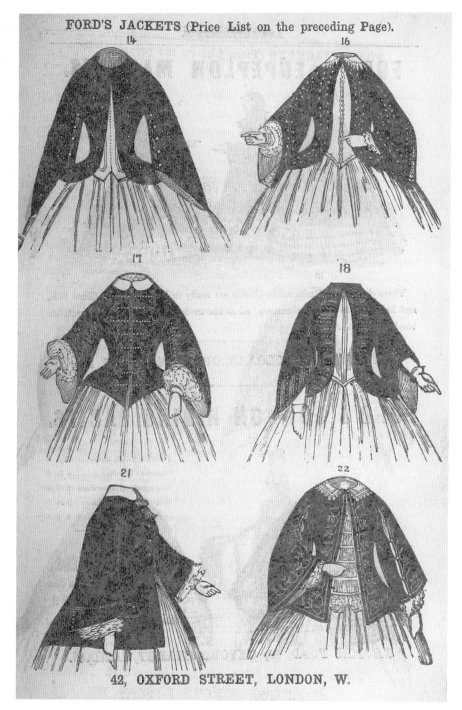

FIGURE I.8 *Advertisement for Ford's Jackets from the* Popular Overland Guide: India, Australia, and China *(London: Ward and Lock, 1861), p. 140. Public domain image courtesy of the British Library, shelfmark HMNTS 10055.c.13.*

FIGURE I.9 *Ball gown with bustle, British (c. 1875), silk, cotton. Public domain image courtesy Metropolitan Museum of Art, Ascension number C.I.69.14.5a–c.*

By the early 1890s, the nascent women's movement began to have an increasing impact on daywear, with separates competing with dresses or matched bodices and skirts. Aesthetic (see fig. I.11) or Rational dress offered an alternative to mainstream designs by resisting the **corset** and advocating less structured clothing that encouraged mobility; and New Women embraced menswear-inspired fashions.

FIGURE I.10 *Dress with cuirass bodice, British (c. 1878), silk, cotton, metal. Public domain image courtesy Metropolitan Museum of Art, Ascension number C.I.69.14.11a,b.*

FIGURE I.11 *Draped evening dress, British, attributed to Liberty & Co. (1880s), silk. Public domain image courtesy Metropolitan Museum of Art, Ascension number 1985.155.*

All the while, menswear continued apace. Once **breeches** were abandoned after the **Regency**, a relatively stable uniform arose of full-length trousers, shirt, **waistcoat** and jacket (see fig. I.12). Variation in proportions often aligned with womenswear: fuller trousers and sleeves in the mid-century gave way to straight legs by the end. It was in the details – the cut of the jacket, the fabric of the waistcoat – that individuality could be detected. The brief Aesthetic craze of the early 1880s, which saw Oscar Wilde return to the knee breeches of the previous century, provided a respite from the generally staid male uniform and demonstrated that fashion could be deployed to signal sexual as well as artistic dissidence.

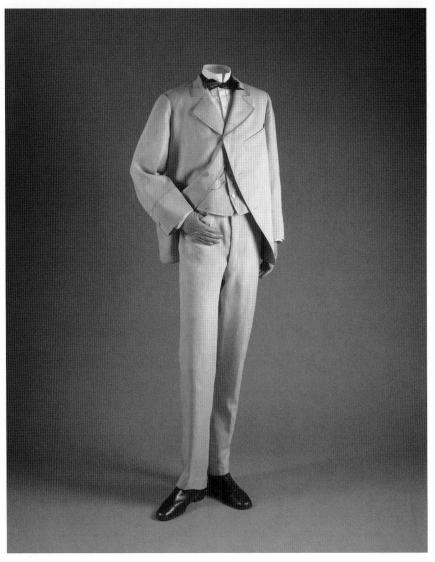

FIGURE I.12 *Suit, British (1865–70), wool, silk, cotton. Public domain image courtesy Metropolitan Museum of Art, Ascension number 1986.114.4a–c.*

Thus in three paragraphs can the fashions of over sixty years be dispensed. These sweeping strokes are evident only in the long retrospective view that blunts the countless minor variations that challenged every major shift in style and were charted in nineteenth-century print culture. It is, in fact, now more possible than ever to recuperate those variations, to attend to even seemingly insignificant changes in dress because of the sheer amount of data available digitally. Thanks to ongoing efforts to digitize Victorian periodicals and ephemera, we can search the voluminous stocks of print production that documented fashion developments in real time. These databases and online texts facilitate discoveries, but they only make partially accessible what the Victorians themselves accessed and produced. And produce they did, in quantities unknown prior to the mid-nineteenth century, when, as Laurel Brake and Marysa Demoor argue, 'the relative importance of books and serials in the period achieves a balance rare in the history of print culture'.[2]

A confluence of events and innovations is responsible for this print revolution. In 1836, the stamp duty was reduced, and the subsequent 1855 repeal of the Stamp Act further lowered prices of newspapers, making periodicals available to a far broader range of readers. At the same time, mandatory, state-funded education was introduced over the course of the second half of the century. Legislative interventions in particular had palpable effects: the Education Act 1870 (Forster Act), which established compulsory schooling up to age ten, while allowing for a range of exceptions, was an important step, albeit one that acknowledged the financial pressures on the working classes who depended on the income of wage-earning children, and one that left enforcement to local jurisdictions. Additional Elementary Education Acts in 1876 and 1880 took matters further, eliminating exceptions and requiring attendance.[3] Naturally following the broadening of compulsory education was a vast increase in literacy, and a corresponding increase in the audience for newspapers and magazines.[4]

The press was ready to meet the demands of this ever-growing audience. Niche magazines appeared, appealing to specific readerships, from women – e.g. *Englishwoman's Domestic Magazine* (1852–1879), *Bow Bells* (1862–1897) and *Myra's Journal of Dress and Fashion* (1875–1912) – to children – e.g. *Boy's Own Magazine* (1855–1874), *Girl's Own Paper* (1880–1956) and *Our Young Folks* (1871–1897) – to bicyclists – e.g. *Bicycling Times and Tourist's Gazette* (1877–1887) and *Cyclist* (1879–1902). Eager advertisers capitalized on the audience-specific venues. They, along with publishers and readers alike, benefitted from advances in print technology. Steam-driven presses introduced in the early decades allowed newspapers to multiply their output exponentially. Trade and cigarette cards exploited chromolithography and die cutting, putting brightly coloured ads into the hands of the masses. Although intended to be ephemeral, many have survived, some simple, some in collectible series, and many engaging the popular fads, such as a corset ad touting the 'latest Æsthetic craze' (see fig. I.13) or a later trade card employing stylized Arts and Crafts iconography (see fig. I.14).

[2] *Dictionary of Nineteenth-Century Journalism in Great Britain and Ireland*, Laurel Brake and Marysa Demoor, eds. (Ghent: Academia Press and the British Library, 2009), p. 5. Brake and Demoor's indispensable *Dictionary* is an outstanding resource for nineteenth-century periodicals.
[3] For additional details, see Donald K. Jones, *The Making of an Education System, 1851–81* (London: Routledge and Kegan Paul, 1977).
[4] See also Richard Altick, *The English Common Reader: A Social History of the Mass Reading Public, 1800–1900* (Chicago: University of Chicago Press, 1957).

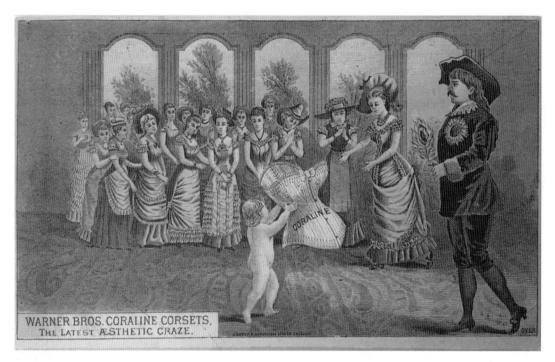

FIGURE I.13 *Advertisement for Warner Bros. Coraline Corsets (c.1883). Jay T. Last Collection, Aesthetic Movement Binder (uncatalogued), Huntington Library, San Marino, California.*

In magazines, colour was still sparingly used, though many journals featured a coloured plate in each issue. But even the long-trusted wood engraving allowed for highly detailed black and white images that enlivened pages (the many delicate **lace** patterns appearing in *Bow Bells*'s regular 'Work Table' column are one such example; see fig. I.15), and photogravure helped introduce photographic images to the reading public. Large audiences across the country now had access to fashion plates – the *same* fashion plates – and a dependable, collective understanding of the latest styles could emerge, along with the consumerist desires primed by editorial content and advertisements.

The increased production of print and material wares often sacrificed individuality or customizability for gains in economy and efficiency. Nevertheless, the same periodical press that facilitated the dissemination of uniform information also accommodated resistant, and even transgressive, views. In response to the mechanized, mass production of goods and clothes, the Arts and Crafts Movement eschewed industrialization and promoted the work of the handicraftsman in their own publications. Aesthetic and Rational dress advocates vowed that beauty and function, not fealty to fashion plates, should determine clothing design. Through the accretion of these diverse sources, trends emerge that are not as obvious as the colour or cut of a skirt. What is most curious is not the very range of responses to dress culture, but the fact that enduring anxieties and hopes appear across those varied responses. In addition to providing deep context for Victorian dress history, the selections in *Fashioning the Victorians* can cast into relief some of the common threads that connect accounts of fashion told from incongruous perspectives, from the beginning of the period until its end.

* * * * * * *

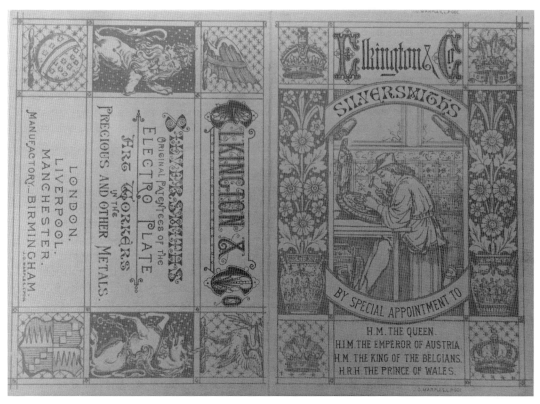

FIGURE I.14 *Advertisement for Elkington & Co. Silversmiths (1876). Jay T. Last Collection of Fashion Prints and Ephemera, Huntington Library, San Marino, California.*

In many cases, encountering these readings will help to challenge conventional wisdom. For example, one influential account of the Victorian woman as 'exquisite slave' was drawn compellingly by Helene Roberts in 1977. Echoing nineteenth-century separate spheres doctrine, she argues that dress 'defined the role of each sex', and that women's clothing defined her as 'delicate (their clothing accentuated tiny waists, sloping shoulders, and a softly rounded silhouette)' and 'submissive (their silhouette was indefinite, their clothing constricting)'.[5] The crinoline was central to this constriction, as Roberts writes that it 'literally transformed women into caged birds surrounded by hoops of steel'.[6] It is a compelling vision, one that chimes with the potentially reassuring notion that our own milieu is quite different from an oppressive patriarchal society inhabited by our Victorian forbears. Still, critics pushed back on Roberts's argument almost immediately, including Valerie Steele, who allowed that is there is 'some truth' to Roberts's claims, but who insisted that 'they are highly oversimplified, as is [her] stylistic

[5] Helene E. Roberts, 'The Exquisite Slave: The Role of Clothes in the Making of the Victorian Woman', *Signs: Journal of Woman in Culture and Society* 2 (Spring 1977), p. 555.
[6] Roberts, 'The Exquisite Slave', p. 557.

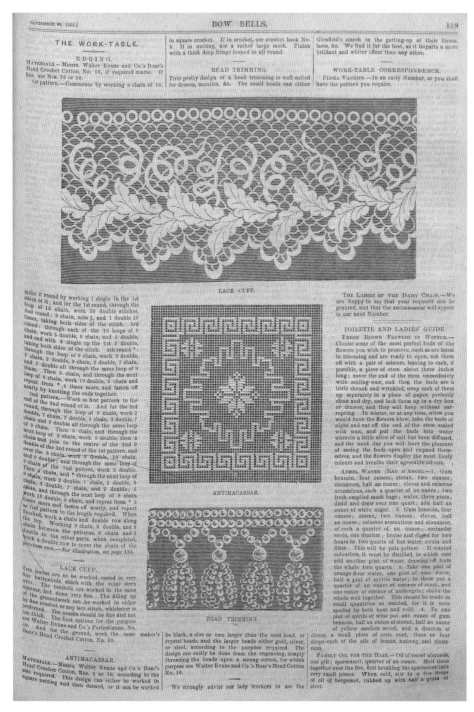

FIGURE I.15 *'The Work Table'*, Bow Bells *(20 September 1865), p. 189. Image courtesy of Cadbury Research Library: Special Collections, University of Birmingham.*

analysis of female dress';[7] and David Kunzle, whose nuanced work on corsetry and tight-lacing sedulously avoids 'oversimplified' conclusions.[8] Yet Roberts's 'exquisite slave' has had remarkable staying power. The image of a woman in a bell-shaped cage crinoline would, for many viewers, readily signify the 'Victorian Period' itself, despite the fact that the exaggerated cage held sway for only five years, from around 1858 until 1862. Moreover, as will become clear when reading the contents of 'Crinolines and Corsets' (Section Three), the cage was initially regarded by detractors as a symptom of irresponsible feminine folly, an absurdity that endangered the wearer's life and inconvenienced those around her. Advocates, conversely, vaunted its lightness as an improvement in comfort and mobility. There is precious little suggestion in the contemporary writing, either for or against the crinoline, that it was regarded by the Victorians as a sign of wifely devotion or submission, a veritable symbol of woman's status as a caged pet. To be sure, this absence does not preclude us from interpreting the crinoline as a symbolic cage, but understanding the terms through which Victorian women engaged their own dress can only enrich the conclusions we draw about their experience.

An exploration of writings on the crinoline makes apparent other links – anxieties that extend beyond the single garment or its implications for gender roles. The repetition of concerns about class, for example, suggests that the crinoline was simply one object on which to project angst that persisted well beyond the lifespan of the fad. Consider the *Punch* cartoon, 'Cause and Effect' (see fig. 3.2). In it, a housemaid who has left a trail of destruction in her wake, complains about the 'bothering china cups and things' that 'they be always a-knocking up against one's crinoline'.[9] As is often the case with *Punch*'s cartoons, the humour does not fully disguise the motivating sentiments, which are as serious as the images are comic. Although ostensibly making fun of the crinoline, the cartoon in fact assails the class aspirations of its self-deluded wearer. She is doubly misguided: dressing in the crinoline renders her unable to do her work, knocking over the objects she is meant to keep clean and tidy, and her conclusion that the fault lies with the objects, and not with her choice of dress, is presented as utterly unfounded. Moreover, her incorrect syntax, and her shoddy appearance (the thin fabric of her skirt revealing the sparse hoops of a poorly constructed crinoline) emphasize her relative poverty even as she is attempting to perform a higher station. The fault seems to be the maid's, both in thought and action, as it is the home owner's possessions that are being destroyed.

Harriet Martineau's polemic against crinoline, 'A New Kind of Wilful Murder', couches worries about the lower class in paternalistic terms. She bemoans the many needless deaths caused by the garment, but she also wonders whether crinoline-wearing ladies 'have any sense of responsibility for the sacrifice of life they have caused in the class of maid-servants, and of schoolgirls who are to be maid-servants'.[10] At least some of the 'murders' alluded to in her article's title are thus blamed on the elites. Possibly anticipating the kind of humour that drives

[7] Valerie Steele, *Fashion and Eroticism* (New York: Oxford University Press, 1985), p. 90.

[8] See especially David Kunzle, 'Dress Reform as Antifeminism: A Response to Helene E. Roberts's "The Exquisite Slave: The Role of Clothes in the Making of the Victorian Woman"', *Signs* 2, no. 3 (Spring 1977), pp. 570–9; and David Kunzle, *Fashion and Fetishism: A Social History of the Corset, Tight Lacing, and Other Forms of Body Sculpture in the West* (Totowa, NJ: Rowan and Littlefield, 1982).

[9] 'Cause and Effect', *Punch* (26 March 1864), p. 123.

[10] Harriet Martineau, 'A New Kind of Willful Murder', *Once a Week* (3 January 1863), p. 38. See #10.

a cartoon such as 'Cause and Effect', Martineau argues that the working classes must not be judged according to harsher standards than those setting the trends: 'If ladies are burnt by the dozen in muslin and gauzes, are housemaids and cooks to be scolded for being burnt in **calico** and print?'[11] Before expecting 'housemaids and cooks' to abandon the fashion, Martineau appeals to those in muslin and gauzes to do so, trusting that the housemaids will follow suit. Class anxieties, in other words, underscore much criticism of the crinoline. Such concerns were rarely framed as an overt desire to maintain an inequitable status quo. Rather, they were presented in terms of protection: protecting the home (as in 'Cause and Effect'), or protecting the safety of the wearer (as in Martineau's article).

Steele writes that in Victorian fashion, 'Class distinctions, while very important, were nonetheless secondary' to the 'clear sartorial distinction between men and women'.[12] But the contents of this collection show that class was on everyone's minds, if not explicitly readable through their wardrobes; similar complaints arise in writings on topics outside of the crinoline's circumference. Here too it is difficult to tease apart the industrial and the social. Some of the same advances that put periodicals into the hands of the lower classes also increased their access to clothing and other material goods. For decades, magazines had featured rudimentary clothing patterns that depicted the shape of the pieces in relation to each other, but left the complex process of re-scaling, sizing and customization to the home sewer. In the 1860s in the United States, Ellen and William Demorest pioneered the mass production of tissue-paper patterns; their countryman Ebenezer Butterick made further progress by producing full-scale tissue patterns in standard, multiple sizes. These patterns, and the technology they employed, soon reached Europe, where they complemented the ongoing expansion of the domestic sewing machine market. Standard sizing was also a feature of ready-made clothes, which contributed to the success of burgeoning department stores. As clothing and associated accoutrements became affordable and widely available, middle- and working-class people gained access to these goods for the first time, introducing variety to newly larger wardrobes. This meant that fads such as the cage crinoline – first popularized by an Empress – could be worn by women of all classes. Who could object to this increased access? A stubborn resistance to the democratization of fashion demonstrates the degree to which it had always served to denote status.

Some writers allow that the movement of styles from the upper to the lower classes is simply a fact to be dealt with. The author of 'Modern Beau Brummellism' notes in 1867 that on the Continent, 'there is still a considerable distinction between the various classes is matters of dress',[13] but in England 'the lowest menials endeavour to imitate, to the best of their powers, the grandest lord and ladies in the land'. Nearly thirty years later, Violet Greville admits that 'Fashions filter downwards; and, exaggerated, depreciated, rendered common, the example of those [ultra-fashionable] people is followed by people in a lower grade of life'.[14] The cycle demands constant novelty, a never-ceasing stream of new fashions to supplant those that were vulgarized. Merchants and **couturiers** were happy to oblige.

[11] Martineau, 'A New Kind', p. 39.
[12] Steele, *Fashion and Eroticism*, p. 53. She later continues,

> [S]pecialized class costumes died out over the course of the century as more and more middle- and working-class people imitated current fashions to the extent that they could afford to. The materials they used were cheaper and the designs simpler and sometimes clumsy, but to a considerable extent they wore the style of the day. The so-class 'democratization' of clothing was (and remains) a complex phenomenon.

(*Fashion and Eroticism*, p. 71).

[13] 'Modern Beau Brummellism', *London Society* (April 1867), p. 300. See #14.
[14] Violet Greville, 'Victims of Vanity', *The National Review* 21 (March 1893), p. 77. See #11.

In case the upper classes could not be trusted to resist the lure of the latest vogue, other reformers appeal directly to the aspirants. Sarah Stickney Ellis, torchbearer for self-abnegating Angel in the House, argues that there is 'a gross violation of good taste, in assuming for the middle classes of society, whose occupations are closely connected with the means of bodily subsistence, the same description of personal ornament as belongs with more propriety to those who enjoy the luxury of giving orders, without any necessity for further occupation of time and thought'.[15] Ellis's position is inherently conservative; her vision of womanhood depends on clear delineations of duties and clear demarcation of roles, true of the differences between men and women, and true as well of the differences between the 'middle classes' and those who need not work for their living. As it is inconceivable that one who 'enjoys the luxury of giving orders' would wish to transgress class boundaries, it is up to the middle-class woman, who might be induced to imagine her workload lightened or her 'personal ornament' enhanced, to embrace her current position along with its apparel.

Even weddings and funerals, occasions for communal sharing of emotions, contribute to (and do not relieve) these class pressures. One writer notes that 'England more than any other country rejoices in a distinct Middle Class' but bemoans the fact that this large middle class insists on mimicking the wedding customs of the upper classes, leading to a wholesale inflation of the event, its requisite attire, and – most significantly – its cost.[16] So too with elaborate mourning rituals; widows' **weeds** had a levelling effect, obfuscating the class markers that would otherwise be instantly readable in one's attire, even as the pressures to purchase mourning goods fell on the lower classes most keenly. The same author assigned some blame to the press for printing detailed accounts of the extravagant weddings of society belles, infecting the imagination of those without similar means. That is not to say that class- and occupation-specific clothing was not marketed directly to potential purchasers; indeed it was (see fig. I.16), but as reflected in the contents of this collection, contemporary publications, much like today's glossy magazines, emphasized the aspirational over the practical.[17]

Among the other emergent links that unite writers with disparate motivations and interests are the (perhaps not disconnected) themes of nationalism and envy. Great Britain reached its imperial pinnacle in the latter half of the nineteenth century, when the sun famously never set on Victoria's empire. The global reach of British trade ensured the flow of materials that fuelled the northern textile industry, expanded the range of available fabrics and goods, and encouraged the fetishizing of the foreign; the enduring affection for cashmere shawls, which persisted through the century, is one example of imported success. It is with palpable pride, even wonder, that George Dodd recounts the rise of the Lancashire and Yorkshire mills (see #20). Temple Works in Leeds stands as a shrine to British industry: its mechanical capabilities aside, the mill boasted what was for many years the largest single room in Europe and an extraordinary stone facade designed by a prominent Egyptologist to recall the temple at Edfu. Though a leader in industrial might, Britain did not achieve the same ascendency in dress design. Its reach was leveraged to serve as arbiter and provider, if not innovator, of fashion. The Great Exhibition of 1851 exemplifies such efforts on the grand scale, bringing industries and arts from across the globe for

[15] Sarah Stickney Ellis, *The Women of England* (London: Fisher, Sons, & Co., 1839), p. 96. See #2.
[16] 'A Few Words upon Marriage Customs', *Chambers's Journal of Popular Literature, Science, and Art* (8 January 1881), p. 17. See #16.
[17] This emphasis is, for better or for worse, reflected in major museums, which tend to include far more examples of clothing from wealthier owners because they are better preserved and more likely to find their way into collections.

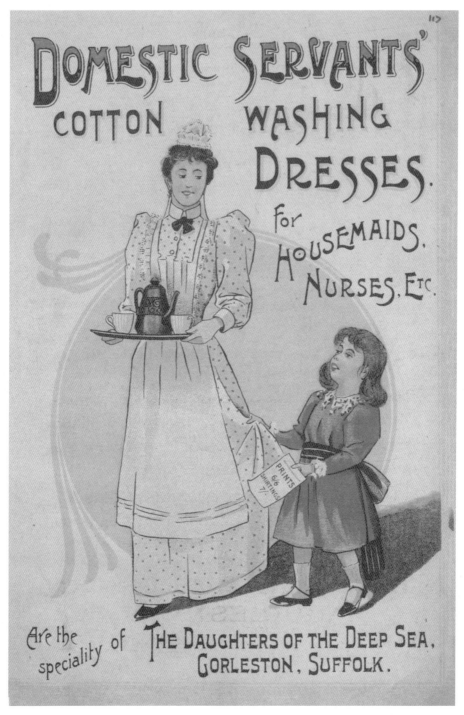

FIGURE I.16 *Advertisement for Domestic Servants' Cotton Washing Dresses (c. 1880). © Bodleian Library, University of Oxford 2009. John Johnson Collection: Women's Clothes and Millinery 7 (17). Used with permission.*

grand public display in South Kensington (see fig. I.17). On a more local scale, British magazines routinely carried accounts and plates of the latest French fashions (see #23), offering details that could be brought to one's local tailor in the hopes of following the latest mode if one could not travel to Paris. As with class anxieties, nationalism arises curiously in the excerpts across the ideological spectrum, rallying an English spirit that, when allied to good taste, could rival the competing attractions of other nations (and their women).

Whereas the Greek ideal was a touchstone for writers such as Haweis and Wilde, Lady Harberton held that a reformed costume should first be appropriate for the wearer's immediate milieu. '[The Greeks] had their climate and habits', she writes, 'and we have *our* climate and habits, than which nothing could well be more dissimilar; and as may be expected, without modifications which rob them of all meaning and beauty, Greek fashions are perfectly unfit for England or English ways'.[18] It is a subtle evocation of national pride in the name of common sense, even if history does not bear out her conclusions: Regency muslins handily demonstrate that climate is rarely the foremost factor in determining fashion.

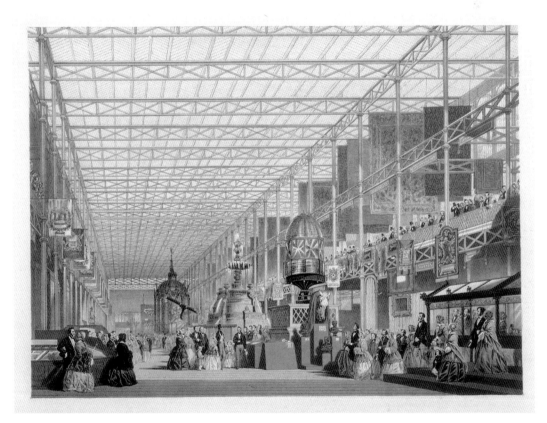

FIGURE I.17 *'British Nave at the Great Exhibition, Crystal Palace, London, 1851' (1854) from Dickinson's* Comprehensive Pictures of the Great Exhibition. © *Getty Images #90743155.*

[18] Florence Pomeroy, Viscountess Harberton, 'Rational Dress Reform', *Macmillan's Magazine* 45 (April 1882), pp. 457–8. See #7.

More successful appeals to the national spirit address the ego of individuals by promoting the country's exceptionalism. Extolling the virtues of Englishwomen is Ellis's primary goal in *Women of England*, where she maintains that their discriminating taste is aided by the fact that 'they are free from many of the national prejudices entertained by the women of other countries'.[19] Eliza Lynn Linton's detested 'girl of the period' is deplorable precisely because she apes the French *demimondaine* – note that Linton is careful to employ French when describing actions or people too uncouth even for the English language – whereas in the recent past, the 'fair young English girl' was dependably 'something franker than a French woman, more to be trusted than an Italian, as brave as an American but more refined, as domestic as a German and more graceful'.[20]

On the one hand, Englishwomen are held up as superior to young women of all other nationalities. On the other hand, according to an equal number of articles, they are creatures governed by envy. It is an old saw that women are jealous primarily of other women, and Ellis cites it as a cautionary tale, commenting that 'well do [women] learn, under the secret tutelage of envy, jealousy, and pride, how to make this engine of discord play upon each other'. Even progressive fashion reformers draw on it repeatedly. Oscar Wilde calls on women's jealousy for laughs: 'I am told, and I am afraid that I believe it, that if a person has recklessly invested in what is called "the latest Paris **bonnet**", and worn it to the rage and jealousy of the neighborhood for a fortnight, her dearest friend is quite certain to call upon her, and to mention incidentally that that particular kind of bonnet has gone entirely out of fashion'.[21] Greville is perfectly serious when remarking that women, 'as is well known, dress at, for, and against, one another'.[22] It is left to Lady Harberton to frame the dynamic more positively. Men's taste in fashion does not motivate changing modes because 'it is the women [that men] admire, and the clothes for their sakes, but never the women for the sake of the clothes'.[23] A focus on envy as a motivation for fashion choices challenges the basic assumption that men's sexual desire determines what women wear, even if snaring a husband is the endgame. Once more, rather than documenting a one-sided influence of a patriarchal order on women's choices, the readings attest to the plurality of women's views, and the plurality of views *of* women's views.

* * * * * * *

What emerges from the contents of *Fashioning the Victorians* is, I hope, the sense that no single narrative can account for the myriad expressions of Victorian dress. It can be tempting to think of fashion as a linear progression evolving alongside but independent of major political, social and industrial movements, with only sporadic imbrication. But upon closer examination, the situation is, at it can only be, far more complicated; rather than a concurrent stream, or even a telling measurement or indicator of social change, clothing is fully woven into the aesthetic, political and technological fabric of Victorian society. There are few innovations, few regulations, few artistic movements that do not 'tell' upon the clothing worn by citizens of all classes. Nor is influence unilateral. Women writing about crinoline were informed on the latest

[19] Ellis, *Women of England*, p. 67.
[20] Eliza Lynn Linton, 'The Girl of the Period', *Saturday Review* (14 March 1868), p. 339. See #5.
[21] Oscar Wilde, 'Philosophy of Dress', *New York Daily Tribune* (19 April 1885), p. 9. See #8.
[22] Greville, 'Victims of Vanity', p. 71.
[23] Harberton, 'Rational Dress Reform', p. 461.

developments in health and medicine; **fancy dress** designers kept up with the shifting art world; textile and steel magnates responded to the latest modes; fictional characters propelled new dress fads; scholars and writers addressed clothing in the periodical press. In addition to Woolf's review, the collection includes works by Thomas Carlyle and Oscar Wilde, literary titans of the beginning and end of the period, respectively. Neither was dallying with dress. They, as nearly all of the authors included here, treat it as a foundational component of an individual's spiritual and material life. Ultimately, we can learn from them as much about the period and its citizens as we can about the garments and technologies described, championed, or derided. We might conclude, to borrow Harberton's phrasing, that 'it is the Victorians that we admire, and the clothes for their sakes, but never the Victorians for the sake of their clothes'.

SECTION ONE

Fashion Theory in the Nineteenth Century

In 1967, Roland Barthes described fashion as a semiotic system, a classifiable set of signs that are readable by other people.[1] It was a fitting sentiment in the early decades of structuralist literary theory, but one that had been long anticipated by nineteenth-century writers. Texts in this section discuss the fashion in the abstract – its uses, semiotics and socio-scientific applications – as opposed to offering specific advice or instructions. More than a century before Barthes's study, Thomas Carlyle's *Sartor Resartus* (1836, see #1) turned to clothing as an analogy for the relationship between spiritual reality and the material world. 'All visible things are emblems', he writes, and 'matter exists only spiritually, and to represent some Idea, and *body* it forth'. Clothes, 'as despicable as we think them', are therefore 'so unspeakably significant'. Carlyle dressed up his theory of clothing as the work of a fictional eighteenth-century German philosopher and tailor. As a novel, with its obscure prose and digressive plot, *Sartor Resartus* sits uneasily next to its contemporaries – Balzac's *Le Père Goriot* (1835), for example, or Charles Dickens's *Pickwick Papers* (1836) – but his theory of clothing was prescient. In its entirety, Carlyle's *Sartor Resartus* lives up to its notoriety for being difficult; this selection from Chapters 5 and 11 of Book I offers Carlyle's clearest articulation of his 'Philosophy of Clothes', which stand as the readable manifestation of the soul.

Sarah Stickney Ellis drew on the idea that clothing was emblematic of the wearer's spirit in her 1843 conduct manual, *Women of England* (see #2). Appearing in the early years of Victoria's

[1] Roland Barthes, *The Fashion System* [*Système de la mode*, 1967], trans. Matthew Ward and Richard Howard (New York: Hill and Wang, 1983).

reign, the work advocates a social and familial role for women, who should aim to please and whose appearance should reflect the modesty and moderation expected in their character. For Ellis, the link between exteriority and interiority was direct: disordered clothing would give viewer's insight into the wearer's 'inner mind', where, she argued, 'it is almost impossible to believe that the same want of order and purity does not prevail'.[2]

George Darwin, son of Charles, is less concerned with the signification of clothing than with its evolutionary characteristics. Drawing on the recent work on sexual selection, he argues that the development of clothing is plainly analogous to the development of organisms via natural selection (see #3). As environments change due to technological, industrial, or natural means, those elements of clothing best adapted to the new circumstances would persist, whereas newly obsolete details – a **buttonhole** here, a fabric flap there – eventually become merely ornamental. The piece demonstrates the degree to which clothing pervaded thinking across the social and scientific spectrum.

Nearer the end of the century, Thorstein Veblen extended the purview of the political sciences to fashion: he too believed that clothing signified meaning far beyond its practical application, although he understood it as an economic, rather than a spiritual, mental or evolutionary indicator (see #4). In a classic work of early political economy (and a precursor to much Marxist criticism of fashion), Veblen argues that constantly changing fashion provided a way for wearers to demonstrate their access to capital, and those very aspects of clothing that exceeded utility were evidence of the wearer's wealth. The more ostentatious and decorative the fashion, the greater wealth it represented. Women's clothing takes on special import in his view, since it allows for greater variation and because, in a hegemonic social order, it is the site wherein most meaning inheres: 'Under the patriarchal organization of society', he writes, 'where the social unit was the man (with his dependents), the dress of the women was an exponent of the wealth of the man whose chattels they were [....] indeed, the theory of woman's dress quite plainly involves the implication that the woman is chattel'.[3]

[2] Sarah Stickney Ellis, 'Dress and Manners'. In *The Women of England, Their Social Duties, and Domestic Habits* (New York: George S. Appleton, 1843), p. 62.
[3] Thorstein Veblen, 'The Economic Theory of Woman's Dress', *Popular Science Monthly* 46 (1894), p. 199.

1

Thomas Carlyle, from *Sartor Resartus*, London: Chapman and Hall, 1869 (1836)

Although rarely read today, Sartor Resartus *by Thomas Carlyle (1795–1881) proved enduringly influential in his own time. From our perspective, it stands as a departure for Carlyle, who is better known for his non-fiction prose than his only published novel. With its dense diction and rhetorical complexity, it defies many conventions of popular reading: an early critic famously described it as a 'heap of clotted nonsense'.[1] But* Sartor Resartus *[The Tailor Remade] forwards an early example of a sustained philosophy of clothes. Carlyle presents the work as an edited compilation of the writings of Diogenes Teufelsdröckh, Professor of Things in General, where the 'editor' interjects to comment upon the Professor's ideas; Teufelsdröckh's contributions appear in quotation marks. In 'The World in Clothes', Teufelsdröckh justifies his choice to address clothing, situating his contribution outside of the rational, 'cause and effect' school of thought typified by Hume. After playfully jibing those historians who offer simple catalogues of different types of garments, Teufelsdröckh (literally, 'devil's shit') offers instead an account of the motivation behind clothing. The editor tells us that, for the Professor, the primary function of clothing is not 'warmth or decency, but ornament'. From ornament developed shame and other less tangible qualities; 'Clothes gave us individuality, distinctions, social polity; Clothes have made Men of us; they are threatening to make Clothes-screens of us'. The excerpt from Chapter XI, 'Prospective', offers perhaps the novel's clearest articulation of the analogy between clothing and spirit: as an 'unspeakably significant' emblem, clothes manifest the individual much like man manifests the divine spirit.*

Employing both the editor and Teufelsdröckh to control the novel's tone, Carlyle creates two levels of remove, allowing him the authorial distance to sharpen his satire. The idiosyncratic capitalization and diction – neologisms abound – are intended to mimic seventeenth- and eighteenth-century philosophical writing. First appearing over eight instalments in Fraser's Magazine *from November 1833 to August 1834, it was published in a single volume in 1836; the excerpts reprinted here, from Chapman and Hall's 1869 edition, include Carlyle's revisions.*

[1] ['*Sartor Resartus*'], *Sun* (London), 1 April 1834, p.2. To be fair, the critic continued, 'mixed, however, here and there, with passages marked by thought and striking poetic vigor'.

Book I, Chapter V, 'The World in Clothes', pp. 34–40

'As Montesquieu[2] wrote a *Spirit of Laws*', observes our Professor, 'so could I write a *Spirit of Clothes*; thus, with an *Esprit des Lois*, properly an *Esprit de Coutumes*, we should have an *Esprit de Costumes*.[3] For neither in tailoring nor in legislating does man proceed by mere Accident, but the hand is ever guided on by mysterious operations of the mind. In all his Modes, and habilatory endeavours, an Architectural Idea will be found lurking; his Body and Cloth are the site and materials whereon and whereby his beautified edifice, of a Person, is to be built. Whether he flow gracefully out in folded **mantles**, based on light sandals; tower-up in high headgear, from amid peaks, spangles and bell-**girdles**; swell-out in starched **ruffs**, **buckram** stuffings, and monstrous tuberosities; or firth himself into separate sections, and front the world an Agglomeration of four limbs,—will depend on the nature of such Architectural Idea: whether Grecian, Gothic, Later-Gothic, or altogether Modern, and Parisian or Anglo-Dandiacal.[4] Again, what meaning lies in Colour! From the soberest drab to the high-flaming scarlet, spiritual idiosyncrasies unfold themselves in choice of Colour: if the Cut betoken Intellect and Talent, so does the Colour betoken Temper and Heart. In all which, among nationals as among individuals, there is an incessant, indubitable, though infinitely complex working of Cause and Effect: every snip of the Scissors has been regulated and prescribed by ever-active Influences, which doubtless to Intelligences of a superior order are neither invisible nor illegible'.

'For such superior Intelligences a Cause-and-Effect[5] Philosophy of Clothes, as of Laws, were probably a comfortable winter-evening entertainment: nevertheless, for inferior Intelligences, like men, such Philosophies have always seemed to me uninstructive enough. Nay, what is your Montesquieu himself but a clever infant spelling Letters from a hieroglyphical prophetic Book, the lexicon of which lies in Eternity, in Heaven?—Let any Cause-and-Effect Philosopher explain, not why I wear such and such a Garment, obey such and a such a Law; but even why *I* am *here*, to wear and obey anything!—Much, therefore, if not the whole of that same *Spirit of Clothes* I shall suppress, as hypothetical, ineffectual, and even impertinent: naked Facts, and Deductions drawn therefrom in quite another than that omniscient style, are my humbler and proper province'.

Acting on which prudent restriction, Teufelsdröckh has nevertheless contrived to take-in a well-nigh boundless extent of field; at least, the boundaries too often lie quite beyond our horizon. Selection being indispensable, we shall here glance over his First Part only in a cursory manner. This First Part is, no doubt, distinguished by omnivorous learning, and utmost patience and fairness: at the same time, in its results and delineations, it is much more likely to interest the Compilers of some *Library* of General, Entertaining, Useful, or even Useless Knowledge than the miscellaneous readers of these pages. Was it this Part of the Book which Heuschrecke[6] had in view, when he recommended us to that joint-stock vehicle of publication, 'at present the glory of British Literature'?[7] If so, the Library Editors are welcome to dig in it for their own behoof.

[2] Montesquieu (1689–1755), French Enlightenment philosopher, published his *De l'esprit des loix* in 1748.

[3] *Esprit des Lois*: Fr. Spirit of Law; *Esprit de Coustumes*: Fr. Spirit of Customs; *Esprit de Costumes*: Fr. Spirit of Costume

[4] Anglo-Dandiacal: of the English dandy (a typical Carlylean neologism).

[5] Cause-and-Effect: rational philosophy associated with Enlightenment thinkers; Carlyle is critical of such thinking applied to the study of clothing, which might conclude, as in the previous sentence, that every change in fashion ('every snip of the [tailor's] Scissors) is the result of a discrete, knowable event.

[6] Fictional; friend of Teufelsdröckh.

[7] Encyclopaedia-type compendiums were increasingly popular following the success of Denis Diderot's (1713–84) *Encyclopédie*, which began publication in 1751.

To the First Chapter, which turns on Paradise and Figleaves, and leads us into interminable disquisitions of a mythological, metaphorical, cabalistico-sartorial and quite antediluvian case, we shall content ourselves with giving an unconcerned approval. Still less have we to do with 'Lilis, Adam's first wife, whom, according to Talmudists, he had before Eve, and who bore him, in that wedlock, the whole progeny of aerial, aquatic, and terrestrial Devils',—very needlessly, we think. On this portion of the Work, with its profound glances into the *Adam-Kadmon*,[8] or Primeaval Element, here strangely brought into relation with the *Nifl* and *Muspel* (Darkness and Light) of the antique North, it may be enough to say, that its correctness of deduction, and depth of Talmudic and Rabbinical lore have filled perhaps not the worst Hebraist in Britain with something like astonishment.

But, quitting this twilight region, Teufelsdröckh hastens from the Tower of Babel, to follow the dispersion of Mankind over the whole habitable and habilable globe. Walking by the light of Oriental, Pelasgiv, Scandinavian, Egyptian, Otaheitean, Ancient and Modern[9] researches of every conceivable kind, he strives to give us in compressed shape (as the Nürnbergers give an *Orbis Pictus*) an *Orbis Vestitus*;[10] or view of the costumes of all mankind, in all countries, in all times. It is here that to the Antiquarian, to the Historian, we can triumphantly say: Fall to! Here is learning: an irregular Treasury, if you will; but inexhaustible as the Hoard of King Nibelung,[11] which twelve wagons in twelve days, at the rate of three journeys a day, could not carry off. Sheepskin cloaks and wampum belts; phylacteries,[12] stoles, albs;[13] chlamydes,[14] togas, Chinese silks, Afghaun **shawls, trunk-hose**, leather **breeches**, Celtic philibegs[15] (though breeches, as the name *Gallia Braccata*[16] indicates, are the more ancient), **Hussar** cloaks, **Vandyke** tippets, ruffs, **fardingales**, are brought vividly before us,—even the Kilmarnock nightcap[17] is not forgotten. For most part, too, we must admit that the Learning, heterogeneous as it is, and tumbled-down quite pell-mell, is true concentrated and purified Learning, the drossy parts smelted out and thrown aside.

Philosophical reflections intervene, and sometimes touching pictures of human life. Of this sort the following has surprised us. The first purpose of Clothes, as our Professor imagines, was not warmth or decency, but ornament. 'Miserable indeed', says he, 'was the condition of the Aboriginal Savage, glaring fiercely from under the fleece of hair, which with the beard reached down to his loins, and hung round him like a matted cloak; the rest of his body sheeted in its thick natural fell. He loitered in the sunny glades of the forest, living on wild-fruits; or, as the ancient Caledonian, squatted himself in morasses, lurking for his bestial or human prey; without implements, without arms, save the ball of heavy Flint, to which, that his sole possession and defence might not be lost, he had attached a long cord of plaited thongs; thereby recovering as well as furling it with deadly unerring skill. Nevertheless, the pains of Hunger and Revenge once satisfied, his next care was not Comfort but Decoration (*Putz*).[18] Warmth he found in the toils

[8] *Adam-Kadmon*: Kabbalistic original or Primordial man.
[9] Pelasgiv: of the ancient Greek Pelasgians; Otaheitean: Tahitian.
[10] *Orbis Pictus*: 'World in Pictures', 1658 children's encyclopedia by John Amos Comenius (1592–1670); *Orbis Vestitus*: World in Clothes.
[11] King Nibelung: king in Germanic and Norse lore.
[12] Phylacteries: small leather boxes containing scripture on parchment, worn by Jewish men during prayer.
[13] Alb: floor-length clerical vestment.
[14] Chlamydes: cloak worn in Ancient Greece.
[15] Philibeg: small kilt.
[16] *Gallia Braccata*: Latin. literally, 'trousered Gaul', indicating those not governed by the Romans.
[17] Kilmarnock nightcap: traditional flat cap worn by Scottish peasants, similar to a tam-o'-shanter.
[18] *Putz*: German. now archaic: decoration.

of the chase; or amid dried leaves, in his hollow tree, in his bark shed, or natural grotto; but for Decoration he must have Clothes. Nay, among wild people, we find tattooing and painting even prior to Clothes. The first spiritual want of a barbarous man is Decoration, as indeed we still see among the barbarous classes in civilised countries'.

'Reader, the heaven-inspired melodious Singer; loftiest Serene Highness; nay thy own amber-locked, snow-and-rosebloom Maiden, worthy to glide sylphlike almost on air, whom thou lovest worshippest as a divine Presence, which, indeed, symbolically taken, she is,—has descended, like thyself, from that same hair-mantled, flint-hurling Aboriginal Anthropophagus![19] Out of the eater cometh forth meat; out of the strong cometh forth sweetness. What changes are wrought, not by Time, yet in Time! For not Mankind only, but all that Mankind does or beholds, is in continual growth, re-genesis and self-perfecting vitality. Cast forth thy Act, thy Word, into the ever-living, ever-working Universe: it is a seed-grain that cannot die; unnoticed today (says one), it will be found flourishing as a Banyan-grove (perhaps, alas, as a Hemlock-forest!) after a thousand years'.

'He who first shortened the labour of Copyists by device of *Movable Type* was disbanding hired Armies, and cashiering most Kings and Senates, and creating a whole new Democratic world: he had invented the Art of Printing.[20] The first ground handful of Nitre, Sulphur, and Charcoal drove Monk Schwartz's pestle through the ceiling:[21] what will the last do? Achieve the final undisputed prostration of Force under Though, of Animal courage under Spiritual. A simple invention it was in the old-world Grazier,—sick of lugging his slow Ox about the country till he got it bartered for corn or oil,—to take a piece of Leather, and thereon scratch or stamp the mere Figure of an Ox (or *Pecus*); put it in his pocket, and call it *Pecunia*, Money. Yet hereby did Barter grow Sale, the Leather Money is now Golden and Paper, and all miracles have been out-miracled: for there are Rothschilds[22] and English National Debts; and whoso has sixpence is sovereign (to the length of his sixpence) over all men; commands cooks to feed him, philosophers to teach him, kings to mount guard over him,—to the length of sixpence. Clothes too, which began in foolishest love of Ornament, what have they not become! Increased Security and pleasurable Heat soon followed: but what of these? Shame, divine Shame (*Schaam*, Modesty), as yet a stranger to the Anthropophagous bosom, arose there mysteriously under Clothes; a mystic grove-encircled shrine for the Holy in man. Clothes gave us individuality, distinctions, social polity; Clothes have made Men of us; they are threatening to make Clothes-screens of us'.

'But, on the whole', continues our eloquent Professor, 'Man is a Tool-using animal (*Handthierendes Their*). Weak in himself, and of small stature, he stands on a basis, at most for the flattest-soled, of some half-square foot, insecurely enough; has to straddle out the legs, lest the very wind supplant him. Feeblest of bipeds! Three quintals[23] are a crushing load for him; the steer of the meadow tosses him aloft, like a waste rag. Nevertheless he can use Tools, can devise Tools: with these the granite mountain melts into light dust before him; he kneads slowing iron, as if it were soft paste; seas are his smooth highway, winds and fire his unwearying steeds. Nowhere do you find him without Tools; without Tools he is nothing, with Tools he is all'.

[19] Anthropophagus: cannibal, man-eater.

[20] Although movable type was used by printers in ancient China, its Western introduction is credited to Johannes Gutenberg (*c*.1398–1468), whose printing press (*c*.1440) used metal type.

[21] German alchemist Berthold Schwarz (*c*. late 14th century) discovered the recipe for gunpowder and was credited across Europe with its discovery, though it, like movable type, had been in use for centuries in the far East.

[22] German banking family who were, at the time of *Sartor Resartus*, among the richest in the world.

[23] Quintal: one hundred weight, usually one hundred pounds or kilograms.

Here may we not, for a moment, interrupt the stream of Oratory with a remark, that this Definition of the Tool-using Animal appears to us, of all that Animal-sort, considerably the precisest and best? Man is called a Laughing Animal: but do not the apes also laugh, or attempt to do it; and is the manliest man the greatest and oftenest laugher? Teufelsdröckh himself, as we said, laughed only once. Still less do we make of that other French Definition of the Cooking Animal;[24] which, indeed, for rigorous scientific purposes, is as good as useless. Can a Tartar be said to cook, when he only readies his steak by riding on it? Again, what Cookery does the Greenlander use, beyond stowing-up his whale-blubber, as a marmot, in the like case, might do? Or how would Monsieur Ude[25] prosper among those Orinocco Indians who, according to Humboldt, lodge in crow-nests, on the branches of trees; and, for half the year, have no victuals but pipe-clay, the whole country being under water? But, on the other hand, show us the human being, of any period or climate, without his Tools: those very Caledonians,[26] as we saw, had their Flint-ball, and Thong to it, such as no brute has or can have.

'Man is a Tool-using Animal', concludes Teufelsdröckh in his abrupt way; 'of which truth Clothes are but one example: and surely if we consider the interval between the first wooded Dibble[27] fashioned by man, and those Liverpool Steam-carriages,[28] or the British House of Commons, we shall note what progress he has made. He digs up certain black stones from the bosom of the earth, and says to them, *Transport me and this luggage at the rate of five-and-thirty miles an hour*; and they do it: he collects, apparently by lot, six-hundred and fifty-eight miscellaneous individuals, and says to them, *Make this nation toil for us, bleed for us, hunger and sorrow and sin for us*; and they do it'.

Book I, Chapter XI, 'Prospective', pp. 68–71

The Philosophy of Clothes is now to all readers, as we predicted it would do, unfolding itself into new boundless expansions, of a cloudcapt, almost chimerical aspect, yet not without azure loomings in the far distance, and streaks as of an Elysian brightness; the highly questionable purport and promise of which it is becoming more and more important for us to ascertain. Is that a real Elysian brightness, cries many a timid wayfarer, or the reflex of Pandemonian lava? Is it of a truth leading us into beatific Asphodel meadows, or the yellow-burning marl of a Hell-on-Earth?

Our Professor, like other Mystics, whether delirious or inspired, gives an Editor enough to do. Ever higher and dizzier are the heights he leads us to; more piercing, all-comprehending, all-confounding are his views and glances. For example, this of Nature being not an Aggregate but a Whole:—

[24] Any French origin is unclear; the line comes from James Boswell's journal: 'My definition of man is, "a cooking animal". The beasts have memory, judgment, and all the faculties and passions of our mind, in a certain degree; but no beast is a cook' (*The Life of Samuel Johnson, including a Journal of a Tour to the Hebrides*, ed. John Wilson Croker, 5 vols [London: John Murray, 1831], p. 269).

[25] Louis-Eustache Ude (*c*.1769–1846) served as chef in the kitchen of Louis XVI and Napoleon's mother before moving to London; he wrote *The French Cook* in 1815.

[26] Caledonians: ancient people of Caledonia, now Scotland.

[27] Dibble: n. tool for making holes in the ground.

[28] An example of cutting-edge technology, the successful, steam-powered Liverpool and Manchester Railway opened in 1830, providing passengers with fast and economical travel between the two cities.

'Well sang the Hebrew Psalmist: "If I take the wings of the morning and dwell in the uttermost parts of the Universe, God is there".[29] Thou thyself, O cultivated reader, who too probably art no Psalmist, but a Prosaist, knowing GOD only by tradition, knowest thou any corner of the world where at least FORCE is not? The drop which thou shakest from thy wet hand, rests not where it falls, but to-morrow thou findest it swept away; already on the wings of the North-wind, it is nearing the Tropic of Cancer. How came it to evaporate, and not lie motionless? Thinkest thou there is aught motionless; without Force, and utterly dead?'

'As I rode through the Schwarzwald, I said to myself: That little fire which glows star-like across the dark-growing (*nachtende*) moor, where the sooty smith bends over his anvil, and thou hopest to replace thy lost horse-shoe,—is it a detached, separated speck, cut off from the whole Universe; or indissolubly joined to the whole? Thou fool, that smithy-fire was (primarily) kindled at the Sun; is fed by air that circulates from before Noah's Deluge, from beyond the Dog-star; therein, with Iron Force, and Coal Force, and the far stranger Force of Man, are cunning affinities and battles and victories of Force brought about; it is a little ganglion, or nervous centre, in the great vital system of Immensity. Call it, if thou wilt, an unconscious Altar, kindled on the bosom of the All; whose iron sacrifice, whose iron smoke and influence reach quite through the All; whose dingy Priest, not by word, yet by brain and sinew, preaches forth the mystery of Force; nay preaches forth (exoterically enough) one little textlet from the Gospel of Freedom, the Gospel of Man's Force, commanding, and one day to be all-commanding'.

'Detached, separated! I say there is no such separation: nothing hitherto was ever stranded, cast aside; but all, were it only a withered leaf, works together with all; is borne forward on the bottomless, shoreless flood of Action, and lives through perpetual metamorphoses. The withered leaf is not dead and lost, there are Forces in it and around it, though working in inverse order; else how could it rot? Despise not the rag from which man makes Paper, or the litter from which the earth makes Corn. Rightly viewed no meanest object is insignificant; all objects are as windows, through which the philosophic eye looks into Infinitude itself'.

Again, leaving that wondrous Schwarzwald Smithy-Altar, what vacant, high-sailing air-ships are these, and whither will they sail with us?

'All visible things are emblems; what thou seest is not there on its own account; strictly taken, is not there at all: Matter exists only spiritually, and to represent some Idea, and *body* it forth. Hence Clothes, as despicable as we think them, are so unspeakably significant. Clothes, from the King's **mantle** downwards, are emblematic, not of want only, but of a manifold cunning Victory over Want. On the other hand, all Emblematic things are properly Clothes, thought-woven or hand-woven: must not the Imagination weave Garments, visible Bodies, wherein the else invisible creations and inspirations of our Reason are, like Spirits, revealed, and first become all-powerful; the rather if, as we often see, the Hand too aid her, and (by wool Clothes or otherwise) reveal such even to the outward eye?'

'Men are properly said to be clothed with Authority, clothed with Beauty, with Curses, and the like. Nay, if you consider it, what is Man himself, and his whole terrestrial Life, but an Emblem; a Clothing or visible Garment for that divine ME of his, cast hither, like a light-particle, down from Heaven? Thus is he said also to be clothed with a Body'.

'Language is called the Garment of Thought: however, it should rather be, Language is the Flesh-Garment, the Body, of Thought. I said that Imagination wove this Flesh-Garment; and does not she? Metaphors are her stuff: examine Language; what, if you except some few primitive

[29] Psalm 139:9.

elements (of natural sound), what is it all but Metaphors, recognized as such, or no longer recognized; still fluid and florid, or now solid-grown and colorless? If those same primitive elements are the osseous fixtures in the Flesh-Garment, Language,—then are Metaphors its muscles and tissues and living integuments. An unmetaphorical style you shall in vain seek for: is not your very *Attention* a *Stretching-to*?[30] The difference lies here: some styles are lean, adust, wiry, the muscle itself seems osseous; some are even quite pallid, hunger-bitten and dead-looking; while others again glow in the flush of health and vigorous self-growth, sometimes (as in my own case) not without an apoplectic tendency. Moreover, there are sham Metaphors, which overhanging that same Thought's-Body (best naked), and deceptively bedizening, or bolstering it out, may be called its false stuffings, superfluous show-cloaks (*Putz-Mantel*), and tawdry woollen rags: whereof he that runs and reads may gather whole hampers,—and burn them'.

Than which paragraph on Metaphors did the reader ever chance to see a more surprisingly metaphorical? However, that is not our chief grievance; the Professor continues:—

'Why multiply instances? It is written, the Heavens and the Earth shall fade away like a Vesture; which indeed they are: the Time-vesture of the Eternal. Whatsoever sensibly exists, whatsoever represents Spirit to Spirit, is properly a Clothing, a suit of Raiment, put on for a season, and to be laid off. Thus in this one pregnant subject of CLOTHES, rightly understood, is included all that men have thought, dreamed, done, and been: the whole External Universe and what it holds is but Clothing; and the essence of all Science lies in the PHILOSOPHY OF CLOTHES'.

[30] 'Attend' and 'attention' are derived from the Old French '*atendre*', from the Latin *adtendere*, 'to stretch'.

2

Sarah Stickney Ellis, from 'Dress and Manners' in *The Women of England, Their Social Duties, and Domestic Habits*, pp. 89–101, London: Fisher, Son, & Co., 1839

Sarah Stickney Ellis (1799–1872) produced a range of creative work, from illustrations through to anti-slavery narratives, but is best known for her didactic writing. The Women of England, *the first of her very successful conduct manuals, forwards advice that emphasizes Christian morals and practical common sense. In the following selection, Ellis eschews vanity, maintaining that a woman's clothing is representative of her interiority. The most charming accomplishments or intellectual achievements are undermined by a 'soiled hem' or 'tattered frill', as 'imagination naturally carries the observer to her dressing-room, her private habits, and even to her inner mind, where it is almost impossible to believe that the same want of order and purity does not prevail'. It follows that tidiness and restraint in dress are indicative of similarly positive personal qualities. Ellis argues that the niceties of 'dress and manners' might seem to be 'minute' points that 'scarcely seem to bear upon the great object of doing good', but that they are in fact the means by which women can exert influence in their sphere.*

THAT the extent of woman's influence is not always commensurate with the cultivation of her intellectual powers, is a truth which the experience and observation of every day tend to conform; for how often do we find that a lavish expenditure upon the means of acquiring knowledge is productive of no adequate result in the way of lessening the sum of human misery!

When we examine the real state of society, and single out the individuals whose habits, conversation, and character produce the happiest effect upon their fellow-creatures, we invariably find them persons who are *morally*, rather than intellectually great; and consequently the profession of genius is, to a woman, a birthright of very questionable value. It is a remark, not always charitably made, but unfortunately too true, that the most talented women are not the most agreeable in their domestic capacity: and frequent and unsparing are the batteries of sarcasm and wit, which consequently open upon our unfortunate *blues*![1] It should be

[1] Literary or intellectual women were referred to as 'bluestockings'; originally descriptive, it often has a pejorative connotation today.

remembered, however, that the evil is not in the presence of one quality, but in the absence of another; and we ought never to forget the redeeming excellence of those signal instances, in which the moral worth of the female character, is increased and supported by intellectual power. If, in order to maintain a beneficial influence in society, superior talent, or even a high degree of learning, were required, solitary and insignificant would be the lot of some of the most social, benevolent, and noble-hearted women, who now occupy the very centre of attraction within their respective circles, and claim from all around them a just and appropriate tribute of affection and esteem.

It need scarcely be repeated, that although great intellectual attainments are by no means the highest recommendation that a woman can possess, the opposite extreme of ignorance, or natural imbecility of mind, are effectual barriers to the exercise of any considerable degree of influence in society. An ignorant woman who has not the good sense to keep silent, or a weak woman pleased with her own prattle, are scarcely less annoying than humiliating to those who, from acquaintance or family connexion, have the misfortune to be identified with them: yet it is surprising how far a small measure of talent, or of mental cultivation, may be made to extend in the way of giving pleasure, when accompanied by good taste, good sense, and good feeling, especially with that feeling which leads the mind from self and selfish motives, into an habitual regard to the good and the happiness of others.

The more we reflect upon this subject, the more we must be convinced, that there is a system of discipline required for women, totally distinct from what is called the learning of the schools, and that, unless they can be prepared for their allotment in life by some process calculated to fit them for performing its domestic duties, the time bestowed upon their education will be found, in after life, to have been wholly inadequate to procure for then either habits of usefulness, or a healthy tone of mind.

It would appear from a superficial observation of the views of domestic and social duty about to be presented, that in the estimation of the writer, the great business of a woman's life was to make herself agreeable; for so minute are some of the points which properly engage her attention that they scarcely seem to bear upon the great object of doing good. Yet when we reflect that by giving pleasure in an innocent and unostentatious manner, innumerable channels are opened for administering instruction, assistance or consolation, we cease to regard as insignificant the smallest of those means by which a woman can render herself an object either of affection or disgust.

First, then, and most familiar to common observation, is her personal appearance; and in this case, vanity, more potent in woman's heart than selfishness, renders it an object of general solicitude to be so adorned as best to meet and gratify the public taste. Without inquiring too minutely into the motive, the custom, as such, must be commended; for, like many of the minor virtues of women, though scarcely taken note of in its immediate presence, it is sorely missed when absent. A careless or slatternly woman, for instance, is one of the most repulsive objects in creation; and such is the force of public opinion in favour of the delicacies of taste and feeling in the female sex, that no power of intellect, or display of learning, can compensate to men, for the want of nicety or neatness in the women with whom they associate in domestic life. In vain to them might the wreath or laurel wave in glorious triumph over locks uncombed; and wo betide the heroine, whose stocking, even of the deepest blue, betrayed a lurking hole!

It is, however, a subject too serious for jest, and ought to be regarded by all women with earnest solicitude, that they may constantly maintain in their own persons that strict attention to good taste and delicacy of mind; a quality without which no woman ever was, or ever will be, charming. Let her appear in company with what accomplishments she may be, let her charm by her musical talents, attract by her beauty, or enliven by her wit, if there steal from underneath

her graceful drapery, the soiled hem, the tattered frill, or even the coarse garment out of keeping with her external finery, imagination naturally carries the observer to her dressing-room, her private habits, and even to her inner mind, where it is almost impossible to believe that the same want of order and purity does not prevail.

It is a prevalent but most injurious mistake, to suppose that all women must be splendidly and expensively dressed, to recommend themselves to general approbation. In order to do this, how many, in the sphere of life to which these remarks apply, are literally destitute of comfort, both in their hearts and in their homes; for the struggle between parents and children, to raise the means on one hand, and to obtain them either by argument or subterfuge on the other, is but one among the many sources of family discord and individual suffering, which mark out the excess of artificial wants, as the great evil of the present times.

A very slight acquaintance with the sentiments and tone of conversation familiar amongst men, might convince all those minds are open to conviction, that *their* admiration is not to be obtained by the display of any kind of extravagance in dress. There may be occasional instances of the contrary, but the praise most liberally and uniformly bestowed by men upon the dress of women, is, that it is neat, becoming, or in good taste.

The human mind is often influenced by association, while immediate impression is all that it takes cognizance of at the moment. Thus a splendidly dressed woman entering the parlour of a farm-house or a tradesman's drawing-room, bursts upon the sight as an astounding and almost monstrous spectacle; and we are scarcely aware that the repulsion we instantaneously experience, arises from a secret conviction of how much the gorgeous fabric must have cost the wearer, in time, and thought, and money; especially when we know that the same individual is under the necessity of spending her morning hours in culinary operations, and is, or ought to be, the sharer of her husband's daily toil.

There is scarcely any object in art or nature, calculated to excite our admiration, which may not, from being ill-placed, excite our ridicule or disgust. Each individual article of clothing worn by this woman, may be superb in itself, but there is a want of fitness and harmony in the whole, from which we turn away.

Perhaps there are no single objects in themselves so beautiful as flowers, and it might seem difficult to find a situation in which they could be otherwise; yet I have seen—and seen with a feeling almost like pity—at the conclusion of a feast, fair rose-leaves and sweet jessamine floating amidst such inappropriate elements, that all their beauty was despoiled, and they were fit only to be cast away with the refuse of gross matter in which they were involved.

Admiration of a beautiful object, how intense soever it may be, cannot impart that high tone of intellectual enjoyment which arises from our admiration of fitness and beauty combined; and thus the richest silk, and the finest **lace**, when inappropriately worn, are beautifully manufactured articles, but nothing more. While, therefore, on the one hand, there is a moral degradation in the consciousness of wearing soiled or disreputable garments, or in being in any way below the average of personal decency, there is, on the other, a gross violation of good taste, in assuming for the middle classes of society, whose occupations are closely connected with the means of bodily subsistence, the same description of personal ornament as belongs with more propriety to those who enjoy the luxury of giving orders, without any necessity for further occupation of time and thought.

The most frequently recurring perplexities of woman's life arises from cases which religion does not immediately reach, and in which she is still expected to decide properly and act agreeably, without any other law than that of good taste for her guide. Good taste is therefore most essential to the regulation of her dress and general appearance; and wherever any striking

violation of this principle appears, the beholder is immediately impressed with the idea that a very important rule of her life and conduct is wanting. It is not all who possess this guide within themselves; but an attentive observation of human life and character, especially a due regard to the beauty of fitness, would enable all to avoid giving offence in this particular way.

The regard to fitness here recommended, is a duty of much more serious importance than would at first sight appear, since it involves a consideration which cannot too often be presented to the mind, of what, and who we are?—what is the station we are appointed to fill, and what the objects for which we are living!

Behold yon gorgeous fabric in the distance, with its rainbow hues, and gems, and shining drapery,

'And flowers the fairest that might feast the bee'.[2]

A coronet of beauty crowns the whole, and feathery ornaments, on frail silvery threads, glitter, and wave, and tremble at every moving breath. Surely the countenance of Flora blooms below, and Zephyrus[3] suspends his gentle wings at her approach. The spectacle advances. It is not health, nor youth, not beauty that we see; but poor, decrepit, helpless, miserable old age. We gaze, and a shudder comes over us, for Death is grinning in the back ground, and we hear his voice triumphantly exclaiming, 'This is mine!'

Look at that moving garden, and those waving plumes, as they pass along the aisle of the church or the chapel. They form the adornment of a professedly Christian woman, the mother of a family; and this is the day appointed for partaking of that ordinance to which Christians are invited to come in meekness and lowliness of spirit, to commemorate the love of their Redeemer, who, though he was rich, for their sakes became poor—who humbled himself, and became obedient unto death, to purchase their exemption from the penalty of sin, and the bondage of the world.

We would earnestly hope that, in the greater number of such cases as these, the error is in the judgment—the mockery thoughtlessly assumed: but would not the habit of self-examination, followed up by serious inquiry respecting our real and individual position in society, as moral agents, and immortal beings, be a likely means of averting the ridicule that age is ill prepared to bear; and, what is of infinitely more consequence, of preventing the scandal that religion has too much cause to charge upon her friends?

It frequently happens that women in the middle class of society are not entirely free from provincialisms in their manner of speaking, as well as other peculiarities, by which it may easily be discovered that their interests are local, and their means of information of limited extent; in short, that they are persons who have but little acquaintance with the polite or fashionable world, and yet they may be persons highly estimable and important in their own sphere. Very little either of esteem or importance, however, attaches to their characters, where their ingenuity is taxed to maintain what they believe to be a fashionable or elegant exterior, and which, in connexion with their unpolished dialect and homely occupations, renders them but too much like the chimney-sweepers' queen decked out for a May-day exhibition.[4] The invidious question unavoidably occurs to the beholder—for what or for whom has such a person mistaken herself? while, had she been dressed in a plain substantial costume, corresponding with her mind and

[2] Ellis slightly misquotes Byron's *Lara*: 'And flowers the fairest that may feast the bee' (Canto I, X.162).
[3] Flora is the Roman goddess of flowers and Zephyrus the Greek god of the west wind.
[4] May Day, celebrated on 1 May, traditionally honours springtime with dancing and other festivities.

habits, she might have been known at once, and respected for what she really was, —a rational, independent, and valuable member of society.

It is not, by any means, the smallest of the services required by Christian charity, to point out to our fellow-countrymen how they may avoid being ridiculous. Perhaps a higher degree of intellectual dignity would raise us all above the weakness of being moved to laughter by so slight a cause. But such is the constitution of the general order of minds, that they are less entertained by the most pointed witticisms, than by those striking contrasts and discrepancies, which seem to imply that rusticity has mistaken itself for elegance, deformity for beauty, age for youth. I pretend not to defend this propensity to turn so serious a mistake into jest. I merely say that such propensity does exist, and, what is amongst the anomalies of our nature, that it sometimes exhibits itself most unreservedly in the very individuals who in their turn are furnishing food for merriment to others.

The laughing philosopher might have reasoned thus, 'Let them all laugh on, they will cure each other'.[5] But the question is—Does ridicule correct the evil? Most assuredly it does not. It does something more, however. It rankles like a poison in the bosom where it falls, and destroys the peace of many an amiable but ill-judging candidate for public admiration. Women, especially, are its victims and its prey; and well do they learn, under the secret tutelage of envy, jealousy, and pride, how to make this engine of discord play upon each other.

When we listen to the familiar conversation of women, especially those whose minds are tainted by vulgarity, and unenlightened by the higher principles of religion, we find that a very large portion of their time and attention is bestowed upon the subject of dress—not of their own dress merely, but of that of their neighbours; and looking farther, we find, what is more astonishing, that there exists in connexion with the same subject, a degree of rivalry and ambition which call forth many of the evil passions that are ever ready to spring into action, and mar the pleasant pictures of social life. In awakening these, the ridicule already alluded to is a powerful agent; for, like the most injurious of libels, it adheres so nearly to the truth, as to set contradiction at defiance. Thus, there are few persons who would not rather be maligned than ridiculed; and thus the wounds inflected by ridicule are the most difficult to heal, and the last to be forgiven.

Surely, then, it is worth paying regard to the principles of fitness and consistency, in order to avoid the consequences necessarily resulting from every striking deviation from these rules, and the women of England possess many advantages in the cultivation of their natural powers of discrimination and reason, for enabling them to ascertain the precise position of this line of conduct, which it is so important to them to observe. They are free from many of the national prejudices entertained by the women of other countries, and they enjoy the inestimable privilege of being taught to look up to a higher standard of morals, for the right guidance of their conduct. It is to them, therefore, that we look for what rational and useful women ought to be, not only in the essentials of Christian character, but in the minor points of social, domestic, and individual duty.

[5] Democritus (c. 460–c. 370BC) was known as the Laughing Philosopher for his mocking regard of human frailties.

3

George H. Darwin, 'Development in Dress', *Macmillan's Magazine* 26 (September 1872), pp. 410–16

Sir George Howard Darwin (1845–1912), son of Charles Darwin (1809–96), displayed early aptitude for the natural sciences and, after abandoning the law as a profession due to ill health, was a successful geologist and mathematician, elected fellow of the Royal Society in 1879 and the Plumian chair of Astronomy and Experimental Philosophy at Cambridge from 1883. This early essay, published years before his major scientific articles, builds upon the idea of sexual selection developed in his father's recent evolutionary treatise, The Descent of Man *(1871). In it, the elder Darwin establishes analogies between humans' behaviour towards fashion and the courting rituals of animals: 'As any fleeting fashion in dress comes to be admired by man, so with birds a change of almost any kind in the structure or colouring of the feathers om the male appears to have been admired by the female'.[1] George Darwin focuses here only on men's dress to argue that evolutions in fashion have many of the same characteristics as those in the natural world, as demanded by use and as evidenced by vestigial ornament. Throughout, he employs anthropomorphic diction to describe changes in clothing: button holes 'die away' and buttons 'trace their pedigree', his rhetoric echoing his argument.*

The development of dress presents a strong analogy to that of organisms, as explained by the modern theories of evolution; and in this article I propose to illustrate some of the features which they have in common. We shall see that the truth expressed by the proverb, 'Natura non facit saltum',[2] is applicable in the one case as in the other; the law of progress holds good in dress, and forms blend into one another with almost complete continuity. In both cases a form yields to a succeeding form, which is better adapted to the then surrounding conditions; thus, when it ceased to be requisite that men in active life should be ready to ride at any moment, and

[1] Charles Darwin, *The Descent of Man, and Selection in Relation to Sex*, 2 vols (London: John Murray, 1871), vol. 2, p. 74.

[2] Natura non facit saltum: Latin. 'Nature does not make jumps', attributed to Gottfried Wilhelm Leibniz (1646–1716) but regarded as a foundational idea in natural history. Charles Darwin notes that 'we meet with this admission in the writing of almost every experienced naturalist'. *On the Origin of Species* (London: John Murray, 1859), p. 194.

when riding had for some time ceased to be the ordinary method of travelling, knee **breeches** and boots yielded to trousers. The **'Ulster Coat'**, now so much in vogue, is evidently largely fostered by railway travelling, and could hardly have flourished in the last century, when men either rode or travelled in coaches, where there was no spare room for any very bulky garment.

A new invention bears a kind of analogy to a new variation in animals; there are many such inventions, and many such variations; those that are not really beneficial die away, and those that are really good become incorporated by 'natural selection',[3] as a new item in our system. I may illustrate this by pointing out how **macintosh**-coats and **crush-hats** have become somewhat important items in our dress.

Then, again, the degree of advancement in the scale of dress may be pretty accurately estimated by the extent to which various 'organs'[4] are specialized. For example, about sixty years ago, our present evening-dress was the ordinary dress for gentlemen; top-boots, always worn by old-fashioned 'John Bull'[5] in *Punch*'s cartoons, are now reserved for the hunting-field; and that the red coat was formerly only a best coat, appears from the following observations of 'a Lawyer of the Middle Temple', in No. 129 of the *Spectator*: 'Here (in Cornwall) we fancied ourselves in Charles II.'s reign, the people having made little variations in their dress since that time. The smartest of the country squires appear still in the **Monmouth cock**; and when they go awooing (whether they have any post in the militia or not) they put on a red coat'.[6]

But besides the general adaptation of dress above referred to, there is another influence which has perhaps a still more important bearing on the development of dress, and that is fashion. The love of novelty, and the extraordinary tendency which men have to exaggerate any peculiarity, for the time being considered a mark of good station in life, or handsome in itself, give rise I suppose to fashion. This influence bears no distant analogy to the 'sexual selection', on which so much stress has recently been laid in the *Descent of Man*.[7] Both in animals and dress, remnants of former stages of development survive to a later age, and thus preserve a tattered record of the history of their evolution.

These remnants may be observed in two different stages or forms. 1st. Some parts of the dress have been fostered and exaggerated by the selection of fashion, and are then retained and crystallized, as it were, as part of our dress, notwithstanding that their use is entirely gone (e.g. the embroidered pocket-flaps in a court uniform, now sewn fast to the coat). 2ndly. Parts originally useful have ceased to be of any service, and have been handed down in an atrophied condition.

The first class of cases have their analogue in the peacock's tail, as explained by sexual selection; and the second in the wing of the apteryx, as explained by the effects of disuse.[8]

[3] Charles Darwin's principle, articulated in *On the Origin of Species*, that individuals best suited to their environment will be most likely to reproduce; heritable advantageous traits will thus be passed on to future generations.

[4] George Darwin is analogizing by again borrowing phrasing from *Origin of Species*, comparing the functional part of clothing to 'organs' in living creatures.

[5] John Bull is an imaginary figure used to personify England and Englishness, usually depicted in cartoons as a stout man in a **Regency** cutaway jacket, often with a Union Jack **waistcoat** and – as Darwin suggests – boots; satirist John Arbuthnot (1667–1735) invented the figure, but it quickly came to be widely used.

[6] [Author's foot note: See p. 356 of Fairholt's 'Costume in England': London, 1846.] Frederick William Fairholt (bap. 1813–66) both wrote and lavishly illustrated his *Costume in England: A History of Dress from the Earliest Period till the Close of the Eighteenth Century* (London: Chapman and Hall, 1846).

[7] See headnote.

[8] In Darwin's *Descent of Man*, he writes of the male peacock's extraordinary plumage, 'Many female progenitors of the peacock must, during a long line of descent, have appreciated this superiority; for they have unconsciously, by the continued preference of the most beautiful males, rendered the peacock the most splendid of living birds' (vol. 2, p. 141); the apteryx is a flightless bird and its wing is, as Darwin writes in *On the Origin of Species*, 'quite useless' (4th edition, London: John Murray, 1866), p. 536.

Of the second kind of remnant Mr. Tylor gives very good instances when he says:[9] 'The ridiculous little tails of the German postillion's coat show of themselves how they came to dwindle to such absurd rudiments; but the English clergyman's bands no longer convey their history to the eye, and look unaccountable enough till one has seen the intermediate stages through which they came down from the more serviceable wide collars, such as Milton wears in his portraits, and which gave their name to the 'band-box' they used to be kept in'. These collars are curiously enough worn to this day by the choristers of Jesus College, Cambridge.

According to such ideas as these it becomes interesting to try to discover the marks of descent in our dresses, and in making this attempt many things apparently meaningless may be shown to be full of meaning.

Women's dress retains a general similarity from age to age, together with a great instability in details, and therefore does not afford so much subject for remark as does men's dress. I propose, therefore, to confine myself almost entirely to the latter, and to begin at the top of the body, and to work downwards through the principal articles of clothing.

HATS. — Hats were originally made of some soft material, probably of cloth or leather, and in order to make them fit the head, a cord was fastened round them, so as to form a sort of contraction. This is illustrated on p. 524 of Fairholt's *Costume in England*, in the figure of the head of an Anglo-Saxon woman, wearing a hood bound on with a head-band; and on p. 530 are figures of several hats worn during the fourteenth century, which were bound to the head by rolls of cloth; and all the early hats seem provided with some sort of band (see fig. 1.1a–b). We may trace the remnants of this cord or band in the present hat-band. A similar survival may be observed in the strings of the **Scotch-cap**, and even in the mitre of the bishop.[10]

It is probable that the hat-band would long ago have disappeared had it not been made use of for the purpose of hiding the seam joining the crown to the brim. If this explanation of the retention of the hat-band is the true one, we have here a part originally of use for one purpose applied to a new one, and so changing its function; a case which has an analogy to that of the development of the swimming-bladders of fishes, used to give them lightness in the water, into the lungs of mammals and birds, used as the furnace for supporting animal heat.

The duties of the hat-band have been taken in modern hats by two running strings fastened to the lining, and these again have in their turn become obsolete, for they are now generally represented by a small piece of string, by means of which it is no longer possible to make the hat fit the head more closely.

The ancestor from which our present **chimney-pot hat** takes most of its characteristics is the broad-brimmed low-crowned hat, with an immense plume falling down on to the shoulder, which was worn during the reign of Charles II.[11] At the end of the seventeenth, and during the eighteenth century, this hat was varied by the omission of the plume, and by giving of the brim various 'cocks'.[12] That these 'cocks' were formerly merely temporary is shown by Hogarth's picture of Hudibras beating Sidrophel and his man Whacum, where there is a hat, the brim of which is buttoned up in front to the crown with three buttons. This would be a hat of the

[9] [Author's footnote: P. 16, vol. i., of 'Primitive Culture', London, 1871.] Darwin quotes with slight variation p. 16 of Edward B. Taylor's *Primitive Culture: Researches into the Development of Mythology, Philosophy, Religion, Art, and Custom* (London: John Murray, 1871).

[10] [Author's footnote: For the origin of this curious head-dress, see Fairholt, p. 564.] The mitre, as worn by bishops in the Anglican and Catholic churches, is a tall ceremonial cap with flat-profiled crown rising to a distinctive point.

[11] [Author's footnote: See Fairholt, p. 540.]

[12] Cock: turning up of a hat's brim.

FIGURE 1.1 *Figures from Frederick William Fairholt,* Costume in England: A History of Dress from the Earliest Period till the Close of the Eighteenth Century *(London: Chapman and Hall, 1846), a: p. 254; b: p. 311; c: p. 524; d: p. 530.*

seventeenth century. Afterwards, during the eighteenth century, the brim was bent up in two or three places, and notwithstanding that these 'cocks' became permanent, yet the hats still retained the marks of their origin in the button and strap on the right side. The **cockade**, I imagine, took its name from its being a badge worn on one of the 'cocks'.

The modern cocked-hat, apparently of such an anomalous shape, proves, on examination, to be merely a hat of the shape above referred to; it appears further that the right side was bent up at an earlier date than the left, for the hat is not symmetrical, and the 'cock' on the right side forms a straight crease in the (quondam[13]) brim, and that on the left is bent rather over the crown, thus making the right side of the hat rather straighter than the left. The hat-band here remains in the shape of two gold tassels, which are just visible within the two points of the cocked-hat.

A bishop's hat shows the transition from the three cocked hat to our present chimney-pot; and because sixty years ago beaver-fur was the fashionable material for hats, we must now needs wear a silken imitation, which could deceive no one into thinking it fur, and which is bad to resist the effects of weather. Even in a lady's **bonnet** the elements of brim, crown, and hat-band may be traced.

The '**busby**' of our hussars[14] affords a curious instance of survival. It would now appear to be merely a fancy headdress, but on inspection it proves not to be so. The hussar was originally a Hungarian soldier, and he brought his hat with him to our country. I found the clue to the meaning of the hat in a picture of a Hungarian peasant. He wore a red night-cap, something like that worn by our brewers' men, or by a Sicilian peasant, but the cap was edged with so broad a band of fur, that it made in fact a low 'busby'. And now in our hussars the fur has grown enormously, and the bag has dwindled into a flapping ornament, which may be detached at pleasure. Lastly, in the new 'busby' of the Royal Engineers the bag has vanished, although the top of the cap (which is made of cloth and not of fur) is still blue, as was the bag formerly; the top cannot, however, be seen, except from a bird's-eye point of view.

It appears that all cockades and plumes are worn on the left side of the hat, and this may, I think, be explained by the fact that a large plume, such as that worn in the time of Charles II., or that of the modern Italian Bersaglieri,[15] would impede the free use of the sword; and this same explanation would also serve to show how it was that the right side of the hat was the first to receive a 'cock'. A London servant would be little inclined to think that he wears his cockade on the left side to give his sword-arm full liberty.

COATS. — Everyone must have noticed the nick in the folded collar of the coat and of the waistcoat; this is of course made to allow for the buttoning round the neck, but it is in the condition of a rudimentary organ, for the nick would probably not come into the right place, and in the waistcoat at least there are usually neither the requisite buttons nor button-holes.

'The modern gentleman's coat may be said to take its origin from the **vest**, or long outer garment, worn towards the end of the reign of Charles II'.[16] This vest seems to have had no gathering at the waist, and to have been buttoned all down the front, and in shape rather like a loose bag; to facilitate riding it was furnished with a slit behind, which could be buttoned up at pleasure; the button-holes were embroidered, and in order to secure similarity of embroidery on each side of the slit, the buttons were sewn on to a strip of **lace** matching the corresponding button-hole on

[13] Quondam: formerly.
[14] Hussar: light cavalry soldier.
[15] Bersaglieri: rifleman.
[16] [Author's footnote: Fairholt, p. 479.]

the other side. These buttons and button-holes left their marks in the coats of a century later in the form of gold lacing on either side of the slit of the tails.

In about the year 1700, it began to be the fashion to gather in the vest or coat at the waist, and it seems that this was first done by two buttons near the hips being buttoned to loops rather nearer to the edge of the coat, and situated at about the level of the waist. Our soldiers much in the same manner now make a waist in their loose overcoats, by buttoning a short strap to two buttons, placed a considerable distance apart on the back.

This old fashion is illustrated in a figure dressed in the costume of 1696, in an old illustration of the *Tale of the Tub*,[17] and also in the figure of a dandy smelling a nosegay, in Hogarth's[18] picture, entitled 'Here Justice triumphs in his Easy Chair', &c., as well as elsewhere. Engravings of this transition period of dress are, however, somewhat rare, and it is naturally not common to be able to get a good view of the part of the coat under the arms. This habit of gathering in the waist will, I think, explain how it was that, although the buttons and button-holes were retained down the front edges, the coat came to be worn somewhat open in front.

The coat naturally fell in a number of **plaits** or folds below these hip buttons; but in most of Hogarth's pictures, although the buttons and plaits remain, yet the creases above the buttons disappear, and seams appear to run from the buttons up under the arms. It may be worth mentioning that in all such matters of detail Hogarth's accuracy is notorious, and that therefore his engravings are most valuable for the study of the dress of the period. At the end of the seventeenth, and at the beginning of the eighteenth centuries, coats seem very commonly to have been furnished with slits running from the edge of the skirt, up under the arms, and these were made to button up, in a manner similar in all respects to the slit of the tails. The sword was usually worn under the coat, and the sword-hilt came through the slit on the left side. Later on these slits appear to have been sewed up, and the buttons and button-holes died away, with the exception of two or three buttons just at the tops of the slits; thus in coats of about the year 1705, it is not uncommon to see several buttons clustered about the tops of all three slits. The buttons at the top of the centre slit entirely disappeared, but the two buttons now on the backs of our coats trace their pedigree up to those on the hips. Thus it is not improbable that although our present buttons represent those used for making the waist, as above explained, yet that they in part represent the buttons for fastening up these side slits.

The fold which we now wear below the buttons on the back are the descendants of the falling plaits, notwithstanding that they appear as though they were made for, and that they are in fact commonly used as, the recesses for the tail-pockets; but that this was not their original object is proved by the fact that during the last century the pockets were either vertical or horizontal, placed a little in front of the two hip buttons (which have since moved round towards the back), and had highly embroidered flaps, buttons, and button-holes. The horizontal pockets may now be traced in the pocket-flaps of court dress before alluded to; and the vertical pocket is represented by some curious braiding and a row of buttons, which may be observed on the tails of the **tunics** of the foot-guards. The details of the manner in which this last rudiment became reduced to its present shape may be traced in books of uniforms, and one of the stages may now be frequently seen in

[17] Jonathan Swift's satirical novel, published 1704.
[18] The paintings and engravings of London-born William Hogarth (1697–1764) proved enormously popular in the eighteenth century and beyond; here Darwin refers to 'A Woman Swearing a Child to a Grave Citizen', the verse caption of which opens with the line 'Here Justice triumphs in his elbow chair', painted circa 1729 and engraved in the 1730s.

the livery of servants, in the form of a row of three or four buttons running down near the edge of the tail, sewn on to a scolloped[19] patch of cloth (the pocket-flap), which is itself sewed to the coat.

In the last century, when the coats had large flapping skirts, it became the custom (as may be seen in Hogarth's pictures) to button back the two corners of the coat, and also to button forward the inner corners, so as to separate the tails for convenience in riding.[20] This custom left its traces in the uniform of our soldiers down to the introduction of the modern tunic, and such traces may still be seen in some uniforms, for example, those of a Lord Lieutenant and of the French gensdarmerie.[21] In the uniforms of which I speak, the coats have swallow-tails, and these are broadly edged with a light-coloured border, tapering upwards and getting broader downwards; at the bottom of the tail, below where the borders join (at which joining there is usually a button), there is a small triangle of the same colour as the coat, with its apex at this button. This curious appearance is explained thus: — the two corners, one of which is buttoned forwards and the other backwards, could not be buttoned actually to the edge of the coat, but had to be fastened a little inland as it were; and thus part of the coat was visible at the bottom of the tail: the light-coloured border, although sewn to the coat, evidently now represents the lining, which was shown by the corners being turned back.

It was not until the reign of George III[22] that coats were cut back at the waist, as are our present evening coats, but since, before that fashion was introduced, the coats had become swallow-tailed in the manner explained, it seems likely that this form of coat was suggested by the previous fashion. And, indeed, stages of development of a somewhat intermediate character may be observed in old engravings. In the uniforms of the last century the coats were double-breasted, but were generally worn open, with the flaps thrown back and buttoned to rows of buttons on the coat. These flaps, of course, showed the lining of the coat, and were of the same colour as the tails; the **buttonholes** were usually embroidered, and thus the whole of the front of the coat became richly laced. Towards the end of the century the coats were made tight, and were fastened together in front by hooks, but the vestiges of the flaps remained in a double line of buttons, and in the front of the coat being of a different colour from that of the rest, and being richly laced. A uniform of this nature is still retained in some foreign armies. This seems also to explain the use of the term '**facings**' as applied to the collar and cuffs of a uniform, since, as we shall see hereafter, they would be of the same colour as these flaps. It may also explain the habit of braiding the front of a coat, as is done in our Hussar and other regiments.

In a 'History of Male Fashions', published in the *London Chronicle* in 1762, we, find that 'surtouts have now four laps on each side, which are called 'dog's ears;' when these pieces are unbuttoned, they flap backwards and forwards, like so many supernumerary patches just tacked on at one end, and the wearer seems to have been playing at backswords till his coat was cut to pieces … . Very spruce *smarts* have no buttons nor holes upon the breast of these their surtouts, save what are upon the ears, and their garments only wrap over their bodies like a morning gown'. These dog's ears may now be seen in a very meaningless state on the breasts of the patrol-jackets of our officers, and this is confirmed by the fact that their jackets are not buttoned, but fastened by hooks.

[19] Scolloped: scalloped.
[20] [Author's footnote: It seems to have been in actual use in 1760, although not in 1794. See Cannon's 'Hist Rec. of Brit. Army' (London, 1837), the 2nd Dragoon Guards.]
[21] Gensdarmerie: Fr. military force responsible for civil law enforcement; more commonly *gendarmerie*.
[22] George III reigned 1760–1801.

In early times, when coats were of silk or velvet, and enormously expensive, it was no doubt customary to turn up the cuffs, so as not to soil the coat, and thus the custom of having the cuffs turned back came in. During the latter part of the seventeenth and during the eighteenth century, the cuffs were very widely turned back, and the sleeves consequently very short, and this led to dandies wearing large lace cuffs to their shirts.

The pictures of Hogarth and of others show that the coat cuffs were buttoned back to a row of buttons running round the wrist. These buttons still exist in the sleeves of a Queen's Counsel,[23] although the cuffs are sewed back and the button-holes only exist in the form of pieces of braid. This habit explains why our soldiers now have their cuffs of different colours from that of their coats; the colour of the linings was probably determined for each regiment by the colonel for the time being, since he formerly supplied the clothing; and we know that the colour of the facings was by no means fixed until recently. The shape of the cuff has been recently altered in the line regiments, so that all the original meaning is gone.

In order to allow of turning back with ease, the sleeve was generally split on the outer side, and this split could be fastened together with a line of buttons and embroidered holes. In Hogarth's pictures some two or three of these buttons may be commonly seen above the reversed cuff; and notwithstanding that at first the buttons were out of sight (as they ought to be) in the reversed part of the cuff, yet after the turning back had become quite a fixed habit, and when sleeves were made tight again, it seems to have been usual to have the button for the cuff sewed on to the proper inside, that is to say, the real outside of the sleeve.

The early stage may be seen in Hogarth's picture of the 'Guards marching to Finchley',[24] and the present rudiment is excellently illustrated in the cuffs of the same regiments now. The curious buttons and gold lace on the cuffs and collars of the tunics of the Life Guards[25] have the like explanation, but this is hardly intelligible without reference to a book of uniforms, as for example Cannon's 'History of the 2nd Dragoon Guards'.[26]

The collar of a coat would in ordinary weather be turned down and the lining shown; hence the collar has commonly a different colour from that of the coat, and in uniforms the same colour as have the cuffs, which form, with the collars, the so-called 'facings'. A picture of Lucien Bonaparte in Lacroix's work on Costume[27] shows a collar so immense that were it turned up it would be as high as the top of his head. This drawing indicates that even the very broad stand-up collars worn in uniforms in the early part of this century, and of a different, colour from that of the coat, were merely survivals of an older form of turn-down collar. In these days, notwithstanding that the same difference in colour indicates that the collar was originally turned down, yet in all uniforms it is made to stand up.

The pieces of braid or seams which run round the wrist in ordinary coats are clearly the last remains of the inversion of the cuffs.

TROUSERS. — I will merely observe that we find an intermediate stage between trousers and breeches in the **pantaloon**, in which the knee-buttons of the breeches have walked down to the

[23] Honorific given to lawyers appointed by a reigning Queen to 'Her Majesty's Counsel learned in the law'; their distinctive black robes feature a row of buttons on the lower half of each sleeve.

[24] Hogarth's *The March of the Guards to Finchley* (1750), now housed in the Foundling Museum, London, depicts British troops at the start of the 1745 Jacobite rebellion.

[25] Senior regiment of the British Army.

[26] Richard Cannon (1779–1865), a prolific military historian, produced accounts of over sixty-five regiments; his *Historical Record of the Second, or, Queen's Regiment of Dragoon Guards* was published in 1837.

[27] Paul Lacroix, *Costumes Historiques de la France* (Paris: Administration de Librairie, 1852), p. 193.

ankle. I have seen also a German servant who wore a row of buttons running from the knee to the ankle of his trousers.

BOOTS. — One of the most perfect rudiments is presented by top-boots. These boots were originally meant to come above the knee; and, as may be observed in old pictures, it became customary to turn the **upper** part down, so that the lining was visible all round the top. The lining being of unblacked leather, formed the brown top which is now worn. The original boot-tag may be observed in the form of a mere wisp of leather sewn fast to the top, whilst the real acting tag is sewn to the inside of the boot. The back of the top is also fastened up, so that it could not by any ingenuity be turned up again into its original position.

Again, why do we black and polish our boots? The key is found in the French cirage, or **blacking**. We black our boots because brown leather would, with wet and use, naturally get discoloured with dark patches, and thus boots to look well should be coloured black. Now, shooting boots are usually greased, and that it was formerly customary to treat ordinary boots in the same manner is shown by the following verse in the ballad of 'Argentile and Curan':—

He borrowed on the working dales
His holy russets oft,
And of the bacon's fat to make
His startops black and soft.[28]

Startops were a kind of rustic high shoes. Fairholt in his work states that 'the oldest kind of blacking for boots and shoes appears to have been a thick, viscid, oily substance'.[29] But for neat boots a cleaner substance than grease would be required, and thus wax would be thought of; and that this was the case is shown by the French word cirer, which means indifferently to 'wax' or to 'polish boots'. Boots are of course polished because wax takes so good a polish. Lastly, **patent-leather** is an imitation of common blacking.

I have now gone through the principal articles of men's clothing, and have shown how numerous and curious are the rudiments or 'survivals', as Mr. Tylor calls them; a more thorough search proves the existence of many more. For instance, the various gowns worn at the Universities and elsewhere, afford examples. These gowns were, as late as the reign of Queen Elizabeth, simply upper garments,[30] but have survived into this age as mere badges. Their chief peculiarities consist in the sleeves, and it is curious that nearly all of such peculiarities point to various devices by which the wearing of the sleeves has been eluded or rendered less burdensome. Thus the plaits and buttons in a barrister's gown, and the slit in front of the sleeve of the B.A.'s gown, are for this purpose. In an M.A.'s gown the sleeves extend below the knees, but there is a hole in the side through which the arm is passed; the end of the sleeve is sewed up, but there is a kind of scollop at the lower part, which represents the narrowing for the wrist. A barrister's gown has a small hood sewed to the left shoulder, which would hardly go on to the head of an infant, even if it could be opened out into a hood shape.

It is not, however, in our dress alone that these survivals exist; they are to be found in all the things of our every-day life. For instance, anyone who has experienced a drive on a road so bad that leaning back in the carriage is impossible, will understand the full benefit to be derived

[28] A version of the poem was included in Percy's *Reliques of Ancient English Poetry* (London: J. Dodsley, 1765), p. 238, which introduced ancient ballads to a new audience.

[29] Fairholt, *Costume in England*, p. 437.

[30] [Author's footnote: See figures, pp. 254, 311, Fairholt.] (See fig. 1.1c–d).

from arm-slings such as are placed in first-class railway carriages, and will agree that in such carriages they are mere survivals. The rounded tracery on the outsides of railway carriages show the remnants of the idea that a coach was the proper pattern on which to build them; and the word 'guard' is derived from the man who sat behind the coach and defended the passengers and mails with his blunderbuss.

In the early trains (1838–39) of the Birmingham Railway there were special 'mail' carriages, which were made very narrow, and to hold only four in each compartment (two and two), so as to be like the coach they had just superseded.

The words *dele*, *stet*, used in correcting proof-sheets, the words *sed vide* or *s.v.*, *ubi sup.*, *ibid.*, *loc. cit.*, used in footnotes, the sign '&' which is merely a corruption of the word *et*, the word *finis* until recently placed at the ends of books, are all doubtless survivals from the day when all books were in Latin. The mark ^ used in writing for interpolations appears to be the remains of an arrow pointing to the sentence to be included. The royal 'broad-arrow' mark is a survival of the head of 'a barbed javelin, carried by serjeants-at-arms in the king's presence as early as Richard the First's time".[31] Then again we probably mount horses from the left side lest our swords should impede us. The small saddle on the surcingle of a horse, the seams in the backs of cloth-bound books, and those at the backs of gloves are rudiments, but to give a catalogue of such things would be almost endless. I have said enough, however, to show that by remembering that there is *nihil sine causa*, the observation of even common things of every-day life may be made less trivial than it might at first sight appear.

It seems a general rule that on solemn or ceremonial occasions men retain archaic forms; thus it is that court dress is a survival of the everyday dress of the last century; that uniforms in general are richer in rudiments than common dress; that a carriage with a postilion is *de rigueur* at a wedding; and that (as mentioned by Sir John Lubbock) the priests of a savage nation, acquainted with the use of metals, still use a stone knife for their sacrifices just as Anglican priests still prefer candles to gas.

The details given in this article, although merely curious, and perhaps insignificant in themselves, show that the study of dress from an evolutional standpoint serves as yet one further illustration of the almost infinite ramifications to which natural selection and its associated doctrines of development may be applied.

[31] [Author's footnote: Fairholt, p. 580.]

4

Thorstein Veblen, 'The Economic Theory of Woman's Dress', *Popular Science Monthly* 46 (1894), pp. 198–205

American Economist Veblen (1857–1929) was a sharp critic of what he termed 'conspicuous consumption'. One of the earliest thinkers to theorize the role of dress in shaping and reflecting social class structures, Veblen's work argues that while clothing's primary role is practical, providing protection and warmth, dress serves as a 'function as an index of the wealth of its wearer' or owner. Moreover, he suggests that because dress indicates its wearer's wealth, it has special impact for women, helping to keep them in the role of 'chattel'. He minces no words. 'Dress', he concludes, is nearly synonymous with 'display of wasteful expenditure', and the constant need for new attire compelled by changing fashions contributes to this dynamic. Though Veblen's analysis is primarily economic, the result is a scathing critique of the social pressures on women, as evidenced in dress. The piece below was originally published in an American journal, and Veblen would go on to develop his ideas on dress in his seminal Economic Theory of the Leisure Class *(1899), which left at least one British critic unimpressed. Writing for* The Speaker, *the reviewer recalled Veblen's view that 'Woman is a chattel, and one method of conspicuous waste is to dress her sumptuously' and concluded that the study 'is audacious, sometimes offensive, sometimes amusing, never convincing'.*[1]

In human apparel the element of dress is readily distinguishable from that of clothing. The two functions—of dress and of clothing the person—are to a great extent subserved by the same material goods, although the extent to which the same material serves both purposes will appear very much slighter on second thought than it does at first glance. A differentiation of materials has long been going on, by virtue of which many things that are worn for the one purpose no longer serve, and are no longer expected to serve, the other. The differentiation is by no means complete. Much of human apparel is worn both for physical comfort and for dress; still more of it is worn ostensibly for both purposes. But the differentiation is already very considerable and is visibly progressing.

[1] 'Unorthodox Economics', *Speaker* (1 July 1889), p. 751.

But, however united in the same object, however the two purposes may be served by the same material goods, the purpose of physical comfort and that of a reputable appearance are not to be confounded by the meanest understanding. The elements of clothing and of dress are distinct; not only that, but they even verge on incompatibility; the purpose of either is frequently best subserved by special means which are adapted to perform only a single line of duty. It is often true, here as elsewhere, that the most efficient tool is the most highly specialized tool.

Of these two elements of apparel dress came first in order of development, and it continues to hold the primacy to this day. The element of clothing, the quality of affording comfort, was from the beginning, and to a great extent it continues to be, in some sort an afterthought.

The origin of dress is sought in the principle of adornment. This is a well-accepted fact of social evolution.[2] But that principle furnished the point of departure for the evolution of dress rather than the norm of its development. It is true of dress, as of so much else in the apparatus of life, that its initial purpose has not remained its sole or dominant purpose throughout the course of its later growth. It may be stated broadly that adornment, in the *naïve* aesthetic sense, is a factor of relatively slight importance in modern dress.

The line of progress during the initial stage of the evolution of apparel was from the simple concept of adornment of the person by supplementary accessions from without, to the complex concept of an adornment that should render the person pleasing, or of an enviable presence, and at the same time serve to indicate the possession of other virtues than that of a well-favored person only. In this latter direction lies what was to evolve into dress. By the time dress emerged from the primitive efforts of the savage to beautify himself with gaudy additions to his person, it was already an economic factor of some importance. The change from a purely aesthetic character (ornament) to a mixture of the aesthetic and economic took place before the progress had been achieved from pigments and trinkets to what is commonly understood by apparel. Ornament is not properly an economic category, although the trinkets which serve the purpose of ornament may also do duty as an economic factor, and in so far be assimilated to dress. What constitutes dress an economic fact, properly falling within the scope of economic theory, is its function as an index of the wealth of its wearer—or, to be more precise, of its owner, for the wearer and owner are not necessarily the same person. It will hold with respect to more than one half the values currently recognized as 'dress' especially that portion with which this paper is immediately concerned—woman's dress—that the wearer and the owner are different persons. But while they need not be united in the same person, they must be organic members of the same economic unit; and the dress is the index of the wealth of the economic unit which the wearer represents.

Under the patriarchal organization of society, where the social unit was the man (with his dependents), the dress of the women was an exponent of the wealth of the man whose chattels they were. In modern society, where the unit is the household, the woman's dress sets forth the wealth of the household to which she belongs. Still, even to-day, in spite of the nominal and somewhat celebrated demise of the patriarchal idea, there is that about the dress of women which suggests that the wearer is something in the nature of a chattel; indeed, the theory of woman's dress quite plainly involves the implication that the woman is chattel. In this respect the dress of women differs from that of men. With this exception, which is not of first-rate importance, the essential principles of woman's dress are not different from those which govern the dress of men; but even apart from this added characteristic the element of dress is to be seen

[2] See George Darwin on the evolutionary development of fashion (#3).

in a more unhampered development in the apparel of women. A discussion of the theory of dress in general will gain in brevity and conciseness by keeping in view the concrete facts of the highest manifestation of the principles with which it has to deal, and this highest manifestation of dress is unquestionably seen in the apparel of the women of the most advanced modern communities.

The basis of the award of social rank and popular respect is the success, or more precisely the efficiency, of the social unit, as evidenced by its visible success. When efficiency eventuates in possessions, in pecuniary strength, as it eminently does in the social system of our time, the basis of the award of social consideration becomes the visible pecuniary strength of the social unit. The immediate and obvious index of pecuniary strength is the visible ability to spend, to consume unproductively; and men early learned to put in evidence of their ability to spend by displaying costly goods that afford no return to their owner, either in comfort or in gain. Almost as early did a differentiation set in, whereby it became the function of the woman, in a peculiar degree, to exhibit the pecuniary strength of her social unit by means of a conspicuously unproductive consumption of valuable goods.

Reputability is in the last analysis, and especially in the long run, pretty fairly coincident with the pecuniary strength of the social unit in question. Woman, primarily, originally because she was herself a pecuniary possession, has become in a peculiar way the exponent of the pecuniary strength of her social group; and with the progress of specialization of functions in the social organism this duty tends to devolve more and more entirely upon the woman. The best, most advanced, most highly developed societies of our time have reached the point in their evolution where it has (ideally) become the great, peculiar, and almost the sole function of woman in the social system to put in evidence her economic unit's ability to pay. That is to say, woman's place (according to the ideal scheme of our social system) has come to be that of a means of conspicuously unproductive expenditure.

The admissible evidence of the woman's expensiveness has considerable range in respect of form and method, but in substance it is always the same. It may take the form of manners, breeding, and accomplishments that are, *prima facie*,[3] impossible to acquire or maintain without such leisure as bespeaks a considerable and relatively long-continued possession of wealth. It may also express itself in a peculiar manner of life, on the same grounds and with much the same purpose. But the method in vogue always and everywhere, alone or in conjunction with other methods, is that of dress. 'Dress', therefore, from the economic point of view, comes pretty near being synonymous with 'display of wasteful expenditure'.

The extra portion of butter, or other unguent, with which the wives of the magnates of the African interior anoint their persons, beyond what comfort requires, is a form of this kind of expenditure lying on the border between primitive personal embellishment and incipient dress. So also the brass-wire bracelets, anklets, etc., at times aggregating some thirty pounds in eight, worn by the same class of persons, as well as, to a less extent, by the male population of the same countries. So also the pelt of the arctic fur seal, which the women of civilized countries prefer to fabrics that are preferable to it in all respects except that of expense. So also the ostrich plumes and the many curious effigies of plants and animals that are dealt in by the **milliners**. The list is inexhaustible, for there is scarcely an article of apparel of male or female, civilized or uncivilized, that does not partake largely of this element, and very many may be said, in point of economic principle, to consist of virtually nothing else.

[3] *prima facie*: Latin. on its face; upon first impression.

It is not that the wearers or the buyers of these wasteful goods desire the waste. They desire to make manifest their ability to pay. What is sought is not the *de facto* waste, but the appearance of waste. Hence there is a constant effort on the part of the consumers of these goods to obtain them at as a good a bargain as may be, and hence also a constant effort on the part of the producers of these goods to lower the cost of their production, and consequently to lower the price. But as fast as the price of the goods declines to such a figure that their consumption is no longer *prima facie* evidence of a considerable ability to pay, the particular goods in question fall out of favor, and consumption is diverted to something which more adequately manifests the wearer's ability to afford wasteful consumption.

This fact, that the object sought is not the waste but the display of waste, develops into a principle of pseudo-economy in the use of material; so that it has come to be recognized as a canon of good form that apparel should not show lavish expenditure simply. The material used must be chosen so as to give evidence of the wearer's (owner's) capacity for making it go so far in the way of display as may be; otherwise it would suggest incapacity on the part of the owner, and so partially defeat the main purpose of the display. but what is more to the point is that such a mere display of crude waste would also suggest that the means of display had been acquired so recently as not to have permitted that long-continued waste of time and effort required for mastering the most effective methods of display. It would argue recent acquisition of means; and we are still near enough to the tradition of pedigree and aristocracy of birth to make long-continued possession of means second in point of desirability only to the possession of large means. The greatness of the means possessed is manifested by the volume of display; the length of possession is, in some degree, evidenced by the manifestation of a thorough habituation to the methods of display. Evidence of a knowledge and habit of good form in dress (as in manners) is chiefly to be valued because it argues that much time has been spent in the acquisition of this accomplishment; and as the accomplishment is in no wise of direct economic value, it argues pecuniary ability to waste time and labor. Such accomplishment, therefore, when possessed in a high degree, is evidence of a life (or of more than one life) spent to no useful purpose; which, for purposes of respectability, goes as far as a very considerable unproductive consumption of goods. The offensiveness of crude taste and vulgar display in matters of dress is, in the last analysis, due to the fact that they argue the absence of ability to afford a reputable amount of waste of time and effort.

Effective use of the means at hand may, further, be taken to argue efficiency in the person making the display; and the display of efficiency, so long as it does not manifestly result in pecuniary gain or increased personal comfort, is a great social desideratum. Hence it happens that, surprising as it may seem at first glance, a principle of pseudo-economy in the use of materials has come to hold a well-secured though pretty narrowly circumscribed place in the theory of dress, as that theory expresses itself in the facts of life. This principle, acting in concert with certain other requirements of dress, produces some curious and otherwise inexplicable results, which will be spoken of in their place.

The first principle of dress, therefore, is conspicuous expensiveness. As a corollary under this principle, but of such magnificent scope and consequence as to claim rank as a second fundamental principle, there is the evidence of expenditure afforded by a constant supersession of one wasteful garment or trinket by a new one. The principle inculcates the desirability, amounting to a necessity wherever circumstances allow, of wearing nothing that is out of date. In the most advanced communities of our time, and so far as concerns the highest manifestations of dress, e.g., in ball dress and the apparel worn on similar ceremonial occasions, when the canons of dress rule unhampered by extraneous considerations—this principle expresses itself in the maxim that no outer garment may be worn more than once.

This requirement of novelty is the underlying principle of the whole of the difficult and interesting domain of fashion. Fashion does not demand continual flux and change simply because that way of doing is foolish; flux and change and novelty are demanded by the central principle of all dress—conspicuous waste.

This principle of novelty, acting in concert with the motive of pseudo-economy already spoken of, is answerable for that system of shams that figures so largely, openly and aboveboard, in the accepted code of dress. The motive of economy, or effective use of material, furnishes the point of departure, and this being given, the requirement of novelty acts to develop a complex and extensive system of pretenses, ever varying and transient in point of detail, but each imperative during its allotted time—**facings**, edgings, and the many (pseudo) deceptive contrivances that will occur to any one that is at all familiar with the technique of dress. This pretense of deception is often developed into a pathetic, child-like make-believe. The realities which it simulates, or rather symbolizes, could not be tolerated. They would be in some cases too crudely expensive, in others inexpensive and more nearly adapted to minister to personal comfort than to visible expense; and either alternative is obnoxious to the canons of good form.

But apart from the exhibition of pecuniary strength afforded by an aggressive wasteful expenditure, the same purpose may also be served by conspicuous abstention from useful effort. The woman is, by virtue of the specialization of social functions, the exponent of the economic unit's pecuniary strength, and it consequently also devolves on her to exhibit the unit's capacity to endure this passive form of pecuniary damage. She can do this by putting in evidence the fact (often a fiction) that she leads a useless life. Dress is her chief means of doing so. The ideal of dress, on this head, is to demonstrate to all observers, and to compel observation of the fact, that the wearer is manifestly incapable of doing anything that is of any use. The modern civilized woman's dress attempts this demonstration of habitual idleness, and succeeds measurably.

Herein lies the secret of the persistence, in modern dress, of the skirt and of all the cumbrous and otherwise meaningless drapery which the skirt typifies. The skirt persists because it is cumbrous. It hampers the movements of the wearer and disables her, in great measure, for any useful occupation. So it serves as an advertisement (often disingenuous) that the wearer is backed by sufficient means to be able to afford the idleness, or impaired efficiency, which the skirt implies. The like is true of the high heel, and in less degree of several other features of modern dress.

Herein is also to be sought the ground of the persistence (probably not the origin) of the one great mutilation practices by civilized Occidental womankind—the constricted waist, as well as of the analogous practice of the abortive foot among their Chinese sisters. This modern mutilation of woman is perhaps not to be classed strictly under the category of dress; but it is scarcely possible to draw the line so as to exclude it from the theory, and it is so closely coincident with that category in point of principle that an outline of the theory would be incomplete without reference to it.

A corollary of some significance follows from this general principle. The fact that voluntarily accepted physical incapacity argues the possession of wealth practically established the futility of any attempted reform of woman's dress in the direction of convenience, comfort, or health. It is of the essence of dress that it should (appear to) hamper, incommode, and injure the wearer, for in so doing it proclaims the wearer's pecuniary ability to endure idleness and physical incapacity.

It may be noted, by the way, that this requirement, that women must appear to be idle in order to be respectable, is an unfortunate circumstance for women who are compelled to provide their own livelihood. They have to supply not only the means of living, but also the means of advertising the fiction that they live without any gainful occupation; and they have to

do all this while encumbered with garments specially designed to hamper their movements and decrease their industrial efficiency.

The cardinal principles of the theory of woman's dress, then, are these three:

1 Expensiveness: Considered with respect to its effectiveness as clothing, apparel must be uneconomical. It must afford evidence of the ability of the wearer's economic group to pay for things that are in themselves of no use to any one concerned—to pay without getting an equivalent in comfort or in gain. From this principle there is no exception.

2 Novelty: Woman's apparel must afford *prima facie* evidence of having been worn but for a relatively short time, as well as, with respect to many articles, evidence of inability to withstand any appreciable amount of wear. Exceptions from this rule are such things as are of sufficient permanence to become heirlooms, and of such surpassing expensiveness as normally to be possessed only by persons of superior (pecuniary) rank. The possession of an heirloom is to be commended because it argues the practice of waste through more than one generation.

3 Ineptitude: It must afford *prima facie* evidence of incapacitating the wearer for any gainful occupation; and it should also make it apparent that she is permanently unfit for any useful effort, even after the restraint of the apparel is removed. From this rule there is no exception.

Besides these three, the principle of adornment, in the æsthetic sense, plays some part in dress. It has a certain degree of economic importance, and applies with a good deal of generality; but it is by no means imperatively present, and when it is present its application is closely circumscribed by the three principles already laid down. Indeed, the office of the principle of adornment in dress is that of handmaid to the principle of novelty, rather than that of an independent or co-ordinate factor. There are, further, minor principles that may or may not be present, some of which are derivatives of the great central requisite of conspicuous waste; others are of alien origin, but all are none the less subject to the controlling presence of the three cardinal principles enumerated above. These three are essential and constitute the substantial norm of woman's dress, and no exigency can permanently set them aside so long as the chance of rivalry between persons in respect of wealth remains. Given the possibility of a difference in wealth, and the sway of this norm of dress is inevitable. Some spasm of sense, or sentiment, or what not, may from time to time create a temporary and local diversion in woman's apparel; but the great norm of 'conspicuous waste' cannot be set aside or appreciably qualified so long as this its economic ground remains.

To single out an example of the temporary effect of a given drift of sentiment, there has, within the past few years, come, and very nearly gone, a recrudescence[4] of the element of physical comfort of the wearer, as one of the usual requirements of good form in dress. The meaning of this proposition, of course, is not what appears on its face; that seldom happens in matters of dress. It was the show of personal comfort that was lately imperative, and the show was often attained only at the sacrifice of the substance. This development, by the way, seems to have been due to a ramification of the sentimental athleticism (flesh-worship) that has been dominant of late; and now that the crest of this wave of sentiment has passed, this alien motive in dress is also receding.

[4] Recrudescence: revival, recurrence.

The theory of which an outline has now been given is claimed to apply in full force only to modern woman's dress. It is obvious that if the principles arrived at are to be applied as all-deciding criteria, 'woman's dress' will include the apparel of a large class of persons who, in the crude biological sense, are men. This feature does not act to invalidate the theory. A classification for the purpose of economic theory must be made on economic grounds and cannot permit considerations whose validity does not extend beyond the narrower domain of the natural sciences to mar its symmetry so far as to exclude this genial volunteer contingent from the ranks of womankind.

There is also a second, very analogous class of persons, whose apparel likewise, though to a less degree, conforms to the canons of woman's dress. This class is made up of the children of civilized society. The children, with some reservation of course, are, for the purpose of the theory, to be regarded as ancillary material serving to round out the great function of civilized womankind as the conspicuous consumers of goods. The child in the hands of civilized woman is an accessory organ of conspicuous consumption, much as any tool in the hands of a labourer is an accessory organ of productive efficiency.

SECTION TWO

Dress Reform

This section takes up active efforts to reform dress, especially (although not exclusively) women's dress, through the second half of the nineteenth century. As notions of the 'separate spheres' came under increasing scrutiny, public discussion eventually led to the passage of laws such as the Married Women's Property Act (1882), signalling shifts in the cultural and legal landscape that were, as ever, reflected in changing fashions.[1] Even in advance of legislative action, reformers began advocating for alternate modes of dress, recognizing that clothes not only signified, but also determined experience. There is some interesting overlap between – on the one hand – the very conservative voices protesting against faddish fashion on the grounds that it encourages vanity and decadence, and – on the other hand – those protesting against the same fashions because they restrict movement, are uncomfortable or damage the health of the wearer. Consider Eliza Lynn Linton, whose fevered critique of 'the Girl of the Period' (see #5) seems evergreen: revelling in nostalgia for an idealised British girl of the past, she sees only degradation and meretriciousness in young women who dye their hair, paint their faces and follow the latest fashions. In the fin de siècle, writers such as Sarah Grand would push back against complaints such as Linton's, describing a forward-looking 'New Woman' as a counterpoint both to the demure English Rose favoured by Linton and to the showy trend-follower that Linton despised.[2] The New Woman rejected mainstream fashion of the day in favour of menswear-inspired separates that encouraged mobility. It is no wonder that the bicycle became a symbol of New Womanhood; as is clear in many advertisements, the cycle made clothing reform necessary, as heavy, floor-length skirts and long-line **corsets** made for impractical (and unsafe) riding (see figs. 2.1–2.2).

[1] Prior to the passage of the Act, a woman's property became her husband's upon marriage, often leaving women with little control over their assets.
[2] See, for example, Grand's 'The New Aspect of the Woman Question', *North American Review* 158 (March 1894), pp. 270–6.

TO LADY CYCLISTS!

JOHN BELLISS & SONS

beg to announce their

SPECIAL

SHOW

of

Cycling Tweeds, CLOTHS and SERGES, . .

for the '97 SEASON.

BY SPECIAL TREATMENT

ALL THEIR CYCLING CLOTHS are absolutely

Weather Proof.

84 and 85, HIGH STREET, BIRMINGHAM.

PLEASE APPLY FOR PATTERNS.

Valley Printing Co., Ulm Khedish

FIGURE 2.1 *Advertisement for Belliss & Sons Cycling Tweeds (1897). © Bodleian Library, University of Oxford 2009: John Johnson Collection: Women's Clothes and Millinery 7 (37). Used with permission.*

THE "INDOORS REFORMED DRESS LEAGUE," OR THE TYPIST OF THE FUTURE.

'In dirty weather, not wishing to cycle, I put on the longer skirt; arriving at the office, I hang it up, with my hat, on the peg."—Extract from Secretary's Article. 61

FIGURE 2.2 *'The "Indoors Reformed Dress League", Or the Typist of the Future'*, Cycling *(London, England) (Saturday, 26 February 1898), p. 157. Reproduced by permission of the National Library of Scotland. In dirty weather, not wishing to cycle, I put on the longer skirt; arriving at the office, I hand it up, with my hat, on the peg. –Extract from Secretary's Article.*

Mary Eliza Haweis agrees that clothing reflects manners, but her argument for reform in *The Art of Dress* (#6) emphasizes the potential beauty of dress. She implores readers to consider the impact of their choices on others and on themselves, opting always for harmony, and while she offers no definition of or recipe for beauty, she draws an analogy between dress and the fine arts: fashion is not the mere whim of the milliner, but is 'as direct an outcome of the love of beauty as schools of sculpture and painting'. She, like Wilde after her, connects the function of clothing to its aesthetic merit: not everything with a function is necessarily beautiful, but, she writes, 'everything without purpose is without beauty', and needless or non-functional decorations 'outrage the morality of art' and are 'intolerable to taste'.

In light of the anxiety centred on the degradation of a virtuous, British, feminine modesty voiced by writers such as Linton, Lady Harberton, President of the Rational Dress Society, opens her 1882 article (see #7) by insisting in the first sentence that she 'neither [wishes] to wear men's clothes [herself], nor to see other women do so'. Common sense and nationalism, not aesthetic or moral merit, drive her reform efforts. Acknowledging that some pundits hold up classical Greek dress as an ideal (Haweis certainly did), Harberton counters: 'But we are not Greek. We are English'. For her, it is the English climate, and the needs of English social and working life, that should dictate clothing design, not any passing notion of beauty, a stance that was difficult to impeach. Taking an entirely different tack, Oscar Wilde insisted above all on the beauty of the human form in his 'Philosophy of Dress' (see #8), pointing to ancient Greece as an example of a society that was familiar with and valued the body beneath the clothing. Wilde was no stranger to dress reform: in 1884, he participated in a lively correspondence in the *Pall Mall Gazette* in response to his lecture on Dress, and his wife Constance edited the journal of the Rational Dress Society in 1888 and 1889. Elsewhere in the lectures he delivered to eager audiences in the 1880s, he commented that 'the only well-dressed men' he encountered during his tour of America were 'western miners', whose cloaks he described as 'the most beautiful piece of drapery ever invented'. For him, beauty in dress need not be completely divorced from function: the miners 'wore only what was comfortable, and were therefore beautiful'.[3]

There are reasons why Wilde was able to extol the glories of the Greek body in its toga or the working man's cloak, whereas Harberton hewed firmly to practicality. A man of letters already famous for his commitment to eccentricity and the aesthetic philosophy of *l'art pour l'art*, Wilde had more latitude in his pronouncements. As ever, satirical cartoons both encourage and poke fun at reform fashions, including New Women designs and Aesthetic dress. Both the Aesthetes and the Rational Dress proponents were subject to critique and satire – some scathing, some affectionate – in the periodical press, yet the advances advocated by both groups ultimately constituted the basis of future reform efforts.

[3] Oscar Wilde, 'House Decoration'. In *Complete Works of Oscar Wilde* (London: Methuen, 1909), p. 164.

5

Eliza Lynn Linton, 'The Girl of the Period', *Saturday Review* (14 March 1868), pp. 339–40

Despite being a successful professional writer who championed women's rights early in her career, by the late 1860s Eliza Lynn Linton (1822–98) had little interest in progressive causes. This article, which illustrates her increasingly conservative views, appeared in the widely circulated Saturday Review *and anticipated the vitriol later directed toward the New Woman. The 'girl of the period' is presented in contrast to the traditional 'fair young English girl', with vanity replacing the selflessness of an evidently idealized girl of the past. Cosmetics and fashion receive particular scorn as outward signs of inward immorality, and nationalism – veering close to jingoism in places – underscores many of her critiques. Moreover, Linton suggests that improper dress does not simply reflect, but rather encourages bad behaviour, leading to 'slang, bold talk, and fastness'. While in other articles she is more directly scornful of fashion,[1] this piece proved to be especially influential.*

Time was when the stereotyped phrase, 'a fair young English girl', meant the ideal of womanhood; to us, at least, of home birth and good breeding. It meant a creature generous, capable, and modern; something franker than a French woman, more to be trusted than an Italian, as brave as an American but more refined, as domestic as a German and more graceful. It meant a girl who could be trusted alone if need be, because of the innate purity and dignity of her nature, but who was neither bold in bearing nor masculine in mind; a girl who, when she married, would be her husband's friend and companion, but never his rival; one who would consider their interests identical, and not hold him as just so much fair game for spoil; who would make his house his true home and place of rest, not a mere passage-place for vanity and ostentation to go through; a tender mother, an industrious housekeeper, a judicious mistress. We prided ourselves as a nation on our women. We thought we had the pick of creation in this fair young English girl of ours, and envied no other men their own. We admired the languid grace and subtle fire of the South; the docility and childlike affectionateness of the East seemed to us sweet and simple and restful; the vivacious sparkle of the trim and sprightly Parisienne was a pleasant little excitement

[1] See, for example, Linton's 'Costumes and Morals', also in the *Saturday Review* 24 (July 1867), pp. 44–5.

when we met with it in its own domain; but our allegiance never wandered from our brown-haired girls at home, and our hearts were less vagrant than our fancies. This was in the old time, and when English girls were content to be what God and nature had made them. Of late years we have changed the pattern, and have given to the world a race of women as utterly unlike the old insular ideal as if we had created another nation altogether. The girl of the period, and the fair young English girl of the past, have nothing in common save ancestry and their mother-tongue; and even of this the last the modern version makes almost a new language, through the copious additions it has received from the current slang of the day.

The girl of the period is a creature who dyes her hair and paints her face, as the first articles of her personal religion; whose sole idea of life is plenty of fun and luxury; and whose dress is the object of such thought and intellect as she possesses. Her main endeavour in this is to outlive her neighbours in the extravagance of fashion. No matter whether, as in the time of **crinolines**, she sacrificed decency, or, as now, in the time of **trains**, she sacrifices cleanliness; no matter either, whether she makes herself a nuisance and an inconvenience to every one she meets. The girl of the period has done away with such moral muffishness as consideration for others, or regard for counsel and rebuke. It was all very well in old-fashioned times, when fathers and mothers had some authority and were treated with respect, to be tutored and made to obey, but she is far too fast and flourishing to be stopped in mid-career by those slow old morals; and as she dresses to please herself, she does not care if she displeases every one else. Nothing is too extraordinary and nothing too exaggerated for her vitiated taste; and things which in themselves would be useful reforms if let alone become monstrosities worse than those which they have displaced so soon as she begins to manipulate and improve. If a sensible fashion lifts the gown out of the mud, she raises hers midway to her knee. If the absurd structure of wire and **buckram**, once called a **bonnet**, is modified to something that shall protect the wearer's face without putting out the eyes of her companion, she cuts hers down to four straws and a rosebud, or a tag of **lace** and a bunch of glass beads. If there is a reaction against an excess of Rowland's Macassar,[2] and hair shiny and sticky with grease is thought less nice than if left clean and healthily crisp, she dries and frizzes and sticks hers out on end like certain savages in Africa, or lets it wander down her back like Madge Wildfire's,[3] and thinks herself all the more beautiful the nearer she approaches in look to a maniac or a negress. With purity of taste she has lost also that far more precious purity and delicacy of perception which sometimes mean more than appears on the surface. What the *demimonde*[4] does in its frantic efforts to excite attention, she also does in imitation. If some fashionable *dévergondée en évidence*[5] is reported to have come out with her dress below her shoulder-blades, and a gold strap for all the sleeve thought necessary, the girl of the period follows suit next day; and then wonders that men sometimes mistake her for her prototype, or that mothers of girls not quite so far gone as herself refuse her as a companion for their daughters. She has blunted the fine edges of feeling so much that she cannot understand why she should be condemned for an imitation of form which does not included imitation of fact; she cannot be made to see that modesty of appearance and virtue ought to be inseparable, and that no good girl can afford to appear bad, under penalty of receiving the contempt awarded to the bad.

[2] Successful London barber Alexander Rowland (1747–1823) successfully marketed his Macassar oil as a hair treatment (see fig. 2.3 for the oil and fig. I.15 for an **antimacassar** pattern).
[3] Mentally unstable character in Sir Walter Scott's *Heart of Midlothian* (1818).
[4] *demimonde*: Fr. the world outside of respectable society, in this case, that of higher class courtesans.
[5] *dévergondée en evidence*: Fr. woman whose immoral lifestyle is visibly evident.

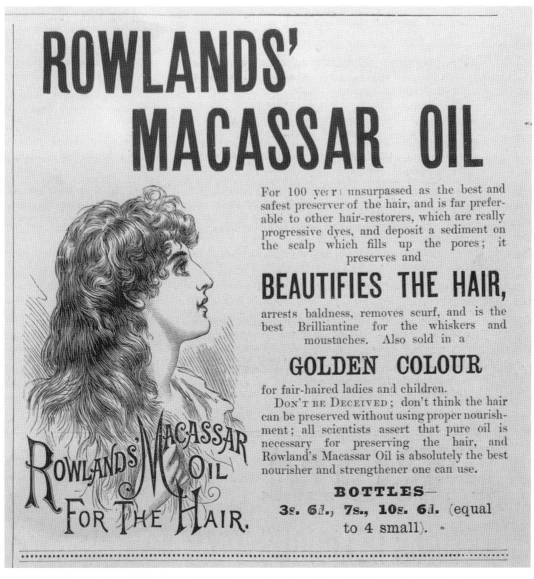

FIGURE 2.3 *'Rowlands' Macassar Oil'*, Illustrated London News *(22 December 1894), p. 793.*

This imitation of the *demi-monde* in dress leads to something in manner and feeling, not quite so pronounced perhaps, but far too like to be honourable to herself or satisfactory to her friends. It leads to slang, bold talk, and fastness; to the love of pleasure and indifference to duty; to the desire of money before either love or happiness; to uselessness at home, dissatisfaction with the monotony of ordinary life, and horror of all useful work; in a word, to the worst forms of luxury and selfishness, to the most fatal effects arising from want of high principle and absence of tender feeling. The girl of the period envies the queens of the *demi-monde* far more than she abhors them. She sees them gorgeously attired and sumptuously appointed, and she

knows them to be flattered, fêted, and courted with a certain disdainful admiration of which she catches only the admiration while she ignores the disdain. They have all for which her soul is hungering, and she never stops to reflect at what price they have bought their gains, and what fearful moral penalties they pay for their sensuous pleasures. She sees only the coarse gilding on the base token, and shuts her eyes to the hideous figure in the midst, and the foul legend written round the edge. It is this envy of the pleasures, and indifference to the sins, of these women of the *demi-monde* which is doing such infinite mischief to the modern girl. They brush too closely by each other, if not in actual deeds, yet in aims and feelings; for the luxury which is bought by vice with the one is the thing of all in life most passionately desired by the other, though she is not yet prepared to pay quite the same price. Unfortunately, she has already paid too much—all that once gave her distinctive national character. No one can say of the modern English girl that she is tender, loving, retiring, or domestic. The old fault so often found by keen-sighted Frenchwomen, that she was so fatally *romanesque*,[6] so prone to sacrifice appearances and social advantages for love, will never be set down to the girl of the period. Love indeed is the last thing she thinks of, and the least of the dangers besetting her. Love in a cottage, that seductive dream which used to vex the heart and disturb the calculations of prudent mothers, is now a myth of past ages. The legal barter of herself for so much money, representing so much dash, so much luxury and pleasure—that is her idea of marriage; the only idea worth entertaining. For all seriousness of thought respecting the duties or the consequences of marriage, she has not a trace. If children come, they find but a stepmother's cold welcome from her; and if her husband thinks that he has married anything that is to belong to him—a *tacens et placens uxor*[7] pledged to make him happy—the sooner he wakes from his hallucination and understands that he has simply married someone who will condescend to spend his money on herself, and who will shelter her indiscretions behind the shield of his name, the less severe will be his disappointment. She has married his house, his carriage, his balance at the banker's and his title; and he himself is just the inevitable condition clogging the wheel of her fortune; at best an adjunct, to be tolerated with more or less practice as may chance. For it is only the old-fashioned sort, not girls of the period *pur sang*,[8] that marry for love, or put the husband before the banker. But she does not marry easily. Men are afraid of her; and with reason. They may amuse themselves with her for an evening, but they do not take her readily for life. Besides, after all her efforts, she is only a poor copy of the real thing; and the real thing is far more amusing than the copy, because it is real. Men can get that whenever they like; and when they go into their mothers' drawing-rooms, to see their sisters and their sisters' friends, they want something of quite different flavour. *Toujours perdrix*[9] is bad providing all the world over; but a continual weak imitation of *toujours perdrix* is worse. If we must have only one kind of thing, let us have it genuine; and the queens of St. John's Wood in their unblushing honesty, rather than their imitators and make-believes in Bayswater and Belgravia.[10] For, at whatever cost of shocked self-love or pained modesty it may be, it cannot be too plainly told to the modern English girl that the net result of her present manner of life is to assimilate her as nearly as possible to a class of women whom we must not call by their proper—or improper—name. And we are willing to believe that she has still some

[6] *romanesque*: Fr. romantic.

[7] *tacens et placens uxor*: Latin. silent and pleasing wife.

[8] *pur sang*: Fr. literally, pure blooded; figuratively, in the truest sense.

[9] *toujours perdrix*: Fr. literally, 'always partridge'; idiomatically, too much of the same luxury will become boring.

[10] St John's Wood, known as a popular residence for kept women, was less respectable than Bayswater or Belgravia: London neighbourhoods; in Linton's time, St John's Wood was less respectable than Bayswater or Belgravia.

modesty of soul left hidden under all this effrontery of fashion, and that, if she could be made to see herself as she appears to the eyes of men, she would mend her ways before too late.

It is terribly significant of the present state of things when men are free to write as they do of the women of their own nation. Every word of censure flung against them is two-edged, and wounds those who condemn as much as those who are condemned; for surely it need hardly be said that men hold nothing so dear as the honour of their women, and that no one living would willingly lower the repute of his mother or his sisters. It is only when these have placed themselves beyond the pale of masculine respect that such things could be written as are written now; when they become again what they were once they will gather round them the love and homage and chivalrous devotion which were then an Englishwoman's natural inheritance. The marvel, in the present fashion of life among women, is how it holds its ground in spite of the disapprobation of men. It used to be an old-time notion that the sexes were made for each other, and that it was only natural for them to please each other, and to set themselves out for that end. But the girl of the period does not please men. She pleases them as little as she elevated them; and how little she does that, the class of women she has taken as her models of itself testifies. All men whose opinion is worth having prefer the simple and genuine girl of the past, with her tender little ways and pretty bashful modesties, to this loud and rampant modernization, with her false red hair and painted skin, talking slang as glibly as a man, and by preference leading the conversation to doubtful subjects. She thinks she is piquante and exciting when she thus makes herself the bad copy of a worse original; and she will not see that though men laugh with her they do not respect her, though they flirt with her they do not marry her; she will not believe that she is not the kind of thing they want, and that she is acting against nature and her own interests when she disregards their advice and offends their taste. We do not see how she makes out other account, viewing her life from any side; but all we can do is wait patiently until the national madness has passed, and our women have come back against to the old English ideal, once the most beautiful the most modest, the most essentially womanly in the world.

6

Mary Eliza Haweis, 'Beauty in Dress' and 'Taste in Dress', in *The Art of Dress*, London: Chatto & Windus, 1879, pp. 9–23

An illustrator, writer and ardent promoter of women's suffrage, Mary Eliza Haweis (1848–98; her surname rhymes with 'pause') is today perhaps best known for her 1877 Chaucer for Children, *an illustrated collection that participated in the medieval revival of the 1870s and 1880s. Following its success, she produced a series of book-length studies on fashion and décor, including* The Art of Beauty *(1878),* The Art of Dress *(1879, excerpted here), and* The Art of Decoration *(1881). Her argument for dress reform is predicated on practical and aesthetic concerns. Elsewhere in the text she acknowledges that the* **corset** *undermines health (see fig. 2.4), but – as is clear from the excerpt below – disharmony with nature is moreover a problem of taste. Her advocacy for the cultivation of beauty, which she regards as essential and not merely an adjacent concern to function, along with her approbation of medieval dress, places her within the Aesthetic tradition. Haweis's original section headings and paragraphs numbers have been retained.*

Chapter 1: Beauty in Dress

Importance of Clothes

1. Clothes are our friends or our foes all the days of our life; they control our very health, to say nothing of our worldly credit; and they are never without some influence, pleasurable or the reverse, upon our associates; like manners, they

> are not idle, but the fruit
> Of loyal nature and of noble mind.[1]

[1] From Alfred, Lord Tennyson's (1809–92) 'Guinivere', in *The Idylls of the King* (1859).

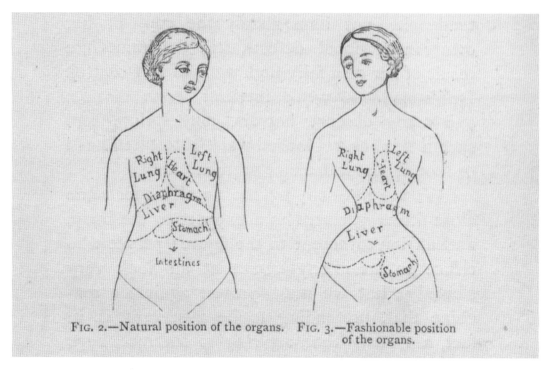

FIG. 2.—Natural position of the organs. FIG. 3.—Fashionable position
 of the organs.

FIGURE 2.4 *Mary Eliza Haweis, 'Natural Position of the Organs' and 'Fashionable Position of the Organs',* The Art of Dress *(London: Chatto and Windus, 1879), p. 36. Image courtesy of Cadbury Research Library: Special Collections, University of Birmingham.*

Yet valuable (nay, indispensable) to us as they are, how few people study them intelligently: how few understand the difference between a woman clad consistently, as a bird or a beast is, every line and hue in harmony and accord—the difference, in fact, between a *well*-dressed person and a mere clothes-prop!

Power of Beauty

2. Many persons are curiously sensitive to colour and shapes in surroundings, certain combinations affecting them with almost physical pain. Now as no surroundings are so inevitable as people's clothes, dress must be held responsible for a certain amount of unintended pleasure or annoyance to others. Besides, one's own apparel is not without an influence on one's own mind: a new colour seems to bring a new atmosphere with it, and changes, oddly enough, the level of thought. Thus, for one's own sake, too, it deserves more than a passing glance, and should claim at least as much attention as, say the paper on the wall, or the sofa and carpets, which are all ministers to our work and play hours. Not that the adorning of the body ought to engross time which belongs to other duties, or exclude more serious studies, exercise, &c. But as we have all got to dress, it is meet and right to do our best with that amount of time we must devote to the matter; to consider the propriety and charm of the outward being as we try in our several ways to consider those of our inner selves; and with a very little study of the right and wrong in dress, the results are found to be fully worth the effort.

The love of beauty in all its forms is an instinct so universal that we feel it must be in a sense divine, and the influence of beauty, not abused, has been seen in all ages to be for good not harm. We owe it to all culture and all pleasure. Our common terms for purely mental qualities are borrowed from it, as 'a beautiful nature', 'a pretty wit', a 'graceful action'.

In old Greece, physical beauty was so prized, that it came to be cultivated in Athens with an almost religious enthusiasm: the mother prayed that her child might be beautiful, because that gift seemed to include all other good gifts. In mediaeval Europe its value was so felt that to 'les belles courtoises dames'[2] much was pardoned, since their beauty was the spur to courage, courtesy, and graceful arts throughout the land.

In modern England there are bitter persons who would admit beauty everywhere except in the human form; but, without attaching romantic importance to physical beauty, it is right and honest to confess that 'it is very good', and it is blind and mischievous to lay a ban upon natural instincts which only become bad when they are called so, and relegated to a sphere of impure surroundings.

What constitutes Beauty

3. What people mean by beauty is commonly their own notion of completeness, leaving nothing to be desired; and hence beauty seems to depend on individual capacity to enjoy. For instance, educated persons, when admiring the beauty of a hand or cheek, admire lines which do not recall what degrades limb or skin, such as disease or undue use, but which recall perfectly just and healthful equilibrium. Common persons, who might praise a 'beautiful' pudding, still refer to pleasure as they understand it, and perfection of work within their own capacity. At the root, all humanity acknowledges a need, a passion, a stream of tendency, for perfectness rounded and complete: i.e. the love of wholesome pleasure. To the question what beauty in the abstract is, and why it is, it may be safest to give the answer of the Chinamen, which won the Wisdom-prize— 'I do not know'.

We only know that art in its sundry forms is the outward imperfect expression of it, and hence we have no satisfactory definition of art, because we cannot define what we mean by abstract beauty.

Art and Fashion

4. Wonderful things are written about art and its limits, and its 'legitimate' developments, and how far principles of beauty are to be applied in our daily life, and whether the line ought to be drawn at the tea-tray or the **broidered** robe. And there are art critics who ought to probe deeper, railing at a sort of mighty bogey, a wanton unreasonable fetish they call 'Fashion', who turns a ceaseless wheel for the benefit of some **millinery**-master.

But 'fashion' is no phantasy of idle minds, no random despot, but a tendency worth study, and eminently instructive, rightly understood, being, with all its blunders, as direct an outcome of the love of beauty as schools of sculpture and painting. It is the last expression of the underlying impulse, the dancing, changing waves which vibrate alternately between the desire to reveal and the necessity to conceal human beauty; and the fashion of Dress was certainly recognized as the legitimate province

[2] les belles courtoises dames: Fr. beautiful courtly women, a phrase from the medieval French tale *Aucassin et Nicolette*. Influential aesthetic critic Walter Pater quotes the phrase in a chapter on the tale in his *Studies in the History of the Renaissance* (London: Macmillan and Co, 1873), p. 17.

of the artist, in the days when art was most previous and most vigorous. We know that Holbein, Jan Van Eyck, and the mighty Michael Angelo designed 'fashions' while at the pinnacle of their fame.

The Culture of Beauty

5. We have plenty of names, ugly and pretty, for that unknown impulse, such as 'a feeling for beauty', an 'eye for colour', 'magnetic attractions', or the fine phrase of the Greeks, καλόυ καὶ ἀγαθόύ, the Beautiful and the Good. Sometimes we rail at it as the 'pride of the eye', 'vanity', 'æstheticism'. Never mind! an appetite which we can neither define nor destroy makes it worth while to seek beauty wherever we can find it—in the body and out of the body; and it follows that dress, that tissue 'which man's soul wears as its outmost wrappage and overall, wherein his whole self lives, moves, and has its being',[3] is no unimportant field for the culture of the beautiful, both for others' good and our own.

It rests with every sensible person to perceive that beauty, like all other pleasant things, may be fairly or unfairly used; may be directed to a good or bad purpose; may be enjoyed within due and wholesome limits, or allowed to run into enervating and evil luxury. People must judge for themselves how far the culture of pleasant things about them is compatible with more solemn duties, how far character is developed or suffers in the process: for no rule can determine what must be to the end of the chapter a question of good sense and good taste.

Rightly followed, the love of all that is beautiful is right and elevating. It is a recreation after dry hard work to look on graceful lines and harmonious colours. They bring fresh thoughts, revive sweet old memories; they remind us of wild, untrammelled nature; they soften our hearts, and improve our tempers.

Things are beautiful in proportion as they recall things more beautiful than themselves. The bit of enamel, or the fragment of silk which recalls the woodland moss or the April sky, is more beautiful than that which recalls darkness and mire. Hence, the more pleasant are our surroundings, the oftener the mind is refreshed and delighted, and the more we should learn and love to learn that we were meant to enjoy what can have had no *motif*[4] but to please.

If, then, we can agree that the beautiful is, that it may be sought, and discovered, even without being accurately defined, and that it is right, not wrong, for everybody to contribute to the common fund of social amenity and enjoyment, we may pass on to consider what is beautiful or the reverse in dress, and seek in each instance an answer to the question, Why?

Chapter II: Taste in Dress

What is Taste?

6. Everything without purpose is without beauty.

And although everything that has a purpose can *en revanche*[5] be called beautiful, yet appropriateness forms so large a share of beauty that everything which fulfils its own purpose well, may be said to have some claim to beauty. A very little taste will generally make it beautiful.

[3] A slight truncation of a line from the opening paragraphs of Thomas Carlyle, *Sartor Resartus* (London: Chapman and Hall, 1869 [1836]), p. 4. See #1.
[4] *motif*: Fr. motive.
[5] *en revanche*: Fr. on the other hand.

And what is taste?

Alas! no word has been more misused—it has been confounded with capacity, with opinion, with habit, nay, with *hobby!*

But I suppose it originally implied the faculty which the palate has of distinguishing flavours; and the term was transferred to those subtler 'flavours' which reach the mental palate. Taste, then, is rightly the faculty of distinguishing between the agreeable and the disagreeable—one which is never found in really coarse-minded people, though it is confined to neither rank nor education—and its function is to so arrange and display what gives agreeable impressions as to suppress what gives disagreeable ones.

Want of Taste a Fault

7. An unmeaning shape or device, an incongruous end or beginning or combination, is intolerable to a person whose taste is keen and healthy. Why? Because the associations are broken, common sense outraged and the purpose of the thing ignored. Yet people possessing real taste often feel a thing to be wrong without being able to give a reason. True; taste is frequently so much an instinct that I suspect its root is in the heart. Why else are there people who will confess to any other deficiency—even spelling—so eager to claim 'taste', with all the cardinal virtues whose absence would be reckoned a fault of character?

'A fault in feeling induces also a fault in style', says Ruskin somewhere,[6] and this seems to be true in every department where taste enters.

Let us then use the word 'taste' for the faculty, natural or acquired, possessed by those whose swift sympathy with others' feelings makes impossible for them to give or to endure 'jars', for taste guards ever against severe friction, and is indeed cousin-german[7] to 'tact'. Taste of course, like manners, may be cultivated; and a woman who is always well dressed (not overdressed), like one who is always well mannered, will be not only a thing of beauty, but a joy for ever.[8]

Imbecile Ornament

8. Natural taste will detect at once a flagrant breach of natural laws; and this is why nothing that is purposeless is in any high sense beautiful. Any part of dress, like any part of architecture, which has no *raison d'être*,[9] and does not belong to the rest, and form part of an harmonious whole, is ungraceful and uncomfortable looking—in fact, bad in art. How much better is the kerchief that really folds, than a bodice trimmed to imitate a kerchief! the apron that really protects, than a garniture that looks like it one place, but is seen in another to have no local habitation nor a name! The real thing is rich in light and shade; every wrinkle has its meaning, every line is accounted for, and the result satisfies eye and mind.

A hood that is seen to be incapable of going over the head; bows (which are nothing but strings tied together) stuck about the dress in an aimless manner, where by no possible means could two portions be fastened to each other; clasps and buckles sewn to parts which they neither unite nor support; buttons which do not button; lacings that cannot lace, and begin and end for no reason; as I have said, are intolerable to taste. They outrage the morality of art.

[6] John Ruskin, *Stones of Venice*, vol. 3 (London: Smith and Elder, 1853), p. 85.
[7] cousin-german: first cousin.
[8] 'A thing of beauty is a joy for ever' is the first line of 'Endymion' by John Keats (1795–1821).
[9] *raison d'être*: Fr. reason for existing.

No detail ought to be admitted in a dress that is not indispensable there. When you have got the form right, you can 'clothe upon' the form with as much ornament as you can afford; as far as possible, however, repeating by the ornament the lines of the form, or at least never denying or effacing the lines. Space being limited here, the fitness of certain kinds of ornament for certain positions and purposes of art, is a question I shall treat at length in a future Manual on the 'Art of Decoration'.[10] Suffice it to say, let a **tunic** be acknowledged as a tunic, a **bodice** as a thing to be got in and out of, as much as a coat. Let the fastenings be apparent, and let the human form command the clothing, and not be subservient to it.

Truth in Art

9. In mediæval times, simplicity and honesty in art arrived at perfect taste, which we have lost by increased skill and corresponding false shame for the steps by which we rose. You will see the hinges of old doors, books, chests, not concealed as our workmen try to conceal them (as though a thing could swing without a hinge!), but acknowledged and even accentuated. They admitted what was inevitable, and beautified it by ornament, into which they put their best work and their freshest thought. This was a more honourable spirit than that which actuates the modern artisan, who never tries to work by the light of truth. And such a spirit entered into mediæval dress, and should enter into ours: for art in dress should, above all other domestic art, be good and noble, seeing that clothes are the indispensable and honourable accompaniment of a being which we believe was created in the highest image.

Freedom in Art

10. We must therefore give intelligent attention to the chief points which go to make up our clothing. And who is so fit to consider those points as the wearer? It is no part of a **milliner's** business to think for us. It is not her province to consider what amount, form, or fabric best accords with our tone of mind, habits, and appearance; that is the wearer's province. And until individual opinion is admitted to be free, we can have no true, original art in England, in dress, nor anything else: for the secret of all true art is freedom, to *think for ourselves*, and *to do as we like*.

And Englishwomen will never efface their sad reputation for ill-dressing and general want of taste until they do think more for themselves, and individualise their daily garb as a part of their individual character.

But freedom were apt to lapse into licence, and general harmony to end in hopeless discord, unless the clear perception of right and wrong (afforded in the present instance by shrewd and cultivated taste) took the helm. Taste is then, undoubtedly, a matter of principle and sympathy. Care of others' feelings and views, honestly of purpose, and a sense of propriety and fitness go a long way to render people charming.

[10] *Art of Decoration* (London: Chatto and Windus, 1889).

7

Florence Pomeroy, Viscountess Harberton, 'Rational Dress Reform', *Macmillan's Magazine* 45 (April 1882), pp. 456–61

Florence Wallace Pomeroy, Viscountess Harberton (1843/4–1911) was a staunch advocate of dress reform. President of the Rational Dress Society (founded 1881), Lady Harberton made waves wearing split skirts and **bloomers** *in public. Her advocacy also included the bicycle, which promised mobility for women, and conventional fashion inhibited its use. In this piece for the mainstream literary magazine* Macmillan's, *she outlines an argument for reform based on practicality and health concerns. Unlike reformers such as Wilde (see #8) who point to the Greek example, Harberton advocates an English dress, suitable to the citizens' needs and the country's weather.*

Bearing in mind the determination of the world, as far as possible, to misunderstand every new idea presented to it, it may be as well to preface the remarks put down here by stating distinctly that I neither wish to wear men's clothes myself, nor to see other women do so.[1] One of the most curious circumstances connected with the subject of reform in dress is this: As soon as any one says some considerable change is advisable, the world at large—either from excess of imaginative power or the want of it—exclaims aloud that that person wishes women to wear men's clothes. 'Bloomerism'[2] still lurks in many a memory. Therefore I begin by saying that I can imagine nothing more unsuitable, ugly, and in every way objectionably, than that the dress of European men should be adopted by women; and, having said this, it is to be hoped that any one reading this article will dismiss men's costume from their thoughts for the present as a subject having nothing to do with the matter in hand.

[1] The fear that equality-seeking women would adopt masculine garb was a common one and provided fodder for many satirical cartoons (see figs. 2.2, 2.5).

[2] American Amelia Bloomer (1818–94) was an activist dedicated to women's rights and abolition; the loose, gathered trousers advocated by her fellow dress reformers were termed 'Bloomers', earning much derision in the press, and 'Bloomerism' the movement for wearing them.

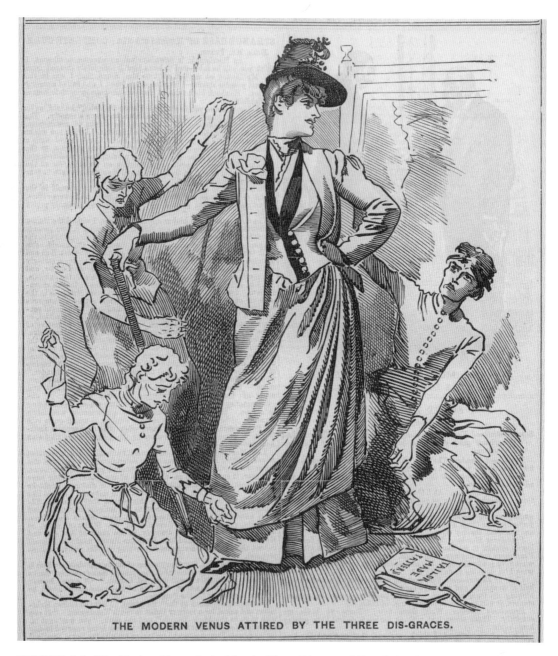

THE MODERN VENUS ATTIRED BY THE THREE DIS-GRACES.

FIGURE 2.5 *'The Modern Venus Attired by the Three Dis-graces'*, Punch *(16 June 1888), p. 278. Image courtesy of Cadbury Research Library: Special Collections, University of Birmingham.*

In order to justify an attempt to change the present style of women's dress, it would not be a difficult task to show that the clothing now in vogue, instead of fulfilling its original purpose and being a useful servant, has become a species of tyrant or idol, subjecting the human form to an inconvenient, unsightly, and tormenting control, and indeed standing almost in the same relation to reason that superstition may be said to do to religion. A curious sort of conventionality is thoughtlessly and blindly followed, and no one seems to think they have the slightest responsibility in the matter, however strange and incongruous the result may be. For instance, let us take the universal practice of going to parties with the upper part of the body uncovered in all weathers, provided it is after six or seven p.m. Certainly there are people to be found who say it is done for a defence against the extreme heat of our climate even in winter; but it is questionable whether they would not hesitate greatly before appearing at breakfast with so little clothing on the hottest day in summer. Then, again, no one sees anything objectionable in a leg being shown up to the knee in getting into a carriage or crossing a street, provided it is only covered by a stocking, while any more complete covering is thought most indecent. One reason why we have arrived at this stage is probably because we have ceased to consider what the form is like which we are trying to clothe. When once this is lost sight of a standard of beauty is set up, which, as far as beauty in the abstract goes, may or may not be a true one; but it is not beauty as far as human beings are concerned, since it bears no resemblance to them. The form which poets and artists think of is what we see in art galleries, statues of Venus and others, which indeed we all occasionally go and admire, as a statue of painting of some mythological being with which we have no personal concern. But the form to be clothed is very different. This is to be seen in the shop windows; in shape at the top like an hour-glass, and with a bell stuck on in place of legs; or even like a gigantic wine bottle. Surely to go on perpetuating such a monstrosity till health itself is endangered is to proclaim ourselves beneath contempt. And that health is not only endangered but irreparably injured by such a course, is so unquestionable and true, that it does not seem necessary to go much into the medical and anatomical view of the subject. Those anxious for information would easily obtain it by asking any doctor a few questions, or reading some of those books which treat on the matter, such as *Fashion in Deformity*, by Professor Flower.[3] Rather let us agree to begin, slowly it may be, and without any too sudden change, which is always difficult, to make our clothing suitable to ourselves and to the lives we lead. Strangely enough the people who are most opposed to any alteration are not, as might be expected, the young and smart-looking women, but those who adopt what is sometimes called the 'sensible woman style of dress'. This is usually of no particular cut or colour; it is chiefly worn by those who take no great pride in their personal appearance, and who, if they are ever spoken to about the need for reform, are apt to say, 'I see no necessity for change; my clothes could hurt no one—look how loose they are!' Restrained by politeness one makes no reply; but the thought arises in the mind, 'True; and a remarkably ugly object you are!' We do not want a continued style of fussing over a style of dress which from its perverted shape never to the end of time can or will be made at once healthy and—there is no English word for it—*chic*. For this reason it will never attract young women; and by all the laws of nature young women will ever be the guides in dress; so that what people should turn their attention to, and try to bring about, is a new departure in dress. Here and there, for instance, a person will be found who can wear a tight-fitting dress-**bodice** without **stays** or (what often produces

[3] Sir William Henry Flower, surgeon and ultimately the Director of Britain's National History Museum, published *Fashion in Deformity* in 1881 (London: Macmillan and Co.). It documents skeletal irregularities ostensibly caused by **corsets**, among other clothing-induced physical changes.

the same effect) padding. But speaking generally, quite tight-fitting bodice-dresses without stays look untidy and like pincushions. If, then, we keep in mind these positive facts, that so far from a small waist being a beauty, if such a thing could exist naturally, it would be a great deformity; and that in proportion to the width of their shoulders, women are larger in the waist than men—thus following an obvious natural law—we shall begin to realise that our clothes are planned upon a mistaken idea. Without a waist, and with a skirt completely hiding the outline of the legs, the figure becomes one long straight piece from shoulders to feet, a thing in itself too ugly to be long endured. This is clearly why we have adopted the plan of making a waist, and as much variety of shape as possible in the way of humps and excrescences, in the clothing of the upper part of our bodies. In warm climates the skirt was originally either very short or very thin, so that the legs were permitted to be seen; but in colder climates, and with the advance of civilisation, this could not be, so we have arrived at the present plan of concealing all sign of legs, which causes the attention of women to be almost morbidly directed to the body alone. If some form of dress were devised, with a covering or skirt for each leg, and a lightly draped skirt over it, reaching to about the knees, or even a little below them, and allowing the legs to appear slightly, we should have a costume which, being in accordance with nature, the rest of the lines of the body would resume their proper proportions, and deformities of the sort to which we now are so accustomed, would at once strike us as hideous and out of drawing.

There is not space here to go into the theory maintained by some that clinging skirts, such as are depicted on bas-reliefs and Christmas cards, are the most truly lovely. Of course they are Greek, and that to some minds is an argument which admits of no reply. But we are not Greek. We are English. They had their climate and habits, and we have *our* climate and habits, than which nothing could well be more dissimilar; and as may be expected, without modifications which rob them of all meaning and beauty, Greek fashions are perfectly unfit for England or English ways. Such skirts are extremely dirty for walking, as the heel must rub against them at every step; they are distinctly injurious to health from the waste of nerve power caused by the constant friction round the ankles; and, as must always be the case where only skirts are worn, if the wearer attempts to do more than walk quietly along a road, they appear not only ludicrous but almost indecent. The harm this does to our young girls seems to have escaped public attention; yet now that our daughters are being properly educated, and much on the same lines as our sons, it is likely to have a very serious effect on their health if they cannot also have the counteracting influence of really stirring interesting games. In their present clothes this is neither possible nor desirable. That there is something wrong in the physical education of girls is obvious, else why should they suffer from colds, headaches, and chilblains to an extent unheard of among boys? Neither among animals, nor the young of savage tribes, do we see any such difference between the sexes in point of health, and it seems rather a disgrace to us women not to exert ourselves more heartily to put this matter right.

Most people have remarked in reading the accounts of fires in theatres that one of the first things recorded as happening is that 'several women fainted', as soon as the crowd began to rush. Did they faint? One rather doubts it. What seems much more probably is that some one behind trod on their dresses, and that then, pushed on by those beside them, they fell in a manner exactly like a faint. Almost straight, but rather backwards, they would go down where they stood, without being able to help themselves, and others falling over them, would make the matter at once hopeless; for dressed as they are women certainly do not give themselves much chance of escape when any sudden danger arises, since they have reduced all physical movement to a minimum, with at the same time the maximum of fatigue, and are thus notable examples of 'how not to do it'.

One of the customs of the present day is to take it for granted that women's dress is beautiful and men's hideous. Without laying down a dogmatic opinion, this axiom would appear hardly proved. The majority take it mean simply that **petticoats** are pretty, and trousers ugly. If this be true, it follows that the dress of a charwoman is more pleasing that that of a working man; but if this is felt to be doubtful, then may it not be that the thing which is really pleasing is not the cut of the clothes so much as the charm of rich and suitable materials with varied and well assorted colours? So far from this being necessarily lost in a different kind of dress it might be materially heightened, as instead of 'good taste misplaces', we should have good taste crowning a costume were, with no muscle cramped, and no horrible deformity slowly but surely undermining the health, the true curves of the human form, which are no less admirable and harmonious than those of other created beings, might be seen with advantage. A very pertinent question has been lately asked more than once in connection with this idea, to the effect why it should be supposed that the male form came perfect from the hands of the Creator, while that of the female needs constant tinkering and screwing into shape to make it presentable? Exactly so; but the form women choose to call theirs never came from the hands of any Creator. Nature repudiates it, and true art denounces it, so no wonder it requires propping up.

Some ladies say that unless they wear stays they could not wear enough clothes to keep the legs warm from the drag and pressure round the waist. This is only because they have their clothes made in one loose piece. With a separate skirt for each leg they would be as warm with one undergarment as with four or five on the old principle. Of course they may object to a costume recently introduced on this plan on the score of beauty, but they must remember it is in their own power to remedy this. A form of dress which in deference to a mistaken public opinion has to simulate a perfectly different one, is at a great disadvantage. If generally acknowledged and adopted, there would be no difficulty in making it as pretty as any dress can be.

A great deal might be said on the subject of head gear, but it seems almost in vain. Many people must have wondered why every woman from seventeen to twenty thinks it advisable to go about with her head adorned with imitations of flowers? Why has an out-of-doors head-dress been selected, which though varying a good deal in shape, is careful never to cover or protect the head nor shade the eyes? and why may a young woman wear a hat, while one past middle age who wishes for more protection to the eyes than is afforded by a spotted veil, is thought extremely odd? It is also worthy of notice that the **chimney-pot hat** denounced by men as injurious and uncomfortable is the one and only article of male attire thought fit and suitable to be adopted by women in its pristine and unmodified form. It is however a mere waste of time to inveigh against bits of dress, such as boots, stays, **bonnets** and so on. The foot for example was meant to appear joined to an ankle and leg; and seen so, it looks a shapely and perfect thing in its way; but on our system of ignoring all idea of legs the feet are apparently attached to nothing particular, and may as well be one shape as another. We therefore soon begin to try if we cannot contrive something more fanciful, and in all conscience we have succeeded fairly well in this matter, though at what amount of suffering and injury to health one may leave the medical world to declare, since here at least they give forth no uncertain sound. Now that women are being gradually allowed to take their place in Society as rational beings, and are no longer looked upon as mere toys and slaves; and now that their livelihood is becoming more and more to be considered their own affair, the question of dress assumes proportions which it did not use to have. Physically rather weaker than men we undoubtedly are, but why exaggerate this weakness by literally so tying ourselves up in clothing that the muscles in some parts of the body dwindle till they become useless? When the brain deteriorates from want of oxygen in the blood—brought about by the reduced breathing power inseparable from clothing so tight

that the walls of the chest being unable to expand—the lungs cannot properly do their work of aërating the blood. This makes the work of those who have to labour with their hands four-fold more exhausting than it need otherwise be; and at the same time from its unready and unfit appearance, such unsuitable clothing cannot fail to prevent, nay positively prevents, them from obtaining much easier and lighter work than that which they actually have to do. And that this is no fancy, a very little observation of those employed in active work will prove to most. Observe simply the extra fatigue which is ensured to every woman, in merely carrying a tray up stairs, from the skirt of the dress. Ask young women who are studying to pass examinations whether they do not find loose clothes a *sine quâ non*[4] while poring over their books, and then realize the harm we are doing ourselves and the race by habitually lowering our powers of life and energy in such a manner. As a matter of fact it is doubtful whether any persons have ever been found who would say that their stays were at all tight; and indeed by a muscular contraction, they can apparently prove that they are not so by moving them about on themselves, and thus probably believe what they say. That they are in error all the same, they can easily assure themselves by first measuring round the waist outside the stays; then, taking them off, let them measure while they take a deep breath, with the tape merely laid on the body as if measuring for the quantity of braid to go round a dress, and mark the result. The injury done by stays is so entirely internal that it is not strange that the maladies caused by wearing them should be attributed to every reason under the sun except the true one, which is, briefly—that all the internal organs being by them displaced, are doing their work imperfectly, and under the least advantageous conditions; and are therefore exactly in the state most favourable to the development of disease, whether hereditary or otherwise.

The well-worn saying that ornament preceded dress is doubtless true, and many people at present draw the inference that because women's dress appears designed for ornament rather than convenience, women must be immeasurably lower in the intellectual scale than men whose dress has not this fault. There perhaps they judge hastily. For one thing; it affords to many men quite as keen a delight to see their wives and daughters decked out in absurd costumes, trailing yards of material on the floor after them about a room (and possibly a mat or two accidentally caught up on the way), or tottering feebly along a street on high heels, as it ever afforded any woman to wear such things. Hence it is that we do not have the help from men in the matter of dress reform which reason would lead us to expect; and then the question arises whether they are after all so much in advance as first appears. Possibly they are not aware of the daily and hourly discomfort inflicted by the garments they admire so much, as even women often say they consider their dresses quite comfortable for walking! However, as it is well known that those born blind know little about the charm of colour, so those who have never tried a divided skirt, or freedom of lung power, may not be aware of the drag they are subject to, and may believe the fatigue they feel to be inseparable from the act of walking, which is a very comprehensible error. On this subject, as has been said before, we have one sure guide only—and that is to keep steadily before our mind the creature for which we are devising clothes. Once we lose sight of this and we open the door for every kind of comical deformity possible—for one is as good and no worse than another. We have no anchor to hold us back, no object to attain, not even any actual standard of beauty, so we stray about helplessly among shapes and materials put forward from time to time as some dressmaker or manufacturer happens to rise temporarily above the rest. Commerce is injured, health destroyed, happiness of children sensibly curtailed, morality

[4] *sine quâ non*: Latin. essential element.

certainly not improved, and one finally asks, 'For whose good?' This question must be left to others to answer. Some of those optimists who see good in everything may possibly see some even here; but there are many who can see nothing but a useless martyrdom to an intellectual apathy which refuses to see, or hear, or put out a little finger to help itself.

If ever anything is to be done to raise us out of this quagmire of mistakes and folly it will certainly not be by the majority looking—*not* at what in their heart of hearts they honestly wish and believe but—at the difficulties in the way, saying, people will never do this, that, or the other; or even uttering the more terrible watchword, 'The men won't like it'. In the first place, 'people', as a noun of multitude, think very much alike; and in the second place those who believe that the aims of the 'Rational Dress Society' are likely in their most extended sense to benefit the community, should join the Society openly, whether they choose to actually be among the first to change their dress or not, and they will be surprised to find how many there are ready to go with them when once they see that they have not to go alone. And as for men not liking it! Where is our common sense? Where is our self-respect? Why, men have admired the queer and scanty garments of the beginning of this century, they have admired the huge and outrageous **crinolines** of twenty years ago, and the ludicrous tied-in dresses of later days. No doubt even the Turk thinks there is nothing as admirable as the clothes of his woman kind; and whatever women wear it is very certain men will go on admiring it still. Unconscious as their admiration may be, it is none the less real, for it is the women they admire, and the clothes for their sakes, but never the women for the sake of the clothes. No one ever saw men in rows in front of shop windows admiring the dresses on the stands, but every one sees beautiful women gazed at with admiration and delight wherever they go; and so far from changes as are here advocated taking beauty out of the world, it would, as far as men are concerned, be doing them good service by giving them something worthy of admiration in a graceful natural walk and carriage; in the general harmony of appearance that accompanies health and strength, and in the true beauty of nature which makes a real flower so incomparably more beautiful than an artificial one.

8

Oscar Wilde, 'The Philosophy of Dress', *New York Daily Tribune* (19 April 1885), p. 9

Although perhaps best known for his fiction and Society plays, Oscar Wilde (1854–1900) was a prolific lecturer and journalist. In his early public appearances, he established a reputation for idiosyncratic Aesthetic dress that persisted even after he adopted more conventional attire. He was, in any case, a strong proponent of dress reform, arguing with Haweis that beauty and functionality were not mutually exclusive and insisting that art trumps fashion: 'Fashion rests upon folly. Art rests upon law. Fashion is ephemeral. Art is eternal'. While retaining Wilde's signature tone, the 'Philosophy on Dress' forwards common sense ideas that prompted surprise in some observers. A May 1885 column in the Dundee Evening Telegraph *carried an excerpted version of Wilde's article, prefaced with a representative comment: 'The whole article is tinged, of course, with the writer's beautiful but extravagant ideas on the subject of dress reform; but there is so much sound reasoning and unquestionable truth in the course of the essay that its perusal does much to qualify the impression we are too apt to form of the writer's eccentric, artistic genius'.[1] The essay was omitted in the collected editions of Wilde's works and was not reprinted in full until 2013.[2] Ellipses throughout appear in the original.*

There has been within the last few years, both in America and in England, a marked development of artistic taste. It is impossible to go into the houses of any of our friends without seeing at once that a great change has taken place. There is a far greater feeling for color, a far greater feeling for the delicacy of form, as well as a sense that art can touch the commonest things of the household into a certain grace and a certain loveliness. But there is a whole side of human life which has been left almost entirely untouched. I mean of course the dress of men and of women …

I have been sometimes accused of setting too high an importance on dress. To this I answer that dress is itself a thing to me absolutely unimportant. In fact the more complete a dress looks on the dummy-figure of the **milliner**'s shop, the less suitable it is for being worn. The gorgeous

[1] 'Ladies Column: The Philosophy of Dress', *Evening Telegraph* (Dundee) (7 May 1885), p. 4.
[2] John Cooper's *Oscar Wilde on Dress* (Philadelphia; CSM Press, 2013) features a critical edition of the essay and a sustained discussion of its position within Wilde's oeuvre.

costumes of M. Worth's[3] *atelier* seems to me like those Capo di Monte[4] cups, which are all curves and coral-handles, and covered over with a Pantheon of gods and goddesses in high excitement and higher relief; that is to say, they are curious things to look at, but entirely unfit for use. The French milliners consider that women are created specially for them by Providence, in order to display their elaborate and expensive wares. I hold that dress is made for the service of Humanity. They think that Beauty is a matter of frills and **furbelows**. I care nothing at all for frills, and I don't know what furbelows are, but I care a great deal for the wonder and grace of the human Form, and I hold that the very first canon or art is that Beauty is always organic, and comes from within, and not from without, comes from the perfection of its own being and not from any added prettiness. And that consequently the beauty of a dress depends entirely and absolutely on the loveliness it shields, and on the freedom and motion that it does not impede.

From this it follows that there can be no beauty of national costume until there is a national knowledge of the proportions of the human form. To Greek and Roman such knowledge came naturally from the gymnasium and the palaestra,[5] from the dance in the meadow and the race by the stream. We must acquire it by the employment of art in education. And knowledge of the kind I propose would soon become the inheritance of all, if each child were taught to draw as early as it is taught to write...

And if a child does study the human figure it will learn a great many valuable laws of dress. It will learn, for instance, that a waist is a very beautiful and delicate curve, the more delicate the more beautiful, and not, as the milliner fondly imagines, an abrupt right angle suddenly occurring in the middle of the person. He will learn again that size has nothing to do with beauty. This, I dare say, seems a very obvious proposition. So it is. All truths are perfectly obvious once one sees them. The only thing is to see them. Size is a mere accident of existence, it is not a quality of Beauty ever. A great cathedral is beautiful, but so is the bird that flies round its pinnacle, and the butterfly that settles on its shaft. A foot is not necessarily beautiful because it is small. The smallest feet in the world are those of the Chinese ladies, and they are the ugliest also.

It is curious that so many people, while they are quite ready to recognize, in looking at an ordinary drawing-room, that the horizontal line of frieze and **dado** diminishes the height of the room, and the vertical lines of pillar or panel increase it, yet should not see that the same laws apply to dress also. Indeed in modern costume the horizontal line is used far too often, the vertical line far too rarely, and the oblique line scarcely at all.

The waist, for instance, is as a rule placed too low down. A long waist implies a short skirt, which is always ungraceful as it conveys an effect of short limbs, whereas a high waist gives an opportunity of a fine series of vertical lines falling in the folds of the dress down to the feet, and giving a sense of tallness and grace. Broad puffed sleeves, again, by intensifying the horizontal line across the shoulders, may be worn by those that are tall and slight, as they diminish any excessive height and give proportion; by those who are small they should be avoided. And the oblique line, which one gets by a cloak falling from the shoulder across the body or by a gown looped up at the side, is suitable to almost all figures. It is a line which corresponds to the direction of motion, and conveys an impression of dignity as well as of freedom. There are of course many other applications of these lines. I have mentioned merely one or two in order to remind people how identical the laws of architecture and of dress really are, and how much

[3] Charles Frederick Worth (1825–95), leading British-born, Paris-based **couturier** in the late nineteenth century; see #24.
[4] Capo di Monte: Italian porcelain factory known for intricate figures and highly decorative wares.
[5] palaestra: Greek wrestling school.

depends on line and proportion. Indeed the test of a good costume is its silhouette, how, in fact, it would look in sculpture.

But besides line there is also color. In decorating a room, unless one wants the room to be either chaos or a museum, one must be quite certain of one's color-scheme. So also in dress. The harmony of color must be clearly settled. If one is small—the simplicity of one color has many advantages. If one is taller two colors or three may be used. I do not wish to give a purely arithmetical basis for an aesthetic question, but perhaps three shades of color are the limit. At any rate it should be remembered that in looking at any beautifully dressed person, the eye should be attracted by the loveliness of line and proportion, and the dress should appear a complete harmony from the head to the feet: and that the sudden appearance of any violent contrasting color, in bow or **riband**, distracts the eye from the dignity of the *ensemble*, and concentrates it on a mere detail.

Then as regards the kinds of colors, I should like to state once for all that there is no such thing as a specially artistic color. All good colors are equally beautiful: it is only in the question of their combination that art comes in. And one should have no more preference for one color over another than one has for one note on the piano over its neighbor. Nor are there any sad colors. There are bad colors, such as Albert blue, and magenta, and **arsenic green**, and the colors of aniline dyes generally,[6] but a good color always gives one pleasure. And the tertiary and secondary colors[7] are for general use the safest, as they do not show wear easily, and besides give one a sense of repose and quiet. A dress should not be like a steam-whistle, for all that M. Worth may say.

Then as regards pattern. It should not be too definite. A strongly marked check, for instance, has many disadvantages. To begin with, it makes the slightest inequality in the figure, such as between the two shoulders, very apparent; then it is difficult to join the pattern accurately at the seams; and lastly, it distracts the eye away from the proportions of the figure, and gives the mere details an abnormal importance.

Then again, the pattern should not be too big. I mention this, because I happened lately in London to be looking for some stamped gray plush or velvet, suitable for making a cloak of. Every shop that I went into the man showed me the most enormous patterns, things far too big for an ordinary wall paper, far too big for ordinary curtains, things, in fact, that would require a large public building to show them off to any advantage. I entreated the shopman to show me a pattern that would be in some rational and relative proportion to the figure of somebody who was not over ten or twelve feet in height. He replied that he was extremely sorry but that it was impossible: the smaller patterns were no longer being woven, in fact the big patterns were the fashion. Now when he said the word fashion, he mentioned what is the great enemy of art in this century, as in all centuries. Fashion rests upon folly. Art rests upon law. Fashion is ephemeral. Art is eternal. Indeed what is a fashion really? A fashion is merely a form of ugliness so absolutely unbearable that we have to alter it ever six months! It is quite clear that were it beautiful and rational we would not alter anything that combined those two rare qualities. And wherever dress has been so, it has remained unchanged in law and principle for many hundred years. And if any of my practical friends in the States refuse to recognize the value

[6] 'D'Albert blue', invented by Ferdinand D'Albert in 1852, was a synthetic substitute for indigo; arsenic green, also known as Paris green, was developed in 1814, though its poisonous effects ended its usage by the turn of the century; these and synthetic aniline dyes produced brighter colours than many of their naturally derived antecedents (see also #21).
[7] Blends of primary colours; see also 'When I First Put my Uniform on' (#15).

of the permanence of artistic laws, I am quite ready to rest the point entirely on an economic basis. The amount of money that is spent every year in America on dress is something almost fabulous. I have no desire to weary my readers with statistics, but if I were to state the sum that is spent yearly on **bonnets** alone, I am sure that one-half of the community would be filled with remorse and the other half with despair! So I will content myself with saying that it is something quite out of proportion to the splendor of modern dress, and that its reason must be looked for, not in the magnificence of the apparel, but rather in that unhealthy necessity for change, which Fashion imposes on its beautiful and misguided votaries.

I am told, and I am afraid that I believe it, that if a person has recklessly invested in what is called 'the latest Paris bonnet', and worn it to the rage and jealousy of the neighborhood for a fortnight, her dearest friend is quite certain to call upon her, and to mention incidentally that that particular kind of bonnet has gone entirely out of fashion. Consequently a new bonnet has at once to be bought, that Fifth-ave.[8] may be appeased, and more expense entered into. Whereas were the laws of dress founded on art instead of on fashion, there would be no necessity for this constant evolution of horror from horror. What is beautiful looks always new and always delightful, and can no more become old-fashioned than a flower can. Fashion, again, is reckless of the individuality of her worshippers, cares nothing whether they be tall or short, fair or dark, stately or slight, but bids them all be attired exactly in the same way, until she can invent some new wickedness. Whereas Art permits, nay even ordains to each, that perfect liberty which comes from obedience to law, and which is something far better for humanity than the tyranny of tight lacing or the anarchy of aniline dyes.

And now as regards the cut of the dress.

The first and last rule is this, that each separate article of apparel is to be suspended from the shoulders always and never from the waist. Nature, it should be noted, gives one no opportunity at all of suspending anything from the waist's delicate curve. Consequently, by means of a tight **corset** a regular artificial ledge has to be produced, from which the lower garment may be securely hung. Where there are **petticoats**, there must be corsets. Annihilate the former and the latter disappear. And I have no hesitation in saying that whenever in history we find that dress has become absolutely monstrous and ugly, it has been partly of course through the mistaken idea that dress has an independent existence of its own, but partly also through the fashion of hanging the lower garments from the waist. In the sixteenth century, for instance, to give the necessary compression, Catharine de Medicis, High-Priestess of poison and petticoats, invented a corset which may be regarded as the climax of a career of crime. It was made of steel, had a front and a back to it like the **cuirass** of a fire-brigade man, and was secured under the left arm by a hasp and pin, like a Saratoga trunk.[9] Its object was to diminish the circumference of the waist to a circle of thirteen inches, which was the fashionable size without which a lady was not allowed to appear at court: and its influence on the health and beauty of the age may be estimated by the fact that the normal waist of a well-grown woman is an oval of twenty-six to twenty-eight inches certainly.

As one bad habit always breeds another, in order to support the weight of the petticoats the **fardingale** was invented also. This was a huge structure, sometimes of wicker-work like a large clothes-basket, sometimes of steel ribs, and extended on each side to such an extent that in the reign of Elizabeth an English lady in full dress took up quite as much room as we would give now to a very good sized political meeting. I need hardly point out what a selfish fashion this

[8] Fashionable street with high-end merchants in New York City.
[9] Saratoga trunk: large, wooden trunk with a rounded top, designed for travel on steamboats.

was, considering the limited surface of the globe. Then in the last century there was the hoop, and in this the **crinoline**. But, I will be told, ladies have long ago given up crinoline, hoop, and fardingale. That is so. And I am sure we all feel very grateful to them. I certainly do. Still, does there not linger, even now, amongst us that dreadful, that wicked thing, called the **Dress-Improver?** Is not that vilest of all diminutives, the **crinolette**, still to be seen? I am quite sure that none of my readers ever dream of wearing anything of the kind. But there may be others who are not so wise, and I wish it could be conveyed to them, delicately and courteously, that the hour-glass is not the Ideal of Form. Often a modern dress begins extremely well. From the neck to the waist the lines of the dress itself follow out with more or less completeness the lines of the figure; but the lower part of the costume becomes bell-shaped and heavy, and breaks out into a series of harsh angles and coarse curves. Whereas if from the shoulders, and the shoulders only, each separate article were hung, there would be then no necessity for any artificial supports of the kind I have alluded to, and tight lacing could be done away with. If some support is considered necessary, as it often is, a broad woollen band, or band of elastic webbing, held up by shoulder straps, will be found quite sufficient.

So much on the cut of the dress, now for its decoration.

The French milliner passes a lurid and lucrative existence in the sewing on bows where there should be no bows, and flounces where there should be no flounces. But, alas! his industry is in vain. For all ready-made ornamentation merely makes a dress ugly to look at and cumbersome to wear. The beauty of dress, as the beauty of life, comes always from freedom. At every moment a dress should respond to the play of the girl who wears it, and exquisitely echo the melody of each movement and each gesture's grace. Its loveliness is to be sought for in the delicate play of light and line in dainty rippling folds, and not in the useless ugliness and ugly uselessness of a stiff and stereotyped decoration. It is true that in many of the latest Paris dresses which I have seen there seems to be some recognition of the value of folds. But unfortunately the folds are all artificially made and sewn down, and so their charm is entirely destroyed. For a fold in a dress is not a fact, and item to be entered into a bill, but a certain effect of light and shade which is only exquisite because it is evanescent. Indeed one might just as well paint a shadow onto a dress as sew a fold down on one. And the chief reason that a modern dress wears such a short time is that it cannot be smoothed out, as a dress should be, when it is laid aside in the wardrobe. In fact in a fashionable dress there is far too much 'shaping'; the very wealthy of course will not care, but it is worth while to remind those who are not millionaires that the more seams the more shabbiness. A well-made dress should last almost as long as a **shawl**, and if it is well made it does. And what I mean by a well-made dress is a simple dress that hangs from the shoulders, that takes its shape from the figure and its folds from the movements of the girl who wears it, and what I mean by a badly made dress is an elaborate structure of heterogeneous materials, which having been first cut to pieces by the shears, and then sewn together by the machine, are ultimately so covered with frills and bows and flounces as to become execrable to look at, expensive to pay for, and absolutely useless to wear.

Well, these are the principles of Dress. And probably it will be said that all these principles might be carried out to perfection, and yet no definite style be the result. Quite so. With a definite style, in the sense of a historical style, we have nothing whatsoever to do. There must be no attempt to revive an ancient mode of apparel simply because it is ancient, or to turn life into that chaos of costume, the **Fancy Dress** Ball. We start, not from History, but from the proportions of the human form. Our aim is not archæological accuracy, but the highest possible amount of freedom with the most equable distribution of warmth. And the question of warmth brings me to my last point. It has sometimes been said to me, not by the Philistine merely but

by artistic people who are really interested in the possibility of a beautiful dress that the cold climate of Northern countries necessitates our wearing so many garments, one over the other, that it is quite impossible for dress to follow out or express the lines of the figure at all. This objection, however, which at first sight may seem to be a reasonable one, is in reality founded on a wrong idea, on the idea in fact, that the warmth of apparel depends on the number of garments worn, but the warmth of apparel depends entirely on the material of which those garments are made. And one of the chief errors in modern costume comes from the particular material which is always selected as the basis for dress. We have always used **linen**, whereas the proper material is wool.

Wool, to begin with, is a non-conductor of heat. That means that in the summer the violent heat of the sun does not enter and scorch the body, and that the body in winter remains at its normal natural temperature, and does not waste its vital warmth on the air. Those of my readers who play lawn tennis and like out-door sports know that, if they wear a complete **flannel** suit, they are perfectly cool on the hottest day, and perfectly warm when the day is cold. All that I claim is that the same laws which are clearly recognized on the tennis ground, flannel being a woolen texture, should be recognized also as being equally suitable for the dress of people who live in towns, and whose lives are often necessarily sedentary. There are many other qualities in wool, such as its being an absorber and distributor of moisture, with regard to which I would like to refer my readers to a little hand-book on 'Health Culture', by Dr. Jaeger,[10] the Professor of Physiology at Stuttgart. Dr. Jaeger does not enter into the question of form or beauty, at least when he does he hardly seems to me very successful, but on the sanitary values of different textures and colors he speaks of course with authority, and from a combination of the principles of science with the laws of art will come, I feel sure, the costume of the future.

For if wool is selected as the basis and chief materials of dress, far fewer garments may be worn than at present, with the result of immensely increased warmth and much greater lightness and comfort. Wool also has the advantage of being almost the most delicate texture woven. Silk is often coarse compared to it, being at once harder and colder. A large **Cashmere** shawl of pure wool can be drawn through a tiny ring, indeed by this method do the shawl-sellers of the Eastern bazaar show to one the fineness of their goods. Wool, again, shows no creases. I should be sorry to see such a lovely texture as **satin** disappear from modern dress, but every lady who wears anything of the kind knows but too well how easily it crumples; besides it is better to wear a soft than a hard material, for in the latter there is always a danger of harsh and coarse lines, whereas in the former you get the most exquisite delicacy of fold.

We find, then, that on the question of material Science and Art are one. And as regards the milliners' method of dress I would like to make one last observation. Their whole system is not merely ugly but useless. It is of no avail that a stately lady pinches in her waist in order to look slight. For size is a question of proportion. And an unnaturally small waist merely makes the shoulders look abnormally broad and heavy. The high heel, again, by placing the foot at a sharp angle bends the figure forward, and thus so far from giving any additional height, robs it of at least an inch and a half. People who can't stand straight must not imagine that they look tall. Nor does the wearing of a lofty headdress improve the matter. Its effect is merely to make the head disproportionately large. A dwarf three feet high with a hat of six cubits on his head will look a dwarf three feet high to the end. Indeed height is to be measured more by the position

[10] Selections from Gustav Jäger's (1832–1917) *Health-Culture and the Sanitary Woollen System* were published in English in 1884 (London: Dr. Jaeger's Sanitary Woollen System Co., Ltd.).

of the eyes and the shoulders than by anything else. And particular care should be taken not to make the head too large. Its perfect proportion is one-eighth of the whole figure

But I know that, irrespective of Congress, the women of American can carry any reform they like. And I feel certain that they will not continue much longer to encourage a style of dress which is founded on the idea that the human figure is deformed and requires the devices of the milliner to be made presentable. For have they not the most delicate and dainty hands and feet in the world? Have they not complexions like ivory stained with a rose-leaf? Are they not always in office in their own country, and do they not spread havoc through Europe? *Appello, non ad Caesarem, sed ad Caesaris uxorem.*[11]

[11] *Appello, non* ...: Latin. I appeal not to Caesar, but to Caesar's consort. The Vulgate offers an antecedent, recording Paul's appeal to Caesar as 'Caesarem appello' (Acts 25.11).

SECTION THREE

Crinolines and Corsets

Today, **crinolines** are often pointed to as signs of the constriction of Victorian women, a literal cage that reflected the less tangible social restrictions that bound women to home and hearth. Introduced to England by the French Empress Eugénie, consort of Napoleon III in the late 1850s (see fig. 3.1), the cage actually presented an advance in comfort and ease for many women. Built upon the industrial innovation of lightweight sprung steel, the wire cage hung from the waist and provided support for the heavy, full skirts that increased in circumference through the early 1860s. Prior to the introduction of the cage, this fullness was achieved through layers of heavy **petticoats**; replacing these bulky, difficult to clean layers with the light, open cage meant that those fashions could be worn more comfortably. Increased mobility and ease of movement was a selling feature of the crinoline, but not all were convinced. If crinolines allowed women greater freedom of movement, their sheer bulk posed problems for others: namely men who shared sidewalks, omnibuses, church pews and drawing rooms with crinolined women. Satirical cartoons abound (see figs. 3.2–3.3), many depicting men inconvenienced by the intrusion of the steel crinoline. The frustration that underscores such satires might be understood as springing from a threatened patriarchal hegemony, but even that outrage could be applied to reform, as in the male exasperated by the invading crinoline who calls for an end to the fashion (see #9).

On the moral front, absurdly large crinolines were identified as evidence of the wearer's vanity. That a woman could be so vain as to follow empty fashion trends – and trends that infringed upon the comfort of others in her life as well as on her own modesty – was a thing to be repented of and deplored. Bell-shaped and suspended from the waist, the cage could swing from side to side as a woman walked, and because they replaced voluminous petticoats, crinolines could, when lifted to mount a step or a carriage, reveal more of ankle and leg than previous fashions. Even more alarming was another consequence of the crinoline's relatively free movement: one's skirts could all too easily catch fire by sweeping across a fireplace grate or hearth. Countless

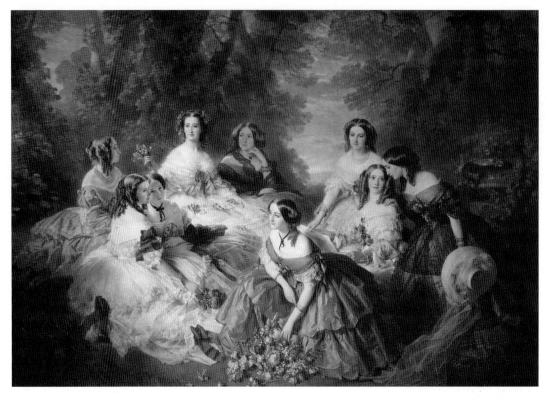

FIGURE 3.1 *Franz Xaver Winterhalter,* Eugénie, Empress of the French and her Ladies *(1855), oil on canvas, 295x420cm, Palais de Compiègne. Public domain image via Creative Commons.*

examples of 'hearth death' were attributed to crinoline. As Harriet Martineau's 'A New Kind of Wilful Murder' documents (see #10), the newly appointed London coroner seized upon these accidents, along with the numerous cases of infanticide said to be attributable to the concealing powers of the crinoline, as a needless epidemic wrought by women's senseless fealty to fashion.

The dramatic sweep of a crinoline skirt made the waist look small by comparison, and women's fashion through the 1850s and 1860s was not dependent on the tightly corseted **bodice**. As skirt circumference shrank and volume shifted to the back of the skirt in the 1870s, the use of the **corset** to define the waist became increasingly important (see figs. 3.4–3.5). As with many fads, the newly important corsetry was taken to extremes with **tight-lacing**; yet, as is the case with the crinoline, the corset cannot simply be dismissed as tool of masculine domination. Violet Greville (see #11) argues passionately to end tight-lacing, but insists that women 'dress at, for, and against, one another', not for men. It is thus women's expectations for themselves and for each other that must be overcome, though Greville does call on men to speak out against the practice, since it is ostensibly their preference that drives women to achieve ever-smaller **wasp waists**. A series of shorter contemporary reports of crinoline and corsets (#12) fleshes out the range of responses to these two divisive garments.

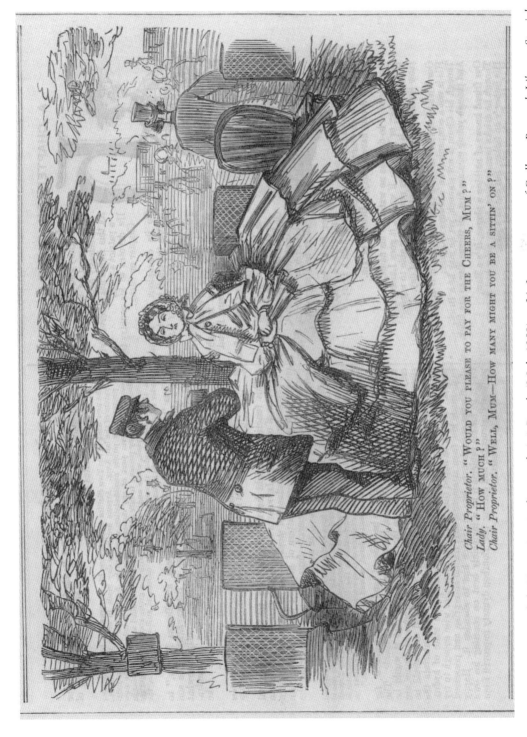

Chair Proprietor. "WOULD YOU PLEASE TO PAY FOR THE CHEERS, MUM?"
Lady. "HOW MUCH?"
Chair Proprietor. "WELL, MUM—HOW MANY MIGHT YOU BE A SITTIN' ON?"

FIGURE 3.2 Untitled (Woman in crinoline on chairs), Punch (9 July 1859), p. 21. Image courtesy of Cadbury Research Library: Special Collections, University of Birmingham.

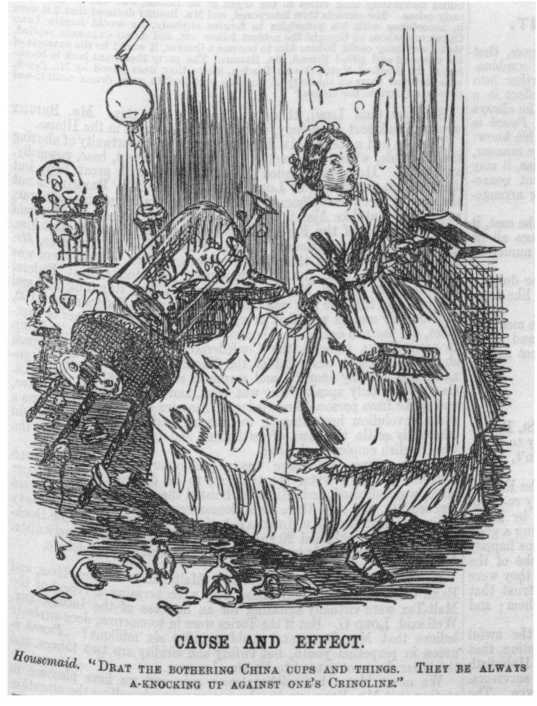

CAUSE AND EFFECT.

Housemaid. "Drat the bothering China cups and things. They be always a-knocking up against one's Crinoline."

FIGURE 3.3 *'Cause and Effect'*, Punch *(26 March 1864), p. 123. Image courtesy of Cadbury Research Library: Special Collections, University of Birmingham.

Housemaid. "Drat the bothering China cups and things. They be always a-knocking up against one's Crinoline."

DOCTORS RECOMMEND REAST'S PATENT

INVIGORATOR
CORSET

Made to Order in Any Shape.

SPECIALITE, Long Waist, 12/9.

Dr. M. O. B. Neville, L.R C.P., Edinburgh Medical Officer to Health, says, Nov. 1st, 1890—

"From a scientific point of view, I am of opinion that your Corset is the only one that gives support without unduly compressing important organs. Its elasticity, in a great measure, prevents this. I am satisfied, by its support of back and shoulders, that it is a material help to expanding the chest."

"Health," (edited by Dr. And. Wilson, F.R.S.E., Lecturer on Health under the Combe Trust, Lecturer on Physiology, at the Edinburgh University), says—

"We recommend Reast's Invigorator Corsets on account of their thoroughly hygienic nature. It is made especially to correct round shoulders and stooping."

Dr. P. H. Moriarty, L.R.C.P., says, Nov. 4, 1890—

"Your Invigorator Corset has afforded my patient great comfort. Having regard to the admirable manner in which the Corset has been constructed, and considering how nicely adapted the various parts of the Corsets are to the requirements of the shoulders chest, and spine, its health-giving powers are assured."

"Mrs Weldon's Fashion Journal," says, July, 1890—

"Undoubtedly supplies a long-felt want for ensuring an upright form and graceful carriage, combines Elegant of Form with Comfort. It renders a corset what it should be, comfort and support to the wearer, strengthening the spine, expanding the chest, and giving necessary support without tight-lacing or undue pressure."

Prices—Child's under 5 years, 3/4 ; Boys' and Girls' over 5 years, 4/6 ; Maids', 5/6 ; Ladies', 4/11, 6/6, 8/6, 12/9, 18/6, 22/6, 63/-. Pine Wool--Childs', 5/6 ; Boys', and Girls', 7/6 ; Maids', 8/6 ; Ladies', 12/9. If any difficulty in obtaining from Drapers, send P.O. with 5d. carriage to Patentee, 15 Claremont, Hastings.

FIGURE 3.4 *'Invigorator Corsets'*, Irish Society *(21 February 1891), p. 149. Image courtesy of the British Newspaper Archive.*

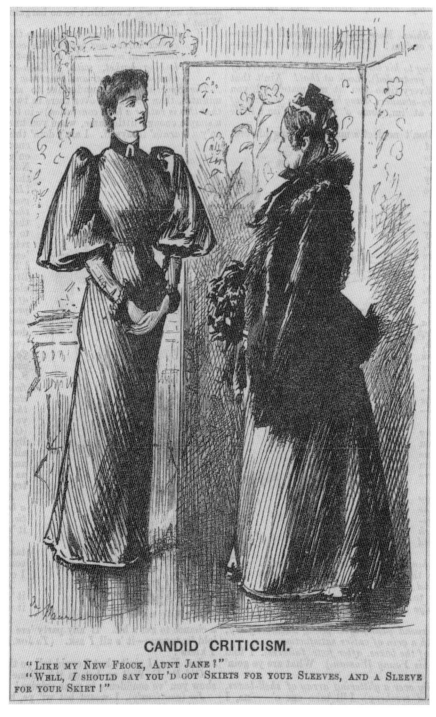

FIGURE 3.5 *'Candid Criticism'*, Punch *(19 November 1892), p. 231. Image courtesy of Cadbury Research Library: Special Collections, University of Birmingham.*

9

'Crinoline', from *Illustrated News of the World* London: Emily Faithfull, 1863

Emily Faithfull (1835–95) was a writer, editor, publisher and activist. A member of the progressive Langham Place Circle, she fought for women's suffrage and access to university education and employment in addition to dress reform. She published the following article, which originally appeared unsigned in the Illustrated News of the World, *near the height of the **crinoline** craze. Presented from a male perspective, the piece forwards men's complaints – such as frustration with the incursion of crinolines (and the women who wear them) into the public space of the sidewalk, or feeling hoodwinked into believing a woman has a better figure than her actual one – to harness their support in ending the fashion, even as a hint of satire is detectable in the tone.*

As a general rule, men have no right, either morally or aesthetically, to interfere with the manner in which women choose to dress. We hope this admission will procure us an impartial reading from members of the beautiful sex. In rich harmony and contrast of colours, and in general taste, the female is far before the male costume, were it not for one little—we mean one very big—article, crinoline. Let us observe here that we use the word 'crinoline' in its conventional meaning—that is, an extravagantly large hoop, or congeries of hoops, whether made of steel, **whalebone**, or other material. On this subject we really think men have some right to speak, both as men, and as fathers, sons, brothers, lovers, and husbands.

'Long years!—It tries the thrilling soul to bear!' Have we not borne long and patiently? After mature deliberation (having, of course, insured our life and made our will), we have at length resolved to uplift our voice. Miss Amazon (a charming young lady-friend to whom we communicated our intention) assures us that it will be of no use; that masculine protestations, arguments, persuasions, raillery, and sneers are all of no avail—that women will wear crinoline in spite of us. No matter. Like Quintus Curtius,[1] we devote ourselves to the good of our country—rather for the good of the civilised world. We shall, at least, have the applause which springs from the '*mes conscia recti*',[2] and, we trust, the reputation of moral courage, even although at this moment our complexion, like that of the Emperor of Cochin China,[3] is of a greenish hue, at

[1] Roman historian known for his biography of Alexander the Great.
[2] *mens conscia recti*: Latin. mind conscious of what is right.
[3] Napoleon III, known for his sickly pallor, who in 1858 seized control of Cochinchina, the southern section of Vietnam; his wife, the Empress Eugénie, popularized the cage crinoline (see #10).

the harrowing thought that we may possibly offend the whole female sex. Posterity may learn that there was at least one man who dared, in 1863, to protest against the reigning fashion, and to utter his honest convictions on the subject of crinoline.

Far be it from us to intrude on any mystery of the female toilet. But will it be pretended that crinoline is a mystery? We wish it were. On the contrary, does it not invite our criticism by invading and assailing us on almost every occasion, in the most uncalled-for and excruciating manner? These are not figures of speech. We confidently appeal to the stern logic of facts. Where is the man who, whatever may be his detestation of it, can avoid crinoline? We defy you to produce him. At home, abroad, in the sanctum of domestic life, at the ball, opera, lecture-room, at church, in the streets, in omnibuses, in business, pleasure, worship, literally 'through all the changing scenes of life, in trouble or in joy',[4] –no matter where or how engaged, are we not made painfully aware of the fact (principally through the medium of our shins) that the late Mr. Burke was premature in asserting that the days of chivalry had departed,[5] since women have adopted the custom (generally abandoned by men) of wearing habiliments of steel? Verily it is a wonderful age, in which our ships and women are iron-clad.

In his detestation of the reigning fashion, a man may repudiate all female society. He may shun the presence of his mother and sister; he may avoid the wife of bosom with or without the mediation of that real friend in need, Sir Cresswell Cresswell,[6] (continually invoked with blessings by the grateful hearts of husbands and wives he has separated); he may cease attending any place of worship (unless he can find one where crinoline is not worn), and thereby acquire the reputation of being a heathen, and perversely injuring his temporal and eternal prospects. He may cease going to balls, and may become, socially, intellectually, and morally, a pariah. He may even forfeit the delightful recreation of riding inside omnibuses. But he cannot live without some exercise, independently of the calls of business. He must go into the public streets. But are they public? Have men had their fair share of the streets since crinoline came into fashion? Not satisfied with crowding men out of pews, omnibuses, cabs, and carriages, they now sweep us off the *trottoir*.[7] In the interesting language of the stump-orator[8]—'That's what's the matter'.[9] What is our unfortunate pedestrian to do? He may succeed in saving his shins from actual contact with crinoline by making a practice of diving into the street, to avoid a charge of crinoline, that is, whenever he perceives the approach of a fashionably-dressed woman, who of course requires a space of two yards in diameter for the development of her hoop. This process is accompanied with many inconveniences. A man may be in a hurry to keep some pressing appointment. The exercise is better suited to a young than to an old man. A fat man could not practise these gymnastics at all. The performer actually practises at the risk of his own life; and if he escapes being knocked down and run over, his little games bring down on his devoted head a whirlwind of oaths and foul language from indignant omnibus and cab drivers. Lastly, he arrives at his place of destination heated and out of temper, and (if the weather be wet) with dirtier boots, and

[4] First line of standard hymn, written by Nahum Tate and Nicholas Brady (*c* 1696) and drawn from Psalm 34.

[5] Edmund Burke (1729–97), Irish statesman and philosopher, wrote that 'the age of chivalry is gone' in his *Reflections on the Revolution in France* (1790).

[6] Sir Cresswell Cresswell (1793–1863) was the British judge appointed to oversee the first civil divorce court in 1858, a move facilitated by the Matrimonial Causes Act of 1857, which transferred divorce cases from the jurisdiction of the ecclesiastical (religious) courts to the civil courts.

[7] *trottoir*: Fr. paved footpath; sidewalk.

[8] Stump orator: person or politician appealing to the public through speeches on the stump or soapbox.

[9] Stephen Foster's popular anti-Confederate song with this title was published in 1862, in the thick of the American Civil War.

a larger amount of mud spattered over his person, than is generally carried about by any one above the rank of a scavenger.

But a man cannot put his eyes in his pocket. The blind alone can escape the last crowning aggravation of the fashion. Crinoline is seen as well as felt. It is seen not merely when displayed on the person of the wearer. It glares at us from shop-windows. Women, exasperated by masculine sneers at this article of apparel, seem determined to thrust it on our observation at every possible opportunity. It is thus that modest bachelors are, in spite of themselves, made acquainted with the female toilet. We have marked men of all ages, dispositions, and ranks in life, staring in at these windows. Who can resist the terrible fascination, the very natural curiosity to inspect minutely the instrument of torture and discomfort from which we have long suffered, and which, when thus employed is being actually whisked against our legs, impressed upon our *understanding* with apparent unconsciousness, but real malignity by its wearers. Possibly the ladies, acting with their usual frankness and philanthropy, may charitably desire to assist us to withstand the effect of their charms, by showing us how much they are indebted to art for their fine figures. If this be not the intention, we ask seriously, is it wise to dispel the innocent illusions of our sex by thus enabling a man who fancied he was in love with a woman, to discover that he has been in reality admiring the work of an artificer in iron?

Why do women wear the hoops? Because it is the fashion. But why is it the fashion? Because it is supposed to be graceful. We are sure our friend Miss Amazon does not wear crinoline because she thinks it is healthy or convenient—'nor any other girl'. That is the excuse set up. Let an article of costume be ever so conducive to health, it will never become the fashion unless it is thought becoming also. There must be a vague general impression among women that crinoline is becoming, or they would not wear it. What is the general opinion among men with any pretensions to taste respecting crinoline? That the monstrous hoop now worn is the grand eyesore in female—that it is both ugly and indecorous. Why? Because it makes a woman look more or less like a ballet-girl in full stage costume. If it is admitted that women should resemble pyramids, why need the base of the pyramid be so large? A due degree of fullness in the skirt may be obtained without, and is indeed incompatible with, a hoop, which destroys all the yielding of the drapery to a decent and graceful carriage of the body. The elastic bounding step of the finely-formed slender girl of seventeen is completely lost and confounded with the waddle of the stout woman of fifty, owing to the zigzag, swinging motion of the hoop. It bestows on the wearer an unnatural and unbecoming width, dwarfing a little, and causing a tall woman to display that appearance expressed by the significant slang phrase, 'very extensive'. It is at variance with acknowledged ideas of elegant female contour. Compare the statue of a matron of ancient Rome wearing the *stola*[10] with a modern woman of fashion. Turn from the graceful folds of flowing drapery, covering, but not concealing the shape of the figure, to the wearer of crinoline—which looks most elegant and womanly?

The other day we observed Mrs. Paragon and her two daughters walking in Regent-street.[11] The young ladies were walking close to, and one on each side of their mother. Consequently their respective crinolines were tilted up in the air on the 'off-side'. An opportunity was thus afforded to all anxious spectators to study the manufacture of the young ladies' **balmorals**, and the fit of their open-worked silk stockings over their ankles, a word which is by courtesy applied to some

[10] *stola*: Roman women's garment corresponding to the toga and familiar thanks to classical statuary, comprising a loose **linen** dress gathered to the body with ribbons or belts.
[11] Fashionable shopping street in London.

eighteen inches or thereabouts of the leg. In short, this fashion would be termed, in the ultra-refined language of the penny-a-liners, 'not strictly in accordance with our ideas of feminine propriety'; in old-fashioned English, 'immodest' and 'indelicate'. What would our grandfathers and grandmothers have thought of such an extraordinary spectacle as that presented by a modern fashionable young lady in crinoline, **pork-pie hat** and feather? According to Alphonse Karr,[12] if a lady in undressing at night found herself really formed so as to correspond to the preposterous figure she makes of herself, she would be found in the morning drowned in her tears.

To enlarge on the fact that hoops are dangerous, when scarcely a day passes without the papers recounting a fatal accident through crinoline, would be superfluous. When the skirt of a dress expanded over a wire hoop or cage catches fire, the wearer has hardly a chance of escape. No matter how inflammable the material may be, when no hoop is worn an ignited dress may be compressed, and the flames thus extinguished; but the hoop thoroughly defies compression, and is generally so unfortunately well made as to defeat all attempts to tear it off. The hoop, then, actually serves as a scaffolding to expand the dress and permit a free current of air to feed the flames. From this point of view the hoop may be considered as a skilfully-devised and thoroughly efficient infernal machine to promote death by cremation.

It is a subject too sad for levity, to reflect that every fashionably-dressed woman carries constantly an article of costume which may, almost at any moment, contribute to inflict a sudden and horrible death. Take what precautions we may against fire, so long as the hoop is worn, life is never safe. The terrible destroyer comes in the most insidious, unexpected manner, without a moment's warning. The blooming maiden, the loved and loving wife, the respected matron, the venerable dowager, the light-hearted girl who is the pride, life and joy of the household, alike wear crinoline: all are, by the tyranny of fashion, living under a sentence of death which may occur unexpectedly in the most appalling form. The thought is enough to make Paterfamilias dread to leave his home, and poison his hours of absence. Every man with female relatives must shudder as he reflects that they are continually tempting destruction, coquetting with a frightful death; that in the midst of the brightest hopes and perfect health they may be struck down to expire in agonies. Yet in spite of fatal facts, and possibilities which may become facts, women continue to wear—and repeat that men have no right to object to their wearing—crinoline![13]

[12] Jean-Baptiste Alphonse Karr (1808–90), editor of the French paper *Le Figaro* and prolific journalist, was a sharp critic of the crinoline.

[13] [Author's footnote in the 1863 reprinting: 'One lady, who read and admired this paper when originally published, said, nevertheless, in her reply, "I do not think I could have the courage to diminish my circumference to its pristine dimensions except by slow degrees – '"fine by degrees and beautifully less'". This is just the right way to proceed'.]

10

Harriet Martineau [From the Mountain], 'A New Kind of Wilful Murder', *Once a Week* (3 January 1863), pp. 36–9

The rise of the cage **crinoline** *met with consternation and scorn in the public press. Prolific novelist and journalist Harriet Martineau (1802–76), writing under a pseudonym, frames the fad in terms of women's lack of respect both for themselves and for others. The 'murder' referred to in the title is primarily death by fire, caused when the wide edge of the crinolined skirt catches on an open hearth, with vanity being the primary motive fuelling the disasters. Other arguments are summoned as well: in addition to threatening the safety and sanctity of the home, the crinoline is cited as a corruptor of the working classes, and hearth death is compared unfavourably to the then-much-derided Hindu practice of sati – a not uncommon comparison in the contemporary press – wherein a woman would immolate herself on her husband's funeral pyre. The article is notable for its catalogue of references to specific instances, offered in the hope that, through the sheer number of examples, readers would be 'startled into reason and conscience' to abandon the practice. It was a sentiment shared by Dr. Edwin Lankester, Middlesex Coroner from 1862, whose inquests supplied newspapers with a constant source of accounts of sensational deaths. All italics below are reprinted from the original.*

I make no apology for reproducing some facts from the newspapers, for once; nor for earnestly—I wish I might be allowed to say, peremptorily—desiring the attention of the readers of ONCE A WEEK to these facts in their collected form. I do so for a purpose eminently practical.

It is a common thing to hear women say that they are tired of the abuse of crinoline: and it is almost as common to hear men say that there is no use in declaring their opinion of the present fashion in dress, as the women have shown very plainly that no considerations of self-respect, no regard for the convenience or feelings of others, no appeal to either sense of sentiment has any effect in regard to a fashion in dress which, instituted by an Empress,[1] has enslaved her whole

[1] Eugénie María de Montijo de Guzmán (1826–1920), known widely simply as Eugénie, was the wife of Napoleon III. Serving as Empress of France from 1853 to 1870, her fashion sense proved highly influential, often setting the tone for European trends (see fig. 3.4).

sex, except the very few who cannot surrender their self-respect even under a prevalent mania. All this is very true: but I think there may be some hope that a glance over the domestic tragedies disclosed by some of the Coroners'[2] inquests of the past year may possibly hasten the change of fashion which, of course, must come sooner or later. It is too late now for my countrywomen of the present generation to regain the position they held in the respect and confidence of men before this perilous and selfish madness carried them away. It is too late for society and for households to forget the sacrifices imposed on all their members by the unreasonable and ungenerous indulgence of a fancy in dress on the part of women whose proper business it is to promote the comfort and safety of home and of society. It is too late to repair the mischief done to the women of the working classes by tempting them to extravagance and affectation in the pursuit of a masquerading mode of dress. It is too late now to help the bereaved parents who have lost the dutiful daughter, to console the sorrowing widower, or to save the many motherless children in the country from the consequences of the loss of a parent in infancy. The victims of this perilous fashion cannot be brought to life again; nor is there any rational comfort which can be offered to those who mourn them: for of all deaths none surely are so shocking to the feelings of survivors as those which proceed from a dangerous fashion in dress. If the Coroner's jury, in the case of Dr. Allen's cook, 'could not separate without expressing their disgust and horror'[3] at the feelings of husbands, fathers, and orphaned children at having their home made desolate by such a frailty as compliance with an absurd fashion in skirts. The folly and crime of the past are irreparable; but I cannot help hoping that the evidence, if presented in groups of cases, may fix the imagination and the conscience of some women who are superior to the ordinary levity and shallowness, and childish wilfulness which are in this case as bad as malice and cruelty would be. Some few women of my acquaintance have throughout had the courage and firmness to resist the prevalent mania; and knowing this, and witnessing the effect of their virtue on the feelings of the neighbours of both sexes, I see every reason to hope that there may be more who can be startled into reason and conscience by a display of a few facts in their right order.

Before me lie the details of some of the deaths by crinoline, which have been inquired into by Coroners' juries within a few months. They are not nearly all the cases that might have been collected by any one on the look-out for them. They are a mere handful, preserved on account of something remarkable in them, or from their following each other, at certain periods, in striking succession. On a recent occasion, Dr. Lankester[4] declared his belief that at least six deaths per month occur in London from burns through the wearing of crinoline, while deaths from machinery are also frequent. At another inquest he said that 'deaths from wearing crinoline were now so common that many are never reported in the public journals. If every fatal crinoline accident were reported, the public would know of them, and then crinoline would soon be abandoned'.[5] My instances must therefore be considered a mere sample of the evils caused by this detestable fashion within the last few months.

The most interesting class to us all is probably that of wives and mothers.

[2] Thomas Wakley (1795–1862) served as coroner of West Middlesex (including London) from 1839 until his death, extending the scope and power of the office. Wakley was succeeded by Dr Edwin Lankester (1814–74), who had built a career combining medicine and social amelioration; he regularly used his post as a bully pulpit for dress reform, seizing in particular on the crinoline as a social, moral and physical bane.
[3] 'An Angry Attack on Crinoline', *Berkshire Chronicle* (3 January 1863), p. 7.
[4] See note 2.
[5] 'Shocking Crinoline Fatality', *London Evening Standard* (15 August 1862), p. 2.

The wife of an engineer, Mrs. M. A. B——-, was on a visit to a friend on Notting Hill when she met her death at the age of twenty-eight. She reached for something over the mantel-piece, and her skirt went into the fire. She was carried to St. Mary's hospital, and immediately died there.— This was the way in which the guest of the Mr. and Mrs. Charles Mathews perished lately. The sufferer and her daughter were from America; and probably there was the exaggeration in the style of dress which is usual in that country. She was standing before the fire when her skirt touched the bars. She ran out upon the stairs, after setting on fire the drapery round the fire-place she had left. Her screams will never be forgotten by her child, or any who heard them. Before night she was silent forever.

More deaths are caused by the skirt catching fire behind than in front. It was but the other day that a poor young collier's wife, M. A. R——, was stooping to her baby's cradle, when her large hoop drove her dress behind against the bars. Then followed the useless endeavours of neighbours, with their blankets and wet towels; useless in these days, because the hoops prevent any effectual compression of the dress, and admit air within the burning garment. The poor babe has lost its young mother. She lingered through several days in agony, and then died at the age of twenty. In another case a little boy of ten appeared at the inquest of his mother, and told what he had tried to do to save her. Her skirt went into the wood fire behind, without her being aware of it. The boy squeezed her clothes, and knocked out some of the flames with a stick. When a man came to help, the boy called the neighbours: but in a minute or two she was seen in the road with her cotton-dress in flames, the canes preventing their being put out. There was a piece of steel hoop also left in the road. 'For mercy's sake! for mercy's sake! put it out!' she cried, till she fell: but not till she fell could anything be done. She was just thirty-three,—old enough to have dressed herself more wisely. The same thing happened to Mrs. R—, when she was standing with her back to the fire, in the midst of her little children. Stooping to look at something they wanted to show her, she struck her skirts against the bars. She, too, rushed into the open air; and the neighbours in this case, too, could only burn their hands without saving her. She was young; but who can replace her to her children? A young wife comes next on my melancholy list. She had been married only a few weeks: and her husband was in the house. He had left her busy at the oven, and presently heard shrieks from the kitchen. She wore a large crinoline, and as she passed the fire-place her dress caught. Thus perished the bride of one-and-twenty. There was another younger still,—only eighteen. She was dressed in **muslin**, widely spread out; and, on crossing the room, she whisked her flounced against the grate. She died on the stairs; but she had set two rooms on fire; and her husband, being called home, had to work at extinguishing the flames, while she lay dead. This was the case that drew the severest rebuke from Dr. Lankester. Another of his grave remonstrances was called forth by the case of a widow who kept a tavern, and sat up at night to post the books. She, widow as she was, was a slave to the fashion; and she seems to have set her skirts on fire while undressing near a candle which was placed low. She died at noon next day. Another lady, a young mother, escaped only through the fact of her dress fastening in front, all the way down. She was caressing her child by the fireside, when the little creature cried out that mamma's gown was on fire behind. She gathered her skirts about her, and ran to the kitchen, where she desired a servant to hold her clothes tight, while she tried to get out of her cage. She unfastened gown and **petticoat**, and threw them off,—the under petticoat being burned to ashes, leaving only the steel apparatus. Her hands were much burnt; but she escaped with her life.

Are any of my readers complaining already of the monotony of these stories? They must hear more; but they may remember, perhaps, the two ladies who not long ago, and within a few days of each other, were crushed out of life, and out of all human semblance, by their skirts catching

in the shaft of a mill. Here is a break to the sameness: but what an alteration it is! Shall we ever forget how one of those victims was seen, within a few minutes of being torn to pieces, gaily walking down the village street, with some friends and her son,—all elated at the new machinery being set to work that day. She was near her confinement; and due care seems to have been taken of her: but no care will constantly avail when the dress is out of the sphere of sensation to the wearer. No mind can be incessantly awake to the danger. Thus, after caution and warning, this victim's wide-spreading dress was caught, and all was presently over.

If further variety is asked for, there is the case of Mrs. B——, who was about to enter the omnibus in the Euston Road when a passing mail-cart caught her apparatus of steel and cane, and dragged her a considerable distance. She was carried home with a dislocated wrist and a compound fracture of her leg. Such cases have been frequent; and children and gentlemen have often suffered from them, by being entangled in the trammels of the ladies they are walking with.

There are, besides, many accidents to children and others, by being pushed,—not only into ditches, and from the causeway into the road, but from boats and gangways and jetties into the water, and from the side pavements of London under the wheels of waggons or of cabs. Before me lies a published letter from a London surgeon, who declares that there are many more accidents from the hoop than any but men of his profession are aware of. He had just been called to a case which grieved his heart. A pretty child of three and a half, was dreadfully scalded because the parlour-maid, while carrying the urn, hissing hot, caught her foot in the steel cage of a young lady seated near the sister in whose lap the child was sitting. The maid stumbled forwards, and the urn shed its boiling contents over the poor child. Who would have slept that night, or for many nights, after having worn that hoop? Who would ever have liked the seashore so well again after witnessing the fate of the young lady who was disembowelled by the snapt steel hoop of her petticoat? 'Take me to my mother!' was all her entreaty when people gathered to ask if she was hurt. Striving to the last to conceal what happened, she could only cry—'Take me to my mother!' The widowed mother received her only child with a fatal gash across the abdomen; and thus the poor lady lost her only child, —her support and comfort in life!

The next class is that of young ladies. Of the gay young creatures who, a year ago, were looking forward to a sunny life in this happy world, how many are now mouldering in the grave,—sent there through the torture of fire!

Torture indeed! S. W.——, a girl of fourteen, who 'wore a very large crinoline', was alone at the time; and all we know is that the burning began with her skirts. The poor thing was 'roasted' all over, except her feet, 'which were protected by boots'. E. C—— was visiting Mrs. W——; and another young lady was in the room, when she caught fire by poking her skirt against the bars. 'O! put it out!' she cried, as they all do. She was rolled on the ground, and wrapped round with woollen things; but the hoop spoils the received methods of extinguishing such a fire. She died in the Infirmary; and the Leicester Coroner declared at the inquest that the 'absurd expansion and profusion of the dress now worn by females, had occasioned more fatal accidents than he had ever before read or heard of'.[6] M. C——, aged fifteen, was sitting by the fire with another girl about her own age, when she stood up to reach something on the mantel-piece. Of course her dress touched the bars, and in a moment the flames were rushing over her head. –There was one younger woman whose fate seems to me more pitiable than almost any. Little J. B.——, aged ten, had taken pains to dress herself for school, and had put on the fatal present just received from a cousin—a crinoline. 'O mother! I was lacing Freddy's boots by the first', was the explanation she

[6] 'Another Crinoline Victim', *Leicester Mercury* (24 March 1862); widely reprinted.

gave. She was stooping down to her little brother's feet when the new petticoat thrust itself into the fire. The foreman of the Coroner's jury strongly commended the fatal fashion; and the jury agreed with him: but they were too much afraid of 'the sex' to put their judgment on record in the newspapers. Who, of the whole sex, would like now to have been the giver of that fatal gift?

Many of the young ladies' cases arise from their dressing their hair before the glass with their extended petticoats on. The act of raising the arms to the head is sure to stick out the skirts in one direction or the other; and we find, therefore, that several have perished in this way when the glass was within several feet of the fire-place.

M. A. L—, living with her parents in lodgings near London, rushed screaming out of her bedroom, —the flames reaching above her head. The landlord was on the stairs; and he did the best that could be done, at great risk to himself; but she died that night, from burns and the shock together. She had stooped before the glass, and so thrust her skirt against the bars of the grate. She was a fine healthy girl of seventeen. Miss M. J— combed her hair with her face to the fire, and perished in the same way, except that her skirts caught fire in the front, instead of behind. Both these young ladies died in Guy's Hospital, where the doctors must have long ago seen enough of the burnings of women to have a very strong opinion about the fashion of crinoline. Perhaps they may be fond of quoting, as some other doctors are, the saying of old gentlemen from India, that we English have made a great outcry against the Suttee[7] in India; but that we burn more women in the twelvemonths by slavishness to fashion than the Hindoos do by their superstition. One morning last winter, M— died of burns received since midnight, by her having hung up her gown on a peg before she took off her crinoline petticoat. She had set her candle on a box at some distance; but the act of reaching had brought her clothes against the flame, and she was dead before the observances of the day began.

A good many people say that all this sacrifice of life happens because ladies will not insist on their muslins being dressed with a preparation that would render them non-inflammable. They are saying so now about Mademoiselle Emma Livry, who was burned almost to death on the stage of the Grand Opera at Paris, the other day, during a rehearsal of 'La Muette de Portici'.[8] They say so about Miss C—, who was a guest at Lord Monteagle's, at Mount Trenchard,[9] when she set herself on fire by reaching to a window-curtain, and igniting her **hanging sleeve**. (Another perilous fashion!) They say so of the case of Miss E. M. S—, who was dressing for dinner after a wedding, in the same week, and, stooping to a trunk, set her sleeve on fire. Both these young ladies died; and it is alleged that they, and the crinoline victims, could have escaped, if their muslins and gauzes had been dressed with starch duly prepared. It may be so: but I should be sorry that more lives should hang on the question of what will happen first,—the going out of the wide petticoats or the general introduction of non-inflammable starching. Let the laundresses of empresses, princesses, peeresses, and prima donnas extol the life-saving property of the starch they use: but how long will it be before the ordinary starch is superseded by any new article in the laundries of the great middle class, and the kitchens of cottages throughout the land?

This brings me to the class of victims which, I own, interests me the most.

[7] Suttee, or sati, is the ritual of a Hindu widow self-immolating on her husband's funeral pyre. Although not widely practised, it presented a figure of wifely devotion that alternately fascinated and shocked Victorian readers.
[8] In November 1862, ballerina Emma Livry (1842–63) was rehearsing *La Muette de Portici* – an 1828 French opera by Daniel Auber and librettists Dermain Delavigne and Eugène Scribe – when her costume was set alight by the gas lamps lighting the stage. She never recovered from the severe burns, dying in July 1863, months after this piece was published.
[9] Mount Trenchard, in County Limerick, is the seat of the Barons Monteagle of Brandon.

I wonder whether the Empress of the French, who is responsible for the introduction of the fashion; —whether our Queen, who is, it seems, not supreme in the world of English fashion; — whether the high-spirited young ladies of the aristocracy, who conceal their slavery to the mode under an air of wilfulness, ever cast a thought towards the humbler orders of their own sex, whose lives they put in peril by their caprices. I can fancy these ladies laughing at the cautions, and resenting or despising the remonstrances of their friends of the other sex on this particular matter, and claiming to be the sole judges of what they shall wear. I have seen some of them enjoying the opportunity of defying opinion, and of proving that they dress to please their own notions, and not men's taste. I have known the extent of daring to which some middle-class ladies will go in spending more money on their skirts than they have warning that husband or father can afford. I have long ago perceived the recklessness with which they throw away, in this case, the *prestige* of their sex, which it will take generations to repair. Of all this I am fully aware. I see how the habitual politeness of well-bred women gives way when the question is of incommoding their neighbours by their dress. From knocking my furniture about when they come to see me, to cutting my shins with their sharp steel in a throng, and allowing me and other acquaintance of the order of gentlemen no room at the dinner table, or at church or the theatre, they give pain and do mischief without remorse or regret. All this I know; and perhaps I hear more of the consequences to their repute than they do: but what I yet want to know is, whether they have any sense of responsibility for the sacrifice of life they have caused in the class of maid-servants, and of schoolgirls who are to be maid-servants. It is no doing of theirs that deaths do not happen in that way in factories. The mill-owners have very properly taken the matter into their own hands; and the crinoline must be left outside the walls. But there is no such general rule in kitchens, servants' halls and schoolhouses; and dozens of young women of the working class perish yearly, because of the circumference of ladies' dresses.

As for me, I took my part at once in my own house. In the kitchen no hoop or crinoline is permitted; and this is easy to enforce, because in the parlour nobody desires to wear either. The servants must do as they choose out of doors; and if they annoy fellow-worshippers at church, I cannot help it: but I will not have my family fires made and my family dinners cooked by women so dressed as to invite destruction by burning. What I want to know is whether responsible women of this country ever think of this class of their sisters; whether they are unaware that the same feelings which make *them* imitate empresses and princesses in style make our servant-maids imitate ladies? I want to know whether the slavery is more degrading and absurd in one rank than in another; and whether the sense which should despise it ought to be expected among maid-servants while ladies are incapable of it? I want to know whether any lady in England really expects the cottager's wife to go buying patent starches, used in royal laundries, in order to render safe her child's cotton frock for school, or Molly's **calico** petticoat, when she goes to be scullion at the Squire's? If ladies are burnt by the dozen in muslin and gauzes, are housemaids and cooks to be scolded for being burnt in calico and print?

Enough! A few illustrations, and I have done.

Servant-maids have not the benefit of the now necessary training in sailing about, with skill and grace, in houses not built with a view to the present mode of dress. They preserve a greater simplicity of manners; but they are in more danger of accidents. I like to have to guard neither my flower-pots and china from my guests, nor my guests from my fire-bars: and I certainly prefer the carriage and manners of a waiting-maid who can move swiftly and deftly about my drawing room to those of any lady in a barrel whoever enters it. Further, I prefer the cheerfulness of a handmaiden who never needs to think of danger within my walls to the levity of damsels who, when I catch their skirt in its sweep of the bars, thank me carelessly with the observation, 'I have

no wish to be a victim of crinoline'. From some comments which reach me from without, I am satisfied that other people,—well-bred persons of both sexes,—are under the same impression. If it exists, wherever there is opportunity to note such a contrast, and where we all mentally pronounce *vulgar* the death of a poor scullion or chambermaid who perishes by crinoline, what ought those ladies to feel who have temped their humbler sisters to their death, and who then despise them for it?

On a Sunday morning, M. A. E—, a nurse, was busy at the kitchen fire, when her hoop turned upon a fire-bar. (She was certainly no pupil of Florence Nightingale.[10]) She was instantly wrapped in flame. A nursemaid, a young creature of sixteen, E. L—, was stooping down to look at a picture in a new book which one of the children wanted to show her, when her skirt went into the fire behind, and she was on fire all over. She rushed into the garden, where two men put out the flames. Whether she died we know not; but there was no expectation of her recovery. —That a woman who had been forty years cook in one family should die such a death seems strange; but there are certainly ladies in the peerage as old as M. F— who wear crinolines. This woman was kneading her dough very vigorously, when the action drove her petticoats against the grate; and, after a day and night of agony, she died. M. A. W— was preparing dinner for her master, a London physician, one evening between five and six, when her crinoline caught fire. She rushed into the street, where there were plenty of hands to tear off the burning fragments, wrap her in rugs, put her into a cab, and take her to the Westminster Hospital. She was burned all over; and it was at the inquest on her body that the jury expressed their 'disgust and horror' at the wearing of crinoline by domestic servants. S. B— was a nursemaid, in the service of Mrs. P—, who was in the nursery when the poor girl thrust her hooped petticoat into the fire in reaching for a pin from the mantel-piece. Her mistress was much burned in trying to help without doing much good; but two men rushed in from the road, and put out the flames—too late. One Sunday, a servant girl of nineteen from Pimlico was allowed to spend her day with her friends; and she went dressed in a muslin. On her return she struck a light with a lucifer,[11] which she threw down, forgetting that her muslin skirt interposed between it and the hearth. Her master took her to St. George's Hospital as soon as her burning clothes were torn off; and there she lingered for some days, and died.

Some of these domestics were 'much regretted'. I trust there may be more to regret them now that their cases have been thus grouped, and the responsibility for their fate brought home. It is said that the ladies of Austria have begun the opposition to crinoline, in the name of their sex, very smartly. They will countenance no theatre where it is worn. Of course we may conclude that they do not wear it themselves. There are Englishwomen who never have worn or countenanced it. There must be more capable of the requisite courage, if once convinced of the reality of the call for it. A few hundreds of such sensible and resolute women in any country would presently reduce the leaders of fashion to change their mode. How many more of my countrywomen will be burnt alive, crushed, disembowelled, or drowned before this is done?

[10] Florence Nightingale (1820–1910), nurse and healthcare reformer, was an outspoken critic of the crinoline (see, for example, *Notes on Nursing: What It Is and What It Is Not* [London: Harrison, 1859]).

[11] lucifer match: friction match, an early version of which were marketed as 'lucifers'.

11

Violet Greville, 'Victims of Vanity', *The National Review* 21 (March 1893), pp. 71–9

Beatrice Violet Greville (née Graham, 1842–1932), journalist and novelist, wrote extensively for the Graphic. *Here, she tackles the fad of **tight-lacing**, challenging the view that it is a device beholden solely to men's desire. She turns her aim to women's motivations for tight-lacing, in addition, of course, to capturing a husband: namely the drive to compete with other women and the drive to masochism. 'Pain, once conquered', she notes, 'becomes delicious'. That their bodies are one site over which women have control underscores this analysis. Despite falling into some conventional views on attraction and marriageability, Greville's article forwards a broad range of arguments against the practice of **corsets** and demonstrates a thorough awareness of contemporary writing on the subject. One recent trend was the drive towards empirical measurement and statistical study of human qualities, as typified by phrenology, physiognomy and eugenics: 'Beauty is measurable', she writes, with palpable criticism, 'and the tape its oracle'.*

Woman's 'emancipation' has begun. She has entered into competition with man and has beaten him on his own ground. Her capacity is recognized; her rights are acknowledged; her demands are respected. In an age of social awakening like the present a jarring note is struck when we find side by side with this sweeping-away of old prejudices and stupidities, silently and unobtrusively, yet none the less surely, a retrograde movement. Womankind have divided themselves into two classes: those who soar above and defy public opinion and the laws of conventionality, and those who grovel like slaves beneath their iron rule. Certain current notions, instilled by custom and heredity into the latters' minds, have taken firm root, and nothing seems like to eradicate them. Of these antiquated notions, the most popular is that man must be subjugated by personal attractions, and that the desirable result can be achieved by inches only. The diameter of the waist expresses the measure of success. As a matter of fact, the average man is far from admiring abnormal figures, an hour-glass shape, or *outré*[1] dressing. Women

[1] *outré*: Fr. extravagant, over-the-top.

do admire these things, and, as is well known, dress at, for, and against, one another. With the advance of civilization, inexperienced people flattered themselves that some follies were extinct. Wiser people noted certain recurrences and feared. Of these follies, **crinoline** and tight-lacing were the most notorious, the silliest, and the least beautiful. Crinoline claimed its victims by the score. A whisk of the skirts, a sudden careless movement, and the reckless wearer escaped the Charybdis of the fireplace only falling in the Scylla of the dressing-table candles.[2] Crinoline was always inconvenient, generally ridiculous, hideous, and unmanageable. Men poured torrents of abuse upon it, newspapers railed violently, **Punch** mildly ridiculed; yet for several years it held its ground securely. At last women of their own accord waxed tired of it, and lingeringly allowed it to die out. Now history repeats itself, and we are threatened with its presence once more, notwithstanding the lapse of thirty years in which to grow wiser. Crinoline dead, dress became rational, sensible, and decent; but the demon of unrest slumbered in woman's breast. It was fanned by the persuasions of dressmakers and **modistes**, and the magic word 'Tight-lacing'. 'Do not be satisfied with the shape nature gave you. Distort it, spoil it; get rid of harmony and proportion; become a caricature and a monstrosity; destroy your health, your digestion, your comfort, and your happiness; and you will be beautiful in the eyes of your silly sisters'. Beauty is proportion, said the sculptor; beauty is grace, said the painter; but woman knew better. Beauty is measurable, and the tape its oracle.

Fine figures and slender waists tend to be the rule rather than the exception; but it was reserved for *The Gentlewoman*[3] to describe the manner of their development. The revelations therein contained, stated even soberly, are such as to cause grave reflection. What, for example, can we think of the heroism of the girl who, determined to reduce her waist to a maximum of sixteen inches and a half, cheerfully deprived herself not only of dainties, but even of necessary food, lived the severe regimen of a jockey training to ride a light weight, took exercise daily and late, and finally slept in her corsets? She reduced herself from half to three-quarters of an inch every month. History does not relate what was the end of this benighted damsel. We do not know whether she faded away into nothingness, or whether, seeing the error of her ways, she renounced beauty and espoused reason. I should be surprised to hear that she espoused a man.

What is to be said of the sinful folly (the mania is apparently not confined to the young) of the mother who put her child into corsets at six years old, or the young lady who 'enjoys the feeling of tight-lacing so much', and never lets her waist exceed seventeen inches, or fifteen and three-quarters if she has no breakfast? We are not surprised to hear that she cannot walk. Are there really such foolish relatives as the one who insisted on a young woman reducing her waist to seventeen inches, saying 'No man will marry a girl unless she looks smart'? These unfortunate victims of fashion sleep in their corsets, and know no release night or day from the agony of tight ligaments pressing gradually on soft and growing bones. The torture of the Chinese lady's crushed toes, and the disfigurement of the savage who shaves off her eyebrows, saws off and blacks her teeth in a mistaken search for beauty, are mild discomforts compared to this prolonged and life-long discipline. Men should be proud to think how women value their admiration, and to what lengths they are prepared to go to be pronounced 'smart'. These young ladies are satisfied with their courage; they revel in their self-sacrifice; they are the pioneers and the martyrs of progress.

[2] Scylla and Charybdis, competing sea monsters who, in Greek mythology, guard the Strait of Messina; to avoid one means encountering the other.

[3] Marketing itself for the social elite, the illustrated newspaper *Gentlewoman* (1890–1926) enjoyed a wide circulation and featured advertisements with large, rather daring illustrations of corsets.

Of them it may truly be said, 'Out of your own mouth shall ye be judged;' for it is they who have revealed the secrets of the prison-house, torn the veil from their sufferings, and gloried in the pain which, once conquered, becomes *delicious*. Reading the effusions of these devotees of fashion, one is reminded of the lucubrations of some wild fanatical sect of the East, who inflict injuries on themselves and mortify the flesh, rejoicing in pain as a means to a future and unalienable joy. What is the joy of a victim of tight-lacing? The gratification of a contemptible vanity, coupled with the trembling hope of obtaining a husband. Men must indeed be valuable prizes if they are worth so much misery before marriage: not to speak of the unhappiness often caused by them after marriage when yoked in an unsuitable and unsympathetic union. The man who is captivated by the slenderness of his wife's waist can scarce be a very exemplary or high-minded member of society. Such an one would probably, after a year or two of marriage, cease to know how she looked, or care whether her waist were large or small. He belongs to the tribe of indifferent husbands who, one fine sunshiny day, notice with surprise new dresses which the partners of their bosoms have worn all through the fogs of winter, and comment on their extravagance; or, when they are proud of their nice appearances in a new frock, say, 'Yes, my dear: very pretty: I always liked you in that gown;' or, worse still, run after younger and handsomer women, whose waist diameters are less and their busts more largely developed. However, seeing that there do not exist enough men in England to provide husbands for our superfluous women, perhaps we can scarce blame girls for resorting to any trick of attraction, howsoever despicable. The questions rather is, Do men prefer unnaturally-small waists? Most people declare they dislike them—some deprecatingly, some sadly, some sneeringly; some cynically, like the writer who said, 'The corset is charged with hurting women, and, at times, killing them. But is this to its discredit? Already there is an excess of uncorseted womankind. War and travel keep the number of men within limits, and perhaps the greatest use of the corset is that it does, though less effectually, the same by women'.[4] If, therefore, this agony of tight-lacing (not the mere wearing of the corset, for every man prefers to see a neat, trim woman) does not answer the purpose of husband-catching, why do women endure it? Possibly they believe that men are not sincere in their disapproval, remembering how lavish their admiration on some padded, painted, or made-up 'creature', noting their predilection for actresses in tights and for plays called by the French '*Une pièce à femmes*';[5] or perhaps, to seek no further reason, it is 'pure cussedness' on the part of women, inspired more by disease than by any tangible motive. Judging by the revelations of hypnotism, by the recondite consequences of the still uncomprehended laws of heredity, and by the fact of the stated increase in neuropaths and female lunatics (most of whom drag on existence placidly to a good old age), I should be inclined to attribute this outbreak of tight-lacing rather to a diseased mania than to any real desire for love or admiration.

Further revelations on the part of the ministrants to the cult of woman's beauty commonly known as 'Artistes en corsets'[6] certainly lead to this conclusion. One of these ladies solemnly avers that she has the tightest-lacing *clientele* in London, that she makes **stays** of all shapes and sizes, from diaphanous **satin** to rude **coutil**, for all times and seasons, for rowing, riding, dancing, and even bathing! Henceforth, let no one believe in the slim figure of the nymphs disporting themselves airily in the silver waters: all is vanity, even the waist of the bather! Further, she

[4] A slight misquotation of the unsigned 'The Evolution of Dress', *National Observer* (3 September 1892), p. 399.

[5] *Une pièce à femmes*: Fr. women's play. According to E. Lorédan Larchey's *Dictionnaire de l'argot Parisien*, it is 'une pièce dont la réussite est basée sur l'exhibition de jolies femme' ('a play whose success is based on the exhibition of pretty women') (Paris: F. Polo, 1872), p. 195.

[6] Artistes en corsets: Fr. corset artists.

deposed that the smallest corset she had ever made was twelve inches and a half. The assistant young lady even appeared for a few moments with a waist of thirteen inches and a quarter. Smilingly the maiden explained that she could not bear this compression for longer than half-an-hour. One and all of these ladies declared that the size of corsets had perceptibly diminished of late years. Manufacturers, they said, constantly made them of thirteen inches, and fourteen or fifteen inches was quite ordinary. Girls are forced by mothers and schoolmistresses and urged by the comments of their sisters into corsets at an early age; in many cases they sleep in them, tightening them daily. Dress has undergone a change in consequence. The bulky underclothing of our mothers has given place to closely-fitting garments, warranted not to wrinkle or to take up too much room. Fashionable finishing-schools appear to be great offenders in this respect; but ladies of high rank, married and single, countesses and marchionesses, are not proof against the insinuations of this abominable practice, which, like drink, grows upon its victims. Envy tempts each fair one to outrival her friend. When exercise is indulged in, it is at risk and discomfort which only medical men can fully appreciate. With flushed cheeks, bursting bosom, and struggling respiration, a girl will dance, or play tennis, or ride sooner than yield an inch to the torturing tyrant, or let out a hold in the enveloping zone. Like the predatory savage, she goes hungry, though not (like him) unwillingly, from motives of necessity, and retires to her room to still the pangs of hunger by an extra pull at her waist. That shrewd observer of human nature, Mr. J. M. Barrie, makes the heroine of his idyllic play, *Walker, London*, celebrate the college success of her lover by tightening her belt. 'I must do something in honour of the dear man', she says, and gets her schoolboy cousin to perform the office of lady's maid.[7]

The heroines of old novels had their stay-laces cut when they fainted. Our young ladies have long since surpassed that performance. They neither faint nor require their laces cut. With steadfast endurance they sit through a long dinner, eating nothing, and being 'complimented on their creamy whiteness'. These congested beauties must have stones for hearts. No natural woman's impulse can beat in their marble bosoms, no sweet girlish enthusiasms stir their stagnant blood. They are stoic philosophers of the severest type; though the foundation of their philosophy is not eternal trust, but flimsy vanity. They seem to have adopted some of the sayings of Epictetus,[8] while, alas! plunged in sad remoteness from the true source of his teachings. 'The cynic ought to have such power of endurance to seem insensible'. 'To these objects he directs all his attention and energy, but as to everything else he snores supine'.[9] The spectacle of a girl, still almost a child, conquering her natural appetites, killing her love of luxury and ease, suppressing the desire for sweetmeats and good living, bearing pain uncomplainingly and stoically, and doing all this without hope of reward, knowing that she will suffer, and must suffer still more in the future, is pitiable.

Do these deluded enthusiasts, these Jogis[10] of nineteenth-century civilization, given over to penances and sufferings, really believe in their immunity from disease and death? Have they no knowledge of physiology, no faith in science, no natural leanings towards love and motherhood? Do they not know that their actions are more than foolish—that they are sinful? Like Schopenhauer,[11] they have irretrievably mixed up pleasure and pain: they reck nothing

[7] Sir James Matthew Barrie's (1860–1937) play was first produced in 1892; in Act II, Nanny O'Brien insists to her cousin that she can 'stand another two inches' cinched off her waist. *Walker, London* (London: Samuel French, 1907), p. 38.

[8] Epictetus (*c*. AD 50–135), Greek Stoic philosopher.

[9] Epictetus, *Discourses*, III.14.

[10] Jogi: variant of yogi; spiritual leader.

[11] Arthur Schopenhauer (1788–1860), German philosopher; well known among his pessimist phenomenology is the idea that 'we generally find pleasure to be not nearly so pleasant as we expected, and pain to be much more painful' ('On the Sufferings of the World', in *Studies in Pessimism*, trans. T. Bailey Saunders [New York: Humbolt, 1891], p. 5).

where the one begins and the other ends. Pleasure is the absence of pain; yet mere pain is pleasure. They have accustomed themselves to pain until they scarce recognize it as such. 'To be perfectly accustomed to a thing—that is to say, to perceive it without experiencing any resistance in any of our senses, and in any of our intellectual or motor activities—is almost tantamount to feeling it to be beautiful or good. Every habit begets a kind of personal rule: the act accomplished without resistance in the past becomes a type of action in the future'.[12] So speaks the man of science. Doctors preach, parents warn; yet the woman goes on her way rejoicing. Almost one is tempted to believe, as has been asserted by cold-blooded men, that women do not feel pain as men do: that, indeed, they are insentient.[13] Such an idea destroys another sweet illusion. What becomes of the tender, sensitive, sympathetic ideal of womanhood? The physician who remarked that 'a fashionable lady does not consider herself well-dressed unless she is a little uncomfortable', and that 'the proportion of discomfort experienced is the measure of mischief done',[14] was in the right; and even more right was another who said, 'Disease is absence of ease, health means going easily'.[15] Herein we must acknowledge the superiority of the male. He never wears tight ligaments: he insists on all his garments being made loose and comfortable. Utility is the test by which he judges new fashions, and the old ones are good enough for him as long as they answer the purpose for which they were intended. The **stock**—that instrument of torture to young soldiers—has long since been abolished. **Smoking jackets** and **shooting-coats** reach perfection in the matter of comfort. The high collar worn by very dandified young men in town is eschewed directly they get into the country and join in any sport. A 'smart woman', on the other hand, walks about like a trussed fowl, with mincing gait, balancing herself on high-heeled, pointed boots, her centre of gravity displaced, and her waist looking as if it must snap at the least shock. Then the results—what are they? 'It does not hurt me at all, and I like it', says the wretched fool. Impartial observers think differently. Almost every woman at some period of her life is anæmic, or suffers from hysteria. It is a malady that, like dyspepsia and neuralgia, grows commoner every day. It is not confined to the upper classes. It attacks maidservants, **sempstresses**, clerks, and governesses. It is generated in cities, and is prevalent even in the country. It means simply that there is a want of good healthy blood circulating freely in the system. What sort of circulation can there be in a tightly-laced body? What must be the strain on the heart? How do the processes of nutrition and digestion go on? They scarce go on at all. Consequently, a condition of semi-starvation is begun, which results in chronic disease or in death. Of two instances that came under my own personal observation, in one case the lady died, with her child, in her first confinement; in the other she became a confirmed invalid, suffering agonies at intervals. A certain illustrious lady, whose waist measured only eighteen inches, used to be carefully weighed and measured every month in order to keep her circumference always the same. She was a fine rider, and took an immense amount of exercise, studying her complexion, drinking chiefly milk, and going early to bed; yet she fell eventually into bad health. The consequences of tight-lacing cannot, unfortunately, be measured or eradicated

[12] Jean-Marie Guyau's (1854–88) *Education and Heredity: A Study in Sociology* (London: W. Scott, 1891), p. 51.

[13] Likely a reference to César Lombroso's (1835–1909) view as presented in 'The Physical Insensibility of Women', *Fortnightly Review* 51 (March 1892), pp. 354–7.

[14] A report on tight-lacing in the British medical journal *The Lancet* credits these statements to a Dr Hoyle, as presented at a meeting of the British Medical Association in Bath. 'Tightlacing', *Lancet* 2 (22 September 1888), p. 580.

[15] A common sentiment attributable to no sole physician.

in a moment. They affect more than the women themselves. They affect the children. Is there not already enough suffering in the world without blindly and recklessly introducing more? Even beauty, doubtless the object aimed at, is not attained. Sallow complexions, purple cheeks, and red noses are the accompaniments of tight-lacing. The spinster who has persisted in the practice shrivels and becomes sour-looking as she ages. Nature takes its revenge upon the matron, and induces an unpleasant condition of *embonpoint*,[16] which necessitates massage, Turkish baths, and a severe system of diet. Certain modes of action react on themselves till it may be said that 'the causes of discord among mankind are always a more or less complete transubstantiation of a primitive piece of bread: man's real vice is hunger in all its forms'.[17] A well-nourished frame induces happiness and good temper. Nothing depresses like dyspepsia, the modern equivalent of diabolical possession. All persons who have had dealings with children know that the happy child is the good child.

In which class of society do we find the deluded women that carry the practice of tight-lacing to such an extreme? Precisely where we should expect to look for them: among the ultra-fashionable, the *nouveaux riches*,[18] and the lower middle class; the people who live on shams—whose whole aim and object it is to pretend to be what they are not, and to throw dust in the eyes of their neighbours. The woman-of-the-people may be unlovely from age, work, and privation; but she is at any rate what nature made her. She walks from her hips, she carries weights on her head, she plants the sole of her foot firmly on the ground. A Scotch lassie would give many points to the London beauty. Her hair is bronzed by the sunshine; her complexion is transparent with the hue of health; her figure is untrammelled; her bodily vigour is almost equal to that of a man; her children are chubby-cheeked and flaxen-haired, and play about the cottage door, hatless and shoeless, in all weathers, gay as the birds, free as air, till the day they are caught, and tamed, and shod, by the vigilant pedagogue of the village school. The bulk of the middle-classes, the backbone of the nation, disdain to follow the vagaries of fashion. They do not live to dazzle: they have their homes, their children, their professions. Eccentricity is no recommendation in business. The *nouveaux riches*, set on a pinnacle, which causes them to feel dizzy, must be talked about. Notoriety is the breath of life to them, as to all ultra-fashionable people, who imagine that because their names are always in the society papers they must needs be leaders of society. Fashions filter downwards; and, exaggerated, depreciated, rendered common, the example of those people is followed by people in a lower grade of life. Whether it be short hair, or **chignons,** or bulged-out sleeves, or humped-up collars, or **bustles,** or large hats, or small **bonnets,** the new thing is eagerly seized on, appropriated, vulgarized. The wide-brimmed head-gear, the trailing, dabby ostrich feathers, and the birds-nest fringe of the East-End girl, are homage paid to West-End ladies. For this reason, pernicious practices indulged in by the upper classes work havoc unmentionable when they are introduced in another society. Already the cheap tailor-made gown means the cheap tightly-fitting corset. Fashion-plates permeating through halfpenny papers to the lowest strata instil ideas and desires that must be carried out in common materials. Steels[19] and **whalebone** are within the reach of all who can afford to dress at all, in the common acceptation of the term; and a waistband that can be tightened at will is a dangerous implement in the hands of a foolish woman.

[16] *embonpoint*: Fr. plumpness, usually in a pleasing sense.
[17] Guyau, *Education and Heredity*, p. 32.
[18] *nouveaux riches*: Fr. the newly rich.
[19] steels: steel-boned corsets.

The air is thick with the roar of leagues of all kinds. We have temperance leagues, anti-tobacco leagues, anti-crinoline leagues. Why not a man's league against tight-lacing? If men, once for all, pronounced themselves boldly in abhorrence of the practice, and vowed never to marry a woman who was guilty of it, by degrees, the evil might be mitigated. While men tolerate, and occasionally even admire, an abnormally small waist, women, we may be sure, will justify themselves in indulgence in this baneful habit. Be the mode what it please—statuesque, or **Empire**, or realistic 1830—the waist is there. High or low, it manages to invite compression. Woman blindly sacrifices the largest ingredient of beauty—grace. No one laced with a **cuirass** of steel and whale-bone can be anything but still. The delicious lines of a beautiful human figure, the swaying motion, the lissomness, the suppleness, the willow-like appearance celebrated by poets,—all are thrown to the winds. We are presented with the image of a hard Dutch doll, moving all of a piece; its motions angular, its joints stiffened, unable to bend, or to stoop, or to display the gracious harmony of motion. In what consists the principal charm of Spanish dancing? In the inexpressible rhythm of the motion of the upper part of the body, caused entirely by its freedom. Taglioni, the celebrated dancer, insisted on the free movement of the arms and the bodies of her pupils, devoting all her attention to this: the feet, she said, would naturally follow in unison.[20] Walking, or dancing, or riding, a stiff body is hideous. If women would only believe this, what an enormous step would be gained!

When the ardent lover places his arm round the waist of the girl he adores, he longs to clasp a young, warm, living form to his breast, not a cage of steel and whalebone. As she sways like a lily on her stalk, and yields to his gentle pressure, the grace of her movements charms him. he does not wish to be repelled by the hard, unyielding touch of a jointed lay-figure. When he gradually realizes his disappointment and discovers that what he thought so beautiful is merely an artificial sham, his first feeling is of dismay, his second of disgust. Love is not proof against disillusionment. It is better to promise nothing than to raise hopes that cannot be realized. If a woman's beauty be a sham, what security has one that her moral qualities also are not shams?

The gist of the matter seems to lie in a vicious circle. Women wish to please men, and they have heard vaguely somewhere that a good figure is more appreciated by them than a pretty face. So they compress and squeeze themselves into the shape they believe to be the ideal one. We do not live habitually with nature. Many a girl has never seen the Venus de Medici, or, if she has, probably votes her hideous, because of her large waist. So the argument runs. We must please men; men admire small waists; therefore we must make our waists small. We may suffer, we may die; but we must fulfil our mission, the law of our being—we must please. Man alone can refute this erroneous reasoning. Man alone can dispel this illusion. Whether even man is strong enough to combat a mania which has gained strength through succeeding generations, and become an inherited habit, must remain a doubtful point. At any rate, man alone can make a wholesome public opinion. Men, however, are blind in matters of dress and beauty, and apt to tolerate venial sins in women in consequence of their implied inferiority. Perhaps, after all, woman will need to be her own saviour. Until she decides to renounce this degrading, immoral, and idiotic practice, she should not ask for further privileges, or chatter with impunity about the equality of the sexes.

[20] Marie Taglioni (1804–84), one of the most celebrated ballet dancers and instructors of her time.

12

Contemporary Reports of Crinoline and Corsets

This group of articles drawn from regional newspapers addresses a range of issues related to the wearing of **crinoline** *and* **corsets**, *most of which verge on the antisocial and criminal.*

'Infanticide and Crinoline', *Surrey Comet* (20 September 1862), p. 3

At an inquest held before the coroner in London, on Tuesday, Dr. Lankester[1] observed that he felt he must call the attention of the legislature to this fearful increase of infanticide and concealment of birth. On the average he held an inquest of this kind every other day. A juror asked if the coroner did not think that the present fashion of wearing crinoline was an incentive to this crime, as women were thus afforded greater facilities for concealing their condition. The coroner certainly thought that if the artificial style of dress was abolished facilities would not be so easily afforded for concealing the condition of females, and when the eyes of other people were upon them, the crime would be avoided in a great measure. As a proof, he opened an inquiry the other day of a serious nature respecting the death of a newly-born infant, where the mother, by aid of the present style of dress, was actually enabled to conceal her condition so far as to be waiting at table up to the moment when she was taken with the pains of labour. Crinoline was objectionable in many respects, and it was especially so on this ground and on that of danger to life from fire. The jury returned an open verdict.

[1] Dr Edwin Lankester, Middlesex Coroner and social reformer. See p. 104, note 2.

'Servants' Crinolines', *Midlands Workman* (20 November 1861), p. 6

Among the applicants for relief from the poor-box, Lambeth, a young woman, who stated that she was a servant out of place, requested assistance to get her clothes out of pawn, in order that she might obtain another place. The magistrate was informed that part of the applicant's wearing apparel consisted of an ample crinoline, whereupon his worship took occasion to remark upon the absurdity of woman servants wearing these foolish and dangerous garments, and expressed his opinion that no mistress ought to allow her servants to use them. The applicant promised that she would not put on her crinoline while at work, and she was assisted with a trifle for the purposes required.

'A Smuggler in Crinoline', *Examiner* (7 August 1858), p. 508

At the Thames Office on Tuesday, Ellen Carey, a neatly dressed young woman, was charged on a Custom house information with smuggling 22½ weight of cigars, by which she had incurred a penalty of 100*l*. She pleaded guilty to the information, and the magistrate at once sentenced her to pay a fine of 100*l*. to the Queen, and in default of payment to be imprisoned for six months. Mr. Gardner, a tide surveyor of customs, introduced to the notice of the magistrate three large **petticoats**, lined with cigars, and said the prisoner was a passenger by the General Steam Navigation Company's ship, the *Moselle*, and on her arrival at St Katherine's wharf was about to step on shore, when her immense rotundity of dress excited his suspicions, and he asked her if she had anything about her liable to duty. She declared she had not, and explained that her blown appearance arose from crinoline, which she and every lady in the land considered as very becoming, whatever the gentlemen might say on the subject. He hinted to her that her crinoline petticoat was of extra dimensions, and handed her over to a female searcher, who stripped her in a private cabin, took the three petticoats lined with cigars from her person, and brought her out again with her size diminished to reasonable proportions, as she now appeared. Mr Gardner added that henceforth he should always suspect every woman who wears crinoline.

'Mrs. Surly on Tight Lacing', *Bow Bells* (14 September 1864), p. 163

I'll tell you what it is, my friends, **tight-lacing** is the same sort of thing as Dutch gardening.[2] Have you a yew-tree such as Nature made it—graceful, if rather heavy, nicely proportioned, beautiful, as everything natural is; but it doesn't suit your gardener of Dutch William's days? Beautiful: he has his own ideas of what beauty is. Nature—pooh! So he takes his shears and goes to work on the unfortunate tree; he clips here and clips there, and shapes it into a pyramid, or a peacock, and then stands afar off, contemplating his work in silent ecstasy. But what has he done? Ruined the tree, of course; produced a hideous nothing, not a tree, or a peacock; something that won't

[2] Dutch gardening: highly structured, symmetrical garden design.

harmonize with anything in Nature; something with which all the beautiful shapes of Nature's foliage around it will not and cannot harmonize. If you had asked a thorough Dutch gardener which was the most beautiful, a spreading umbrageous tree, just as Nature has left it, or one of those clipped, cropped monstrosities, can you doubt to which he would have given the palm? The natural tree would be rugged, uncouth; not *what his* production would be, the perfection of symmetry.

It is just the same with the girls' waists. Nature has done one thing, and we are not satisfied with it; we must get out of Nature's leading strings, it would seem. We must have a beauty of our own, like the Dutch gardeners! It's no use talking to people about Nature; they either knock you down with Fashion, or else tell you Nature is wrong and **Mantua**-making right. If somebody had started an idea that there was a finger too many on our hands, there are plenty of fashionable fools who would send for the chopper and rectify Nature's exuberances! It's no use saying that Nature knows better than we do, and that if mankind needed anything like corsets they would have been born with them. As to the matter of beauty, I don't care what is said about statues being ugly or clumsy when they are dressed. They are beautiful as they are; and the fact that the dress makes them ugly, if it is a fact, only proves our theory of dress is wrong. But, dear me! just set side by side the Greek Slave[3] with a dress over her natural waist, and a dressmaker's dummy (one of those out of the shops, say), with a waist drawn in like a lawyer's blue bag[4] when tied tight round the middle, crinoline below forming another triangle, the apex of which is at the waist, the **bodice** above forming another triangle, with its base upwards at the shoulders. Which is the best? Fashion will tell you the dummy. All the lines which Nature drew are distorted; all her proportions set wrong, and yet that is beauty. Nature never intended that the body should be cut into two by staylaces; and she revenges it, of course, by ruby noses. Perhaps they are beautiful? But supposing that a statue, beautiful as it is, looks hideous when dressed; supposing that dress is a mistake, and that to be beautiful we must wear flesh-coloured tights, or else lace our **stays** like grim death; which is best—to attain to that ideal beauty and lead a life of misery and doctor's bills, or look a little clumsy and be hearty as a milkmaid?

Is it possible that when Nature has given a space of twenty-two inches, say, for certain important functions necessary for life to be performed in, that everything will go on as well when you squeeze the space down to twelve inches? Pooh! Nature hasn't got sufficient elbow-room, I tell you! Now, we have been pretty sensible of late years in the matter of dress (barring excessive crinoline); but don't let us make fools of ourselves again. Wherever you go you see fresh, charming young creatures with the natural bloom of health on their faces. I should think never since the primitive ages of the world, were there so many healthy and beautiful girls.

Well, what is the reason for this? I believe, because they don't lace in so tight as they used to. But only begin the abominable tight-lacing again, and you will soon see cheeks like chalk, obliged to be rouged in the middle; noses like plums, obliged to be coated with pearl powder; you will have wheezy, panting, die-away creatures, painful to look at. Exercise and fresh air can't be taken in sufficient quantities, because the corsets forbid exertion; the want of fresh air and exercise will soon tell on the pinched-up damsels—it would even upon a Hercules; they will pant and wheeze and faint through life, instead of freely inhaling the fresh air and tasting a pleasure in the mere sensation of living. Well, it's an ill wind that blows nobody good—the doctors will flourish, that's certain!

[3] American sculptor Hiram Powers (1805–73) completed his enormously popular marble nude *Greek Slave* in 1844.
[4] Draw-string brief-bags, part of a barrister's regalia, are traditionally blue or red.

SECTION FOUR

Men's Dress

As 'Crinoline' and 'Victims of Vanity' in the previous section show, men's views on changeable fashion trends were given regular attention in the Victorian press. Although men's own attire might not have warranted the same column inches as women's clothing, journals regularly offered historical overviews of men's dress that place contemporary fads in light of fashion's long view. It is true that in the nineteenth century, the rise of the middle classes and increased numbers of clerical workers introduced a kind of business uniform for men that discouraged deviation. Once trousers overtook knee **breeches** for day and for formal wear, the standard pieces of middle-class men's wardrobes stayed relatively stable (see figs. 4.1–4.4). This stability meant that minor variations in the staple wardrobe pieces took on increased importance; an article on men's fashion in *Fraser's* (see #13) notes that there is as much opportunity for vanity and affectation 'in the plainness and simplicity of attire, as in the most gorgeous and pompous apparel'. Indeed, the nineteenth century opened with a legendary example of restrained, refined taste: Beau Brummell's style emphasized quality and tailoring over ostentatious display. As the century progressed, to the degree that uniformity was aligned with heteronormative masculinity, those favouring variety or novelty risked labels of degeneracy. Published in the 1860s, 'Modern Beau Brummellism' (#14) warns that too earnest an embrace of dandyism could lead to 'effeminacy, into a certain listlessness, helplessness, and affectation which are unworthy of a man'.

Some embraced those labels head on. Aesthetic dress took the predilections of the dandy to the extreme. Oscar Wilde, for example, donned the knee breeches of his romantic forebears, famously flouting the rigid norms of men's late Victorian dress. Such idiosyncrasy was easily lampooned, but as was often the case, satirical cartoons likely did more to popularize the style than to kill it. Likewise, Gilbert and Sullivan's comic operetta *Patience*, which sends up Aesthetic dress in contrast to the staid, dignified uniforms of dragoons (see #15 and fig. 4.5),

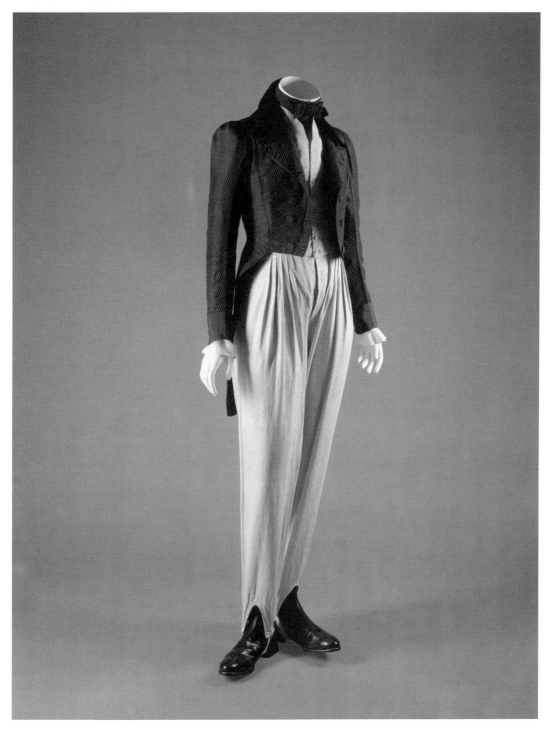

FIGURE 4.1 *Men's pleated trousers, waistcoat and cutaway jacket, British (c. 1833), flax, silk. Public domain image courtesy Metropolitan Museum of Art, Ascension numbers 1982.316.11 and 1981.210.4.*

FIGURE 4.2 *Phiz [Hablot K. Browne], 'The Dancing School', from Charles Dickens's* Bleak House *(London: Bradbury and Evans, 1853), facing p. 134. Image courtesy of Cadbury Research Library: Special Collections, University of Birmingham.*

featured costumes from the fashionable shop **Liberty** and did much to popularize the very styles it parodied. Nevertheless, while both male and female characters in *Patience* explore Aesthetic garb, it is notable that to facilitate the play's happy ending, wherein order is restored and various couples pair off, most of the characters must abandon the 'peripatetics / Of long-haired æsthetics' and return to typical Victorian behaviour and fashion.

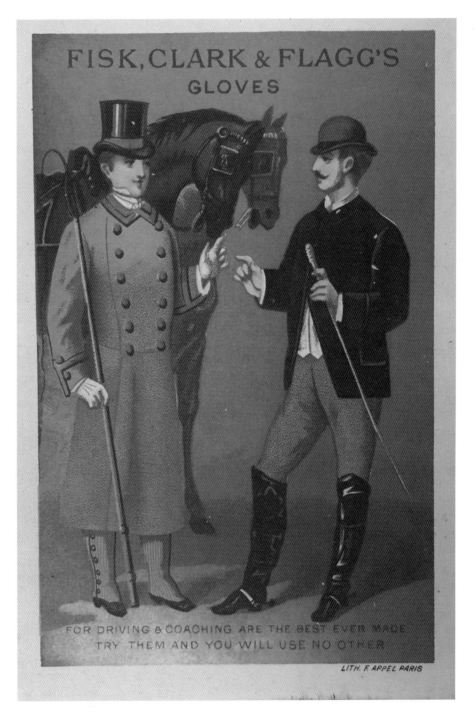

FIGURE 4.3 *Advertisement for Fisk, Clark and Flagg Gloves (c. 1880s). Jay T. Last Collection of Fashion Prints and Ephemera, Huntington Library, San Marino, California.*

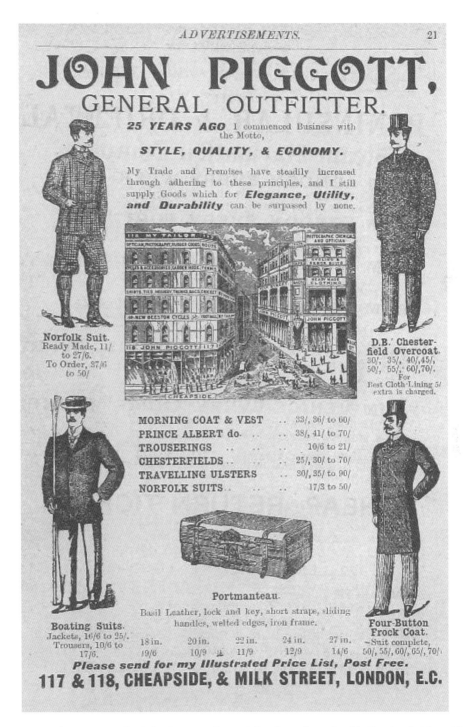

FIGURE 4.4 *Advertisement for John Piggott, General Outfitter, from* Cook's Tourist Guide to Northern Italy *(London: Thomas Cook & Son, 1899), Appendix p. 21. Public domain image courtesy British Library, shelfmark HMNTS 1036.bb.13.*

13

'Dress, Dandies, Fashion, &c.', *Fraser's Magazine* 15 (February 1837), pp. 232–243

This article, dating from just before Victoria ascended to the throne, offers a helpful overview of men's fashion. The first half describes the evolution of men's fashion from the sixteenth to the nineteenth century, spanning from **trunk hose** *to Beau Brummell. The section excerpted here opens with a turn to the contemporary period. Throughout, the unsigned author refers to commentary in the* Spectator *and the* Tatler, *two influential journals from the first decades of the eighteenth century that regularly addressed (and often satirized or critiqued) contemporary fashion. His tone is on the whole ambivalent, balking at the idea of men pursuing fashion, even while endorsing specific merchants who can provide goods of quality acceptable to the author, and all the while discussing costs, a rare phenomenon in fashion writing. Listing prices might have been unusual, but the author's complaint that current fashion elided the differences between the classes was all too common.*

Dress, Dandies, Fashion, &c.[1]

Looking at the great change that has taken place within the period we have glanced over, it must, we think, be admitted that, if we have gained in comfort and economy, we have lost in point of beauty, dignity, and elegance of costume. Moreover, the confusion of classes occasioned by the removal of the lines of demarcation in society that dress afforded, is productive of any thing but convenience, or the maintenance of aristocratic pretension. Formerly, a gentleman was known by his clothes; indeed, by the sumptuary laws, his income was almost defined by his dress:[2] now, the only difference between a gentleman and his valet is, that the valet is frequently the better dressed man of the two. Instead of its being necessary for a man to dress in accordance with his station, a new rule has been introduced, which says that, 'when a man's character is established, he may wear an old coat'. The meeting of the two gentlemen in the theatre, is a happy illustration of the confusion a similarity of dress occasions. Coming from different points, each in a great hurry, one addressed the other with, 'Pray, are you the box-keeper?' 'No', replied the other: 'are you?'

[1] [Author's footnote: History of British Costume, published under the superintendence of the Society for the Diffusion of Useful Knowledge. Knight, London. Five Minutes' Remarks on Gentlemen's Dress. John Nichols, London.] James R. Planché (1796–1880) published *The History of British Costume* in 1834. Publication history of *Five Minutes' Remarks* remains unknown.

[2] sumptuary laws: taxes on luxury goods intended to curb consumption.

At the present day, when every man dresses according to his fancy, it is difficult to say what is the fashion; and the silk collars we have lately seen substituted for velvet, the bits of silk that appear on the fronts of the coats, the cut of the cuffs, and the turn of the **waistcoat** collar, &c., all bespeak the shifts tailors are put to, to devise something before their old ones are worn out. Last spring, some bold genius of the craft struck an expensive sort of fancy button, like Will Sprightly's frosted one of old;[3] but, generally speaking, we should say, the young men of the day incline more to the Tim Dapper[4] than the Will Sprightly school; they are more given to exhibit their fancy in trifles, than to surprise the town by striking 'bold strokes'. Thus, one is curious in gloves and **linen**; another, in studs and pins; a third, in shoes: while some delight in jewellery, and shine forth in rings, chains, buttons, and brooches; but, whatever may be their taste or costume, it is quite clear, that there may be as great puppyism[5] in the plainness and simplicity of attire, as in the most gorgeous and pompous apparel. We see it every day in Quakers.[6]

Jewellery is the peculiar province of the ladies, and, like the language of flowers, is capable of great expression. Speaking of these sort of things, an old writer observes, that you may know by the very buckles of a gentleman usher, what degree of friendship any deceased monarch maintained with the court to which he belongs; and trinkets are equally capable of denoting the degree of affection existing between a lover and his mistress.

Considering how generally interested we all are in the matter of dress, it may not be amiss to devote a few words to the economy of the thing. We do not mean to enter into the mysteries of an exquisite's toilette, nor yet to recommend the management of Addison's old beau, who, with 90*l.* a year, and the ambition of a man of fashion, was sorely put to, to bear the mortality of princes, and had a new suit of black for one king, turned[7] it for a second, kept his chamber while it was scoured for a third; and who used to mark his regret for any potentate of small territories, by a new set of buttons on the iron-gray suit, and add a **crape** hat-band for a prince whose exploits he had admired in the *Gazette*[8]; nor yet the frugality of the two eminent men of Charles I's time, who are described as having but one mind, one purse, one chamber, and one hat[9]: but we purpose looking at the question of dress in its homely every-day garb, as it affects the generality of people.

The clothes that a man *really* and truly wants, are very few; all that he gets beyond what are necessary, are got either from caprice or fashion, which, as Shakespeare observes,

'Wears out more apparel than the man'.[10]

A man of thirty, or five-and-thirty, will be surprised to look at his tailor's bills when he was twenty or five-and-twenty. The amount is produced by a too rigid adherence to what the tailors

[3] Will Sprightly, the name of a fictional writer of a letter to the editor of the *Spectator*, a proud dandy who claimed to have been the 'author' of the frosted button, one of the 'bold strokes' of fashion he pioneered. Eustace Budgell, *Spectator* 319 (March 6 1712).

[4] Tim Dapper was a fictional stand-in for the smartly dressed man of the day, less audacious than Sprightly. See *Tatler* 85 (25 October 1709).

[5] Puppyism: childish, affected or conceited behaviour.

[6] Quakers, members of the Religious Society of Friends established by George Fox in the mid-seventeenth century, were known for austerity of dress.

[7] [Author's footnote: An economist of our acquaintance was in the habit of turning his trousers; and one day, by mistake, the servant sent a pair to the tailor's that had already undergone the operation. Complaining of the error, the tailor consoled him by saying, 'that one good turn deserved another'.]

[8] As described in Robert Steele, *Spectator* 64 (14 May 1711).

[9] As described in Eustace Budgell, *Spectator* 150 (22 August 1711).

[10] Shakespeare, *Much Ado about Nothing*, III.iii.

pronounce new, or the fashion; the unlimited credit that many take; and the number of bad debts that accumulate on a fashionable tailor's books, which are necessarily distributed among those who pay. We have known many men remain five years on their tailors' books without a dunning;[11] though we think, if the law of arrest was abolished, tailors would be gainers instead of losers: for, at present, it is thought all right and proper to make a tailor suffer;[12] and, though they are armed with a power in the law of arrest, all respectable ones agree upon the inexpediency of using it. The great economy in dress consists in adhering to one costume, having it well made, and of the best material. Dealing with a respectable, old-established house, is, therefore, indispensably necessary. Still, there is a medium between those who charge for a name, and the advertising tailors, as they are called. We have now before us a bill from a once-celebrated Bond Street tailor, in which a plain black dress coat figures in the following grandiloquent item:–

A superfine black cloth Coat,
lappels sewed on, cloth
collar, cotton sleeve-lin-
ings, velvet hand-facings,
embossed edges, and fine
wove buttons...............£5 18 0

The neatness with which the amount is made to draw upon six pounds, and yet to leave an impression on the mind that the price was about five, is good, and reminds us of a lady we saw cheapening a yard of **riband** the other day. The shopman asked one shilling and a penny, which she observed was dear: 'Suppose then, marm, we say *thirteen* pence'.[13] The lady took it.

A plain black waistcoat is charged 1*l.*11*s.* 6*d.*, and a superfine dark olive cloth, **Wellington coat**, single-breasted, embossed edges, and fine wove buttons, is charged 6*l.* 6*s.*, with 1*l.* 11*s.* 6*d.* for silk sleeve and skirt-linings!

By way of contrast, we will extract the cash prices set out in the *Five Minutes Advice on Gentlemen's Dress*, the sight of which suggested this paper.

	L.	s.	d.
Dress Coat, any colour, best West of England cloths...	3	5	0
" " black or blue, " "	3	9	0
Frock Coats, any colour, silk linings, "	3	18	0
" " black or blue, " "	4	4	0
Trousers, any colour, kerseymere " "....	1	12	6
" black or blue "	1	16	6
Waistcoats "	0	16	0
Great Coats, waterproof "	4	8	0
Cloaks, from 3l.3s, to circular sizes	4	15	0
Riding Habits, best style, from 5l. to	6	18	0
Court Dresses, &c., &c.			

[11] Dunning: being called to account for a debt.
[12] [Author's footnote: 'Who's the *sufferer?*' –*Tom and Jerry.*] In W. T. Moncreiff's (1794–1857) popular play *Tom and Jerry* (1821), based on Pierce Egan's *Life in London* (1821), Tom jokes his tailor is 'the sufferer'.
[13] There are twelve pence in a shilling, so thirteen pence is equal to one shilling and one penny.

Despite what Mr. Bulwer, a man whose 'soul is in his clothes', makes Brummel say about Stultz's[14] aiming at making *gentlemen*, not *coats*, we question whether any tailor in town excels that house in workmanship and materials. A Stultz coat is as easy the first day on as the last; and they never fail in places, but wear out fairly and evenly to the end. Jackson, in Cork Street, and Perkins, in Argyle Street, are, also, excellent tailors, and a shade or two lower than Stultz in their prices. Coats made by these men will wear out two of inferior cloth and workmanship, looking well to the last; while, what are termed 'cheap coats' are invariably the dearest in the end: they are not good enough to wear, and too good to give away. As to price, we should say, from comparison of various bills, that for four guineas and a half, with a twelve months' credit, or 5*l.* per cent discount for ready money, a man ought to get as good a black dress coat as can be made, and a black surtout *complete*, for from five guineas and half to six guineas at the utmost; with those made of coloured cloths, cheaper in proportion. The great mischief of tailors is, that they charge for a coat first, and then for the materials in the shape of extras. In the country, of course, prices are much lower; but there is a comfort about a well-made London coat that few people like to dispense with, after having once known it. Indeed, many of the London tailors make periodical visits into the country, for the purpose of 'renovating' their customers' 'outward men'.

Trousers, **pantaloons**, and **breeches**, now exercise the talent of distinct *artists*. It is true, that all tailors profess to furnish them; but, if a man once enjoys the luxury of a pair of really well-made ones, he will soon allow, that it is not every one that can make them as they should be. Anderson and Wright, of South Audley Street, are considered at the head of this department, and, though their charges appear high at first glance, yet the excellence of their workmanship, and the lasting, we might almost say, everlasting, quality of their materials, insure them at the continuance of a customer. The mention of 'unmentionables' reminds us of a curious example of the instability of fashion, evinced in this article of dress, within these few years. 'Nimrod,[15] the historian of the chase', writing of the Cheshire (Sir Harry Mainwaring's[16]) hounds in 1825, observed, that there was one peculiarity attending the members of the Cheshire hunt—almost all of them rode in leather breeches. 'That they are well adapted to the saddle and for riding long distances', said he, 'no one will doubt; but in all other countries, they are accounted dead *slow in the field*;' adding, that 'in most countries, "going the pace" in them, was considered an impossibility'.[17] Half-a-dozen years after this was written, saw almost every man pretending to be a sportsman clad in them.

Waistcoats are the indiscriminate productions of tailors and breeches-makers, and afford a wider scope for the display of originality, taste, and eccentricity in the wearer, than any article of male attire. Bulwer reckons them the most difficult of accomplishment; an opinion to which we by no means subscribe, though they certainly exercise an influence over the rest of the apparel. A dashing waistcoat strikes the eye immediately; a fact that a certain ex-joint of the tail was so well aware of, that whenever he intended to speak, he used to attire himself in one of such dazzling brilliancy, as to attract the speaker's eye the moment he rose, by which manœuvre

[14] Johann Stultz, German-born tailor with a fashionable shop in London in the early decades of the eighteenth century, was best known as tailor to Beau Brummell. In Edward Bulwer-Lytton's 1828 novel *Pelham: or, Adventures of a Gentlemen*, the aging dandy Mr Russelton is thought to be based on Brummell; it is Russelton who makes the comment about Stultz (London: Henry Colburn, 1828), p. 278.
[15] Author Charles James Apperley (1777–1843) published sporting and hunting works under the pseudonym 'Nimrod'.
[16] Sir Harry Mainwaring, 2nd Baronet (1804–75) bred hunting hounds from at least 1819, according to Nimrod's 'Masters of Hounds', *New Sporting Magazine* 4 (1834), pp. 143–4.
[17] Nimrod [C. J. Apperley], *Nimrod's Hunting Tours* (London: M. A. Pittman, 1835), pp. 334–45.

he frequently gained possession of the house. A person thus adorned, cannot be passed over without due notice and observation.

Pelham makes Brummell relate, how, at the age of six years, he cut his aunt's best silk **petticoats** into a waistcoat. Judging from what we have seen in recent years, we should be inclined to think, that some aunts' **shawls** had shared a similar fate. These have now exploded, and been succeeded by all sorts, principally plaids and dark-grounded spotted ones in a morning, and beautifully **embroidered** silk ones in the evening. The ladies are now occupied in flowering shawls for themselves and waistcoats for their favourites. Were it not for the delicate sentiment the tasteful blending of lilies and heartsease with forget-me-nots, &c. is capable of conveying, we should be almost tempted to say a word on behalf of our old favourite, the well-washed, well-starched white.

Waistcoats are good friends to the tailors; for, as the fashion is constantly varying, and the material generally difficult of definition, they are enabled to charge a little for fashion, and a little for curiosity. It is no bad economy to get one now and then from a first-rate maker, and employ a country tailor to follow the pattern; but most of them are above copying, and seem to be of Dr. Johnson's opinion, that 'no man ever became great by imitation'.[18]

Still, we have as good waistcoats made in the country, for 10s. or 12s., according to the material, as we have paid 30s. and 35s. for in London. 'Our village' tailor charges us 2s. 6d. for making a waistcoat, let the job be ever so 'critical', as he calls it. This is good economy; for, independently of the saving, there is a good half-crown's worth of amusement in watching its progress—no small consideration to men of few resources.

The hat is a matter of great moment, inasmuch as nothing alters a person's appearance so much as the shape of his hat. Few men seem aware of this; and follow whatever the hatter tells them is the fashion, without considering whether it becomes them or not. There is no face to which some peculiarly shaped hat is not more becoming than others; and when a man has once ascertained what that is, he should keep to it regardless of the caprice of the day. A good hat, is the only article a man can wear with indifferent clothes, without their suffering by the contrast; indeed, a new one, almost sets off an old coat.

A cheap hat is sad economy; and, strange as it may appear, we do not think it possible to get a good one out of London. There are hatters in all large towns, who profess to sell those of the best London makers, whose names they heartlessly stamp in the linings, and offer them at *less* than the town price, leaving us to infer, that they live upon the loss sustained by the transaction. A good hat lasts a long time, even at rough work, and when too old for day work, will dress and new line for night wear. Nothing knocks one to pieces so much as hunting in it, or carrying it into crowded rooms. Twenty-eight shillings ready money, ought to get as good a hat as can be made. Jupp[19] is considered about the top of the tree, though the late king used to employ Cator, in Pall Mall. One of the latest acts of his majesty's dandy existence, was striking a 'bold stroke' at Ascot Races, in the whitey-brown one with a broad riband, which afterwards graced the brow of the late veteran police-officer, Townsend.[20]

[18] Samuel Johnson, *Rambler* 154 (7 September 1751).

[19] Alison Adburgham writes that 'Mr Jupp and Son at No. 222 [Regent Street] had the Royal Warrant within the first year of Victoria coming to the throne'. *Shops and Shopping, 1800–1914*, 2nd ed. (London: Allen and Unwin, 1989 [1964]), p. 28.

[20] John Townsend (1760–1832) had duties far beyond the average policeman, overseeing security for politicians and heads of state. According to the *DNB*, he was 'frequently identified by his smart dress with a characteristic wide-brimmed hat, in a style favoured by his master, the Prince of Wales'. (John Ford, 'Townsend, John (1760–1832)'. In *Oxford Dictionary of National Biography*. Ed. H. C. G. Matthew and Brian Harrison. Oxford: OUP, 2004. Online ed. Ed. David Cannadine.).

From the head to the foot, from the hat to the shoe—is a natural transition: and we must not collude without saying a few words on behalf of the feet. If the hat gives the air, so the foot gives the finish to the man, as nothing sets off the *tout ensemble*[21] more, than a neat well-polished boot. **Patent leather** and **French polish** now effect this in a superlative degree; and a monkey might literally shave himself by the boot of a modern exquisite. We think it is rather overdone, and have no doubt that, ere long, we shall return to honest 'Day and Martin'.[22] Patent leather pumps were introduced at Paris, about the winter of 1828, by the celebrated Spanish beau Valdez. When not too bright, they are very excellent things, particularly convenient for travellers, being always bright and ready for wear. The importation of boots and shoes from the Continent is very considerable; but the French leather cannot compete with the English. There is a great economy in new footing boots, which makes them as good as new at two-thirds the expense. In London, boots are charged variously, from 30*s.* to 2*l.* 18*s.* 6*d.* a pair. Cloth boots are the most sensible introduction of modern times. Top boots are difficult of accomplishment, and it requires great practice to make them properly. Bartley,[23] in Oxford Street, is, perhaps, the most skilful and best maker of the day. A new dress boot, combining the patent leather pump with the silk stocking, is at present the rage, and are very comfortable for winter wear.

Having now traced our subject from early times to the present day, and examined it from top to toe, we will not dwell longer upon a point that to some may appear trivial and unimportant; though we confess, we incline to Lord Chesterfield's opinion, that dress is a thing that ought not to be wholly neglected.[24] A prepossessing appearance is the best introduction; and it has been well observed, that few things make a man appear more despicable, or more prejudice his hearers against what he is going to offer, than an awkward or pitiful attire; inasmuch, that had *Tully*[25] himself pronounced one of his orations with a blanket about his shoulders, more people would have laughed at his dress than have admired his eloquence. A man's appearance falls within the censure of every one that sees him: his talents and learning, very few are judges of.

We are no advocates for puppyism; yet, sooner than see a young man meanly or shabbily attired, we should be tempted to reiterate the words of the old beau, '*Pray, Jack, be a fine gentleman!*'[26]

[21] *tout ensemble*: Fr. all in all.
[22] Founded in 1801 by Charles Day (*c.*1782–1836) and Benjamin Martin (*c.*1774–1834), Day and Martin produced shoe **blacking.**
[23] A. H. Bartley and Sons sold boots from Oxford Street through the 1950s.
[24] Philip Dormer Stanhope, fourth Earl of Chesterfield (1694–1773) was both a statesman and author. His successful *Letters to his Son*, published posthumously in 1774, included the advice, 'Dress is also an article not to be neglected' and 'To neglect your dress, is an affront to all the women you keep company with' (Vol. 3, Dublin: Lynch & Co, 1774), pp. 153, 193.
[25] Thomas Tully (1620–76), Anglican clergyman and fellow of St Edmund Hall, Oxford.
[26] As concluded in Robert Steele, *Spectator* 280 (21 January 1711–12).

14

'Modern Beau Brummellism', *London Society* 11 (April 1867), pp. 298–302

*This unsigned article was widely reprinted. Addressing contemporary men's dress in relation to Beau Brummell, arbiter of **Regency** fashion, the piece alternates between recognising that fine clothing sends a valuably positive message and deriding the vanity and effeminacy that the author believes attends such attention to fashion. Despite being held up as an example of foppishness, Beau Brummell (1778–1840) was more known for restraint in his perfectly tailored clothes than for the ornate frills that the author seems to describe. The article is a good example of the equation of concern about clothing with effeminacy and weakness.*

Beau Brummell was the dandy of his day, and a dandy of a peculiar kind. Etymologists tell us that the word 'dandy' is derived from the French *dandin*, or 'ninny', or from the Italian *dandola*, or 'toy'. Hence a dandy means one who dresses himself like a doll, a fop, a coxcomb, a ninny. The peculiar type which was especially represented by the famous Brummell was combined with an amount of fastidiousness and helplessness to which there is no parallel. He was a remarkable instance of a man pushing himself into a grade of society to which he had no claim, by dint of a certain amount of assurance and a high estimation of himself. There is nothing more true than the saying that the world takes a man at the value he sets upon himself. He who depreciates himself by a humility, whether true or false, will not be esteemed by the world at large. The dealer who cries 'stinking fish' is not likely to find much custom for his wares. Let a man assert himself, and lay claim to a certain amount of wisdom, and talk like an oracle, and the chances are that, unless he is a fool, the world, having neither time nor inclination to go into the matter, will take him at his own valuation. It only requires perseverance, an indomitable will, and inordinate self-esteem, combined with a certain amount of tact, which, in this instance, might almost be better called an instinct of self-preservation, which prevents a man from showing the cards which he hold in his own hands. Some people are easily imposed upon by silence, and are apt to attribute depth of learning and profundity of thought to the man who is silent, for no other reason than that he has nothing to say. Coleridge says, 'Silence does not always mark wisdom;' and goes on to relate an anecdote in illustration. 'I was at dinner, some time ago, in company with a man who listened to me and said nothing for a long time; but he nodded his head, and I thought him intelligent. At length, towards the end of dinner, some apple dumplings were placed on the table, and my man had no sooner seen them than he burst forth with 'Them's the jockeys for me!'

He destroyed whatever *prestige* he had acquired by his silence by showing his folly'.[1] Had he remained silent, Coleridge might have continued to think him intelligent. The man who is wise enough to keep his own counsel while he lays claim to superior gifts, will probably get credit for all he claims. In Brummell we have a remarkable instance of a man valued according to his own estimate of himself. Possessing no great mental gifts, he worked his way into the highest ranks of society, until he came into the very presence of royalty, where he made himself necessary by the force of will, assurance, and self-conceit, which had already obtained for him so great a reputation, that to be spoken to by Brummell, and to dress like him, was the ambition of all the dandies of the day. No doubt he possessed great graces of the body, as well as the natural gift of an almost faultless taste: otherwise it would be impossible fully to account for the completeness of his success while he basked in the sunshine of royal favour. He was the very type of dandies,

> 'neat, trimly dress'd,
>
> Fresh as a bridegroom...
>
> * * * *
>
> He was perfumed like a milliner,
>
> And 'twixt his finger and his thumb he held
>
> A pouncet-box, which ever and anon
>
> He gave his nose, and took't away again'.[2]

Stories without end are told of him, all pointing to him as the great oracle in dress. No lady ever required the attention of her handmaid more than Brummell demanded the assistance of his valet during the tedious operation of his toilet. The great secret of tying a **cravat** was known only to Brummell and his set; and it is reported of him that his servant was seen to leave his presence with a large quantity of tumbled cravats which, on being interrogated, he said were 'failures', so important were cravats in those days, and so critical the tying of them. His fastidiousness and helplessness are exhibited side by side in this anecdote. The one that there should have been so many 'failures' before he could be satisfied; the other, that he should have required the assistance of a valet, or, indeed, of any hand except his own in tying it.

This fastidiousness and helplessness are not, however, confined to any age. Indolence, conceit, love of dress, and helplessness, will always exist so long as we have bodies to pamper and to deck. There will always be men who devote much time and thought to their personal appearance, who 'shine so brisk, and smell so sweet, and talk so like a waiting gentlewoman';[3] men who try on coat after coat, and **waistcoat** after waistcoat, that their effect may be faultless; who consider harmony of colour, and the cut of a coat, or the fit of a shoe or a boot, matters of the greatest moment in life; who, whether beardless boys or elderly men, never pass a looking-glass without stealing sly glances at themselves, and never move except with care and caution, lest the arrangement of their hair, or some portion of their toilet, should be marred. The elderly dandies study to be *bien conserves*,[4] while the younger ones care only never to be behind the fashion of the day, be it what it may. In a

[1] The anecdote derives from *Specimens of the Table Talk of the Late Samuel Taylor Coleridge*, ed. Henry Nelson Coleridge, 2 vols (New York: Harper & Brothers, 1835), vol. 1, p. 171.
[2] Shakespeare, *Henry IV, Part 1* I.iii, ll.358–61.
[3] Shakespeare, *Henry IV, Part 1* I.iii, ll.379–80.
[4] *bien conservés*: Fr. well preserved.

certain listlessness of manner they, like Brummell, demand the constant attention of a valet. They require him to stand behind them and arrange the parting of their hair at the back of the head and to smoothe it, to make the collar and tie tie well, to tighten the waistcoat, and put on the coat artistically and press out any creases, to put the right quantity of perfume on the **handkerchief**, and, in fine, to be responsible for their appearance. These dandies cannot lace or unlace their own boots; they cannot take off their own coat; and never for a moment dream of packing their own clothes, or of looking after their own luggage when they travel. They look for, expect, and demand an amount of attention which any, who do not happen to be somewhat behind the scenes would suppose none but the most helpless of women would require. It by no means follows that they have been brought up in such Sybarite[5] habits. Love of ease, love of self-importance, or a mistaken idea that it indicates high breeding, have led to this unmanliness. There is no greater mistake than to suppose that they who have been most accustomed to what are called the luxuries of life from their very cradle are the most dependent upon them. Perhaps some of the most independent men are to be found among those who have all their lives been in the full enjoyment of every comfort, while, on the other hand, they who have come into possession of them only recently, and by a lucky stroke of fortune, lay the most stress upon them, and are very tenacious of them, as if the secret of true happiness were bound up in them. Nothing illustrates this more than the noble and manly way in which some of those who had been brought up in the very lap of luxury bore the hardships and adversities of a soldier's life during the war in the Crimea. Then it was that the true metal showed itself; that good blood proved itself by noble deeds.

It cannot be denied that it would be difficult to devise anything more hideous or unbecoming than the dress of a gentleman of the nineteenth century. It may be easy and comfortable, and a wider margin may be allowed to the caprice of individuals; but, in all its forms, it is ugly and deficient in both picturesque and pictorial effect. One of the great charms of Vandyke's pictures, apart, of course, from their exquisite painting, lies in the dress. They are all such courtly gentlemen, and one feels to be in such good company as one admires them. Theirs was no **fancy dress** put on for the occasion, no special dandyism, but the ordinary dress of the times, such as men of their rank and position were accustomed to wear. There was much more etiquette in dress formerly than now exists, just as there was much more formality in all they did. Ruffles and buckles, silk hose and **doublets**, were not adopted specially by any one more devoted than his neighbours to the love and science of dress. Men and women were more courteous to one another, outwardly at least, than they are now. Children rose up at the entrance of their parents, and did not resume their seats while they were standing. No man would address any lady in public with his head covered. Young men would take off their hats even to their equals, always to their elders. The old *minuet de la cour*[6] was a very sedate kind of dance compared with those of the present day. If we have gained in freedom, we have lost a great deal of outward mutual respect. Much of what we mean still remains on the Continent, where there is a considerable distinction between the various classes in matters of dress. The peasant has his or her style, and the nobles theirs, while the intermediate classes have their distinctive styles. These distinctions are now abolished. We have no national costume; and the lowest menials endeavour to imitate, to the best of their powers, the grandest lord and ladies in the land.

[5] Sybarite: native of the ancient Greek city Sybaris, whose inhabitants were noted for effeminacy and self-indulgence.

[6] *minuet de la cour*: Fr. formal dance popular from the last quarter of the eighteenth century through the first half of the nineteenth.

It would be a great mistake to infer from the pictures which have been handed down to us, that there was more dandyism formerly than now. Who would lay anything of the kind to the charge of Lord Nelson?[7] Yet we find him represented to us, in paintings descriptive of his great naval actions, dressed in knee-**breeches**, silk stockings, and all the accessories of a court dress.

It was the custom which prevailed at that period, and is by no means a fashion in the sense in which the word is used to denote super-excellence and super-fastidiousness in dress. At the death of Lord Nelson the officers who surrounded that great hero are depicted dressed according to the custom which was as much *de rigueur* as it is now for officers in the army and navy to put on their uniforms when they go into the presence of royalty. To compare small things with great, we find that Lord Winchilsea's Eleven[8] played at cricket in silver-laced hats, knee-breeches, and silk stockings. Bumps and even blood would occasionally show and come through the stockings; and it is related of one man that he tore a finger-nail off against his shoe-buckle in picking up a ball! There must have been a very different kind of bowling then to that which now prevails, if we may judge from the necessity for pads of all kinds and description, and when, in spite of pads and gloves, fingers and, occasionally, even legs are broken by the excessive violence of the bowling.

The formality and courtliness in dress which existed even to so late a period as that to which we have referred, may be said to have gone out with hoops and powder. Our ancestors, no doubt, deplored the changes which took place in their days, and sighed over the introduction of novelties, and the freedom or license, as it may be called, in dress in our times would have shocked their sense of propriety, for we find an amusing account in the 'Spectator' of the alarm felt at the way in which ladies dressed themselves for riding, 'in a hat and heather, a riding-coat and **periwig**, or at least tying up their hair in a bag or a **riband**, in imitation of the smart part of the opposite sex', which the astonished countryman described as 'a gentlewoman, in a coat and a hat'.[9]

There can be no doubt that a certain amount of attention to dress is necessary so far as it effects personal cleanliness and neatness. A well-dressed man, that is to say, a man who dresses like a gentleman, neither like a fop, nor a clerk, nor a tailor who makes his own back his advertisement, is sure to be well received in all good society. Goldsmith says that 'Processions, cavalcades, and all that fund of gay frippery furnished out by tailors, barbers, and tirewomen,[10] mechanically influence the mind into veneration; an emperor in his nightcap would not meet with half the respect of an emperor with a crown'.[11] The only complaint made against our gracious Queen, when she visited Ireland, by some of her poor Irish subjects was, that 'she was dressed like any other lady, and had no crown on her head'. There is much worldly wisdom in paying some heed to the adornment of the outer man. It is a good letter of introduction; but when it goes beyond that, and branches out into excesses of foppery, it becomes unmanly, and, as such, cannot be too much condemned. When young men are either so helpless or fastidious

[7] Horatio Nelson, 1st Viscount Nelson (1758–1805), Vice Admiral of the Royal Navy, capped a career of extraordinary successes with a triumph at Trafalgar, where the British defeated the French and Spanish navies; in the battle, Nelson was shot and died later that day from the injury; his funeral procession included an escort of some 10,000 soldiers.

[8] George Finch, 9th Earl of Winchilsea (1752–1826) was a well known cricketer; his sponsored 'Eleven', a team of 11 players, would likely not all have shared his social station.

[9] Joseph Addison, *Spectator* 435 (19 July 1712), p. 525.

[10] tirewomen: ladies maid or dressmaker.

[11] Oliver Goldsmith, Letter CV, *Citizen of the World* [1760–1]. Goldsmith presented these observations as a series of letters written by the invented Chinese philosopher, Lien Chi Altangi, while visiting England.

that the constant presence of a valet during their toilet is a *sine quâ non*;[12] that the parting at the back of the head requires as much attention as a lady's 'back hair'; it is time, indeed, that some such satirist as the old 'Spectator' should rise up and turn them into ridicule.

But of all the fops in existence, the old fop is the most contemptible. A man who has outlived his generation; who trips like Agag 'delicately',[13] to hide the infirmities of age, or affect a youth that has long ceased; who competes with the young men of the day in his attentions to the fair sex; who dresses in the very extreme of the prevailing fashion of the day, with shirts elaborately **embroidered**, and wristbands, fastened together with conspicuously magnificent **sleeve-links**, which he is always pulling down, either to show them or to establish the fact, which no one would care to dispute, that he has a clean shirt to his back; who is scented and perfumed; whose wig, faultlessly made, is judiciously sprinkled with a few grey hairs that it may appear to be his own hair when he has long ceased to have any to boast of; who uses dyes and cosmetics that the marks of age may be obliterated and the bloom of youth imitated; who is in a flutter of delight when any one conversant with his weakness is kind enough to mistake him for his own son or the husband of one of his daughters; such a man is an object of both pity and contempt. When age is not accompanied by wisdom, but exhibits only the folly of which man's weakness is capable, it is a hopeless case.

Dirty fops are an especial abomination. Men, young or old, who are at great pains to adorn themselves without the most scrupulous regard to cleanliness; who wear many rings upon very indifferently washed fingers; who hang themselves in chains of gold; whose shirt fronts present the greatest variety, at different times, of the most costly jewellery; whose discoloured teeth and ill-brushed hair are a revelation in themselves,—such men only make their defect the more conspicuous by the decorations with which they overlay it. It is related of a *grande dame* who was remarkable for her wit and beauty, that she rejected a man of considerable note in the world, as well as an 'exquisite', of his day, and who was one of her most devoted admirers, for no other reason than that she saw ensconced between his teeth, when he made his appearance at breakfast, a piece of spinach which she had noticed the evening before. It is impossible for anyone, whether man, woman, or child, to be too particular about cleanliness of person and of habits. In these days, when there are such facilities for washing, and when all appliances are so easy of attainment, it is perfectly inexcusable in any one to fail in cleanliness; and of all people, the fop, who professes to make his person his study, is the most inexcusable if he neglect the fundamental principle of dandyism, which is, in fact, its chief, if not its only recommendation.

It has been said that the youth who is not more or less a dandy, will grow into an untidy, slovenly man. There may be some truth in this. Indeed, we should be sorry to see any young man altogether indifferent about his personal appearance. It is not that which offends. It is rather the excess to which it is carried; when self becomes the all-absorbing subject upon which thought, time, and labour are spent; when it degenerates into foppery, into an effeminacy, into a certain listlessness, helplessness, and affectation which are unworthy of a man. It is finicalness of dandyism, and not its neatness and cleanliness, that we quarrel with, on the principle that whatever detracts from manliness is unworthy of a man.

[12] *sine quâ non*: Latin. essential element.
[13] Samuel 15:33: Then said Samuel, Bring ye hither to me Agag the king of the Amalekites. And Agag came unto him delicately. And Agag said, Surely the bitterness of death is past.

15

W. S. Gilbert, 'When I first put this uniform on', from *Patience; or, Bunthorne's Bride!* London: Chappell & Co., 1882, pp. 12–13

Librettist Sir William Schwenck Gilbert (1836–1911) and composer Sir Arthur Sullivan (1842–1900) based their popular comic opera Patience *on the Aesthetic fops typified by Oscar Wilde. A group of dragoons are surprised to find that young women who had swooned over them in previous seasons are now unmoved by their gallant red uniforms, preferring instead the 'cobwebby grey velvet' of the Aesthetes. The Dragoons find the entire trend 'nonsense'. In this Act I song, the dragoons offer a heartfelt paean to their national garb. See fig. 4.5.*

Col. Well it seems to be to be nonsense.

Saph. Nonsense, yes, perhaps—but oh, what precious nonsense!

All. Ah!

Col. This is all very well, but you seem to forget that you are engaged to us!

Saph. It can never be. You are not Empyrean. You are not Della Cruscan. You are not even Early English.[1] Oh, be Early English ere it is too late! (*Officers look at each other in astonishment.*)

Jane. (*looking at uniform.*) Red and yellow! Primary colours![2] Oh, South Kensington!

Duke. We didn't design our uniforms, but we don't see how they could be improved.

Jane. No you wouldn't. Still there *is* a cobwebby grey velvet, with a tender bloom like cold gravy, which, made Florentine fourteenth century, trimmed with Venetian leather and Spanish altar **lace**, and surmounted with something Japanese—it matters not what— would at least be Early English! Come, maidens. (*Exeunt maidens, two and two, singing refrain of 'Twenty love-sick maidens we'. The Officers watch them off in astonishment.*)

Duke. Gentlemen, this is an insult to the British uniform—

[1] Jane lists some of the styles and periods preferred by the Aesthetes: Empyrean (of the highest heaven), Della Cruscan (late eighteenth-century poetic school), and Early English (sixteenth century to the early eighteenth century).

[2] Aesthetic dress preferred half tones and earth tones to bright primary colours.

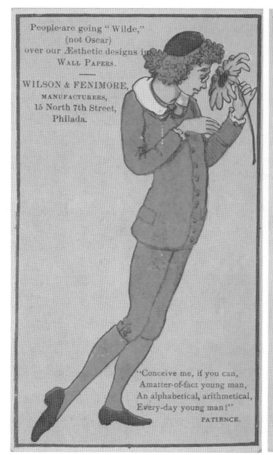
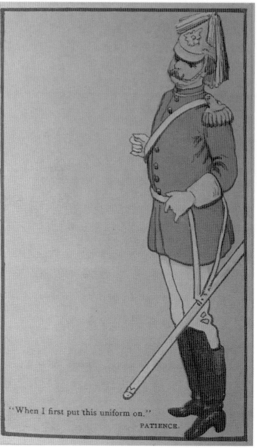

FIGURE 4.5 *Trade card featuring* Patience, Wilson and Fenimore, Philadelphia *(c. 1880s). Jay T. Last Collection of Fashion Prints and Ephemera, Huntington Library, San Marino, California.*

Maj. A uniform that is accustomed to carry everything before it!
Col. A uniform that has been as successful in the courts of Venus as in the field of Mars![3]

SONG.—COLONEL

When I first put this uniform on,
 I said, as I looked in the glass,
 'It's one to a million
 That any civilian,
 My figure and form will surpass.
 Gold lace has a charm for the fair,

[3] As successful in love as on the battlefield.

And I've plenty of that, and to spare,
 While a lover's professions,
 When uttered in **Hessians**,
Are eloquent everywhere!'
 A fact that I counted upon,
 When I first put this uniform on!

CHORUS OF DRAGOONS.

By a simple coincidence, few
 Could ever have reckoned upon,
The same thing occurred to me, too,
 When I first put this uniform on!

 COL.

I said, when I first put it on,
 'It is plain to the veriest dunce
 That every beauty
 Will feel it her duty
To yield to its glamour at once.
 They will see that I'm freely gold-laced
 In a uniform handsome and chaste'—
 But the peripatetics
 Of long haired aesthetics,
Are very much more to their taste—
 Which I never counted upon
 When I first put this uniform on!

 CHORUS

By a simple coincidence few
 Could ever had counted upon
I didn't anticipate that,
 When I first put this uniform on!

SECTION FIVE

Occasional Dress: Wedding, Mourning, Children's and Fancy Dress

One version of idealized Victorian womanhood is distilled in the figure of the 'Angel in the House', a term taken from the title of Coventry Patmore's extended poem (first ed. 1854), in which he glorifies the dutiful, self-abnegating wife: 'Man must be pleased; but him to please / Is woman's pleasure; down the gulf / Of his condoled necessities / She casts her best, she flings herself'.[1] Patmore was certainly not alone in extolling her virtues. The then-prevalent notion of the separate spheres, elucidated pithily by John Ruskin in his series of lectures later published under the title *Sesame and Lilies* (1865), described man's power as 'active, progressive, defensive'; man is 'the doer, the creator, the discoverer' whereas 'women's power is for rule, not for battle – and her intellect is not for invention or creation, but for sweet ordering, arrangement, and decision'.[2] Given these ideas, it is no wonder that in the nineteenth century,

[1] Coventry Patmore, Prelude I, 'The Wife's Tragedy', Canto IX, Book 1, ll.1–4.
[2] John Ruskin, *Sesame and Lilies* (London: Smith, Elder, & Co., 1865), pp. 146–7.

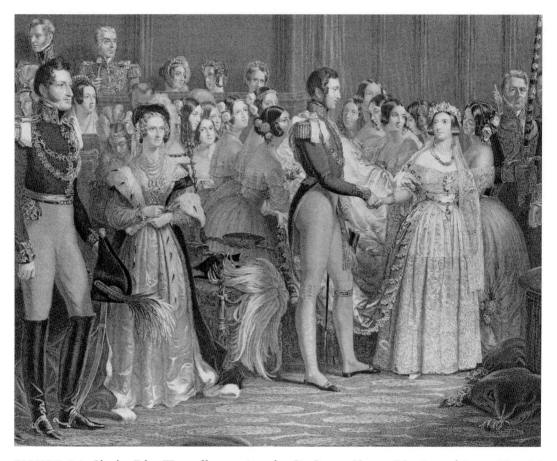

FIGURE 5.1 *Charles Eden Wagstaff, engraving after Sir George Hayter, 'Marriage of Queen Victoria'* *(1884). Public domain image courtesy Metropolitan Museum of Art, Ascension number 47.95.48.*

sartorial expectations reflected the defining moments of a woman's wifely life: her marriage and – upon the unfortunate circumstance of her husband's death – her widowhood.

Victoria again set the tone, with her curious mix of conforming to and shattering gender stereotypes. As the Queen, she had to ask for her beloved's hand in marriage instead of waiting for him to propose.[3] Yet even as ruler of the largest Empire of the time, she performed the role of adoring wife and grieving widow. It helped that Victoria's love for Prince Albert of Saxe-Coburg and Gotha, her first cousin, was evident and – apparently – genuine. No wonder, then, that Victoria's encounter with wedding attire (in 1840) and mourning attire

[3] As reported in Queen Victoria's journal, 15 October 1839:

I sent for Albert; he came to the Closet where I was alone, and after a few minutes I said to him, that I thought he must be aware *why* I wished them to come here,- and that it would make me *too happy* if he would consent to what I wished (to marry me); we embraced each other over and over again, and he was *so* kind, *so* affectionate; oh! to *feel* I was, and am, loved by *such* an Angel as Albert, was *too* great *delight* to describe!

RA VIC/MAIN/QVJ (W) 15 October 1839 *(Lord Esher's typescripts). Retrieved 11 January 2017.*

(beginning in 1861) helped to ossify the conventions of both for years to come. As was widely reported in the contemporary press, Victoria made a point of using British sources for her wedding dress, a tradition that would be perpetuated by later royal brides:[4] the **Honiton lace** was made in Devonshire, the **satin** made in Spitalfields, and the jewels designed and crafted in London (see #16 and fig. 5.1). But even those without the means to be as exacting in their choice of materials could follow Victoria's lead. Prior to the mid-nineteenth century, women were often married in their best dresses, regardless of colour; Victoria's white dress encouraged the expectation that wedding gowns would be white. The style of the royal wedding gown was typical for its day, with a pointed dropped waist, dropped shoulder neckline, and full skirt adorned with **lace** flounces, and it too has remained popular, experiencing regular revivals through today. If Victoria helped to establish the sartorial precedent for the start of married life, she also helped to determine fashion for its end. When Albert died unexpectedly in December 1861, Victoria, their nine children, and the nation as a whole, were plunged into deep mourning which the Queen never fully abandoned; her dedication – wearing black through the remainder of her life – affirmed her devotion to Albert in a public, visible way (see fig. 5.2).

By the 1860s, these customs had grown increasingly cumbersome and expensive. Dickens captures the baldly exploitative side of such rituals when, in *Oliver Twist* (1837–1839), the young Oliver is apprenticed to a conniving undertaker who remarks that the child's 'expression of melancholy' rendered him an ideal mute who could – for a fee – walk along funeral processions, looking appropriately mournful.[5] This kind of ostentatious parade as much for the benefit of onlookers as for the family and friends of the deceased, would be taken to the extreme in the funeral of the Duke of Wellington. Some nine years before Albert's death, the state funeral established a precedent of public commemoration – and, as some have argued, of commercialization[6] – of notable figures. Encouraged by such public displays, ever more elaborate guidelines for mourning wear began to develop, creating both a tangle of worrisome (and sometimes conflicting) social edicts, as well as a ready and reliable market for the appropriate goods. The need for advice fuelled countless column inches in newspapers and magazines; the need for goods spurred the development of mourning emporiums such as Jay's (established 1841; see #17 and figs. 5.3–5.4), stores based on the French *magasins de deuil*, which provided ready-made and custom mourning attire, jewellery, stationery and other accoutrements. In this arena, as in so many others, industrial innovations functioned symbiotically with social rules. The mass-marketed, ready-made clothing that was pioneered in this period made fashionable mourning instantly accessible for those with the will and means to adopt its trappings. For others, to be sure, the financial strain of purchasing mourning attire added stress to an already difficult time.

Mourning attire externalized grief, obviating the need to articulate what one was feeling. Other Victorian fashion trends facilitated a similar self-performance in happier circumstances.

[4] An article about the future Queen Elizabeth II's wedding dress noted that the pearls for her dress 'could have been obtained quite easily from abroad, but the Princess, like Queen Victoria, wanted an all-British wedding dress' ('London Letter', *Sunderland Echo* 26 November 1947, 2). And the BBC noted that 'along with the lace', 'all other fabrics used in the creation of [Kate Middleton's] dress were sourced from and supplied by British companies' ('Kate Middleton's Bridal Dress Designed by Sarah Burton', *BBC News* 29 April 2011, accessed 20 December 2015, http://www.bbc.co.uk/news/uk-13235599).

[5] Charles Dickens, *Oliver Twist*, 3 vols (London: Richard Bentley, 1838), i.76.

[6] See, for example, Sean Grass, 'On the Death of the Duke of Wellington, 14 September 1852'. In *BRANCH: Britain, Representation and Nineteenth-Century History*. Ed. Dino Franco Felluga. Extension of Romanticism and Victorianism on the Net. Web. [12/11/2016].

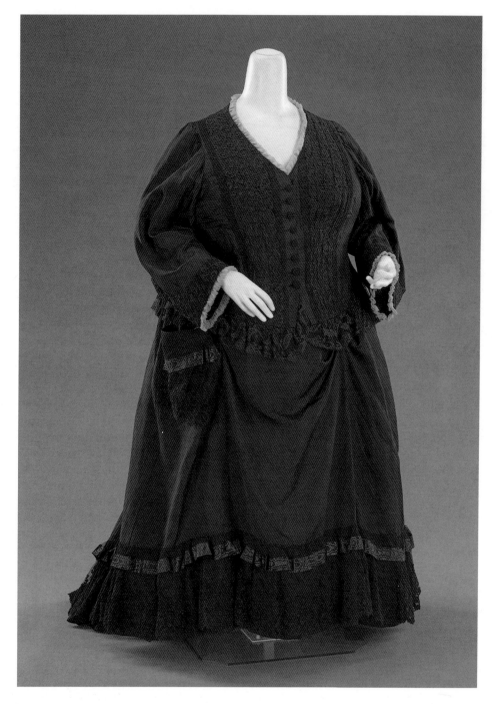

FIGURE 5.2 *Queen Victoria's mourning dress, British (c. 1894), silk. Public domain image courtesy Metropolitan Museum of Art, Ascension number 2009.300.1157a,b.*

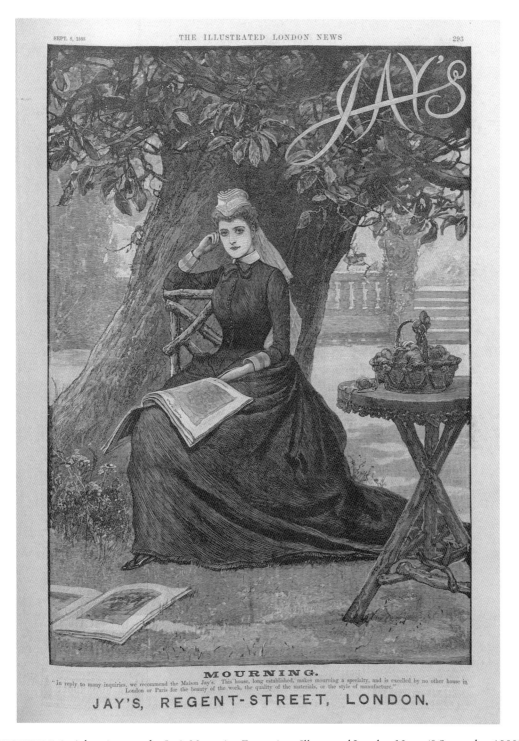

FIGURE 5.3 *Advertisement for Jay's Mourning Emporium,* Illustrated London News *(8 September 1888), p. 293. Image courtesy of Cadbury Research Library: Special Collections, University of Birmingham.*

AT THE COURT MOURNING
WAREHOUSE, Regent-street,
PETER ROBINSON
has just received from Paris
some very elegant MANTLES and POLONAISE;
also a supply of Superb BLACK SILK COSTUMES,
both for in and out of mourning,
to which he invites inspection.
Observe the Address—Peter Robinson's, Regent-street.

ILLUSTRATIONS FREE OF THE NEW
COSTUMES AND MANTLES
on application to PETER ROBINSON
Mourning Warehouse, 256, Regent-street.

NEW COSTUMES, in ALL BLACK,
for £1 19s. 6d.,
including fully-trimmed Skirt and Polonaise,
at PETER ROBINSON'S Mourning Warehouse, Regent-street.

SUPERIOR BLACK SILKS at
PETER ROBINSON'S MOURNING WAREHOUSE.
Peter Robinson has now on Sale
some very rich Black Silks, purchased in Lyons
very advantageously.

Excellent Black Gros Grains ⎱ at 3s. 11d. to 5s. 9d. per yard,
and Glacés.. ⎰ or 47s. to 69s. the Dress.

And Superior and most en- ⎱ at 6s. to 12s. 6d. per yard,
during qualities.. ⎰ or £3 12s. to £7 10s. the Dress.

Also Shades in Greys, Slates, Mauves White, &c., equally cheap.

"If a Whole Piece is taken, a further reduction will be made."

Address for Patterns as above.—256, Regent-street, London.

URGENT MOURNING.
"ON RECEIPT of LETTER or
TELEGRAM,"
MOURNING GOODS will be forwarded to all parts of England on
approbation—no matter the distance—
with an excellent fitting Dressmaker (if required),
without extra charge.
PETER ROBINSON'S GENERAL MOURNING WAREHOUSE,
256, Regent-street, London.

MOURNING FOR FAMILIES,
IN CORRECT TASTE,
can be purchased at PETER ROBINSON'S, of Regent-street, at
a great saving in price.
SKIRTS in New ⎱
Mourning Fabrics, ⎰ 35s. to 5 gs.
trimmed crape,

EVENING DRESSES. — NOVELTIES.
A handsome White or Black and White Tarlatan Skirt,
with Tunics separately made, the whole trimmed with full ruches
and frills,
for 1 guinea.
Also, elegant Black or White Brussels Net Skirts,
with Tunics, from 27s. 6d. to 5 gs.
Engravings forwarded free.
PETER ROBINSON'S Mourning Warehouse, 256, Regent-street.

FIGURE 5.4 *Advertisement for Peter Robinson's department store,* Illustrated London News *(19 October 1872), p. 375.*

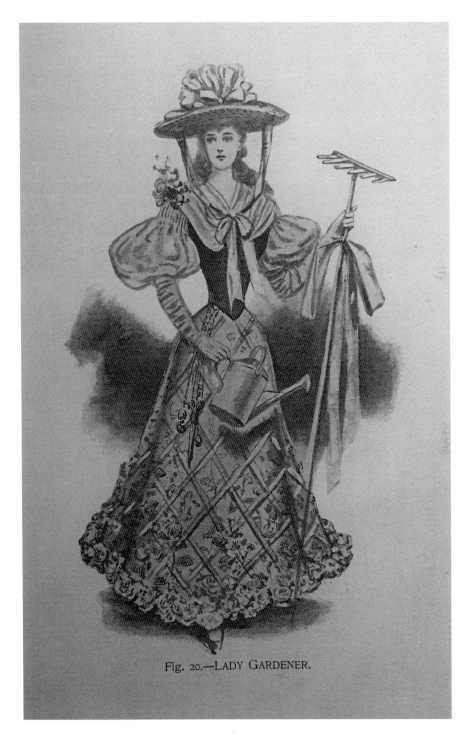

Fig. 20.—LADY GARDENER.

FIGURE 5.5 *Lilian Young, 'Lady Gardener' from Ardern Holt's* Fancy Dresses Described, *6th edition (1897), p. 108.*

A lively interest in **fancy dress** balls – costume balls – served as a counterpoint to the staid banality of everyday. Victoria herself engaged in the practice, holding historically themed balls in 1842, 1845 and 1851.[7] Her guests were expected to create authentically historic costumes; such balls reflect a cognate emphasis on accuracy in stage costumes of the time. But for the majority of those attending the popular balls, which were held throughout the second half of the century and across Britain, the emphasis was not on rigid historical fidelity. Ardern Holt, author of the successful *Fancy Dresses Described* (first ed. 1879, see #18 and fig. 5.5) noted the latitude for interpretation: 'historical dresses worn on such occasions are often lamentably incorrect'. Indeed, costume balls afforded attendees the opportunity to dress far outside of social norms: skirt hems could be acceptably higher, and the events allowed men the rare moment to abandon their relatively limited wardrobes of day and evening wear, turning to **trunk hose** or other historical fashions, or to fictional characters and the native garb of distant lands for inspiration. Whereas masquerade balls in the eighteenth century tended to be regarded as sites to shirk conventional morality, the Victorian fancy dress ball eschewed masks and encouraged costumes that would show off the wearer's features to their best, rather than hide them altogether.

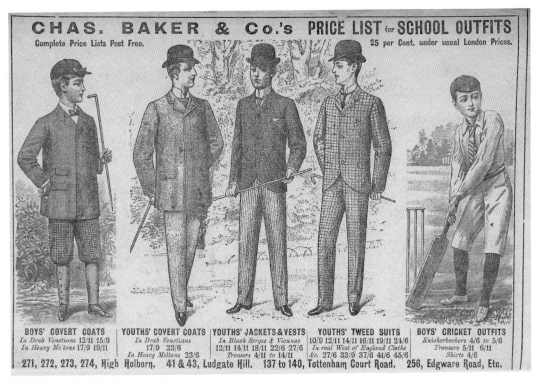

FIGURE 5.6 *Advertisement for Charles Baker's school outfits, from Arthur Sturgess and Arthur Collins,* The Babes in the Woods *(London: Theatre Royal, 1897), p. 101. Public domain image courtesy British Library, shelfmark HMNTS 11781.f.70.*

[7] Helen Rappaport, *Queen Victoria: A Biographical Companion* (Santa Barbara, CA: ABC CLIO, 2003), pp. 113–14.

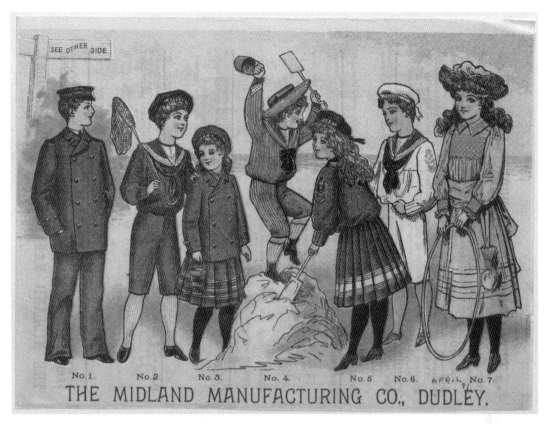

FIGURE 5.7 *Advertisement for children's clothing by the Midland Manufacturing Company (c. 1891).* © *Bodleian Library, University of Oxford 2009. John Johnson Collection: Women's Clothes and Millinery 1 (10). Used with permission.*

They also provided a site for young and old to participate in, and even comment on, social and cultural trends. In later editions, Holt lists costumes such as the Submarine Telegraph and the Suez Canal,[8] and newspaper accounts from the day tell of women wearing costumes lit by electricity and other novelties. Fancy dress balls proved to be favourite events among children, and local newspapers regularly ran accounts of the adult and children's varieties, including long lists of attendees and their costumes.

Children's everyday wear came into its own in the second half of the nineteenth century, with styles developed independent of adult trends. Women's magazines often included columns devoted to children's attire, and advertisers gamely attended to the growing market (see figs. 5.6–5.7). The article included here (#19) raises typical concerns and offers practical advice.

[8] Ardern Holt, *Fancy Dresses Described*, 6th ed. (London: Debenham & Freebody, 1896), pp. 256, 249, 180.

16

Contemporary Accounts
of Victorian Weddings

Queen Victoria's marriage to Prince Albert was a media phenomenon, generating extensive press coverage from across the sectors. The selections below offer a representative survey; the earliest, from the Dublin Mercantile Advertiser, *anticipates the event by focusing on the British origin of the wedding party's attire. That England was not at the time considered the leading nation insofar as fashion was concerned is clear from the claim that the Queen's British dress would 'fairly rival the production of any foreign artists'. Some fifty-five years later, the Queen's wedding dress was still an object of intense interest, as demonstrated by Daybell Trelawney's article, here as excerpted from the* Review of Reviews; *it was reprinted as far away as New Zealand.[1] The unsigned piece on Wedding Customs comes from the popular* Chambers's *magazine, and presents a seemingly timeless complaint about the unnecessary costs of fashionable weddings, a charge similarly directed at extravagant funeral costs.*

'The Queen's Marriage', *Dublin Mercantile Advertiser* (17 January 1840), p. 2

The several branches of our manufactures will receive a seasonable impulse from the determination of her Majesty to be dressed on her approaching nuptials in articles exclusively of British fabrication—an example which will, of course, be generally followed by the ladies of her court. We understand that the Queen's wedding dress will exhibit a superb specimen of British skill, which will fairly rival the production of any foreign artists—the trimming of the gown, which is of **Honiton lace**,[2] will alone cost 1000*l*.[3]

[1] See 'The Queen's Wedding Dress', *The Press* (Christchurch, New Zealand) (2 October 1895).
[2] Originating in Honiton, Devon (although see Trelawney's article), the intricate bobbin **lace** features floral or natural motifs applied onto **net**.
[3] Equivalent values of historical monetary figures are notoriously difficult to calculate; to offer one estimate, according to the Bank of England's inflation calculator, £1000 in 1840 would be worth approximately £91,892 in 2015.

Her Majesty intends to confer upon Prince Albert the Order of the Garter.[4] Mr. Bridge, of Ludgate-hill,[5] has just completed, by her Majesty's direction, a splendid garter, corresponding with the costume of the order. The garter is of purple velvet; the motto of the order, the border and buckle, are composed of diamonds, set in the most exquisite style, and forming altogether an ornament of the most brilliant and unique description.

A star, set with diamonds, and a dressing case, beautifully mounted in gold, are ordered of Rundell and Bridge by the Queen, as a present for Prince Albert. Their cost will be about 1,500*l.*

[Daybell Trelawney], from 'The Queen's Wedding Dress', *Review of Reviews* 12 (July 1895), 42

Daybell Trelawney writes in the *Minster* on 'Some Royal English Wedding Dresses'. His description of the dress work by Her Majesty on the occasion of her marriage is the chief passage of interest:–

The beautiful gown was almost completely veiled with priceless **Honiton lace**—not, however, made at Honiton, but in the secluded Devonshire village of Beer. The **lace** flounce which draped the skirt was four yards in length, and nearly a yard in depth. Over two hundred lace workers were employed upon it for eight months, while the bridal veil (also of Honiton) took more than six weeks to complete, although only a yard and a half square, the greater portion being composed of lace **net** … The **bodice**—which was cut low on the shoulder, in what, I believe, was called the Victorian shape, because it was introduced by the young Queen—was of extreme simplicity, merely finished above the arms by large rosettes and ends of white ribbon, with the same rosettes repeated on the elbow sleeves, which were draped with Honiton lace. A close coronet of white flowers rested on the hair, to which the veil was attached behind, leaving the face free. A magnificent *rivière*[6] of diamonds circled the neck, and completed a wedding-dress suited in its rich simplicity at once to a reigning sovereign and a youthful bride. The **satin** for this dress was made at Spitalfields.[7] The beautiful lace, which cost £1000, will always be regarded as an heirloom; for the design on the completion of the work was immediately destroyed.

The making of the lace kept employed during the winter 200 lace-workers who would otherwise have been destitute.

'A Few Words Upon Marriage Customs', *Chambers's Journal* 8 January 1881, pp. 17–20

It has often been remarked that England more than any other country rejoices in a distinct Middle Class. Within itself, the gradations from one boundary to the other of this class are almost infinite, and of later years a subdivision has been attempted by the term 'Upper' or 'Lower' being

[4] The highest order of knighthood in England.

[5] Dorset-born jeweller John Bridge (1755–1834) founded his London firm with partner Philip Rundell (1746–1827) in 1787.

[6] *rivière*: Fr. a short necklace of simply set gemstones.

[7] Spitalfields, a parish on the eastern side of London, was known for the silk weavers that established the area in the mid-seventeenth century. By the mid-nineteenth century, when silk production moved increasingly to the Continent, the area fell into decline; Victoria's sourcing her wedding fabric in Spitalfields was thus newsworthy.

prefixed to the phrase. This elastic Middle Class is constantly feeding the aristocratic ranks to which it does not itself pretend to belong, and is as constantly recruited from a lower stratum of society. It is the very backbone of the country—a fact it rarely forgets—but is not without its weaknesses. One of these is its persistent aping of the manners and customs of the class above itself.

This is no new fault of human nature; it must have been at any rate displayed in the Elizabethan age, or Shakspeare [*sic*] would not have declared by the mouth of Hamlet 'that the toe of the peasant comes so near the heel of the courtier, he galls his kibe'.[8] Yet never, we think, was the weakness or fault—call it which you will—more rampant than in the present day; and notably it shews itself in lavishness and love of display, in following the reigning fashion however senseless that may be, and especially in the tiresome and extravagant ceremonials which too often take place on the occasion of its weddings.

It is a right and natural instinct which dictates that a certain amount of publicity should attend the Marriage Ceremony; but surely if half-a-dozen witnesses are present, if the event is formally registered, and afterwards announced, the desired publicity may be considered established. We are sure that with sensitive young people, and perhaps still more so when the bride and bridegroom are no longer very young, the formalities of the wedding-day are looked forward to with nothing short of dread; while not a few of the guests, who being invited feel they must attend, would much rather be spared the inconvenience and hurry and flurry of the whole affair.

Mere personal dislike of formal ceremonial is, however, of small account when compared with the temptation that our present manners and customs afford to incur unjustifiable expense on the occasion of weddings. Young people are wonderfully gregarious, and even the bride herself, much as she dreads the ordeal of a large party, the multitudinous congratulations, and the embarrassing compliments to which she must make some pretty reply—even *she* shrinks from the idea of her wedding being different from the weddings of other people, and makes up her mind to bear the brunt of whatever may happen, provided that things are all done in the usual orthodox fashion. It is very well for people of large fortune to make a gorgeous display, and entertain their friends sumptuously on any occasion that may form a pretext for so doing; such hosts have usually large houses and many servants, and it is quite possible to conduct the festivities with little or no inconvenience of any sort. But probably the 'stylish' wedding of which we are thinking is reported in the newspapers in the most circumstantial manner, and the description inflames the imagination of some worthy family who are about giving up a daughter to the man of her choice.

'What a lovely dress!' exclaims the sister of the betrothed girl as she reads the account of Lady Fanny Blank's apparel. 'O mamma, it would just suit Ethel. Do listen'. And then the girl reads with emphasis, the **milliner's** jargon of **satin** and **brocade**, and '**point de gaze**', and overlapping festoons, &c; and when she pants to take breath, the mother perhaps sighs faintly and replies: 'The expense, my dear—remember the expense!'

'But her wedding-dress—it is to be her wedding-dress, mamma'.

'Too costly, too costly', returns the mother with a shake of her head.

'But couldn't Ethel have something like it?' persists the girl; 'it is just in her style: she would look lovely in it, I know'.

[8] *Hamlet* V.i. Hamlet suggests that the peasant (figuratively) nips at the courtier's heels, that is to say, rises above his own station.

The mother who 'hesitates' in the matter of a daughter's bridal-dress is pretty sure to be 'lost'. The fatal paragraph too often does its cruel work, and the costly ultra-fashionable dress is provided, which may possibly never be worn in its original state after the wedding-day. Of course we are speaking of the middle-class bride who does not begin her married life where, in common parlance, her parents leave off. Lady-like, well-educated girls, quite capable of adorning any station to which their husbands' talents and industry can raise them, often begin housekeeping on a comparatively homely scale, with only one or two servants, and in a style quite out of keeping with party-giving or gay visiting. In such cases the rich wedding-dress, though it may be carefully kept for a time on account of its sentimental association, is very likely to be ultimately pulled to pieces and dyed some serviceable colour fit for ordinary wear. Not unfrequently the cost of it is lamented before the year is out.

The sumptuous wedding breakfast, too, is a forced, unnatural meal. It often takes place before the usual luncheon hour, and the gentlemen of the party at anyrate have seldom much appetite for it. Then middle-class men, as a rule, attend weddings at some personal inconvenience. Their thoughts are very often with the business they are neglecting, and they hurry to their offices and counting-houses as soon after the meal as they decently can. At the breakfast there is rarely any sprightly general conversation; the guests all seem rather afraid of hearing their own voices, until the time arrives for the set speeches. How alike these all are! Every bride that ever blushed beneath her wreath of orange flowers,[9] is a paragon of excellence; every bridegroom that ever stammered forth his acknowledgements, is a thoroughly good fellow, not quite worthy of the treasure he has secured, but almost.

We remember once begin seated at a wedding breakfast very near the happy pair. There had been the usual healths drunk, and quite as much champagne consumed as is good for anybody at one o'clock of the day. The laudatory, congratulatory speech had been made, and now it was the bridegroom's place to rise and return thanks. He was a sufficiently cultivated, sensible, and usually self-possessed man; but the situation was apparently a little trying to him. He whispered to his wife, who was infinitely more composed than he—but then she had not a speech to make—'Oh, what shall I say?'

'Thank them for coming', she promptly replied in the same low tone. And so he did in a short but neatly expressed manner. I have since thought that this prompting was typical of the true helpmate that wife has been to her husband.

We are old enough to remember the time when the wedding ceremonies of the middle classes were much less pretentious than they at present are. A few near relatives and dear friends were probably invited for the occasion, almost certainly by word of mouth instead of by printed or written invitation; and the repast offered, though good and substantial, did not necessarily include expensive luxuries. In summer-time, white **muslin** was no uncommon bride-dress among prudent people, and **bonnets** were invariably worn by bride and bride's-maids. Orange flowers were in favour, but these were often removed from the bride's bonnet before it was worn again. Nowadays, the wreath and large veil have become so usual, that we heard the other day of a rustic village maiden wearing them. How much wiser it would have been to make the best bonnet serve!

With regard to wedding-presents, we have long thought the customary display of them intense vulgarity. How frequently must it happen that some trifling gift—trifling because of the donor's slender purse—is weighted with deep affection; while the massive piece of plate

[9] Orange blossoms were standard floral fare for the bride.

that has the place of honour on the show table, displays the giver's wealth rather than his love! The very essence of true generosity is surely to confer benefits without parading them. The Jews, we believe, generally marry early, without waiting for a large income, and we remember hearing a custom which prevails among them when the two young persons are betrothed. The near relatives and friends meet, and arrange among themselves what presents shall be made, carefully avoiding repetitions, but planning that various articles should match. This is surely an excellent system, whereby a superfluity of butter-knives or a paucity of table-spoons is likely to be avoided.

An increase in the number of bride's-maids is one of the innovations of modern times. Formerly one, or at most two bride's-maids were thought amply sufficient for the onerous duties of holding gloves and **handkerchief** and bouquet, and tying up slices of cake, and directing cards. For those were the days when middle-class people did not pretend to have five-hundred acquaintances, and did not find their friends too numerous to remember. Undreamed of then was the curt announcement, 'No cards'. Now, six bride's-maids are a quite usual number; and of course six bachelor friends must be invited, to give their arms to these damsels. Of course, also, the bridegroom must present six trinkets—generally lockets—to the young ladies. All very advantageous to the jewellers certainly, but often a great tax on the young husband with whom sovereigns are not too plentiful.

One curious thing we have observed, and that is, that however anxious they may have been before the occasion to do things in the customary way, the wedded pair often quickly repent of the needless expenditure that has taken place. However much the young wife may have been initiated into household affairs before her marriage, new knowledge comes on her surprisingly fast when she holds the domestic purse-strings herself. She begins to understand 'what bills poor papa must have had to pay for that lovely breakfast, with its ices and confectionery, its choice fruit and hothouse flowers'. In her heart of hearts she feels now that she would like the money to spend very differently. Of course we are speaking of that numerous class who marry as soon as they prudently can, and on means only just sufficient to keep up the appearances of their position.

It is undoubtedly immoral to make marriage difficult and imprudent by artificial means; but this is really what ostentatious weddings often do. They give a false start to people with small incomes. The numerous guests, feeling themselves in a measure chosen and privileged, cannot let the acquaintance languish. Parties are given, and perhaps the bride may wear her wedding-dress a few times after all. But if she does she feels herself the observed of all observers, and probably much finer than any one else in the room; one of the most miserable sensations a sensitive woman can have to endure in society. Every one knows how in visiting one occasion leads to another, and how incompatible much gaiety is with a slender income.

Looking back on careers of which we have seen the beginning, and a long course, sometimes indeed the end, we cannot remember one where economy in early life has been regretted. It is the period too at which it is least difficult to exercise it. Wants increase as we grow older, and the need of many indulgences we cared little about in youth becomes apparent. The claims of others upon us also usually multiply with time. We remember one couple—the bride the daughter of a professional man, the bridegroom precisely in the same station—who on their wedding tour of less than a month made a great hole in a hundred pounds—as they themselves admitted—but who never could again be said to command such a sum. They were both really well-meaning, and in later years exercised self-denial with a good grace. But they made a wrong start, got a little behind the world even before the children—of whom there were many—arrived; and they never were free from worldly cares again. Theirs was a very pleasant house at which to visit,

before by slow degrees the true state of their circumstances became known. Kind-hearted and hospitable, fond of society and buoyed up with hope that every new venture would turn out prosperously, they drifted on till, figuratively speaking, the breakers were ahead. Friends and relatives came to the rescue; but it was a sad story, and the sequel is hardly yet.

No doubt it requires some resolution to make a dead set against the follies of the age; and a dread of singularity is often conspicuous in the young. It is amusing sometimes to notice how frightened a young girl is—frightened is really not too strong a word—lest her dress should not be 'what is worn'. No doubt the dread of singularity—a dread which is somewhat akin to modesty—in a great measure actuates the feeling; but at all times it is a wholesome thing to assert the right, and never more so than when there is singularity in the act.

In all ceremonials there is a great deal in fashion; and it occurs to us that if a few people of consequence would set the fashion of simplicity in marriage ceremonies, they would be doing a great service to the community. In many memorable instances the higher classes have afforded a noble example by leaving instructions that their funerals should take place without pomp or parade; and already we see the good results which have followed, funerals among the middle-classes being as a rule much more simple than formerly; and consequently, to our mind, much more solemn. Births, deaths, and marriages are three events in human life usually classed together, and which the statistician records, and the politician notes; but marriage is the only one of the three in which the chief actors are voluntary and conscious agents. Surely it is the most solemn act of man or woman, and, properly considered, is little allied to pomp and festivity. Think what it is to assume, in a large measure, the responsibility of another's happiness and future wellbeing! And this is really what in marriage we may be said to do. Surely a solemn impressive ceremony with simplicity of attire is more in harmony with the occasion than much pageantry and festivity.

Now and then among the working-classes one hears of weddings that are almost pathetic in their avoidance of anything like display. We mean when the man steals only an hour from his daily labour, returns to it without betrayal of what has just happened, while his newly-made 'missis' begins settling the 'home', probably of only two rooms, in which they are to begin their new life. Such marriages as these are not ill-omened. They tell of energy and perseverance, of a prudent looking forward to consequences, and of the absence of a pretentious false pride. Others, perhaps a little higher in the social scale, give themselves the one day's holiday; and we remember among the touching incidents connected with the loss of the river steamer the *Princess Alice,* was the drowning of a couple wedded only that morning.[10] To be faithful until death should them part they had promised, and lo! by death they were not divided! Surely there is something to be said for a custom which formerly very much prevailed among the middle classes, namely dispensing with any wedding tour, the newly-married pair taking up their abode at once in their appointed home. Especially when the marriage takes place in the winter, this seems a desirable plan. Unless people have wealth to command many luxuries, there is much hardship and very little pleasure connected with travelling in inclement weather. And if people are afraid of being thrown on the monotony of each other's society without the preparatory distraction of new scenes, it would be well to hesitate before marrying at all. Probably a holiday trip when the pair have been married some little time and have fallen into each other's ways, is far more enjoyed than the so-called honeymoon.

[10] The paddle steamer SS *Princess Alice* sank in September 1878 after colliding with an empty boat during a pleasure cruise on the Thames; over 650 perished.

But however much we may deprecate some follies and extravagances of the present day, we must admit there is little of the rude and boisterous display of mirth tolerated at festivities, such as we read of as being common little more than a century ago. At this improvement in manners we may especially rejoice when considering wedding ceremonies—which certainly are of the formalities which ought to be conducted with calm and grave propriety. To make them the occasion of mere frolic and merrymaking would be reverting to barbarous usages; and just in proportion as we approach, however slightly, to this state of things, do we retrograde.

Of this we may be quite sure, that ostentation is but another word for what we understand by the term vulgarity. It is simplicity which is nearly allied to high civilisation and true refinement; for as a great poet declares:

Simplicity is nature's first step and the last of art.[11]

Those who have witnessed a simple wedding and felt its solemnity, will probably acknowledge that it was far more impressive than one in which gorgeous display distracted the attention of all present from the momentous event they came to celebrate. Those therefore who can ill afford unnecessary expense may take heart and resolve on a quiet wedding without dismay. We will conclude with a little anecdote told us by a friend after she had been the wife of a prosperous man for at least a score of years. On the occasion of her marriage, which took place while her husband's means were as yet slender, her parents contributed largely to the furnishing of the house for the young couple. But there was one coveted gift which they would not bestow. They possessed a very large stock of champagne glasses, and the bride-elect begged hard for a dozen, or even half-a-dozen, of a pattern she particularly admired.

'No, no', was the mother's wise reply; 'when William can afford to give champagne, he will be able to buy the glasses'.

Perhaps the possession of the glasses would have been a temptation to give champagne—who knows?—a little sooner than he did; though ample means came in due time. Anyway, the little story is worth remembering, for it may suggest other articles to be wisely dispensed with besides champagne glasses.

[11] From *Festus* (1839), by the Spasmodist poet Philip James Bailey (1816–1902).

17

Richard Davey, from
A History of Mourning,
London: Privately Printed, 1890

Though ostensibly a history of mourning, Davey's volume was produced by Jay's Mourning Emporium, one of the first and largest stores carrying a vast range of clothing and other goods for the bereaved. It therefore functions equally as an extended advertisement, encouraging and perpetuating the mourning customs that would necessitate a trip to the store. After a cursory review of mourning rituals from ancient Egypt and Greece, the work turns to contemporary concerns. These two excerpts focus on the recent death of Prince Albert and the rise of the **magasin de deuil**, *or mourning emporium.*

pp. 86, 88

The solemn but exceedingly simple obsequies of that much regretted and most able man His Royal Highness the Prince Consort, took place at Windsor on the 23rd December, 1861. At his frequently expressed desire it was of a private character; but all the chief men of the state attended the obsequies in the Royal Chapel. The weather was cold and damp, the sky dull and heavy. There was a procession of state carriages to St. George's Chapel, at the door of which the Prince of Wales and the other royal mourners were assembled to receive the corpse. The grief of the poor children was very affecting, little Prince Arthur[1] especially, sobbing as if his heart was breaking. When all was over, and the last of the long, lingering train of mourners had departed, the attendants descended into the vault with lights, and moved the bier and coffin

[1] Prince Arthur, Duke of Connaught and Strathearn (1850–1942), the seventh child of Victoria and Albert, was eleven when his father died.

along the narrow passage to the royal vault. The day was observed throughout the realm as one of mourning. The bells of all the churches were tolled, and in many of them special services were held. In the town the shops were closed, and the window blinds of private residences were drawn down. No respectable people appeared abroad except in mourning, and in seaport towns the flags were hoisted half-mast high. The words of the Poet Laureate were scarcely too strong:

The shadow of his loss moved like eclipse,
Darkening the world. We have lost him: he is gone:
We know him now: all the narrow jealousies
Are silent; and we see him as he moved,
How modest, kindly, all-accomplished, wise;
With what sublime repression of himself,
And in what limits, and how tenderly:
Not swaying to this faction or to that;
Not making his high pace the lawless perch
Of wing'd ambitions, nor a vantage ground
For pleasure; but thro' all this tract of years
Wearing the white flower of a blameless life,
Before a thousand peering littlenesses,
In that fierce light which beats upon a throne,
And blackens every blot: for where is he
Who dares foreshadow for an only son
A lovelier life, a more unstained than his?[2]

When Her Majesty became a widow, she slightly modified the conventional English **widow's cap,** by indenting it over the forehead *à la* **Marie Stuart,**[3] thereby imparting to it a certain picturesqueness which was quite lacking in the former head-dress. This coiffure has been not only adopted by her subjects, but also by royal widows abroad. The etiquette of the Imperial House of Germany obliges the Empress Frederick[4] to introduce into her costume two special features during the earlier twelve months of her widowhood. The first concerns the cap, which is black, having a Marie Stuart point over the centre of the forehead, and a long veil of black **crape** falling like a **mantle** behind to the ground. The second peculiarity of this stately costume is that the orthodox white **batiste** collar has two narrow white bands falling straight from head to foot. This costume has been very slightly modified from what it was three centuries ago, when a Princess of the House of Hohenzollern lost her husband.

pp. 95–6

The ingenious idea of the *Magasin de Deuil*, or establishment exclusively devoted to the sale of mourning costumes and of the paraphernalia necessary for a funeral, has long been held to

[2] Alfred, Lord Tennyson (1809–92), Poet Laureate from 1850, published this 'Dedication' to his *Idylls of the King* in 1862, the year following Prince Albert's death; lines 12–28 appear here.
[3] Mary, Queen of Scots (1542–87), often pictured in an **attifet**, a heart-shaped widow's cap that came to be associated with her name.
[4] Victoria, Princess Royal (1840–1901), Queen Victoria's eldest child, married Emperor Frederick III of Germany in January 1858.

be exclusively French; but our quick-witted neighbours have, to speak the truth, originated very few things; for was not the father of French cookery a German physician in attendance on Francis I., assisted by an Italian cardinal, Campeggio, who, by the way, came to England on the occasion of the negotiations in connection with the divorce of Queen Catherine of Arragon.[5] The *Magasin de Deuil* is but a brilliant and elaborate adaptation of the old *Mercerie de lutto* which has existed for centuries, and still exists, in every Italian city, where people in the haste of grief can obtain in a few hours all that the etiquette of civilisation requires for mourning in a country whose climate renders speedy interment absolutely necessary. Continental ideas are slow to reach this country, but when they do find acceptance with us, they rarely fail to attain that vast extension so characteristic of English commerce. Such development could scarcely be exhibited in a more marked manner than in Jay's London General Mourning Warehouse, Regent Street, an establishment which dates from the year 1841, and which during that period has never ceased to increase its resources and to complete its organisation, until it has become, of its kind, a mart unique both for the quality and the nature of its attributes. Of late years the business and enterprise of this firm has enormously increased, and it includes not only all that is necessary for mourning, but also departments devoted to dresses of a more general description, although the colours are confined to such as could be worn for either full or half mourning. Black silks, however, are pre-eminently a speciality of this house, and the Continental journals frequently announce that '*la maison Jay de Londres a fait de forts achats*'.[6] Their system is one from which they never swerve. It is to buy the commodity direct from the manufacturers, and to supply it to their patrons at the very smallest modicum of profit compatible with the legitimate course of trade. The materials for mourning costumes must always virtually remain unchangeable, and few additions can be made to the list of silks, **crapes, paramattas, cashmeres, grenadines**, and ***tulles*** as fabrics. They and their modifications must be ever in fashion so long as it continues fashionable to wear mourning at all; but fashion in design, construction, and embellishment may be said to change, not only every month, but well-nigh every week.[7]

The fame of a great house of business like this rests more upon its integrity and the expedition with which commands are executed than anything else. To secure the very best goods, and to have them made up in the best taste and the latest fashion, is one of the principal aims of the firm, which is not unmindful of legitimate economy. For this purpose, every season competent buyers visit the principal silk marts of Europe, such as Lyons, Genoa, and Milan, for the purpose of purchasing all that is best in quality and pattern. Immediate communication with the leading designers of fashion in Paris has not been neglected; and it may be safely said of this great house of business, that if it is modelled on a mediæval Italian principle, it has missed no opportunity to assimilate to itself every modern improvement.

[5] Catherine of Aragon (1485–1536), first wife of Henry VIII, was Queen of England from 1509 until the marriage was annulled in 1533.

[6] *la maison Jay de Londres a fait de forts achats*: Fr. Jay's London store has made strong purchases.

[7] This kind of incessant change was, of course, encouraged by the stores, as it necessitated new purchases.

18

Ardern Holt, from *Fancy Dresses Described: Or, What to Wear at Fancy Dress Balls*, London: Debenham & Freebody, 1880, 1896

'Fancy Dress Balls' or costume balls, had their origins in eighteenth-century masquerades, but by the late nineteenth century, they had become an enormously popular recreation for all classes. Ardern Holt's Fancy Dresses Described *capitalized on and encouraged the trend, listing hundreds of costume descriptions, many with accompanying illustrations. A companion volume for men's fancy dress was released in 1882. Victorian balls tended to emphasize the suitability of the costume to the wearer, along with popular trends: Ardern encourages those who 'desire to look well to study what is individually becoming to themselves'. A selection of costume descriptions – some quite inventive – from the manual reflects contemporary concerns (imperial expansion, technology) as well as a reverence for the past, whether one's own (fairy-tale characters) or the nation's (past monarchs). Women's costumes often recalled men's professions by representing tools of the job on traditional feminine dress; the skirt of a Lady Gardener (see fig. 5.5) depicts a flowered trellis, and she holds a rake in one hand, but no one would mistake her for an actual groundskeeper.*

From 'Introduction', *Fancy Dresses Described: Or, What to Wear at Fancy Dress Balls*, 2nd ed. (London: Debenham & Freebody, 1880), pp. 1–9

But, what are we to wear?

As a rule, this is the first exclamation on receipt of an invitation to a Fancy Ball.

It is to assist in answering such questions that this volume has been compiled. It does not purport to be an authority in the matter of costume, for, as a rule, the historical dresses worn on such occasions are often lamentably incorrect. **Marie Stuart's** head-dress appears with powder; Louis XIV. in a beard; and Berengaria[1] with distended drapery. With regard to national costumes,

[1] Berengaria of Navarre (*c.*1165–1230), wife of Richard I and Queen of England (1191–9).

no one would probably view them with more curiosity than the peasantry they are intended to portray, although certain broad characteristics of the country are maintained by Fancy-ball-goers.

Several hundred characters, which a long and varied experience has proved to be the favourite and most effective, are here described. A glance through them will enable readers to choose what will suit them, and to learn how they are to be dressed.

[...]

To be properly *chaussé* and *gante*[2] are difficulties at fancy balls. As a rule, with short dresses the prettiest and most fashionable shoes are worn, either black with coloured heels and bows, or coloured shoes to match the dress, and **embroidered**, the stockings being of plain colour or stripes. With the Viviandière[3] dress **Wellington boots** are the best.

To avoid glaring inconsistencies, it is well to remember that powder was introduced into England in James I.'s reign, though not very generally worn. It attained the height of its glory in the **Georgian** period, and in 1795 fell a victim to the tax raised by Pitt on hair-powder; those that wore it subsequently were called guinea-pigs, on account of the guinea tax.[4] **Periwigs** were first mentioned in 1529. High-heeled shoes were not heard of till Elizabeth's reign.

It is uncomfortable to dance without gloves, so consistency yields to convenience. For most Peasant dresses mittens are best; and when gloves are worn they should be as little conspicuous as possible. For the **Poudré** costumes, long mittens and long embroidered gloves are admissible. Gloves were never heard of till the 10th and 11th centuries, and not much worn till the 14th; but what can pretty Berengaria do if she wishes to dance and does not care to appear ungloved?

[...]

With regard to Historical Characters, up to Queen Elizabeth's time, the hair was parted in the middle, and either allowed to float on the shoulders or was bound up under a coif; Elizabeth introduced frizzing and padding. For Marie Stuart it should be turned over side-rolls, so as to fill the vacuum beneath the velvet headdress. During the time of the Stuarts, a crop of curls was worn over the forehead, and long ringlets at the back. As people desire to look their best at fancy balls, it is advisable to adapt the style required as much as possible to the usual method of dressing the front hair, leaving the more marked change for the back.

[...]

The giving of Fancy Balls requires more pre-arrangement than an ordinary entertainment. The men-servants are often put into the costumes of Family Retainers[5] of old days, the women dressed as Waiting-maids of the 18th century; the Band also in fancy attire.

The Decorations should be arranged with some regard to the many vivid colours worn by the company. Chinese lanterns hung in passages and balconies have a good effect.

Occasionally the hostess elects that her guests shall appear in costumes of a particular period, and Poudré balls find many patrons. Under these circumstances the lady guests only wear powder with ordinary evening dress, the gentlemen making no change from their usual attire.

[...]

[2] *chaussé* and *gante*: Fr. shoed and gloved.
[3] Viviandière: Fr. women who provided French soldiers with food and drink.
[4] The Duty on Hair Powder Act 1795 was not repealed until 1869.
[5] Family Retainer: n. servant.

Fancy balls are said to have been brought over to this country by Mrs. Teresa Cornelys, a German lady, at the end of the last century, when they were held at Carlisle House, Soho.[6] Lady Waldegrave, Lady Pembroke, and the Duchess of Hamilton were among the beauties. But then, as now, the fashions of the day asserted their sway in the costumes of old times. Fashionable materials are used, however inappropriate: when **crinoline** was the mode, even the peasants' dresses were slightly distended; during the reign of the **Jersey**, elastic silk serves for the **bodices** of Gipsies, Folly, and many others, and just now **tulle** has almost entirely superseded **tarlatan**. [...]

Any popular play or opera will be pretty sure to originate the most fashionable costumes of each season, or possibly some pretty picture. Miss Greenaway's[7] charming sketches have suggested many of the quaintest dresses at recent fancy balls; and costumes of the early part of this century and the latter part of the last are much worn, possibly owing to the attention now turned to what is known as artistic dress; and dim blues, peacock greens, brick-red browns, find their way even into Oriental costumes. Dresses of the sixteenth century, fflowing skirts, low square bodices, and puffed sleeves richly broidered owe their resuscitation to the same cause.

It behoves those who really desire to look well to study what is individually becoming to themselves, and then to bring to bear some little thought in the carrying out of the dresses they select, if they wish their costumes to be really a success. There are few occasions when a woman has a better opportunity of showing her charms to advantage than at a Fancy Ball.

From *Fancy Dresses Described: Or, What to Wear at Fancy Dress Balls,* 6th ed. (London: Debenham & Freebody, 1896), pp. 36, 39, 82, 120, 134, 140, 180, 189, 207, 236, 249, 250, 287

CANAL, SUEZ.[8] Long flowing classic robe of cloth-of-gold, **brocaded** with waves of blue **satin** bordered with pearls; under-skirt of red satin embroidered in Egyptian designs. A gold key at the **girdle**; Egyptian head-dress of pearls, turquoise, and diamonds; girdle of roses and lilies.

CARRIER PIGEON: Grey satin skirt with **tunic** in the shape of wings composed of white feathers; pigeons in the hair and on shoulder. Band of red ribbon across bodice from right shoulder to under left arm, with letter attached; letters falling from feather fan; head-dress, cap like pigeon's head. Or the gown may be grey cloth, the draperies caught up by pigeons, and the edged embroidered with feathers; the bodice entirely composed of feathers.

ELECTRICITY: Electric blue satin, covered with silver zigzag flashes; silver cords are wound about the neck, arms, and waist, to typify the electric coils. Bodice of blue satin draped with silver and **crêpe de chine**; wings at the back; an electric light in the hair. A staff carried in the hand with coils encircling the globe which surmounts it.

[6] Venetian-born Anna Maria Teresa Cornelys (née Imer, *c.*1723–97) had a more interesting life than Holt's description ('a German lady') would suggest. An opera singer and canny promoter by trade, she is perhaps best known for being a lover of Casanova; she died in debtors' prison.
[7] Catherine (Kate) Greenaway (1846–1901), illustrator best known for her images of children in pinafores and smocks. See fig. 5.8.
[8] Completed in 1869, the Suez Canal connects the Mediterranean Sea to the Red Sea via an artificial waterway in Egypt.

GREY, LADY JANE. Generally represented in grey and white satin, or black velvet and white satin. The **surcoat** opens over a jewelled **stomacher** and kirtle, and is bordered down the sides and bodice with **ermine**. The bodice is pointed at waist, square at neck, has a **chemisette** of satin, quilted with pearls; close honeycomb **ruff** at throat, a velvet coif, like **Marie Stuart**'s, less pointed, bordered with pearls; gauze veil. Long **hanging** velvet sleeves, tight under-ones of satin, with ruffles. Jewelled girdle, often pearl. The skirt or surcoat is full, and touches the ground. The kirtle is embroidered or quilted with pearls.

INFLUENZA. Dress of grey **tulle** with a hot water bottle on one side and a packet of mustard leaves on the other. A pair of scales in the hair attached to a bandeau on which appears the word 'quinine'.[9]

JAPAN (*Spring Time in.*) The robe is made of Japanese silk and bordered with apple blossoms, introduced also on the shot velvet bands which surround the waist, and border the neck. The Japanese **parasol** is edged with flowers, which likewise ornament either side of the head. The coloring should be bright for Japanese costumes, and the dress trimmed according to the season of the year. The loose outer robe crosses in front, and only fastens with a broad soft silk belt; wide **hanging sleeves**, the edge wadded. Two underskirts, plain and bright coloured. (*See MIKADO*[10])

NEW WOMAN, THE. She wears a cloth tailor-made gown, and her bicycle is pourtrayed in front of it, together with the *Sporting Times* and her golf club; she carries her betting books and her latch-key at her side, her gun is slung across her shoulder, and her pretty **Tam o'Shanter** is surmounted by a bicycle lamp. She has **gaiters** to her **patent leather** shoes, and is armed at all points for conquest.

OPHELIA (*Hamlet*). Long plain skirt of white **cashmere**, one end caught up in the girdle, thus forming a lap filled with poppies, corn, cornflowers, catkins, pansies, forget-me-nots, and marguerites; the bodice is full and low, with long pendent sleeves, the whole trimmed with rows of silver braid and fringe; the fair hair hangs over the shoulders entwined with flowers; a wreath on the head, and a lisse veil studded with flowers; white satin shoes. It may also be carried out in silver tissue or white silk; long plain brocaded silk bodice opening heart shape, sleeves tight to wrist, puffed to elbow; hair flowing, wreaths of flowers on the head, and on the side of dress caught up with girdle and puffed around waist. As Ophelia, Miss Terry[11] wore a costume of pale pink cashmere, bordered with ermine, cut in V-shape at the throat the skirt draped. Second dress: White satin bodice, studded with pearls; missal suspended from girdle, with string of pearls.

PRESS, OR NEWSPAPERS. Made entirely in newspaper; the skirt consists of box-plaited illustrations from the papers, reaching to the waist, with names of newspapers pasted across here and there; the bodice made with **bertha** to match, and bows of scarlet velvet; quill pens, an ink bottle and sealing-wax stuck in the hair. In Paris the same idea was carried out with a white satin dress, having bands of velvet, bearing the names of Paris papers; a **bonnet** *de police*.

[9] Quinine, derived from the bark of the cinchona tree, is more commonly used to treat malaria.
[10] Elsewhere in the volume, Holt describes a similar costume called the Mikado, named after the titular character of Gilbert and Sullivan's 1885 comic operetta, set in Japan and inspired by the Japanese Village (see #25).
[11] Dame Ellen Alice Terry (1847–1928) was a celebrated stage actress known for her Shakespearean roles.

SHOE, OLD WOMAN WHO LIVED IN A. Short black skirt, over it a **chintz** sacque à la **Watteau**, cut square at the throat; with elbow-sleeves; powdered hair; high-pointed black hat; a rod in her hand. A large high-heeled scarlet satin shoe, trimmed with gold, slung across the shoulders and filled with small dolls.

STRAWBERRIES AND CREAM. Short skirt of strawberry-colored satin, arranged with deep box-**plaits** of brocaded cream satin at hem, trimmed with cream **lace,** looped up with strawberries and leaves and strawberry-colored and white ribbon. Paniers of cream brocade edged with a fringe of strawberries; the bodice cream brocade with a long pointed waist laced up the front; **epaulettes** of strawberries, wreath of same across the bodice; gilded punnet of strawberries for head-dress. Cream fan painted with strawberries.

SUNFLOWER (*after Alma Tadema's picture*[12]). A long dress of some dark brown **stuff,** with loose sleeves, falling back so as to show the arms; embroidered at the throat, sleeves, waist, and hem with gold; sunflowers in hand; three gold bands confine the hair. Or, the petals of flower form a crown and border at the waist, making a **basque.**

WIFE OF BATH (*Chaucer*). Striped stuff skirt; close fitting blue bodice; beaver hat, with **muslin** kerchief knotted above the brim, and one end tied beneath the chin, the other falling under the hat; **distaff** carried in the hand.

WIND. Short costume of pink satin, with low yellow satin bodice and white stomacher, laced across with the two shades; powdered hair, the four arms of windmill placed at the back of the head; windmills also on left shoulder in enamel; a pink satin ribbon, with bow at neck, windmill depending. The satin skirt has a landscape on one side, on the other Boreas.[13]

[12] Dutch-born painter Sir Lawrence Alma-Tadema (1836–1912) specialized in neo-classicism.
[13] Boreas: Greek god of the north wind.

19

'Children's Dress', *Bradford Daily Telegraph* (19 March 1894), p. 3

Much of the press dedicated to children's dress falls into two categories: articles emphasizing clothing's function to protect children's health, and articles discussing the latest trends in children's fashion. Myra's Journal, *for example, ran a regular feature on children's dress, much as it did for French fashion (see #23), offering rich descriptions and illustrations of the styles then in vogue. The piece reprinted here addresses issues of health, economy and style in children's clothing.*

Fashions in the matter of children's dress have very appreciably improved of late. There may be these who consider that of late fashion has made the skirts of little girls quite too short; but when is remembered that at the age of three or four the exercise taken is almost continuous from bath time till the hour for retiring, it will be conceded that the small restless leg should be free as air. Of course, the very warmest of stockings must be called upon to supply the missing warmth of the absent skirts, and these, on very cold days, are supplemented by long **gaiters** of closely knitted wool. The skirts are abbreviated further by the length of the **bodice** part of the dress, which is now elongated to such extent that it reaches midway between waist and knee. There is immense advantage to the child-wearers hidden under this very fashion. It admits of no undue compression of the waist; and not only that, but it encourages that form of garment which, being made all in one, serves to equalise the temperature throughout the small bodies. Only those mothers who are very far behind the age now permit their children to wear cutaway bodices and short sleeves. Children looked prettier in these, there is little doubt. But what loving mother would not prefer her child's comfort and lasting good to the gratification of her motherly vanity; and would not at once cover the pretty arms and shoulders in warm and cosy garments? To Miss Kate Greenaway[1] our English children owe an enormous debt. To her charming designs may be attributed much of the trim neatness of the present fashion in skirts, as well the large protectiveness of the **bonnets** now worn by little girls. If mothers will only take heed that these large bonnets shall not be unduly heavy, they will prove to the very best form of head-gear that could be devised for the use of children. The introduction of **jersey** has also

[1] See p. 169, note 7 and fig. 5.8.

been of immense benefit to children. On grown-up women this garment very frequently proved quite detestable; even immodest. For children it is 'the very thing'. Clinging closely to the small frame, yet yielding its knitted meshes to every movement, it at once serves retain the heat of the body and favours the most perfect freedom. The jersey is also to be recommended on the score of economy, its initial cost being trifling, and its durability great. Knitting may, indeed, be said to play a very important part in the clothing of our children. Under-garments of the rational Princess or Gabrilelle shape—i.e., made all in one piece—are knitted; the skirt on large wooden needles, and the bodice on steel ones. The best and most enduring socks and gaiters are produced by the same process. Jerseys and hoods are also knitted, besides the numerous forms of cape and jacket devised for babies and larger children. Not long ago it was the custom to make children's dresses with the bodices quite separate from the skirt, with the effect that the latter were continually shifting round in consequence of the children's endless running and jumping. The whole weight of the skirts was also thrown upon the children's hips. The present mode remedies all that, and, in addition, supplies little ones, as well as their parents, materials which admirably combine warmth and lightness. The small garments can scarcely be too simple,

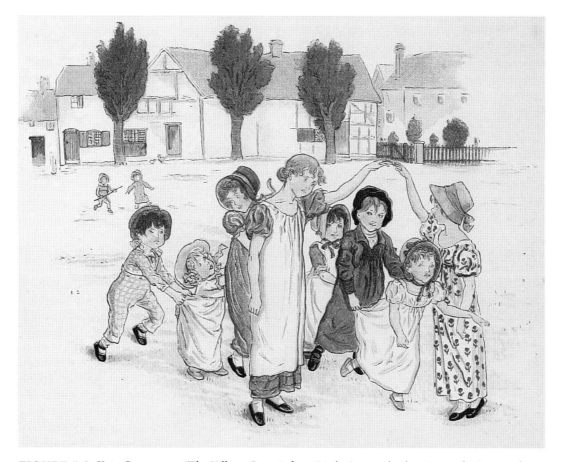

FIGURE 5.8 *Kate Greenaway, 'The Village Green', from* Little Ann and other Poems *by Jane and Ann Taylor (London: Routledge & Sons, 1883), p. 60. Public domain image courtesy British Library, shelfmark HMNTS 1165.h.24.*

too free from trimming. **Serge** in winter, **holland** in summer, give almost choice enough; and some sensible parents confine themselves entirely to the first-named material, which is made in so many graduated stages of thickness and substance as to be suitable to all varied degrees of temperature. It is surprising, too, at how very early an age the little ones become aware of what their nurses call 'finery', and it is a pity that they should be imbued with an exaggerated idea of the value of outside ornament.

SECTION SIX

Production and Industry

Building upon the scientific revolution of the eighteenth century, the industrial innovations of the nineteenth century facilitated the imperial expansion that marked the height of the British Empire under Victoria. Factories propelled by steam engines began automating fabric weaving, altering nearly every aspect of the industry. For some, the shift was a thing of awe; George Dodd's 'Wallotty Trott' (#20) narrates the mechanization of weaving in glowing terms, extolling the virtues of temple-like factories and model villages, and remarking with wonder in 1853, 'What a mighty contrast exists between the manufacturing systems of the last century and the present!' Dodd glosses over the exploitation endemic to such industries, which provoked a series of investigations into work and safety conditions in factories, beginning with the Sadler Commission in 1832 and culminating in the Factory Acts passed through the second half of the nineteenth century.

Weaving moved out of the home into the factory, but other technologies ultimately returned to the domestic space. Consider the development of the sewing machine, a topic on which *Bow Bells*, a women's light-reading magazine, offered a report in 1865 (see #22). Initially developed for factory use, industrial sewing machines were deployed in the mass production of standard-issue clothing, such as uniforms for the armed services, before being adapted for broader commercial use, creating ready-made garments for sale in the department stores that leveraged new economies of scale to stock a wide range of items. The machines were further adapted for home use, and advertisements (see figs. 6.1–6.2) document the novelty and the time- and cost-savings touted by sewing machine manufacturers.

Even the laboratory got involved. We might be surprised today by the number of column inches devoted to the development of synthetic dyes, which often offered readers remarkably detailed scientific information. Dyeing was a mainstay of fashion economy: it represented an easy way to get more use out of expensive clothing, especially for those who could not afford a large wardrobe. Advancements in the safety and cost-effectiveness of dyestuffs could thus have a

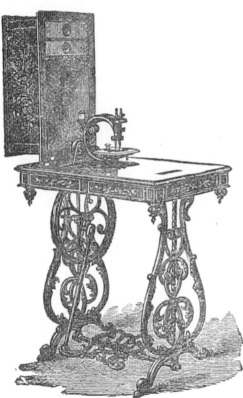

NO HOME COMPLETE
WITHOUT A
WILLCOX AND GIBBS'
NOISELESS FAMILY
SEWING MACHINE.

SILENT, SIMPLE, COMPACT,
ARTISTIC, EFFICIENT, DURABLE,
AND CHEAP.

THE MOST PERFECT FAMILY
Machine in the World

The Gold Medal has been
awarded to this Machine at the
late Fair of the American Insti-
tute, for " Perfection of Work,
and Stillness of Running."
Printed Directions for use ac-
company every Machine.
All Machines Warranted.
Illustrated Price Lists, con-
taining full and detailed par-
ticulars, gratis and post free.
PRICE from £8.
INSPECTION INVITED.

135, REGENT STREET, LONDON.

FIGURE 6.1 *'Wilcox and Gibbs' Noiseless Family Sewing Machine' advertisement preceding Frederick Sheridan's* Cecil Forrester *(London: T. Cautley Newby, 1864). Public domain image courtesy British Library, shelfmark 12629.aaa.16.*

direct impact on the wearer's experience. Aniline dyes that could be produced in vast quantities – as opposed to the often painstaking and often extremely expensive task of deriving dye from natural sources – presented additional savings in cost and time (see #21, fig. 6.3). Progress in the lab also had a direct impact on dress design: designers were beholden to the textile colours they were able to produce and not simply their aesthetic desires, and the shockingly bright gowns that still populate costume museums are testament to the fact that trendy colours could be traced to often-accidental scientific discoveries (see fig. 6.4).

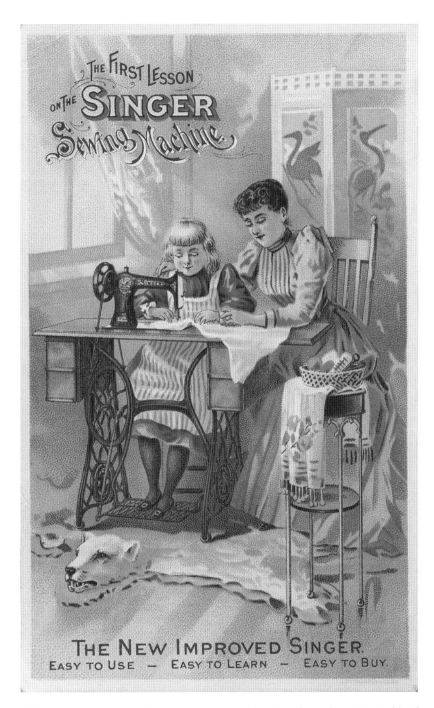

FIGURE 6.2 *'The First Lesson on the Singer Sewing Machine' trade card, c.1892. Public domain image courtesy the Boston Public Library.*

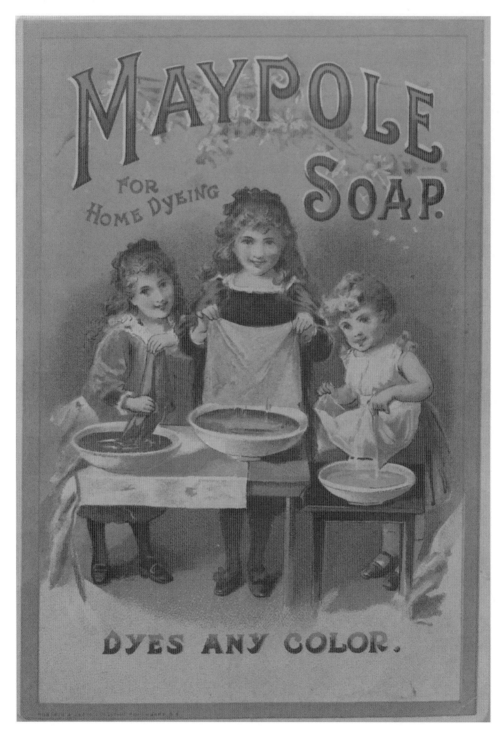

FIGURE 6.3 *Advertisement for Maypole Soap (c. 1890s). Jay T. Last Collection of Fashion Prints and Ephemera, Huntington Library, San Marino, California.*

FIGURE 6.4 *'Le Progres' fashion plate featuring boy in magenta suit and man in mauveine coat (February 1862). Public domain image courtesy Thomas J. Watson Library, Metropolitan Museum of Art, b17520939.*

20

[George Dodd] 'Wallotty Trot', *Household Words* (5 February 1853), pp. 499–503

George Dodd (1808–81), a frequent contributor to Charles Dickens's journal, begins his piece on textile factories with the Irish folktale 'Wallotty Trot', which – as he notes – many will know as the Grimm Brothers' 'Rumpelstiltskin'. He offers a decidedly positive picture of the industrialized weaving industry, serving as a contrast to some of the exploitative and dangerous practices that prompted studies such as the Sadler Commission (1832), which led to legislation on factory reform. Dodd allows that writers cannot ignore the 'social evils [that] have accompanied' the changes wrought by industrialization, but insists that they 'can talk of the great changes themselves, and still do justice to those – whoever and wherever they be – who yearn to pluck out the tares from among the wheat'. Dickens himself wrote approvingly about the textile mills of Lowell, Massachusetts in his American Notes for General Circulation *(1842).*

There was once an old woman who lived with her daughter at the side of a hill in the midst of a forest. They were very poor, their only means of support being the thread which the daughter spun with her **distaff** and **spindle**; and she, poor girl, worked early and late to earn enough for their wants. It so happened that the king's son, while hunting, went astray in the forest, and entered the widow's cottage to inquire his way. He was greatly struck with the girl's beauty, and not less with the numerous hanks of yarn which attested her skill and industry. He inquired how it happened that they had collected such an immense pile; when the old woman—concealing the fact that this was nearly an entire winter's store—declared, that her daughter had spun the whole in a week. 'In a week!' exclaimed the astonished prince; 'if this be true, I have found a wife more worthy and valuable than any other in the country. I will send you a load of **flax**; and if she has it spun by the end of a week, I will make her my bride; but if not, I will have you both cut in pieces for deceiving the son of your sovereign'. The terrified girl saw next day a train of laden mules coming to the cottage; she went out into the forest to weep over her destiny, when she met a decrepit old man. On learning the cause of her weeping, 'Do not weep, daughter', he said; 'I will execute the task imposed on you by the prince, provided that you will either give me your first born son when he is twelve months and a day old, or that you shall, in the meantime, find out my name'. The maiden, wondering greatly, agreed to the terms; the old man conveyed

away the flax from the cottage, she did not know how; and returned it in the form of beautiful yarn just before the week had expired. The prince found all as he had wished, and married her; they were very happy, and when the princess had a son, the joy of the prince knew no bounds. But alas! the year came near its close, and the princess had not yet found out the name of the mysterious old man: she dreaded to lose her little son, and yet dared not tell her husband. The prince, seeing his wife one day disconsolate, told her an anecdote to amuse her. He had been hunting, and lost his way in the forest; he looked around, and saw a cave in which an old man was spinning with a sort of wheel, such as the prince had never before seen; and the old man was singing,

> Little my mistress she knows my name,
> Which shan't be forgot which shan't be forgot,
> When a prince as heir to the fortunes I claim
> Of Wallotty Trot, Wallotty Trot.

The princess instantly guessed that this must be her mysterious friend. When the year and a day expired, the old man appeared and claimed the child. 'Stop', said the lady; 'your name is Wallotty Trot'. It was so; and the old man said that, to reward her ingenuity, he would teach her how to use the wheel, which had enabled him to spin the flax so quickly. Having done so, he disappeared, and was never seen again; but the prince and princess taught this new branch of industry to their subjects, and so enriched their country as to become the admiration of surrounding nations.

Such is an epitome—shorn, we fear, of much of its story-telling attractiveness—of a legend which the late Dr. Cooke Taylor heard from the lips of an old woman in Ireland, and which he believes to be nearly identical with one preserved by the brothers Grimm in Germany.[1] That the old woman believed in her story is very likely: people have believed much worse stories in their time. It is, in truth, one among many examples of a curious tendency in the popular mind— to attribute to fairies or good people, or mysterious people of some kind or other, all useful inventions, the date or the introduction of which is not well known.

The spinning-wheel marked one stage in the great history of clothing—one of the greatest of our social histories. Weaving was, in all probability, an earlier art than spinning; because reeds and rushes and straws, ligaments and fibres and rootlets, can all be woven in their natural state. But spinning was, nevertheless, one of the earliest arts; the distaff and spindle were known to most of the chief nations of antiquity; they are known by everyday use to the Hindoos at the present day; and they were the recognized means of spinning until comparatively modern times. The 'spinsters' or spinners with the distaff and spindle, included the high-born and wealthy ladies of our feudal days. Who was the real Wallotty Trot that invented the spinning-wheel, will, in all probability, remain an unfathomable mystery; but, be he who he may, he was the Arkwright[2] of those days; he levelled one of the roads which led to the gigantic manufacturing system of the present times. Unless the yarn had been spun more rapidly than the distaff and spindle could accomplish it, rapid weaving would have been useless, and improvements in looms unsought for; the spinning-machine would not have appeared, for want of its progenitor

[1] William Cooke Taylor (1800–49) includes a version of 'Wallotty Trot' in his *Handbook of Silk, Cotton, and Woollen Manufactures* (London: Richard Bentley, 1843), pp. 40–2.
[2] Sir Richard Arkwright (1732–92), British industrialist whose inventions revolutionized the spinning of yarn, facilitating its mass production.

the wheel; the steam-giant would not have been called in aid; and the neat cotton dresses and **merino** gowns, the **net** collars and silk kerchiefs, the white stockings and tidy shirts, would not (as now) have been attainable by the families of working men. If social evils have accompanied these changes (and such is doubtless the case), let us not ignore them; we can talk of the great changes themselves, and still do justice to those—whoever and wherever they be—who yearn to pluck out the tares from among the wheat.

What a mighty contrast exists between the manufacturing systems of the last century and the present! If, for example, we take the production of woollens and **worsted**, we find that Norfolk carried on this branch of industry long before the West Riding of Yorkshire; that **serge**, and **camlets**, and other coarse goods were the chief products; and that much of this work migrated to Yorkshire about sixty or seventy years ago, on account of the water power and the cheap coal which that county possesses. But, whether in Norfolk or Yorkshire, in Kendal or in the West of England, the cloth manufacture, before the introduction of machinery, presented an aspect which to us now would seem most strange. No factories: scarcely even workshops. The cloth-maker, the monied man who had to bear the commercial responsibility of supplying the markets, picked up or gathered up his wares in an extraordinary way. In the first place he had to travel about on horseback, to buy the wool, on which the labour of the handicraftsman had afterwards to be bestowed; he visited the sheep-farmers, and also those privileged towns which had the 'staple', or market for wool, and purchased his material in bits and scraps. He next availed himself of the aid of sorters who slowly separated the wool into parcels, cutting up with a hatchet or with scissors those fibres which were too long. When the sorters had finished, the combers took away the wool to their own homes, combed it into 'laps', and brought it back again to the manufacturer. The wool was then carefully packed, strapped to the backs of mules, and carried out to the country districts, in the cottages of which it had to be spun; and not only was this done in the neighbourhood of the large towns, but to very great distances from those towns. In order to save his horse's legs and his own time, he conveyed the wool to one agent in each village, and let him to distribute it among the villagers. The wife and daughters of the cottager, with the old one-thread wheel, spun the wool into yarn, which the agent called for, and sent back to the manufacturer. Another running about ensued: the yarn had to be sent to the weavers. These weavers lived here, and there, and everywhere; they had to be sought out, and the yarn placed in their keeping. When returned in the shape of cloth, the material had yet to be scored and **fulled**, dyed and shorn, and had to go out on its travels again before this could be accomplished.

Nor were the cotton districts less marked by the rambling nature of the manufacturing arrangements; although, from the comparative recency of the cotton trade in England, the circumstances were not quite parallel. The cotton yarn was mostly spun in the houses of the peasants near and around Manchester and Bolton, and other Lancashire towns; the wives and daughters spun it in the intervals of farm labour; and travelling chapmen went with their pack-horses from door to door, to purchase the yarn. The supply was very uncertain, and the weavers were thus frequently brought to a stand-still for want of material; the prices paid for yarn were often high—so high, indeed, as to encourage much of that children's labour which has since become a feature in manufacturing districts. Very frequently the father was a weaver, and the mother a spinner, both working on different sides of the same humble room. Sometimes the manufacturer gave out **warp** yarn, with raw cotton for **weft** yarn, to a cottager, and left him, with his family, to perform all the operations necessary for converting the material into cotton cloth. Travelling pedlars took advantage of this system to tempt the housewives into dishonesty; they offered trinkets for purloined bits of cotton, which it was hoped would not be missed by the manufacturer.

The system pursued among the manufacturers themselves contrasted no less strangely with that which is so familiar to us. The roads of Lancashire were so bad, that cotton could be conveyed from town to town only by pack-horses. Dr. Aikin,[3] who lived at Manchester when the manufacturing system was about developing its gigantic proportions, says that previous to 1690 there were no capitalists among the Lancashire cotton manufacturers: every man worked hard for a livelihood, whether he employed others or not. During the next period of thirty or forty years the manufacturer worked hard and lived plainly, but he accumulated a little capital; he sold his goods to wholesale dealers who came to him. 'An eminent manufacturer of that age used to be in his warehouse before six in the morning, accompanied by his children and apprentices. At seven they all came in to breakfast, which consisted of one large dish of water-pottage, made of oatmeal, water, and a little salt, boiled thick, and poured into a dish; at the side was a pan or basin of milk, and the master and apprentices, each with a wooden spoon in his hand, without loss of time dipped into the same dish, and thence into the milk-pan; and as soon as it was finished they all returned to their work'.[4] About the middle of the last century and down to the time of Arkwright's epoch, the manufacturer gradually established a larger system of dealings. Instead of sending chapmen with laden pack-horses to the small dealers in the small towns, the chapmen merely carried patterns and received orders; and in proportion as the roads became improved, waggons were employed instead of pack-horses. At length came the inventions of Watt and Arkwright, Crompton and Hargreaves;[5] and Lancashire underwent a social revolution such as the world has rarely witnessed.

Let a second Wallotty Trot enable us to jump over a period of sixty or eighty years, and set ourselves down in the middle of the nineteenth century.

Scene the First: a Lancashire cotton mill. Take it where we will: it matters little—Manchester, Bolton, Oldham, Ashton—any will do. It is a brick building of vast length and height, with as many windows as there are days in a year, or perhaps more. Dull are the bricks, unadorned are the windows, and monotonous the whole appearance of the structure: be factory labour good or bad, the factory itself is not a 'thing of beauty' in its externals. But it is a grand machine in its organism—the mind, the fingers, and the iron and steel, all work together for one common end. A bale of cotton goes in at one door, and the cotton comes out at another, in the form of woven **calico** or **fustian**; and a thousand human beings may be marshalled in the path from the one door to the other. The building consists of six or eight stories, and each story of vast rooms or galleries, with many-windowed walls. There is machinery to lift the workers to the upper floors; machinery to raise and lower the cotton; machinery to work the mules[6] and the looms. There is gas for winter-light, warm air for cold days, and ventilating currents of cool air for warm days. The cotton is conveyed in its bag, perhaps to one of the upper floors, and it travels downwards from floor to floor, as the order of processes advances; a 'devil' tears the locks of wool asunder; a 'scuthcher' blows away all the dirt; a 'carding-machine' lays all the fibres parallel; a 'drawing machine' groups them into slender ribbons; a 'roving machine' slightly twists them into a soft spongy cord; a 'mule' or a 'throstle' spins the roving into yarn; and men and women, boys and girls, tend on the machines while all this is being done. There is no running about from cottage

[3] Leicestershire-born John Aiken, MD (1747–1822), published *A Description of the Country from Thirty to Forty Miles round Manchester*, an influential study of early industrialization in the region, in 1795.

[4] Dodd accurately quotes Aiken, *A Description of the Country from Thirty to Forty Miles round Manchester* (Cambridge: Cambridge UP, 2015 [1795]), p. 183.

[5] All contributors to industrial innovation in textile production: Arkwright used James Watt's (1736–1819) steam engine in his factories; Samuel Crompton (1753–1827) invented the spinning mule, which combined the benefits of Arkwright's frame and James Hargreaves' (c.1721–1845) spinning jenny.

[6] Mule: machine used to spin yarns, invented by Crompton in 1779.

to cottage, to get the carding done at one place, the spinning at another, the weaving at a third; all is done as part of one great process; and not only so, but most of the machines cannot do for themselves. It was a mistake to suppose, as some do, that factory labour reduces the factory workers to mere machines: their duties require much quickness, delicacy, and discrimination. And when the yarn has been spun, and has been conveyed down to the weaving-shed, we here find a thousand wonderful machines weaving calico by miles; the machines doing the hard work, and women and girls attending to adjust and supply them. And when the calico reaches the warehouse, we find hydraulic presses and steam presses to pack it into compact masses; while, in the counting-house, the manufacturer and his clerks are carrying on correspondence with every part of the globe, watching the pulsation of the market, and making sales and purchases with (often) a very slender margin of profit.

Scene the Second: a Leeds Flax Mill. If, in respect to the Lancashire cotton factories, one general type might serve for all, without special reference to one particular establishment, such is not the case in respect to flax-mills; for there is one at Leeds so striking, so original in its aspect, so advanced in its organization, as to stand out in broad distinction from all others. This is the celebrated establishment of Messrs. Marshall (see fig. 6.5).[7] What are objects to be attained in a great building devoted to manufactures? To exercise a ready supervision over the whole of the arrangements and operations; to provide facilities of access to all the machinery; to obtain a uniformity of temperature and moisture (very important for some purposes); to avoid draughts of air; to establish good ventilation; all these, added to the ordinary mechanical requirements of the work to be done. Now, it occurred to Messrs. Marshall that one monster room might effect all this; and they constructed a monster room accordingly. They procured designs and drawing from M. Bonomi,[8] derived from the temple architecture of Egypt, and sought how to throw boldness and massiveness into a one-story building. An entrance like an Egyptian temple, a façade of stone, surmounted with a bold cornice; a chimney having the form and proportions of the far-famed Cleopatra's needle—these meet the eye on the exterior. In the interior we find a room nearly four hundred feet in length, by more than half of this in breadth—five times as large in area as Westminster Hall. The roof of this vast hall is supported by half a hundred pillars, and is lighted by ten thousand square feet of conical skylights, occupying the summits of small domes or ground arches. On the floor of this room are ranged rows of machines in almost countless number, by which the flax can be wrought into **linen** yarn, and a thousand or more of busy workers are tending these machines, with ample space to move about. The two-acre roof is formed of concrete so firm and durable that vegetable mould can be spread upon it, grass grown in the mould, and thus a field made on top of a factory. The graining of the field (the rain water of the roof) is carried down the fifty hollow pillars to the ground underneath, as was done at the Crystal Palace. Beneath the vast room are large machines and furnaces for ventilating and warming it, and also some of the apparatus for setting in motion the hundreds of flax machines. Here, therefore, not only are the operations of hundreds of cottages and cottagers concentrated in one building, but the building itself may be said to be concentrated in one room, where all that mechanical skill can effect is effected, to make every hour's work do the best that it can. Flax cannot be wrought and spun without much dust and a little wet; but the workers can pursue their labours with much less of personal discomfort than under any variety of the older system.

[7] Industrialist John Marshall (1765–1845) finished the Egyptian-inspired Temple Works Mill in 1840; when built, it featured the largest single room in the world, and sheep were reported to graze on its grass-covered roof.

[8] Joseph Bonomi (1796–1878) was the son of an architect – Guiseppe Bonomi (1739–1808) – but trained as a sculptor and had an enduring interest in Egyptology; the Leeds Temple Works was one of his only architectural achievements.

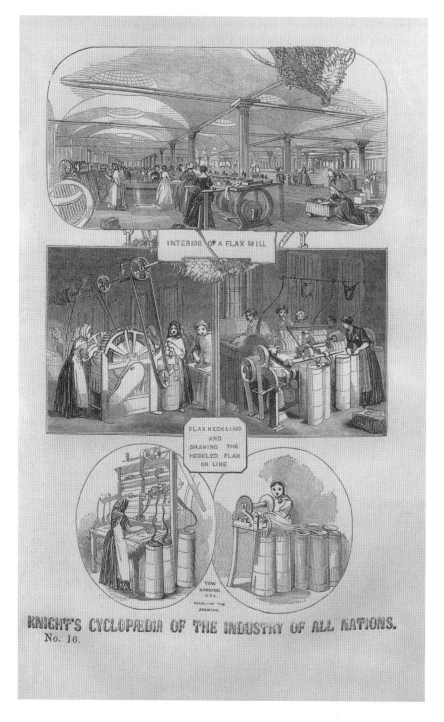

FIGURE 6.5 *'Flax Manufacture' from Charles Knight's* Cyclopaedia of the Industry of All Nations *(London: Charles Knight, 1851), plate 16. Image courtesy of Cadbury Research Library: Special Collections, University of Birmingham.*

Scene the Third—a Bradford alpaca-mill. **Alpaca**, by the care now bestowed upon its production, is made to produce fabrics of much beauty for ladies' dresses, not only in its uncombined state, but also when combined with silk and cotton. **Mohair**, too, (the hair of the Angora goat) has come greatly into favour. Bradford contains many immense factories—on the Lancashire plan—for working up wool, and alpaca, and mohair into cloth or **stuff**; and more are being built: but if the world will continue to demand more stuff, more alpaca, more mohair, there must be an increased expansibility in the manufacturing arrangements for their supply. And thus do we find a clue to the origin of *Saltaire*.[9] Mr. Titus Salt, one of the magnates of industry at Bradford, has several establishments in the town, which have grown with the growth of manufacturers; but the time has come when organisation and centralisation are wanted; and these are about to be obtained by a scheme of (perhaps) unparalleled boldness.

On the line of the Leeds and Skipton Railway there is a point at which a small river-valley branches out southward to the town of Bradford, about three miles distant. And at the point of junction stands the town of Shipley, one of the stuff-working satellites of Bradford. Not far from Shipley is an estate which Mr. Salt has recently purchased, crossed by a road, a river, a canal, and a railway; and on this estate is now being constructed a factory which will, in many respects, be the finest in the world, and will be the nucleus of a town towards which great attention will be attracted. A great power for good and for evil will rest in the hands of the owner of this gigantic establishment; and one feels inclined to encourage a hope that the second half of the nineteenth century may show itself to be something more than a mere steam-engine era.

If, leaving the Shipley railway station, we ramble along the Bingley road, we come shortly to what was once a wide expanse of green fields, but is now the theatre of immense building operations. It seems more like a Legislative Palace, or a Record Office, or some great public work, than a mere factory belonging to one individual, which is here under construction, so solid do appear the masses of stone employed, and so vast the scale on which the operations are planned. The entire buildings will cover or enclose an area of six acres. The chief structure, technically called the 'mill', will be a stone building five hundred and fifty feet in length, six stories in height, and having its crowning cornice and its many hundreds of windows so finished with dressed stone, as to give an architectural grandeur to the whole. And then, instead of frittering away the window surface into numerous small panes of glass, large sheets of cast plate-glass will be employed. All that hollow-bricked floors can effect in giving lightness and facilitating ventilation; all that massive cast iron beams and ornamental cast-iron columns can do to ensure strength; all that can be done in rendering the structure fire-proof by avoiding the use of wood, are duly considered and provided for. Running northward from this fine structure are two subordinate portions, or wings, each about three hundred and thirty feet in length, and as lofty as the main structure; they are to be warehouses. Beyond the western warehouse are large but low buildings for the preparatory manufacturing processes, while the other extremity is to be devoted to weaving and finishing; the main structure itself being the scene of the intermediate or spinning processes. The raw materials will thus enter one warehouse, traverse the huge range in a circuit, and then reach the other warehouse.

The arteries of communication are quite extraordinary for their completeness. There is, in the first place, a handsome new road being formed along the western face of the pile, crossing

[9] Sir Titus Salt (1803–76) produced extremely popular **worsted** wool in his mills. Saltaire was, as Dodd details, the model village built in the early 1850s to house mill workers; a resounding success, the mill only closed in 1987 and the town is today a World Heritage site.

the Leeds and Skipton railway by a cast-iron bridge, and then crossing both the river Aire and the Leeds and Liverpool canal by a wrought-iron tubular girder bridge on the celebrated 'Britannia Bridge'[10] principle, and about four hundred and fifty feet in length. In the next place, the warehouses abut northward on the canal, and will have steam-worked 'hoists' for loading and unloading barges in the canal. In the third place, a branch will be carried from the railway into the building, where hoists will load and unload the railway waggons with great rapidity. And hoists will load and unload ordinary waggons, and will raise and lower materials from one story to another, and will very likely raise and lower the operatives themselves (or some of them) to save leg-power.

Then the power for working this stupendous concern: how vast it must be! The steam-engines, of power adequate to the whole demands of the mill, will occupy two handsome engine-houses on either side of the principal entrance; and will send off their smoke into an Italian-looking compile sort of building, two hundred and fifty feet high. Twelve hundred tons of solid stone are said to have been employed to form the supporting beds for the engines. The boilers beneath the level of the ground, will be fed with water from the Aire by one tunnel, and send forth the used water by another tunnel. Beneath the weaving shed will be an immense filter and reservoir, capable of storing half a million gallons of rain water from the various roofs— rain water being useful in scouring wool. Between the canal and the river are to be gas-works, capable of supplying five thousand jets with their light-giving food. But as to the working-machines, the complex apparatus which will cover ten or twelve acres of flooring in the different stories, no mere paragraph, or no dozen paragraphs, could describe it; all that invention has yet accomplished in the manufacture of stuffs, alpacas, mohair and such like, will doubtless be brought into requisition.

The living machinery has yet to be noticed; and here is the matter that will tax the head and the heart of the founder of this great establishment. The buildings, machines, and appliances will be fitted for a staff of no less than four thousand five hundred workpeople; and as there must be at least an equal number of non-workers to give domestic homes to the workers, the full powers of the mill would require a neighbouring population of nine or ten thousand persons. Now, the factory is still being built out in the fields, beyond the limits of Shipley; and Mr. Salt has therefore to create a town as well as the factory which is to give bread to the townspeople. His plans comprise the building of seven hundred houses, of various sizes and ranks, but all provided with light, ventilation, and drainage, on the most approved modern arrangements; wide streets, gardens, spacious squares, and play-fields and grounds; a church, schools, a covered market, baths and washhouses, a public kitchen such as scientific cooks now know well how to plan, a refectory or large dining hall, and other useful buildings.

And such will be SALTAIRE—a name which, unless anything should occur to frustrate the works now rapidly advancing, will soon occupy a place among the notabilities of Yorkshire. Some of the London newspapers have set down the probable cost now being incurred by Mr. Salt, at half a million sterling; but it has since been stated, apparently on good authority, that the outlay will be much less than this. Be it a hundred thousand more or less, however, here we see before us a prospective community, the daily bread and the social comfort, and the moral advancement of which will very intimately depend on the fortunes of one single establishment. When trade is good, and stuffs are 'looking up' in the Bradford market, and all hands are

[10] The wrought-iron 'Britannia Bridge' connects Anglesey and Wales across the Menai Strait; opened in 1850, it was expressly designed to accommodate rail traffic.

employed, and credit is sound—then may Saltaire possibly be one of the best of our industrial communities, for it appears as if it would have many physical and moral advantages to begin with; but when adversities come (and they do occur to stuff-makers as well as to other makers), then will be the test, to show whether the Saltairians (we will coin a word for the purpose) can bravely stand the buffetings of fortune. How much, how very much of this will depend on the combined wisdom and kindliness of the Captain of Industry, who leads the whole, need hardly be insisted on.

21

'How we get Mauve and Tyrian Purple', *Chambers's Journal* 359 (November 1860), pp. 318–20

As this unsigned article notes, the development of synthetic, aniline dyes sparked a revolution, in large part because the previous, natural means of deriving purple dye was prohibitively expensive. The label 'Tyrian' refers to the purple's historical origins, when the Mediterranean city of Tyre (now in Lebanon) provided the murex shellfish from which the purple dye was laboriously extracted. Chambers's Journal, *launched in 1832 in Edinburgh, offered – as its subtitle suggests – articles on 'Popular Literature, Science, and Art' for a broad readership. See also fig. 6.3.*

Of all knowledge, scientific knowledge, doubtless, holds the foremost place; and each science is so intimately connected with chemistry, that I think it may be fairly stated, that chemical science is the most important and most practical of all. A popular chemist has indeed asserted, that the civilisation and intellectual progress of a country might almost be measured by the quantity of sulphuric acid consumed in that country.[1]

One of the finest and most extensive fields of chemical research and application, is met with in the art of dyeing—an art which has been practised from the most remote periods of antiquity. It is, in fact, impossible to fix either the date of its origin or the place of its birth; all we know on this head is, that dyeing was practiced with some skill by the ancient peoples of India, Persia, Syria, and Egypt. We have no clue to the processes they employed, for the Greeks and the Romans, who learned and practiced them likewise, have neglected to describe them. Among the moderns, we find this beautiful art flourishing first in Italy, as a consequence of the commercial relations established between the Venetians, the Genoese, and the eastern nation. The almost sudden development of the physical sciences at the later part of the eighteenth century, exercised an immense influence upon the dyeing art, which, up to that time, had consisted of a collection of mysterious receipts and empirical practices, but which is now submitted to rational and scientific principles.

[1] German chemist Justus Freiherr von Liebig (1803–73) wrote that 'it is no exaggeration to say, we may judge, with great accuracy, of the commercial prosperity of a country from the amount of sulphuric acid it consumes' in *Familiar Letters on Chemistry* (London: Taylor, Walton, and Maberly, 1851), p. 146.

Discoveries of new colouring matters, and their application to dyeing, are being made every day. Some are, indeed, destined only to an ephemeral existence; others, on the contrary, will survive for ages, and be mentioned by future historians as marks of immense industrial progress. To the latter category belong the aniline dye, extracted from coal, and the murexide dye, extracted from guano. The idea of extracting colouring matter from coal might appear preposterous even to the professional scientific man himself, were not other transformations, equally marvellous, of almost everyday occurrence in that most wonderful of all workshops, the chemical laboratory. Let us take a rapid glance at the operations to which coal tar must be submitted in order to obtain from it *aniline*, the substance which, in certain circumstances, gives birth to those brilliant violet and red colours (**mauve, fuchsine,** &c.), which are now making such a revolution in the tinctorial[2] world.

When coal is submitted to dry distillation in large closed retorts,[3] many products are immediately obtained. First, and among the most important, the carburetted hydrogen gas which lights our streets, and which is distributed into the towns from the gasometers by iron pipes. Second, coke, which remains behind in the retort, and is used for a variety of purposes; and which burned hard, serves for the construction of the electrical apparatus called Bunsen's Battery.[4] Third, water containing a certain amount of ammoniacal salts, which is consequently employed in agriculture, and to produce sulphate of ammonia, a most valuable salt. Fourth, the substance called *gas-tar*, which distils off out of the retorts. This is a semi-liquid product, of a very complex nature. It was so little known a few years since, that, in France, it was actually burned under the retorts to economise the other combustibles! Now, this gas-tar furnishes colouring matters of great value. To quote two French authors, who have written on this subject since the lucky discovery of Mr Perkin,[5] of which I shall speak presently: 'Coal has not yet been transformed into diamonds, but we can extract from it a violet colour equal in value to gold itself!'[6]

Aniline, one of the most remarkable of organic compounds, is found in gas-tar. It is a colourless oily substance, which is obtained likewise by the action of potash upon indigo, and by various other methods practised only in the laboratory. It comports itself with chemical reagents as an alkaloid, such as quinine and strychnine, and resembles much by its chemical nature the substance called nicotine, a poisonous alkaloid extracted from tobacco. This interesting product was formerly studied by Professor Runge,[7] Dr Hoffman,[8] Gerhardt,[9] and many other chemists. It has been quite recently found in the vegetable world by Dr Phipson,[10] who has discovered it in some fungi (*boletus*), which become blue when they are cut open with a knife.

It would be too tiresome an operation to extract anailine directly from gas-tar, which only contains small quantities of it, and where it is mixed with a great variety of substances, such as

[2] Tinctorial: related to dyeing.
[3] Retort: vessel for distillation.
[4] The first zinc-carbon battery, invented in 1843 by Robert Bunsen (1811–99).
[5] British chemist Sir William Henry Perkin (1838–1907) was best known for the discovery of **mauveine.**
[6] Original French source unlocated; a later account attributes the comment to Perkin; see Jules Garcon, 'Appareils et machines a tiendre: les sources de documents'. In *Mémoirs et Compte Rendu des travaux de la Société des Ingénieurs Civils* (Paris: Siège de la société, 1893), p. 628n.
[7] Friedlieb Ferdinand Runge (1795–1867), German chemist, identified aniline blue, the first coal-tar dye.
[8] August Wilhelm von Hofmann (1818–92), a German chemist who made major advances in the study of coal tar and analines, was also Perkin's teacher.
[9] French chemist Charles Gerhardt (1816–56).
[10] Thomas Lamb Phipson (1833–1908) published a range of works on the natural sciences, including *Bioluminescence* (London: L. Reeve & Co., 1862) and *Researches on the Past and Present History of the Earth's Atmosphere* (London: Charles Griffin, 1901) as well as music, including *Famous Violinists and Fine Violins* (London: Chatto & Windus, 1898) and *Bellini and the Opera of 'La Sonnambula'* (London: Wertheimer, 1880).

ammonia, benzin, tolnin, phenic acid, leucolin, napthalin, and some others less known. The tar is therefore submitted to distillation, and the result is a carbonaceous matter which remains in the retorts, and some volatile oils, known as coal-oils, which pass over into the recipient. These oils are of a very complex nature, and contain compounds which distil at different temperatures, so that, by a kind of fractional distillation, two varieties of them are obtained—namely, the 'heavy oils' and the 'light oils'. The former are principally employed for preserving railway sleepers and similar wooden constructions, on account of their powerfully antiseptic qualities. They have also been found in the French hospitals to act beneficially in the treatment of ulcerated wounds; for this purpose, these black matters are mixed with gypsum, or chalk. The light oils, known commonly as coal-tar naphtha,[11] consist of a mixture of benzin, tolnin, phenic acid, &c. They are distilled to obtain benzin, a liquid extensively used to dissolve gutta-percha,[12] to manufacture varnish, for dissolving greasy matters, and so cleansing tissues, clothes, and gloves; besides which it is sometimes employed as a combustible for lamps.

Now, when nitric acid is added carefully to benzin, and the mixture distilled with proper precautions, a reddish liquid passes over. This is called nitro-benzin, and when purified, appears as a yellowish liquid with a delightfully fragrant odour, like that of the essence of bitter almonds, for which it is most economically substituted in perfumery, in the manufacture of scented soaps, and in confectionary. When nitro-benzin is acted upon by nascent hydrogen —which is effected when it is mixed with zinc filings and weak sulfuric acid—it is transformed into aniline, the colourless oily substance I described above; and when this aniline is oxidised by chromate of potash, or any similar oxidizing agent, it is transformed into one of the beautiful dyes which form the subject of this paper. A French chemist has stated that the relative value of this dye (mauve), and that of the coal whence it derives its origin, 'may be readily appreciated when we assert that whilst the coal employed to obtain it would hardly sell at one farthing per pound, a similar weight of aniline dye is said to be worth sixty to eighty pounds sterling!'

We are indebted to an English chemist, Mr Perkin, for the discovery of the manipulations by which aniline is transformed into this precious dye. For this purpose, it is not necessary to take aniline in its pure state, and then oxidate it. Mr Perkin took impure sulphate of aniline, such as found in commerce, and mixed it with a certain quantity of bichromate of potash. The mixture was allowed to repose for some ten or twelve hours, when a blackish-looking powder was deposited. This was collected upon a filter, and washed with water. The powder thus obtained was dried at boiling-water heat, and then digested with coal-tar naphtha, this liquid having the property of dissolving out of the powder a peculiar brown resinous substance which constantly accompanies it. The coal-tar naphtha 'dissolves out' the brown substance without attacking the colouring matter. The latter is then dissolved in wood-spirit, which solution, when evaporated in a water bath, yields the new colouring matter in its pure state.

To dye **stuffs** of a purple of lilac colour (mauve), a strong dissolution of the colouring matter— and, in preference, an alcoholic solution—is added to a weak boiling solution of tartaric or oxalic acid, and the silk or cotton stuffs are plunged into this bath when cold. To dye woollen, it is more advantageous to boil it in the above-named liquid, with a little sulphate of iron, to wash it out, first with water, afterwards with soap.

[11] Naphtha: liquid petroleum.
[12] gutta-percha: natural latex from the sap of the gutta-percha tree (*Palaquium gutta*), native to Indonesia and Southeast Asia.

The great merit of the aniline or mauve dye resposes in the beauty and permanency of the tints it imparts. Moreover, its power of coloration is so great, that very slight quantities suffice to dye a considerable amount of material—in other terms, to give colour to a large number of vats.

Let us now turn to murexide, or the guano dye (majenta), which appears to be the identical colour known in history as the famous Tyrian purple. The ancients prepared it from certain species of shell-fish (mollusca), but their process had not come down to us. Murexide, which has recently been again introduced as a dye, stands a fair chance of never more disappearing. The substance called murexide was formerly discovered by an English chemist, Dr Prout,[13] and described by him under the name of *purpurate of ammonia*. It was called 'murexide' by Liebig and Woehler[14] in their magnificent memoirs on the products derived from the decomposition of uric acid. But, strange to say, the progress of science has turned in favour of Dr Prout's views, and we are told by modern chemists that purpurate of ammonia is its proper name.

To obtain murexide, or purpurate of ammonia, we must first procure uric acid. Now, the substances from which this acid is extracted in the laboratories are the excrements of serpents or birds, especially guano, which is known to be rich in urate of ammonia. It is from guano alone that nearly all the uric acid furnished by commerce is obtained. To this end, the guano is first digested with diluted hydrochloric acid; the insoluble matters are allowed to deposit, and the clear liquid decanted off. The acid dissolves carbonate and oxalate of ammonia, phosphates of lime and magnesia, &c., forming a liquid which is valuable as a manure, or which may serve for preparing ammoniacal salts, phosphates, or oxalates. As this liquid is so valuable, the same quantity of acid is applied to several lots of guano, until the acid is nearly saturated, and will 'dissolve out' no more salts. The insoluble residue, which contains all the uric acid, is washed with fresh quantities of warm hydrochloric acid and water, after which it is dried. This residue, then, contains uric acid mixed with a certain proportion of sand or clay. It may, however, be immediately employed to produce murexide.

When uric acid is acted upon by nitric acid, it gives birth to a host of very interesting compounds, which have been investigated by Prout, Liebig, and Woehler: and when uric acid is dissolved in nitric acid, and ammonia is added to the dissolution, a peculiarly striking purple body is deposited: this is the purpurate of ammonia (murexide) of Prout. It would be impossible here to describe all the numerous compounds derived from the little white crystals of uric acid when they are submitted to the oxidising influence of nitric acid; the most important of them, however, is murexide. In practice, the latter is obtained by dissolving out of the uric acid of the guano residue with nitric acid, and adding a certain amount of ammonia to the liquid, in small quantities at a time, to avoid any sudden rise in temperature. The whole is then slightly warmed, and, on cooling, deposits murexide in the crystalline state. It is, in this condition, a most remarkable substance, and when once seen, is never forgotten. It may be described as consisting of small quadrangular crystalline plates, which reflect light of a green metallic lustre, like the wing-cases of a golden beetle. Two of the prismatic sides of a single crystal of murexide reflect this green metallic light, whilst the other two reflect only a dull brown light. When seen by transmitted light—in other terms, when looked through—these little crystals appear like so many garnets of the finest claret tint; when pulverised, they furnish a red powder, which, under the burnisher, becomes a brilliant metallic green. Murexide is very slightly soluble in water, but give to that liquid the most beautiful and most intense purple colour; so that, by its optical

[13] William Prout (1785–1850), British chemist and physician.
[14] Justus von Liebig (1803–73) and Friedrich Wöhler (1800–82) published *Untersuchungen über die Natur der Harnsäure* (*Investigations on the Nature of Uric Acid*) in 1838. *Annalen der Pharmacie* 26 (1838), pp. 241–336.

properties alone, murexide may be looked upon as one of the most wonderful substances ever discovered.

In the dyer's hands, murexide has furnished brilliant **carmines**, purple, orange, and yellow tints, according to the mordant, or metallic salt, employed in conjunction with it. The best results have hitherto been obtained with salts of zinc for orange or yellow dyes.

For instance, to dye silk of a purple hue, a solution of murexide and corrosive sublimate is mixed, the silk-stuffs are plunged into it, and stirred constantly. They slowly absorb the colour, and are dyed of a lighter or darker tint, according to the strength of the bath, and the time they have remained immersed. With woollen, some difficulties have been experienced, on account of the reducing action the latter possesses with regard to murexide; to dye it purple, corrosive sublimate and oxalic acid are employed with the murexide, or sulphate of mercury and tartrate of potash and mercury. But with these mordants it is necessary to use some oxidising agent, such as chlorine-water or bleaching-powder. After the woollen has passed through these salts, it is dyed in a solution of murexide either pure, or to which some oxalate of soda has been added. Another method of dyeing with murexide, consists in plunging the tissues into a colourless dissolution of uric acid in nitric acid. They acquire a purple colour, when they are afterwards exposed to heat, and the colour is fixed by passing the stuffs through a bath of mercury or of zinc.

Murexide, it appears, is also capable of forming lakes,[15] which are nearly insoluble in water, and which possess very vivid tints.

Such, then, is a slight history of two of the most remarkable substances ever introduced into the chemical world, whether we consider them as purely scientific curiosities, or as useful and important elements of industry. The latter was termed 'murexide' by Liebig, from the name of the shell-fish murex, this mollusca being one of those supposed to have been employed in the production of the ancient Tyrian purple.

[15] Lakes: a pigment formed, as indicated here, by combining coal tars with metallic oxides.

22

'Progress of the Sewing-Machine', *Bow Bells* (19 April 1865), p. 283

Written for an audience of middle-class women, Bow Bells *featured regular pieces on the artistic as well as the practical sides of clothing construction. Here, they document the increasing of use of sewing machines, the earliest versions of which were intended for commercial use, but which were soon adapted for home sewers. The author notes the benefits to home seamstresses as well as the dangers of increasing industrialization with little regard for safety. See also figs. 6.1–6.2.*

This ingenious piece of mechanism is, month after month, coming into more extensive use, and will before long drive the chief part of the hand-work with the needle out of use. Nor should we regret this, for labour of this sort has become a miserable source of existence, as women starve when engaged in this kind of industry. It is also to be noted that steam is now becoming extensively used in connexion with the sewing machine: and instead of poor women working in garrets and miserable apartments, they are in some instances gathered into roomy and well-ventilated places. In other instances of steam-sewing factories this is unfortunately not yet the case; and there is great need of inspection, in order to prevent such extensive factories from becoming as bad in their condition as are some of the City and west end dressmaking and **millinery** establishments. Even at the present day we hear of complaints of the way in which some are managing these machines. Persons who have driven, or 'sweated', as it is called, the poor needle-woman and tailors into much distress, are using the sewing-machine to produce similar effects; for capitalists lend machines to *middle-men*, who reap a separate profit; and those again dispose of their works so that the workers having to support these drones do not get what is actually their due. It is hoped, however, that this evil may in time be remedied; and that, as in the factories of Lancashire,[1] there may be in connexion with the sewing-machine a certain amount in ordinary times of what may be considered fair remuneration.

The advantages to this and other countries of the sewing-machine will be shown by the following figures: –Men's shirts, made by machine, take 3 hours and 10 minutes each to do; by hand, 15 hours and 20 minutes; a lady's dress, by the machine, takes 12 hours 4 minutes; by hand 20 hours 35 minutes: a **merino** dress, by machine, 10 hours 35; by hand, 16 hours 27 minutes: a **calico** dress, by machine, 6 hours 20 minutes: by hand, 11 hours 38 minutes. Other

[1] See Dodd's 'Wallotty Trott' on Lancashire factories, #20.

articles are in somewhat similar proportions; and we will, therefore, only mention that a silk apron is made by machine in 2 hours 30 minutes; and by hand 6 hours 16 minutes: and a **muslin** skirt, by machine, in 4 hours 59 minutes; by hand 10 hours 10 minutes.

A like saving of time is to be noticed in the making of male attire: for instance, a common **frock-coat,** by the machine, occupies 17 hours 20 minutes; by the hand, 27 hours 40 minutes: a **linen vest,** by machine, 3 hours 44 minutes; by hand, 7 hours 18 minutes: a fine overcoat, by machine, 28 hours 13 minutes; by hand, 31 hours 20 minutes: a fine frock-coat, by machine, 21 hours 25 minutes; by hand 35 hours 16 minutes: a fine business coat by machine, 19 hours; by hand, 26 hours 40 minutes: a **satin** vest, by machine, 8 hours 14 minutes; by hand, 12 hours 55 minutes.

Notwithstanding all that has been argued to the contrary, it is certain that the means which save the need of human labour are a great advantage to the community. In this way the general amount of saving in Great Britain alone must be in each year enormous. Nor only in the preparation of clothing, but also of linen, woollen and other fabrics, the sewing-machine has come into extensive use. In the manufacturing of leather articles, and especially in the boot and shoe trade, it is doing useful service. The sewing-machine has been objected to by many workmen, who, when drawing as they call it 'the strings of misery', have a sort of dread of being relieved from a difficulty. At Northampton, one of the chief places where boots and shoes are made on an extensive scale, the machine was introduced in the following manner. A wholesale shoemaker of that town, seeing the value of the machine in his own trade, determined to introduce it; but hearing the opposition it would produce, thoroughly mastered the working of the machine himself. Having done so, and sewn a pair of leather **uppers**, he entered his shop, and put them into the hands of his foreman, with the remark, 'What do you think of these?' The man, after carefully examining them, remarked, 'Why, they are splendid: I never saw such work in my life!' The boots were passed round the shop, the men being chiefly members of the trade society, and were admired by every one who saw them. The master then said, 'The party who made them wants to work; shall I take him on?' The foreman replied, that nothing could be better, and that for his part he should be glad of such a hand. 'But', said the master 'he is deaf and dumb'. 'Dear me', replied the foreman, 'what a misfortune! Not much fear, however, of him quarrelling with his mates, sir'. The master, with emphasis, —'And he neither eats nor drinks'. 'Ah! it is the sewing machine!' exclaimed the foreman; and the excitement in the shop became intense. 'But', said the master, 'listen to me for a moment. I have seen the working of this thing in the United States, and its introduction here is a positive certainty: it is the merest question of time. To attempt to stay the introduction of machinery into any branch of trade is something worse than madness: it never has succeeded, and it never will. I have made up my mind to introduce the sewing-machine into my trade, —and introduce it I must and will; but not at your cost. I know that it will decrease your labour, but it shall increase your pay. You may not think so, but I will guarantee that for twelve months your wages shall never be less than now, and as much more as you can earn you shall have'. The trade-union men agreed to those terms. The movement has been successful; and in Northampton the machine is extensively in use, and the patentees sell them under a system of weekly payments, so that many men have their own machines and work in their own cottages; and this, it is reported, has had an excellent effect upon the habits of the people. One machine gives employment to four people, in preparing the work for the process of sewing. In Stafford, it is said that the machine already finds work for more hands than can be obtained; and women, in this way, can earn from 12s. to 20s. a week.

Up to the present time the sewing-machine is far more extensively used in America than it is in this country. In the United States it is believed that the value of the sewing done by it has been

more than 58,000,000*l*. It is estimated that there are at present at work in the whole world more than 300,000 sewing-machines. Out of this number, 200,000 are at work in America, 50,000 in England, and the remainder elsewhere. These figures will serve to show to what an enormous extent this power has to be developed in Great Britain alone. In the United States there is a manufactory which is especially devoted to the construction of these machines, in which some thousands of men are employed; and from this place 1,000 machines can be turned out weekly.

SECTION SEVEN

International Influences and Echoes

Despite reaching its imperial peak in the late nineteenth century, Britain was rarely the seat of major fashion innovation, rarely defining truly new styles even as the country's industrial advancement facilitated their manufacture. For design, we must turn – as the British did – to Paris and to the near and far East. One way that the British public could sample foreign wares was through the increasingly popular world exhibitions. The 1851 'Great Exhibition of the Works of All Nations in the Crystal Palace', known simply as the 'Great Exhibition' proved to be a watershed occasion: it established London as the cultural and manufacturing centre of the world, and provided a single site where the latest developments in science, industry and fashion from around the globe could be sampled. Attendees themselves became one of the attractions, as strolling the galleries provided an opportunity to see and be seen (see fig. I.17).

France was the largest foreign contributor to the exhibition, and its textiles were central to their pavilion. So powerful was the French influence on fashion design that English periodicals regularly featured fashion plates and columns devoted to styles from France (see fig. 7.1). An example from *Myra's Journal* (see #23) offers a representative example of the detailed accounts presented to readers, who could be expected to be familiar – through their reading, if not through their experience – with the myriad fabrics, trimmings and locations described therein. The public reaction to the death of **couturier** Charles Frederick Worth in 1895 (see #24) is further testament to the persistent sway that France held over fashion even at the end of the century. Worth might have been born in Lincolnshire, but it was in France that he built his **atelier** and made his name as the premier designer to women of fashion.

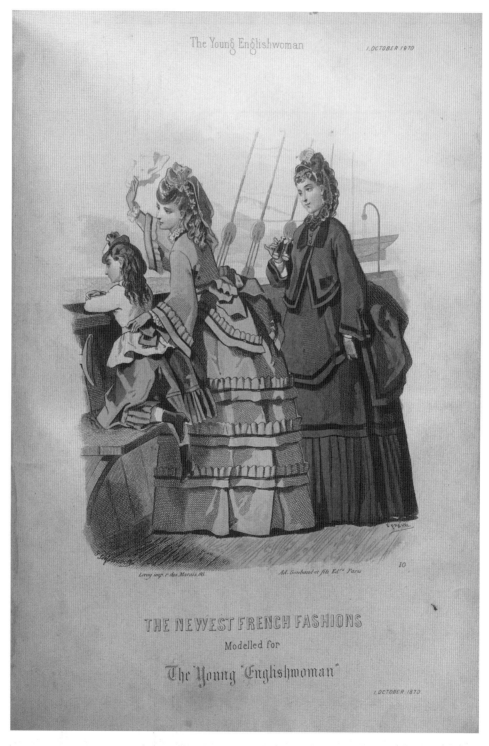

FIGURE 7.1 *'The Newest French Fashions'*, Young Englishwoman's Magazine *(1 October 1870), p. 517.*

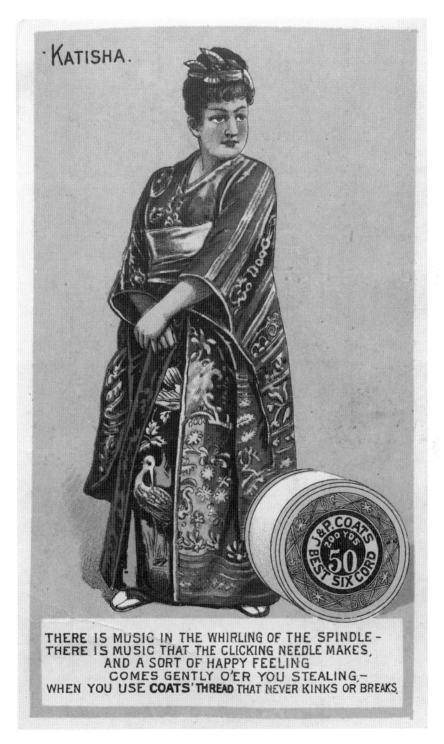

FIGURE 7.2 *Trade card for J. & P. Coats thread featuring 'Katisha' from Gilbert and Sullivan's* The Mikado *(c. 1885).*

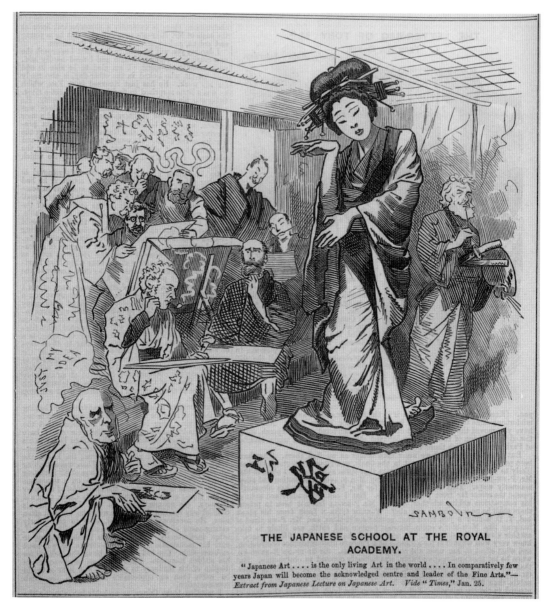

THE JAPANESE SCHOOL AT THE ROYAL
ACADEMY.

"Japanese Art is the only living Art in the world In comparatively few
years Japan will become the acknowledged centre and leader of the Fine Arts."—
Extract from Japanese Lecture on Japanese Art. Vide "Times," Jan. 25.

FIGURE 7.3 *Edward Linley Sambourne, 'The Japanese School at the Royal Academy'*, Punch *(4 February 1888), p. 50. Image courtesy of Cadbury Research Library: Special Collections, University of Birmingham.*

'Japanese Art … is the only living Art in the world … In comparatively few years Japan will become the acknowledged centre and leader of the Fine Arts.' *Extract from Japanese Lecture on Japanese Art. Vide 'Times'*, 25 Jan.

Other influences came from further afield. The Great Exhibition whetted the public's appetite for global cultures, and similar ventures occurred regularly in the following decades. Notable among these was the Japanese Village in Kensington (see #25). Certainly open to critique for forwarding stereotypes and cultural appropriation, it nevertheless introduced scores of British to a nation only recently made accessible by the 1854 Anglo-Japanese Friendship Treaty, which opened Japanese ports to British trade. Notionally purporting to represent Japanese people in a Japanese context by recreating an entire village on a small scale, the event reached far beyond the capital through extensive media coverage. Japanese influence was inescapable in the **Aesthetic movement** as well. The intersections of the worlds of the fine arts, music and literature necessarily overlapped with fashion. Even when legitimately Japanese styles were only hinted at or satirized, or where the iconography was adapted to truly British ends, the lines of influence are still detectable (see figs. 7.2–7.3).

23

[Myra], 'The Latest from Paris', *Myra's Journal of Dress and Fashion* (2 October 1876), p. 216

Myra's Journal of Dress and Fashion was launched in 1875 by Matilda Browne. The popular monthly included fashion plates, advice columns and patterns in addition to article series such as 'Latest from Paris'. This sample column is typical, giving a sense of the range and swiftness of the prose and the degree to which readers might be expected to familiarize themselves with French goods, locations and vocabulary. Detailed accounts of fabrics and design could help home sewers or local tailors recreate the looks described. The piece ends with the offer to take on commissions to purchase, one way that women without means to get to the Continent could access current trends.

The **Juive dress**, which is still *a la mode*,[1] is to be followed by the Egyptian, and this again by the **Moyenâge** or Abélard dress. This latter is no other than a long **Princess dress** cut square in front.

But all these styles form part of the coming fashions for the winter. It is too late for summer toilettes, too early for winter costumes, and the most charming of all, demi-saison toilettes, are the only ones to be considered at present. No woman of true elegance would think of putting, as a suitable costume for the autumn, a winter **mantle** over a summer dress. The laws of harmony are opposed to such combinations as these, and the difficulties of the season are met by the adoption of clothing which is neither too light nor too warm, and colours which, without being light, are yet not dark. Silk, associated with woolen materials, is one of the best combinations, and a costume made in this style, and intended for autumn wear, deserves description. The skirt was of black **faille**, edged with a flounce of **Louisine** in chequers of grey and pink stripes, with black threads. The flounce was gathered and headed by a deeper flounce of black faille, arranged in close pleatings. The Princess **polonaise** of Louisine was rather short in front and very long at the back, and edged with a flounce of Louisine, headed by another of black faille. This last flounce, instead of being laid towards the lower edge of the polonaise, stood straight up, and joined a small drapery ornamented with long loops of black and pink ribbon, which took the place of the now defunct puff. The pockets were of black faille, with pink and black

[1] *à la mode*: Fr. in fashion.

ribbons, and the sleeves of Louisine, with deep black faille cuffs. A black straw **chapeau**, with roses, was to be worn with the dress, which is an excellent type of demi-saison toilettes. A large **fichu** of black Indian **cashmere**, embroidered with pink roses in the corners, was the pretty and appropriate **pardessus**.

Another toilette of the same description was made of light coloured beige tissue over a dark blue faille skirt. It may be remarked that at this time of year complete toilettes of the same material are losing ground; the skirt matching the **tunic** or polonaise gives way to a silk skirt of the same shade as the toilette.

Still everything must match: if the toilette is trimmed with red, the fan must be red on one side, black on the other, and mounted in ebony. Similar fans are also made with one side navy blue instead of red. There are a number of pretty fancy objects made now, all of which tend to give a finished appearance to a toilette which it would not otherwise have. Amongst these is the Marguerite **chatelaine**, fastened to the waist on each side, and forming a kind of trimming to the lower edge of the **bodice**. It is composed of two **plaits** of a metal called antique silver. On one side a watch, scent-bottle, or **parasol** can be suspended, and on the other side, intended for the fan, the chain is so long that the fan can be used without being taken off the chain. Another pretty novelty is a ball-card of pierced silvered metal, containing several leaves, on which engagements for dances are written, with a pencil attached to the card, which is, in fact, more of a note-book than a ball-card, although well serving this purpose.

Indian cashmere **cuirasse** bodices are being already prepared for the forthcoming winter; these cuirasses are made of old Indian cashmeres, and are intended to be worn with black faille skirts, which have been deprived of their bodices, but not of their sleeves, for sleeves to match the skirt are considered indispensable with this style of dress. The first cuirasse of the kind was the work of Madame Morison, 14, Rue d'Antin. It is a new way of utilising those otherwise rather useless articles, Indian **shawls**; they are also made up as beautiful **robes de chambres**, Princess tunics, indoor dresses, opera-cloaks, and large and small circular cloaks. Madame Morison's work is irreproachable, and it is one of peculiar difficulty, for the cashmere designs have to be *re*-embroidered and **appliqué**. In addition to this, the shape she gives all these objects is extremely graceful and becoming.

Kid **corsages**, covered with metallic embroidery, will be much worn; they mould the figure like a glove, and show every beauty of contour, and, alas, every defect also.

During winter evenings our chief élégantes intend to envelope their bodies in white kid cuirasses, laced at the back; the perfect fit of these bodices can be compared to nothing but that of a glove moulding the hand exactly. The bodices will be trimmed with silver braid *en chevron* on the front and back, and the sleeves are to be ornamented in the same way. A few trials in favour of this mode were made last winter, and the bodices are now likely to become more general.

Dressy toilettes of **lampas**, figured velvet, **brocade**, and all sumptuous materials will still be made without trimmings of any kind, and with immensely long **trains**.

The downfall of the **caroubier**, cardinal, **sultan**, and all other violently red shades is decreed to be imminent; which is easily explained by the manner in which it has been abuse: but we prophesy its continuance through December, which is indeed the most suitable month for cheerful colours. The patterns of the materials for the autumn and winter are all dark: indigo blue, dark green, *tête de nègre*,[2] and **aubergine**.

[2] *tête de nègre*: Fr. 'negro's head'; dark brown colour, no longer used as it is considered a racial slur.

For autumn materials one of the favourites is striped Indian cashmere, with a scarf mantle to match, trimmed with deep fringe to match. It is a happy notion, for stripes are far more becoming than chequers, which can only be worn by slender women and young girls. **Walking** toilettes for the winter are likely to be made of light cloth, and the form is to be something perfectly new, but of these I shall be able to speak with more certainty after my return from Paris. I am going over (D. V.) on the day on which this Journal is published, and shall be pleased to make any purchases for ladies who send their commissions, before the 10th of October, to Madame Myra, care of Messrs Goubaud et fils, 92, Rue de Richelieu, Paris, France. But I must beg of them, one and all, *not* to send registered letters or money to Paris, but to Madame Goubaud, 39, Bedford Street, Covent Garden, on account of the great fuss and trouble there is to receive letters registered or containing cash in Paris; one is obliged to go personally, and to produce envelopes to prove that one *is* oneself, and it is too troublesome when much occupied. So kindly send all letters (unregistered) with commissions to me 10 Paris, and the money for the same to Madame Coubaud, 39, Bedford Street. Covent Garden. I hope ladies will allow me carte blanche as to taste in selection, for I cannot buy anything I do not like; but I should be glad if they would fix the price they wish to pay for each article.

24

'Death of the Chief Ruler of the Fashionable World', *The Ladies' Treasury* (1 April 1895), p. 274

This short obituary, published three weeks after the death of Charles Worth, attests to the couturier's reputation in Britain and beyond.

The papers inform us that the death of Mr. Charles Worth, the Lincolnshire man, who for thirty-five years was the elegant arbiter in French, and even universal, fashion in women's dress, took place on March 10th, of congestion of the lungs, in his Paris residence in the Champs Elysées district, at the age of seventy. Mr. Worth made over the management of his great business in the Rue de la Paix[1] to his sons only a few years ago, but down almost to the day of his death he insisted upon visiting his show rooms and taking part in the direction of the establishments.

Charles Worth was born at Bourne, Lincolnshire, in 1825. His father was, it is said, a solicitor, whose professional success was not promising enough to induce him to think of educating his son to follow him in his career, and, after the age of thirteen, the future king of dressmakers spent some time in a large **drapery** establishment in London. Thence he started for Paris, where he obtained, with considerable difficulty, a situation in the house of Hilditch and Co.,[2] a house well known for its silks. It was not, however, until 1860, that the personality of the famous dress designer became defined and conspicuous. About that period he left the Maison Aurelly,[3] which, in the early days of the Empire, disputed the patronage of people of fashion with that of Madame Roger,[4] and started business at No. 5, Rue de la Paix, with a Swede, M. Dobergh, as partner. This associate retired after the Franco-German war, and built himself a chateau among his native mountains.

[1] Parisian street in the second arrondissement known for its upscale shopping; Worth was one of the first couturiers to open a studio there.

[2] Drapers Hilditch and Co. also operated in London, where they routinely advertised their silks.

[3] Maison Aurelly was, along with the Maison Roger, one of the premier fashion houses in Paris during the Second Empire.

[4] Mme Roger opened her store in 1850, one of the first shops to offer ready-made clothing.

It is said that Princess Metternich[5] was Worth's first great customer. She was so satisfied with his skill that the Empress Eugénie,[6] who had her dresses from Madame Roger, resolved to give some orders to the rising couturier of the Rue de la Paix. From that moment the fortune of the Lincolnshire man in Paris was made. Every *grande dame* wanted to be dressed by Worth, and his name became a household word.

The deceased has another title to his fame, inasmuch as he killed the ridiculous **crinoline**, and led the way to a more rational as well as a more graceful style of dress.

Mr. Worth was inflexible in his opinions on costume, and generally had his own way, even with the most august, fastidious, and capricious of customers. 'If you don't like what I have made for you, go elsewhere', was his motto, not openly spoken, but well understood; and his dogged independence was perhaps as great a factor in the building up of his fame and fortune as his skill in choosing **stuff**, combining colours, and cutting out. Even towards the Empress the celebrated ladies' tailor was in the habit of acting with his characteristic stubbornness. He used to send his work to the palace in the morning, and later, in discussions on his newest combinations with the Empress, he usually had his own way. His decisions were often loudly praised at the Tuileries,[7] and when the Empress had fitted on her latest costumes, Worth noted at a glance any shortcomings.

His premises in the Rue de la Paix were enlarged after the war, but although he still continued to do good business, he was often heard to lament the days of the Empire, and to complain that in these degenerate times ladies were dressed by their maids. He was still, however, the favourite designer of foreign Courts, of the greater part of the patricians of the Faubourg Saint-Germain,[8] and of the plutocracy. Every year Mr. Worth sent the Empress Eugénie a large bouquet of Parma violets, tied with a **mauve** ribbon, on which his name was embroidered in gold.

Mr. Worth was very charitable; gave without stint to the poor, never allowing his name to appear as a philanthropist. During the siege of Paris[9] he organized an ambulance in his house in the Rue de la Paix. The deceased had some eccentric tastes, which came out in his curiously-constructed villa at Suresnes, near the railway station. This building of brick and stone is full of artistic objects, and has been described as an 'Aladdin's palace'. Its owner only occupied it for a few months in the summer. MM. Jean and Gaston Worth, who are now carrying on the business in the Rue de la Paix, have the reputation of inheriting their father's skill.

[5] Princess Pauline Clémentine von Metternich-Winneburg zu Beilstein (1836–1921), Viennese socialite and friend of Eugénie.
[6] Empress Eugénie (1826–1920), wife of Napoleon III, see p. 103, n1.
[7] Royal palace that was part of the Louvre complex; it was destroyed during the 1871 Paris Commune uprising.
[8] Exclusive section of Paris on the Rive Gauche, home to nobility and aristocracy in the seventh arrondissement.
[9] The Siege of Paris lasted from September 1870 through January 1871, effectively ending the Franco-Prussian War.

25

'A Japanese Village in London', *The Ladies' Treasury* (1 June 1885), pp. 324–7

*The Japanese Village described in this piece was a popular phenomenon, introducing Japanese culture to an interested audience. Located in the fashionable neighbourhood of Kensington, it participated in the tradition started by the Crystal Palace, and presented itself as part anthropological display, part consumerist playground. The cult of Japonisme was spurred on by the Aesthetes' devotion to blue and white china and evidenced in the works of leading fine artists: James MacNeill Whistler, for example, was deeply inspired by Japanese iconography. Diluted versions of the **kimono** appeared in the fashion pages even before the launch of the Village.*

Since November, 1884, there has been in Knightsbridge, London, an exhibition of one hundred Japanese men, women, and children, working and living in houses of Japanese construction, erected in streets; ten houses, also a Buddhish (*sic*) temple, and Japanese works of art, of varied excellence and often eccentric design, all collected under a roof of glass, and polished wood; the whole constituted an attractive assemblage, never seen in England previously. Throngs of people crowded daily to see the industrial employment of a strange-looking people, hitherto unknown to the multitude, excepting through pictures or books of travel.

The houses, grouped to represent five streets, under a glass roof, were constructed as they are in Japan, of bamboo wood and teak, light but firm. The fronts of the houses were without glass windows, though the bamboo shutters and blinds could be made instantly to close the open space if necessary; thus the occupants could be seen at their various employments, consisting of fan making and painting; pottery making and painting; **embroidery** on silk and **satin**—done by men; plain sewing, cabinet-work, and various ornamental works, including wood carving.

On May 2nd, 1885, the whole construction was burned down, very much to the lamentation of people who had neglected to pay the Japanese a visit. It was altogether a sight well worth many visits. The scene from a far-off land, which not one person in ten thousand was likely to visit, was here brought veritably to the vision. The whole thing was well-conducted, varied, and kept up, and as an agreeable and novel sight it paid well.

The loss to the proprietors of this interesting exhibition, and its valuable contents of bronzes, screens, china, and other matters, is estimated at fifteen thousand pounds.

An old proverb says—'Those who can instantly set about in endeavouring to repair misfortune can control fate'. The Japanese proprietor, Mr. Buhicrosan,[1] had before a week expired telegraphed to Japan for workmen to re-construct the buildings, and taken steps to re-furnish them with costly articles for a second exhibition on the same site.

Our engraving illustrates a street in Japan on a rainy day, and the method of wearing Japanese clogs, which are made of tough teak wood, light in weight, and impervious to wet, and not liable to attacks from insects (see fig. 7.4). The teak tree, of towering height, is of the same species as the shrub Vervain,[2] of English gardens. The wood of the clogs is thin, but does not warp, such clog is secured to the foot by a loop of leather fastened to the clog which loop passes between the great toe and the next, in the manner of the ancient sandal. Most of the Japanese in London wore stockings, not made in the English fashion in a rounded point at the end of the foot, but with a separate casing to admit the great toe only. Women chiefly wear the clogs elevated above the wet ground; men of the same class go barefoot, as seen in the man attired in a cape made of straw of the rice-plant; he wears a saucer-shaped hood covering which prevents the wet from penetrating.

As Japan consists of three thousand eight hundred islands, some districts must be very damp, requiring almost stilts to get over the ground; all the same, the damp, and rain, and mud, are necessary to grow rice, which stands in the place of wheat to the Japanese.

The Japanese umbrella is an outcome of common sense. It has many 'ribs', from each of which the rain shoots off, not as in the English curved form, as if made expressly for rain drips to ruin the clothes and boots. The man with the straw cape represents the style and dress of a propeller or driver of a Jinricksha,[3] answering to an English cab. 'The vehicle somewhat resembles an enlarged perambulator placed upon two light wheels, it has a hood, moveable backwards and forwards at pleasure, and to which curtains of oil-paper are attached, both back and front, to shut out the rain or screen the sun'.[4] Between the two shafts is a leather strap quite against which a man—not a horse—sets the vehicle in motion, and proceeds at the rate of six miles an hour, and can, if necessary, travel forty to fifty miles a day, so men are usually hired for long journeys; the price is sevenpence-halfpenny for the hour. The mode of locomotion is pleasant. (For this and other information respecting the Japanese, past and present, we are indebted to a pleasant and useful shilling book on Japan, purchased at the Japanese Village.[5]) As a poor labourer of Japan consumes two pounds of rice daily, without admixture of other food, it follows that rice must be very nutritious. It is eaten without butter or milk, for these are never used in that country.

[1] Little information is available on Tannaker Buhicrosan, the businessman responsible for overseeing the successful exhibition.

[2] Vervain: verbena.

[3] Jinricksha: rickshaw; as described, a light transport vehicle on two wheels that is pulled by a person.

[4] The lines are drawn from *Japan, Past and Present: The Manners and Customs of the Japanese, and a Description of the Japanese Native Village*, by O. Buchicrosan and edited by R. Reinagle Barnett (London: Privately printed by the Proprietors of the Japanese Native Village, 1885), p. 20. See note 5 below.

[5] [Author's footnote: The Manners and Customs of the Japanese, and a description of the Japanese Native Village (one shilling). Published by the Proprietors of the Japanese Native Village, 27 King Street, Cheapside, London] The small book's full title is listed in the note above. In the Introduction, O. Buchirosan acknowledges that he has '[availed himself] of the valuable information contained in several works on Japan, written by some of the most eminent authorities'. As detailed below, in some cases this information appeared verbatim without citation.

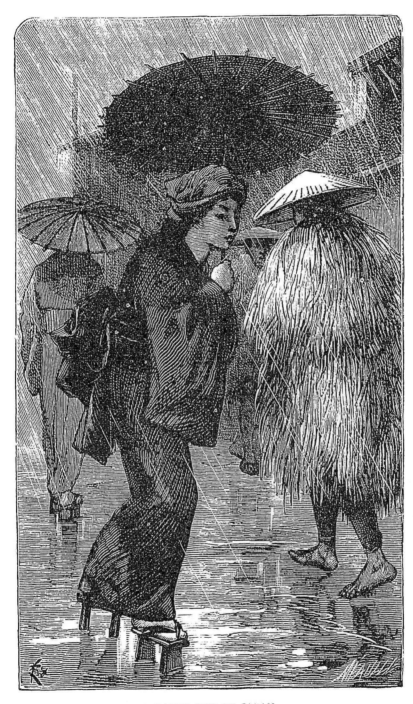

A RAINY DAY IN JAPAN.

FIGURE 7.4 *'A Rainy Day in Japan' in 'A Japanese Village in London'*, Ladies' Treasury *(1 June 1885),* p. 324. Reproduced by permission of the National Library of Scotland.

The Japanese women and girls that were seen in the Japanese Village in London were, nearly all of them, beautiful—that is to say, not exactly in accordance with English appreciation of such (see fig. 7.5). Their complexions were a creamy white, resembling that of Spanish women, lips and cheeks rosy, and with dark expressive eyes, black hair and eye-brows. Not one had light or ginger coloured hair, so often seen in England and Scotland. Two of the girls who officiated at a tea-house were remarkably beautiful, which even English girls acknowledged. Their manners were graceful and quiet, and the picturesqueness and colouring of their silken attire suggested, as they moved about in their sandals, the idea of butterflies of gorgeous colourings; so much so, that as one's eyes turned from these to English ladies in sombre dress, the last suffered by comparison—for too often there is incongruous colouring in their attire. 'For personal wear, Japanese fabrics are generally of a dark neutral tint, but a girl will show a narrow strip of bright colour around her neck, and the sash which she winds round her waist will often be of a rich dark *terré*,[6] with a pattern upon it in velvet and gold, but in no case must she wear obtrusive colours, save round the neck, or as a bow in the hair, and even there bits of colour must be small in quantity'.[7]

Music has made very little progress, if any, among the Japanese, although its origin is considered divine. They have many instruments or playing upon, there is but one, however, which is universally admired and played by all classes. This is the *Samisen*.[8] It has a long neck, like that of the banjo, but a square instead of a round body, which is covered with parchment both back and front. There are three strings secured to pegs in the usual way, two strings is the octave, and the middle string giving the fifth. When performing, the player holds a flat piece of horn between the thumb and third finger, with which the strings are touched when necessary to produce sound. At the 'Japanese Village', three or four girls performed daily on this instrument; the sounds produced were monotonous. There are, however, other instruments which, when played upon, are listened to with delight by the Japanese, and not so with Europeans.

The hands of the Japanese men and women are extremely artistic in shape. Their fingers are half-pointed and half-spatulous,[9] and whether men or women, and whatever employment they are engaged in, save in embroidery, they handle their tools or implements of work with the utmost grace.

'The men and women wore their ordinary Japanese costume in the exhibition, but otherwise they adopt the ordinary costume of the English. According to the measurement for their outfit it was found that the shoulders of the Japanese men were thicker and larger in proportion to their chest measurement than those of Englishmen, but their legs are on the average from two-and-a-half to four inches shorter, thus a Japanese from five feet to five feet three or four inches in height is equal in chest measurement and muscle development to a stalwart European of nearly six feet'.[10]

[6] *terré*: listed as 'terry' in *Japan, Past and Present*, p. 143; pile fabric with uncut loops.
[7] Quotation from Christopher Dresser's *Japan: Its Architecture, Art, and Art Manufactures* (London: Longman, Green, and Co., 1882), p. 439. It is repeated verbatim, without citation, in *Japan, Past and Present*, p. 143.
[8] Samisen: as described, a three-stringed Japanese guitar.
[9] Spatulous: in the shape of a spatula; flattened.
[10] A paraphrase from *Japan, Past and Present*, p. 107.

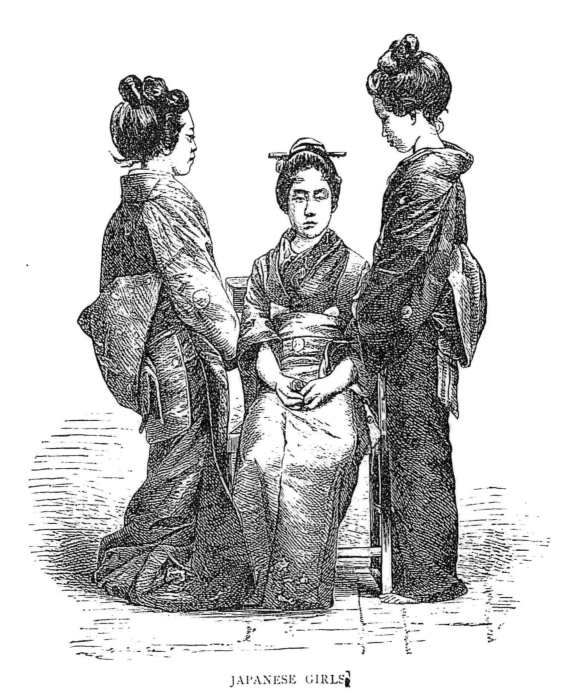

JAPANESE GIRLS

FIGURE 7.5 *'Japanese Girls' in 'A Japanese Village in London'*, Ladies' Treasury *(1 June 1885), p. 325.*
Reproduced by permission of the National Library of Scotland.

Coda: Reflecting on the Victorians

26

Virginia Woolf, 'Modes and Manners of the Nineteenth Century', *Times Literary Supplement* (24 February 1910), p. 64

Novelist and essayist Virginia Woolf (1882–1941) was an astute critic of the Victorians; her father, Sir Leslie Stephen, helped distil a notion of Victorian identity through his work as inaugural editor of the National Dictionary of Biography. *In the piece reproduced here, Woolf reviews the three-volume* Modes and Manners of the Nineteenth Century *(by Max Boehn, trans. M. Edwardes, introduced by Grace Rhys, London: Dent, 1910), a scholarly work of some breadth. Given her talents and predilections, it is perhaps not surprising that she concludes that creative writers are better able than historians to capture a sense of the fashions of a given moment. She notes that evolutions in fashion occur slowly and cannot be as easily divided into periods as we might like, even as she acknowledges the undeniable impressions that events large or small can make on clothing.*

When one has read no history for a time the sad-coloured volumes are really surprising. That so much energy should have been wasted in the effort to believe in something spectral fills one with pity. Wars and Ministries and legislation—unexampled prosperity and unbridled corruption tumbling the nation headlong to decay—what a strange delusion it all is!—invented presumably by gentlemen in tall hats in the forties who wished to dignify mankind. Our point of view they ignore entirely: we have never felt the pressure of a single law; our passions and despairs have nothing to do with trade; our virtues and vices flourish under all Governments impartially. The machine they describe; they succeed to some extent in making us believe in it; but the heart of it they leave untouched—is it because they cannot understand it? At any rate, we are left out, and history, in our opinion, lacks an eye. It is with unusual hope that we open the three volumes in which a nameless author has dealt with the Modes and Manners of the Nineteenth Century. Thin and green, with innumerable coloured pictures and a fair type, they are less like a mausoleum than usual; and modes and manners—how we feel and dress—are precisely what the other historian ignores.

The connexion between dress and character has been pointed out often enough. Because dress represents some part of man picturesquely it lends itself happily to the satirist. He can

exaggerate it without losing touch with the object of his satire. Like a shadow, it walks beside the truth and apes it. The device of making the smaller ridicule the greater by representing it recommended itself to Swift and Carlyle.[1] But to discover soberly how far thought has expressed itself in clothes, and manners as we call them, is far more difficult. There is the temptation to hook the two together by the most airy conjectures. A gentleman had the habit, for example, of walking in the streets of Berlin with a tame deer; that was characteristic, we are told, of a certain middle-class section of German society, in the twenties, thirties, and forties, which was learned, pedantic, Philistine, and vulgar; for to make oneself conspicuous is a mark of the vulgarian, and to walk with tame deer is to make oneself conspicuous.[2] But there are more solid links. The French Revolution, of course, sundered the traditions of ages. It decreed that man in future must be mainly black, and should wear trousers instead of **breeches**. The **waistcoat** alone remained aristocratic, and drew to itself all the reds and oranges of the other garments, and, as they became cotton, turned to plush and **brocade**. At length this rich territory was conquered, and sparks of colour only burnt in the **cravat** and on the fob. The different garments moved up and down, swelled and shrank at intervals, but after 1815 a man's clothes were 'essentially the same as they are now'.[3] Men wished to obliterate classes, and a dress that could be worn at work became necessary. Women, on the other hand, were exposed to fewer influences, so that it may be easier to trace one idea in their clothes. The effect of the Revolution seems to be definite enough. Rousseau had bidden them return to nature; the Revolution had left them poor; the Greeks were ancient, and therefore natural; and their dress was cheap enough for a democracy. Accordingly, they dressed in pure white cottons and **calicoes**, without a frill or an exuberance; nature alone was to shape the lines; nature was to suffer not more than eight ounces of artificial concealment. The effect of these tapering nymphs, dancing on a hilltop among slim trees, is exquisite but chill. Because Greek temples were white, they whitewashed their walls; the bed room was the Temple of Sleep; the tables were altars; the chair legs were grooved into columns; **reticules** were shaped like funeral urns, and classical cameos were worn at the neck. The absolute consistency of their attitude may be ridiculous, but it is also remarkable. In fact, the society of the Empire is the last to 'boast a style of its own, owing to the perfect correspondence between its aims, ideas, and character, and their outward manifestations'.[4] Any unanimity is overwhelming; it is one of the great gifts we bestow upon the Greeks; and, although there were many beautiful episodes in the nineteenth century, no single style was again strong enough to make everything consistent. Before the Revolution some sort of order was stamped upon fashion by the will of the Queen, who could afford to make beauty the prime virtue; but in 1792 Mlle. Bertin, Marie Antoinette's **modiste**,[5] fled from Paris, and although she touched at other Courts, eventually settling in England, her rule was over; shops for ready-made clothing opened as she left. For ten years, 1794–1804,[6] the didactic classic spirit served instead of the Royal will; and then a confusion set in which threatens never to grow calm. Still the author does his best to make one change account for another, at the risk of wide generalization. 'Feeling and sensibility took the place in this generation [the generation of the Napoleonic wars] of religion During the First

[1] *A Tale of a Tub* (1704), by Jonathan Swift (1667–1745), satirized major sects of Christianity through the various alternations three brothers make to their identical suits. For Thomas Carlyle, see the excerpt of *Sartor Resartus* (#1).
[2] Max von Boehn does indeed tell this story of Prince Hermann von Pückler-Muskau. *Modes and Manners of the Nineteenth Century*, trans. M. Edwardes (London: Dent, 1910), vol. 2, p. 76.
[3] *Modes and Manners*, vol. 1, p. 143.
[4] *Modes and Manners*, vol. 1, p. 32.
[5] Marie-Jeanne Rose Bertin (1747–1813) was Marie Antoinette's dress designer and milliner from the early 1770s.
[6] 1794 marked the height of the Terror; in 1804, Napoleon was declared Emperor.

Empire love and passion had been but the passing gratification of the moment, but now love was to be the one lasting object of life and being'[7]—therefore puffs and **ruffs** were worn; the furniture had become rococo, and Gothic cathedrals influenced the chairs and the clocks.

A woman's clothes are so sensitive that, far from seeking one influence to account for their changes, we must seek a thousand. The opening of a railway line, the marriage of a princess, the trapping of a skunk—such external events tell upon them; then there is the 'relationship between the sexes'; in 1867 the Empress Eugénie, wearing a short skirt for the first time, went for a drive with the Emperor and Empress of Austria. As the ladies stepped into the carriage, the Emperor turned to his wife and said, 'Take care, or some one may catch sight of your feet'.[8] The influences of beauty and of reason are always fighting in a woman's clothes; reason has won for the most part, but generally submits to a weak compromise. When we talk of fashion, however, we mean something definite and hard to define. It comes from without; we wake in the morning and find the shops alive with it; soon it is abroad in the streets. As we turn over the pictures in these volumes we see the spirit at work. It travels all over the body ceaselessly. Now the skirt begins to grow, until it trails for six feet upon the ground; suddenly the spirit leaps to the throat, and creates a gigantic ruff there, while the skirt shrinks to the knees; then it enters the hair, which immediately rises in the pinnacles of Salisbury Cathedral; a slight swelling appears beneath the skirt; it grows, alarmingly; at last a frame has to support the flounces; next the arms are attacked; they imitate Chinese pagodas; steel hoops do what they can to relieve them. The hair, meanwhile, has subsided. The lady has outgrown all cloaks, and only a vast **shawl** can encompass her. Suddenly, without warning, the entire fabric is pricked; the spirit moves the Empress Eugénie one night (January, 1859) to reject her **crinoline**. In an instant the skirts of Europe melt away, and with pursed lips and acrimonious manners the ladies mince about the streets clasped tightly round the knees, instead of swimming. It is from the crinoline, no doubt, that Meredith got his favourite 'she swam'.[9]

Fashion dealt more discreetly with men, and chiefly haunted their legs. Nevertheless, there was a great sympathy between the sexes. When her skirts ballooned, his trousers swelled; when she dwindled away, he wore **stays**; when her hair was Gothic, his was romantic; when she dragged a **train**, his cloak swept the ground. About 1820 his waistcoat was more uncontrollable than any garment of hers; five times within eight months it changed its shape; for a long time the cravat preserved a space for jewellery where the necklaces were rivalled. The only parts of men that survived the stark years of the thirties and forties were the hat and the beard; they still felt the sway of political changes. The democratic spirit required felt hats that drooped; in 1848 they dissolved about the ears; stiffening again as reaction set in. The same principle ruled the beard; to be clean shaven was a sign of unflinching respectability; a ragged beard, or even a beard alone, showed that one's opinions were out of control. At the present time, 'Only at home does the gentleman indulge in coloured gold-laced velvet, silk, or **cashmere**; when he appears in public he may only venture by the superior cut of his garments to aim at any distinction; if the male attire thereby loses in effect, it gains in tone'.[10]

[7] *Modes and Manners*, vol. 2, p. 57.

[8] *Modes and Manners*, vol. 3, p. 96. Eugénie de Montijo (1826–1920), married to Napoleon III, was Empress consort of the French from 1853 to 1871 (see p. 103, n1).

[9] Novelist and poet George Meredith (1828–1909) commonly referred to women 'swimming' metaphorically: across a room, across a field etc. Woolf noted his usage of the phrase in her 1928 essay 'The Novels of George Meredith' (reprinted in *The Common Reader, Second Series*); here, she connects the term to the swaying bell of the crinoline, which hides the movement of the legs.

[10] *Modes and Manners*, vol. 3, p. 105.

With furniture we find the same thing. Quite slowly every chair and table round us changes its form; if one had fallen asleep in an early Victorian drawing-room, among the patterns and plush, one would wake up this year with a horrid start. The room would seem little better than an attic. Yet, if one had sat there open-eyed, one would scarcely have seen the things change. Dress and furniture are always moving, but, having done his utmost to make them depend upon 'the spirit of the time', the author declares himself baffled. 'The longer we study the question, the more certain do we become that though we know the how, we shall never know the wherefore'.[11] Are we truly in the grip of a spirit that makes us dance to its measure, or can it be laid without recourse to magic? When one compromises one delivers no clear message. Throughout the nineteenth century both dress and furniture were at the mercy of a dozen different aims, and the original meaning was further blunted by the intervention of machines. Only great artists, giving their minds to nothing else, represent their age; dressmakers and cabinet-makers generally caricature it or say nothing about it. As for manners, the term is so vague that it is difficult to test it; but it is probable that they too only approximate, and that people's behaviour is the roughest guide to what they mean. If manners are not rubbed smooth by a machine, the comfort of society depends upon using a common language, and only saying what can be misunderstood without disaster. For this reason a history of modes and manners must use phrases which are as empty as any in the language, and the history is not a history of ourselves, but of our disguises. The poets and the novelists are the only people from whom we cannot hide.

[11] *Modes and Manners*, vol. 3, p. 43.

GLOSSARY

This glossary is not intended to be comprehensive, but rather to complement the contents of this volume, addressing some of the more common nineteenth-century fashion terms. For more extensive fashion dictionaries, please see also Mary Brooks Picken's *A Dictionary of Costume and Fashion: Historic and Modern* (Mineola, NY: Dover, 1999) – first published as *The Fashion Dictionary* (New York: Funk and Wagnalls, 1957) – and C. Willett Cunnington, Phillis Cunnington, and Valerie Cumming's *Dictionary of Fashion History* (New York: Bloomsbury Academic USA, 2017). As some words are used across centuries with varying meanings, the primary nineteenth-century use is given here.

Abélard dress: n. see *Moyenâge dress*.

Aesthetic movement: n. England-based literary and artistic movement of the 1870–1890s, emphasizing 'art for art's sake', without recourse to moral lessons.

Alençon lace: n. point lace of outlined floral motifs embroidered on a fine net ground.

alpaca: n. wool from the South American alpaca – a long-haired domesticated animal related to the llama – or the fabric woven from it.

amaranth: adj. purplish-red colour, named after the flower.

antimacassar: n. small fabric or lace covering for the back of upholstered chairs, to protect from the sitter's macassar, a hair oil.

appliqué: n. fabric or needlework decoration sewn onto a garment; adj. decorated with such applied ornamentation.

arsenic green: adj. emerald-green colour derived from arsenic-based dye.

ascot: n. broad men's decorative neckcloth.

atelier: n. (Fr. *studio*) dressmaker's studio.

attifet: n. (Fr.) wired Elizabethan cap, often intended to hold a veil, which comes to a point on the forehead; originally worn in the sixteenth to seventeenth centuries, in the mid-to-late nineteenth century, the style was revived for mourning caps.

aubergine: adj. eggplant; dark purple colour.

baize: n. open-weave, coarse fabric, usually wool.

baldrick: n. a sash or belt worn over the shoulder and across the body, used to hold a sword.

baleine/baleen: n., adj. (Fr. *whale*) see *whalebone*.

Balmoral boots: n. high boots with front lacing.

Balmoral petticoat: n. decorated petticoat.

basque: n. bodice extended below the waist.

batiste: n. fine, light plain-weave fabric similar to cambric.

bengaline: n. fabric with fine ribs, usually a mix of silk and wool.

bertha: n. decorative large, cape-like collar, often of lace.

bijou: n. (Fr: *jewel*) decorative bauble.

blacking: n. black shoe polish.

bloomers: n. (also Bloomer costume, Bloomer dress) split skirt gathered at each ankle, intended to be worn under shorter overskirt; named after American Amelia Jenks Bloomer (1818–1894), who popularized the style, although she did not invent it.

boater: n. stiffened straw hat with flat brim and low, flat crown.

bodice: n. garment covering the trunk; in women's dress, can refer to the tightly fitted upper half of an outer garment or to an undergarment worn over a corset.

bombazine: n. twill-weave fabric, usually of silk and wool, frequently used for mourning attire because of its matte finish.

boning: n. see *whalebone.*

bonnet: n. women's headdress for outdoor use, brimless at the back and often tied under the chin.

boutonnière: (Fr. *buttonhole*) see *buttonhole.*

bowler: n. felt, low-crowned men's hat with rounded crown; called a 'derby' in North America.

breeches: n. originally, men's garment with separate legs covering the waist to the knees or ankles; from the nineteenth century, refers only to those fastened to the leg just below the knees.

brocade: n. ornate fabric with textured pattern, often floral or scrollwork.

broderie anglaise: n. white, open-worked embroidery on a white fabric ground, often used as trimming.

buckram: n. coarse, stiffened cloth used in hat-making.

busby: n. tall, cylindrical fur hat; the British Royal Horse Artillery still wears a version as part of its dress uniform.

bustle: n. padding or frame attached at the waist to extend the back of a woman's skirt.

button hook: n. tool with a hook for fastening buttons on shoes or gloves.

buttonhole: n. flower or small spray of flowers worn in a man's lapel buttonhole; called a 'boutonnière' in North America.

calico: n., adj. plain-woven cotton fabric printed with designs, usually floral.

cambric: n., adj. fine white, plain-woven linen fabric, often used for handkerchiefs and shirts.

camisole: n. in the early nineteenth century, a loose woman's jacket worn in lieu of a dressing gown; later, an underbodice.

camlet: n. fabric originally woven of a mixture of silk and camel's hair, later silk and wool.

carmine: adj. crimson colour, originally derived from cochineal.

caroubier: adj. vibrant red colour.

cashmere: n., adj. wool from the Cashmere goat, or the fabric woven from that wool.

Chantilly lace: n. delicately worked, highly detailed bobbin lace, often with floral motifs on a fine net ground originating in Chantilly, France.

chapeau: n. (Fr. *hat*).

chemise: n. in the nineteenth century, loose-fitting, long shirt-like undergarment worn under corset; later, a straight, simple dress.

chemisette: n. camisole-like underbodice to fill the neckline of a dress.

Chesterfield coat: n. fitted men's knee-length overcoat, narrower than the frock coat and without a waist seam, popular from the end of the nineteenth century.

chignon: n. low bun worn at the nape of the neck.

chimney-pot hat: see *top hat.*

chintz: n. plain-weave cotton fabric with printed colour designs, often floral.

cloche: n. bell-shaped woman's hat popular in the early decades of the twentieth century.

cockade: n. decorative rosette, often of ribbon.

corsage: n. (Fr. *bodice*) fitted bodice; also nosegay of flowers pinned to the bodice or worn on the wrist.

corset: n. structured, laced underbodice with whalebone (or synthetic) boning.

coutil: n. course, sturdy twill fabric, commonly used in corset making.

couturier: n. (Fr. *dressmaker*).

crape/crepe: n., adj. embossed, plain-weave fabric, usually of silk or worsted wool, embossed with a slightly puckered, wrinkled appearance; often used in mourning due to its matte finish.

cravat: n. men's decorative neckcloth, tied and or fastened with a pin.

crêpe de chine: n., adj. (Fr. *Chinese crepe*) crepe fabric with especially fine texture.

crinolette: n. variation of the cage crinoline, narrower in the front with volume shifted to behind.

crinoline: n. petticoat structured with steel ribs and hoops, to support a full skirt.

crush-hat: n. a tall men's hat with collapsible crown, also called an opera hat.

cuirass: n. traditionally, leather or metal armour worn over the trunk; in the 1880s, the long, tightly fitted bodice that extended to the hip on fashionable women's dresses.

dado: n. wooden or decorative panelling covering the lower part of a wall: often called wainscoting in North America.

damask: n. heavy, usually satin-woven fabric with rich patterns.

day dress: n. gown worn during the day, not suitable for evening wear.

derby: see *bowler.*

distaff: n. staff or spindle used to hold wool while spinning.

Dolly Varden: n., adj. dress style named after a character in Dickens's *Barnaby Rudge* (set in 1770s), featuring an overskirt, usually in a floral pattern, gathered in swags to reveal an underskirt. See *polonaise*.

doublet: n. man's close-fitting, short jacket; a staple of men's day wear in the fifteenth to mid-seventeenth centuries.

draper: n. in the nineteenth century, seller of fabric and dressmaking goods.

dress improver: see *bustle*.

embroidery: n. decorative needlepoint work.

empire waist: n. elevated waistline just under the bust, popular in the first decades of the nineteenth century.

epaulet/epaulette: n. (Fr. *shoulder*) shoulder ornament.

ermine: n. winter fur of the ermine, a kind of weasel, white with a black-tipped tail.

evening gown: n. dress designed for evening wear, often sleeveless and usually with lower neckline than day dress.

facing: n. fabric used to line collars and cuffs, either of the same fabric as the body or of contrasting fabric.

faille: n. fabric with woven ribbed texture.

fancy dress: n. dress worn to costume balls.

farthingale/fardingale: n. structured underskirt with hoops of whalebone made to support full skirt, popular in the seventeenth century; an antecedent to the cage crinoline.

Fauntleroy suit: n. boy's suit of velvet breeches with wide lace collar, made popular in the late 1880s by Frances Hodgson Burnett's novel *Little Lord Fauntleroy* (1885).

fichu: n. woman's triangular scarf, usually worn around the neckline.

fillet: n. decorative headband.

flax: n. threads of the flax plant, which are woven into linen.

French polish: n. coating of shellac and gum arabic, usually used on wood.

frock-coat: n. men's knee-length, skirted outer coat, often double-breasted with waist seam.

fulled: adj. 'fulled' cloth has been treated – often by beating – in order to clean and thicken it.

furbelow: n. a decorative gathered or pleated ruffle on a petticoat or skirt.

furisode: n. kimono with notably long, extended sleeves.

fuschine: n. rosaniline hydrochloride, magenta-coloured aniline dye.

fustian: n. twill fabric with short nap.

gabardine: n., adj. originally a loose smock, by the late nineteenth century it refers to a twill-weave fabric, often of wool, frequently used to make suits and outerwear.

gaiter: n. garment worn over the shoe and lower leg to protect the wearer's legs.

georgette: n. thin, plain-woven transparent fabric with crape-like texture.

Georgian: adj. referring to 1714–1830, period of the reign of George I–IV, marked by neo-classical lines and symmetry.

gigot: adj. (Fr. *leg*) see leg-of-mutton.

gimp: n. flat trim made from cotton or silk cord, used today chiefly in upholstery; in lace-making, a heavy thread used to define designs.

girdle: n. belt.

grenadine: n. in the nineteenth century, a sheer fabric with a light, gauzy weave; more recently, heavier versions are used to make men's neckties.

guipure: n., adj. a bobbin lace in which motifs are connected to each other without any net ground.

handkerchief: n. square of fabric, often cambric or silk, used to wipe the nose or hands.

hanging sleeve: n. split sleeve with hanging fabric trails, originally common in medieval dress and revived occasionally through the nineteenth century.

heliotrope: adj. pinkish purple colour, named after the flower.

Hessian boots: n. high, tasselled boots as worn by Hessian soldiers.

Holland: n. finely woven linen fabric, originally produced in Holland.

Honiton lace: n. bobbin lace with motifs – often floral – joined to each other or on a fine net ground, named after the Devon town in which the lace originated.

hoop: n. flexible circle used as structure to support a full skirt.

Inverness coat: n. men's overcoat, with long, full, open sleeves, giving a cape-like appearance from the front; worn from the mid-nineteenth century to the early twentieth century as formal wear.

jacquard: n., adj. weaving process to produce patterned, textured fabrics such as brocade and matelassé, or the fabric resulting from such a process; named after Joseph Marie

Jacquard, the French inventor of the loom apparatus that facilitated the process in the early nineteenth century.

jersey: n., adj. fabric machine knitted (instead of woven) and therefore stretchable, originally made of wool from the Island of Jersey, where the woollen industry thrived.

Juive dress: n. (Fr. *Jewish girl*) princess-style overdress with v-neck.

kimono: n. traditional, boxy Japanese robe with wide, non-tapered sleeves.

lace: n. delicate, open-worked decorative fabric; common types include cutwork (in which motifs are cut from a fabric ground), bobbin (composed with threads on multiple bobbins), point or needle (worked with a needle and thread), and crocheted or knitted.

lampas: n. flowered, ornate fabric.

lawn: n. crisp, lightweight, plain-weave fabric, originally of linen but cotton in more recent usage, commonly used to make clerical gown.

leg-of-mutton: adj. used to describe sleeve that is gathered and full at the shoulder, tapering to fit tightly at the forearm and wrist, recalling the shape of a mutton leg.

Liberty of London: n. founded in 1875 by Arthur Lasenby Liberty on London's Regent Street, the department store featured fashionable fabrics designed in-house, and home goods favoured by the Aesthetic set.

linen: n. fabric woven from the thread of the flax plant; it can also refer generically to woven goods.

louisine: n. plain-weave fabric with glossy texture.

macaroni: n. dandy, used primarily in the late eighteenth and early nineteenth centuries; from the OED, 'This use seems to be from the name of the Macaroni Club, probably adopted to indicate the preference of the members for foreign cookery, macaroni being at that time little eaten in England'. ('macaroni, n.'. OED Online. December 2016. Oxford University Press. http://www.oed.com/view/Entry/111762).

macintosh/mackintosh: n. waterproofed overcoat, named after its inventor; now used generically to refer to raincoat.

madras: n., adj. lightweight cotton fabric, often brightly coloured, named after the Indian city (now Chennel) of its origin.

magasin de deuil/maison de deuil: n. (Fr. *mourning store*).

mantle: n. sleeveless overcloak.

mantlet: n. short, sleeveless overcloak.

mantua: n. originally a loose dress, in the late seventeenth and eighteenth centuries, it refers to a closely fitted overgown worn with a stomacher and skirts.

Marie Stuart cap: see *attifet*.

matelassé: n., adj. (Fr. *quilted*) fabric woven with texture that appears quilted.

mauve/mauveine: n., adj. first synthetic aniline dye, or the reddish-pink colour it produces (see #21).

merino: n., adj. fine wool made from the Merino sheep, or the fabric woven from such wool.

millinery: n. hat-making.

modiste: n. (Fr. *milliner*) designer and/or seller of dresses.

mohair: n., adj. hair of the Angora goat, or the fabric woven from that hair.

Monmouth cock: n. men's hat with broad brim turned up at the back, popular in the late seventeenth century.

morning coat: n. men's coat, short in the front sloping to vented tails in the back; commonly worn today only for formal occasions, it was a standard of nineteenth-century dress.

mourning band: n. black arm band worn by men when mourning.

Moyenâge dress: n. derived from *moyen age* (Fr. *middle ages*), a dress in the medieval style, princess style with square neckline.

mule: n. slipper or shoe with an open back, mostly worn by women.

muslin: n. adj., plain-weave cotton fabric.

nap: n. raised pile on fabrics such as velvet and corduroy.

net: n. openwork, mesh-like fabric.

Norfolk jacket: n. men's single-breasted tweed jacket with box pleats, worn in the late nineteenth century for sport or shooting; its popularity in the 1860s and 1870s is traditionally attributed to the then-Prince of Wales (later Edward II).

obi: n. wide sash traditionally worn with a kimono.

opera hat: see *crush-hat*.

organza: n., adj. thin, stiff, translucent fabric.

paletot: n. short, loose overcoat for men or women.

pannier: n. (Fr. *basket*) frame to support extended side skirts, originally of whalebone or cane, popular in the eighteenth century.

pantalets: n. loose pants, often trimmed with lace, worn under skirts by women and girls.

pantaloons: n. tight-fitting men's long trousers, popular in the early nineteenth century.

paramatta: n., adj. coarse fabric woven with silk warp and wool weft, commonly used in mourning dress for its matte finish.

parasol: n. decorated umbrella used to provide shade from the sun.

pardessus: n. woman's overcloak.

patent leather: n. leather with a shiny, weatherproof finish, achieved through layers of linseed oil, produced on a large scale first in the 1810s.

pelerine: n. woman's waist-length overcloak or cape.

pelisse: n. long, narrow women's overcloak.

periwig: n. stylized wig, commonly worn in the seventeenth century; presently worn by judges and barristers in Great Britain.

peruke: see *periwig*.

petticoat: n. undergarment to add warmth or fullness to a skirt.

pince-nez: n. (Fr. *nose-pinchers*) eyeglasses worn on the nose, kept in place with spring clips.

plain-weave: n., adj. basic textile weave in which each weft yard runs over one warp yarn and under the next (one-over, one-under).

plaits: n. braids.

point de gaze: n. Belgian needle lace.

polonaise: n., adj. dress with an overskirt pulled back to reveal a decorative underskirt, originally popular in the late eighteenth century but revived through the nineteenth century.

pongee: n. soft, slub-textured fabric with woven from raw silk.

pork-pie hat: n. women's hat with low, flat, round crown and turned-up brim, popular among women in the 1830s–1860s; in later usage, usually applied to men's hats.

poudré: adj. (Fr. *powdered*) of the period requiring white-powdered wigs.

princess dress: n. dress made without waist seam, shaped with vertical seams and gored skirts.

***Punch*:** n. popular, widely circulated satirical magazine launched in 1841, which frequently addressed fashion, especially in cartoons.

redingote: n. full-length overcoat, usually open at the front and belted, popular in varying designs through the eighteenth and nineteenth centuries.

Regency: n., adj. 1811–20, when the Prince Regent (later George IV) ruled during George III's last years, when the latter was deemed unfit, and the styles characteristic of the period.

reticule: n. small purse or handbag, often fastened with a drawstring.

riband: n. ribbon.

riding habit: n. costume for horseback riding; for women in the nineteenth century, usually involving a tight-fitting jacket and long skirt in dark colours.

robe de chambres: n. (Fr.) dressing gown.

ruff: n. decorative ruffle or frill worn at the neck.

sack-back gown: n. dress with loose, pleated back falling from the neckline to the floor, originally fashionable in the eighteenth century and in subsequent revivals; in the late nineteenth century, the style was also known as a Watteau dress, after Rococo painter Jean-Antoine Watteau (1684–1721) whose paintings depicted the style.

sartop: n. rustic high boot.

satin: n., adj. textile weave in which each weft yard runs over four or more warp yarns, then under one (four-over, one under), or vice versa, that produces fabric with one dull side and one glossy side; n. any fabric produced with satin weave, originally silk but more commonly synthetic.

Scotch cap: n. brimless wool cap worn in Scotland.

seersucker: n. thin cotton or linen fabric with striped and a puckered texture, often used in summer fashions.

semi-worsted: n., adj. wool yarn that has been combed so it is not as rough as untreated wool, although not as tightly combed or twisted as worsted.

sempstress: n. seamstress, dressmaker.

serge: n., adj. twill-weave durable fabric, usually of worsted.

shagreen: n., adj. untanned, textured raw-hide.

shantung: n., adj. silk fabric with slubbed texture.

shawl: n. finished length of fabric, usually rectangular or square, used to cover shoulders or head for decoration or warmth; originally

applied to cashmere shawls imported to England from the East.

shooting coat: see *morning coat*.

sleeve-links: n. cuff links; often decorative fasteners to join cuffs at the wrist.

smoking jacket: n. men's short jacket, often velvet, made to be worn in the home during after-dinner smoking.

spats: n. abbreviated form of 'spatterdash', an accessory worn over the shoe upper and instep to protect against mud.

spindle: n. rod used for wrapping threads while spinning.

stays: n. corset or other stiffened underbodice.

stock: n. stiff neckcloth, worn by men.

stomacher: n. v-shaped fabric insert, often ornamented, to cover front of the bodice, most popular in the late sixteenth century and seventeenth century, when women's bodices were open or laced at the front.

stuff: n. adj. generic term for fabric.

sultan: adj. dark, rich pink colour.

surcoat: n. overcoat.

tapestry: n., adj. heavy fabric decorated with embroidered and/or woven pictorial designs, usually applied to decorative fabrics (e.g. upholstery or wall-hangings), as opposed to those used for clothing.

tarlatan: n. thin, open-weaved muslin, often stiffened and used to structure gowns; in the nineteenth century, could also refer to a dress made from the fabric.

tartan: n., adj. woollen cloth with woven plaid pattern; distinctive colour and plaid patterns were used to identify Scottish clans.

tea gown: n. dress, less formal than evening wear but more formal than a day dress, worn for afternoon teas or entertaining.

tight-lacing: n. practice of cinching corsets to create a markedly small waist, popular in the 1870s and 1880s.

toile de Jouy: n., adj. plain-weave fabric in a solid colour with a repeating figural (often pastoral) scene, often used in upholstery.

top hat: n. men's hat with narrow brim and cylindrical crown, often of stiffened silk.

tulle: n. fine, transparent net fabric.

tunic: n. plain, collar-less shirt extending to the hips.

train: n. extended skirts that trails on the ground behind the wearer.

trunk hose: n. men's full, gathered shorts cinched at the thigh, worn with tights (*c.*sixteenth–seventeenth century).

tweed: n., adj. highly textured woollen fabric, original Scottish.

twill: n. textile weave featuring diagonal pattern resulting from an offset warp/woof (e.g. two-over, one-under), or the fabric made with such weave.

Ulster coat: n. men's overcoat with attached waist-length cape, popular in the nineteenth century.

upper: n. part of the shoe that covers the top, side and back of the foot, as opposed to the sole.

Valenciennes lace: n. bobbin lace with motifs worked within a relatively open net ground.

vamp: n. part of the shoe covering the top of the foot, or part of a sock or stocking that covers the foot.

VanDyck collar: n. large collar, decorated with cut-work or lace, named after the artist whose portraits documented the fashion.

vermillion: adj., n. bright scarlet colour, or the cinnabar dye used to achieve it.

vest: see *waistcoat*.

voile: n. thin, sheer fabric.

waistcoat: n. sleeveless men's front-opening garment worn over shirt and under jacket, often decorative; called a vest in North America.

walking dress: n. dress intended to be worn outdoors, to include an overcloak and head covering.

warp: n., adj. threads running vertical in a loom (see also *weft*).

wasp waist: n. small waist achieved by tightly laced corsets, popular in the 1870s and 1880s.

Watteau back; Watteau dress: see *sack-back gown*.

weeds: n. term for black mourning attire, especially that worn by widows.

weeper: n. black hatband with long, hanging tails, worn during mourning.

weft: n., adj. threads running crossways in a loom.

Wellington boots: n. originally, knee-high boots; from late nineteenth century, waterproofed or rubberized boot.

Wellington coat: n. a frock coat ending at the knees.

whalebone: n., adj. strips made from the flexible, horn-like jaw plates of the baleen whale, used to support corsets and other foundation garments.

widow's cap: n. black head covering worn by women during mourning; styles are kept simple in first mourning, but as time passes they may become increasingly ornamented; see also *attifet*.

woof: see *weft*.

worsted: n., smooth, combed, close-twisted wool yarn, or the fabric made from worsted yarns; adj. made from worsted yarns.

FURTHER READING

General Fashion History and Theory

Barthes, Roland. *The Fashion System*. Berkeley: University of California Press, 1983.
Barthes, Roland. *The Language of Fashion*. Trans. Andy Stafford. Oxford: Berg, 2006.
Hebdige, Dick. *Subculture: The Meaning of Style*. London: Routledge, 1991.
Hollander, Anne. *Seeing Through Clothes*. Berkeley: University of California Press, 1993.
Hughes, Clair. *Dressed in Fiction*. Oxford: Berg Publishers, 2005.
Rocamora, Agnès and Anneke Smelik. *Thinking through Fashion: A Guide to Key Theorists*. London: I.B.Tauris, 2016.
Wilson, Elizabeth. *Adorned in Dreams: Fashion and Modernity*. Berkeley: University of California Press, 1987.

General Victorian Fashion and Consumer Culture

Ableson, Elaine. *When Ladies Go A-Thieving: Middle-Class Shoplifters in the Victorian Department Store*. Oxford: Oxford University Press, 1992.
Adburgham, Alison. *Shopping in Style: London from the Restoration to Edwardian Elegance*. London: Thames and Hudson, 1979.
Adburgham, Alison. *Shops and Shopping 1800–1914*. London: Barrie and Jenkins, 1989.
Aindow, Rosy. *Dress and Identity in British Literary Culture, 1870–1914*. Aldershot and Burlington: Ashgate, 2010.
Blanchard, Mary. 'Boundaries and the Victorian Body: Aesthetic Fashion in Gilded Age America'. *The American Historical Review* 100, no. 1 (Feb., 1995), pp. 21–50.
Bowlby, Rachel. *Just Looking: Consumer Culture in Dreiser, Gissing, and Zola*. London: Taylor & Francis, 2009.
Casteras, Susan. *The Substance or the Shadow: Images of Victorian Womanhood*. New Haven: Yale Center for British Art, 1982.
Crane, Diana. 'Clothing as Non-Verbal Resistance: Marginal Women and Alternative Dress in the Nineteenth Century'. *Fashion Theory* 3, no. 2 (1999), pp. 241–68.
Cunnington, C. Willett. *Fashion and Women's Attitudes in the Nineteenth Century*. New York: Dover, 2003 [1936].
Cunnington, C. Willett and Phillis Cunnington. *Handbook of English Costume in the Nineteenth Century*. London: Faber, 1959.
Flanders, Judith. *Inside the Victorian Home: A Portrait of Domestic life in Victorian England*. New York: Norton, 2005.
Goldthorpe, Catherine. *From Queen to Empress: Victorian Dress 1837–1877*. New York: Publications of the Metropolitan Museum of Art, 1988.

Homans, Margaret. *Royal Representations: Queen Victoria and British Culture, 1837–1876*. Chicago: University of Chicago Press, 1998.

Hosgood, Christopher. '"Doing the Shops" at Christmas: Women, Men, and the Department Store in England, *c*. 1880–1914'. In *Cathedrals of Consumption: The European Department Store, 19505–1939*, ed. Geoffrey Crossick and Serge Jaumain, pp. 97–115. Aldershot: Ashgate, 1999.

Kortsch, Christine Bayles. *Dress Culture in Late Victorian Women's Fiction: Literacy, Textiles, and Activism*. Aldershot: Ashgate, 2009.

Lysack, Krista. *Come Buy, Come Buy: Shopping and the Culture of Consumption in Victorian Women's Writing*. Athens: Ohio University Press, 2008.

Moore, Doris Langley. *Fashion through Fashion Plates 1771–1970*. New York: Clarkson N. Potter, Inc. 1971.

Parker, Sarah. 'Fashion and Dress Culture'. *Literature Compass* 11, no. 8 (August 2014), pp. 583–591.

Rappaport, Erika. *Shopping for Pleasure: Women in the Making of West End London*. Princeton, NJ: Princeton University Press, 2001.

Rose, Clare, Katrina Honeyman, and Vivienne Richmond, eds. *Clothing, Society and Culture in Nineteenth-Century England*, 3 vols. London: Pickering and Chatto, 2010.

Sanders, Lise Shapiro. *Consuming Fantasies: Labor, Leisure, and the London Shopgirl, 1880–1920*. Columbus: Ohio State University Press, 2006.

Stearns, Peter N. *Consumerism in World History: The Global Transformation of Desire*. New York: Routledge, 2006.

Thomas, Julia. *Pictorial Victorians: The Inscription of Values in Word and Image*. Athens: Ohio University Press, 2004.

Valverde, Mariana. 'The Love of Finery: Fashion and the Fallen Woman in Nineteenth-Century Social Discourse'. *Victorian Studies* 32, no. 2 (1989), pp. 168–88.

Walkowitz, Judith. 'Going Public: Shopping, Street Harassment, and Streetwalking in Late Victorian London'. *Representations* 62 (1998), pp. 1–30.

Worth, Rachel. 'Rural Laboring Dress, 1850–1900: Some Problems of Representation'. *Fashion Theory* 3, no. 3 (August 1999), pp. 323–342. DOI: http://dx.doi.org/10.2752/136270499779151351

Zakim, Michael. 'Sartorial Ideologies: From Homespun to Ready-Made'. *Berg Fashion Library*. http://www.bergfashionlibrary.com/view/CMWF/chapter-FCPS0320.xml

Dress Reform (including Aesthetic Dress)

Calloway, Stephen and Lynn Ferderle Orr, eds. *The Cult of Beauty: The Aesthetic Movement 1860–1900*. London: V&A Publishing, 2011.

Cooper, John. *Oscar Wilde on Dress*. Philadelphia, PA: CSM Press, 2013.

Cunningham, Patricia A. *Reforming Women's Fashion, 1850–1920: Politics, Health and Art*. Kent, OH: Kent State University Press, 2003.

Denisoff, Dennis. *Aestheticism and Sexual Parody, 1840–1940*. Cambridge: Cambridge University Press, 2001.

Fortunato, Paul. 'Wildean Philosophy with a Needle and Thread: Consumer Fashion and the Origins of Modernist Aesthetics'. *College Literature* 34, no. 3 (Summer 1997), pp. 37–53.

Hamilton, Walter. *The Aesthetic Movement in England*. New York: AMS Press, 1971.

Jungnickel, Katrina. '"One Needs to be Very Brave to Stand all That": Cycling, Rational Dress and the Struggle for Citizenship in Late Nineteenth Century Britain'. *Geoforum* 64 (2015), pp. 362–71.

Lambourne, Lionel. *The Aesthetic Movement*. London: Phaidon, 1996.

Matthews, Alison Victoria. 'Aestheticism's True Colors: The Politics of Pigment in Victorian Art, Criticism, and Fashion'. In *Women and British Aestheticism*, ed. Talia Schaffer and Kathy Alexis Psomiades. Charlottesville: University of Virginia Press, 1999.

Maynard, M. '"A Dream of Fair Women": Revival Dress and the Formation of Late Victorian Images of Femininity'. In *Classic and Modern Writings on Fashion. Berg Fashion Library*. http://www. bergfashionlibrary.com/view/CMWF/chapter-FCPS0327.xml

Mitchell, Rebecca N. 'Acute Chinamania: Pathologizing Aesthetic Dress'. *Fashion Theory* 14, no. 1 (March 2010), pp. 45–64. DOI: 10.2752/175174110X12544983515277

Newton, Stella Mary. *Health, Art and Reason: Dress Reformers of the 19th Century*. London: John Murray, 1974.

Parkins, Wendy. '"The Epidemic of Purple, White and Green": Fashion and the Suffragette Movement in Britain 1908–14'. In *Fashioning the Body Politic: Dress, Gender, Citizenship*, ed. Wendy Parkins. *Berg Fashion Library*, 2002. DOI: http://dx.doi.org/10.2752/9781847888723/FASHBODPOL0009

Psomiades, Kathy Alexis. 'Beauty's Body: Gender Ideology and British Aestheticism'. *Victorian Studies* 36, no. 1 (Autumn 1992), pp. 31–53.

Schaffer, Talia. *The Forgotten Female Aesthetes: Literary Culture in Late-Victorian England*. Charlottesville: University of Virginia Press, 2000.

Schaffer, Talia and Kathy Alexis Psomiades, eds. *Women and British Aestheticism*. Charlottesville: University of Virginia Press, 1999.

Schwandt, Waleska. 'Oscar Wilde and the Stereotype of the Aesthete: An Investigation in to the Pre-Requisites of Wilde's Aesthetic Self-Fashioning'. In *The Importance of Reinventing Oscar: Versions of Wilde During the Last 100 Years*, ed. Uwe Böker, Richard Corballis, and Julie A. Hibbard. Amsterdam: Rodopi Press, 2002.

Temple, Ruth. 'Truth in Labeling: Pre-Raphaelitism, Aestheticism, Decadence, Fin-de-Siècle'. *English Literature in Transition* 17 (1974), pp. 201–22.

Crinolines and Corsets

Cunnington, C. Willett and Phillis Cunnington. *The History of Underclothes*. London: Faber & Faber, 1981 [1951].

Fields, Jill. *An Intimate Affair: Women, Lingerie, and Sexuality*. Berkeley: University of California Press, 2007.

Kunzle, David. *Fashion and Fetishism: A Social History of the Corset, Tight Lacing, and Other Forms of Body Sculpture in the West*. Totowa, NJ: Rowan and Littlefield, 1982.

Mackie, Erin. 'Lady Credit and the Strange Case of the Hoop-Petticoat'. *College Literature* 20, no. 2 (June 1993), pp. 27–43.

Mitchell, Rebecca N. 'The Rise and Fall of the Cage Crinoline, 15 August 1862'. *BRANCH: Britain, Representation and Nineteenth-Century History* (August 2016). http://www.branchcollective.org/?ps_articles=rebecca-n-mitchell-15-august-1862-the-rise-and-fall-of-the-cage-crinoline

Roberts, Helene E. 'The Exquisite Slave: The Role of Clothes in the Making of the Victorian Woman'. *Signs* 2, no. 3 (1977), pp. 554–69.

Steele, Valerie. *The Corset: A Cultural History*. New Haven: Yale University Press, 2003.

Steele, Valerie. *Fashion and Eroticism: Ideals of Feminine Beauty from the Victorian Era to the Jazz Age*. New York and Oxford: Oxford University Press, 1985.

Summers, Leigh. *Bound to Please: A History of the Victorian Corset. Berg Fashion Library*, 2001. DOI: http://dx.doi.org/10.2752/9781847888655

Walkley, Christina. '"Nor Iron Bars a Cage": The Victorian Crinoline and its Caricaturists'. *History Today* 25 (October 1975), pp. 712–17.

Windle, Lucy-Clare. '"Over what Crinoline Should these Charming Jupons be Worn?": Thomson's Survival Strategy During the Decline of the Crinoline'. *Costume* 41 (2007), pp. 66–82.

Men's Dress

Anderson, Fiona. 'Fashioning the Gentleman: A Study of Henry Poole and Co., Savile Row Tailors, 1861–1900'. *Fashion Theory* 4, no. 4 (November 2000), pp. 405–426. DOI: http://dx.doi.org/10.2752/13627040077910866

Dellamora, Richard. *Masculine Desire*. Chapel Hill: University of North Carolina Press, 1990.

Harvey, John. *Men in Black*. Chicago: University of Chicago Press, 1996.

Irvin, Kate and Laurie Anne Brewer. *Artist, Rebel, Dandy: Men of Fashion*. New Haven: Yale University Press in association with the Museum of Art, Rhode Island School of Design, 2013.

Rose, Clare. *Making, Selling and Wearing Boys' Clothing in Late Victorian England*. Aldershot and Burlington: Ashgate, 2010.

Shannon, Brent. *The Cut of his Coat: Man, Dress, and Consumer Culture in Britain, 1860–1914*. Columbus: Ohio University Press, 2006.

Occasional Dress

Bedikian, Sonia A. 'The Death of Mourning: From Victorian Crepe to the Little Black Dress'. *Omega* 57, no. 1 (2008), pp. 35–52.

Cooper, Cynthia. 'Dressing Up: A Consuming Passion'. In *Fashion: A Canadian Perspective*, ed. Alexandra Palmer, Toronto: University of Toronto Press, 2004.

Cunnington, Phillis E. and Catherine Lucas. *Costume for Births, Marriages and Deaths*. London: Adams and Charles Black, 1971.

Curl, James Stevens. *The Victorian Celebration of Death*. Detroit: The Partridge Press, 1972.

Curren, Cynthia. *When I First Began my Life Anew: Middle-Class Widows in Nineteenth-Century Britain*. Bristol, IN: Wyndham Hall Press, 2000.

Davey, Richard. *A History of Mourning*. London: McCorquodale & Co. Ltd., 1890.

Friese, Susanne. 'The Wedding Dress: From Use Value to Sacred Object'. *Berg Fashion Library*, 2001. DOI: http://dx.doi.org/10.2752/9781847888921/THRWARD0008

Gevirtz, Karen Bloom. *Life After Death: Widows and the English Novel, Defoe to Austen*. Newark, DE: University of Delaware Press, 2005.

Gilmartin, Sophie. 'The Sati, the Bride, and the Widow: Sacrificial Women in the Nineteenth Century'. *Victorian Literature and Culture* 25, no. 1 (1997), pp. 131–58.

Jalland, Pat. *Death in the Victorian Family*. Oxford: Oxford University Press, 1996.

Jones, Barbara. *Design for Death*. Indianapolis, IN: The Bobbs-Merrill Company, 1967.

Lutz, Deborah. *Relics of Death in Victorian Literature and Culture*. Cambridge: Cambridge University Press, 2015.

Mitchell, Rebecca N. 'Death Becomes Her: On the Progressive Potential of Victorian Mourning'. *Victorian Literature and Culture* 41 (2013), pp. 595–620.

Mitchell, Rebecca N. 'The Victorian Fancy Dress Ball, 1870–1900'. *Fashion Theory* (published online May 2016), n.p. DOI: 10.1080/1362704X.2016.1172817

Morley, John. *Death, Heaven and the Victorians*. Pittsburgh, PA: University of Pittsburgh Press, 1970.

O'Brien, Alden. 'Maternity Dress'. In *The Berg Companion to Fashion*, ed. Valerie Steele, p. 502. London: Berg, 2002.

Paoletti, Jo. "Clothes Make the Boy, 1860–1910'. *Dress* 9 (1983), pp. 16–20.

Puckle, Bertram S. *Funeral Customs: Their Origin and Development*. London: T. Werner Laurie Ltd., 1926.

Strange, Julie-Marie. *Death, Grief and Poverty in Britain, 1870–1914*. Cambridge: Cambridge University Press, 2005.

Strange, Julie-Marie. '"She Cried a Very Little": Death, Grief and Mourning in Working-class Culture, *c.* 1880–1914'. *Social History* 27, no. 2 (2002), pp. 143–61.

Taylor, Lou. *Mourning Dress: A Costume and Social History*. London: George Allen and Unwin, 1983.

Production and Industry

Chatterjee, Anuradha. 'Tectonic into Textile: John Ruskin and His Obsession with the Architectural Surface'. *Berg Fashion Library*, 2009. DOI: http://dx.doi.org/10.2752/175183509X411771

Gregory, J. M. 'A History of the Sewing Machine to 1880'. *Transactions of the Newcomen Society* 76, no. 1 (2006), pp. 127–44.

Loxham, Angela. 'Cleric or Conman, Curate or Crook? Understanding the Victorian Draper'. *Textile History* 47 (2016), pp. 171–89.

Nenadic, Stana. 'Designers in the Nineteenth-Century Scottish Fancy Textile Industry: Education, Employment and Exhibition'. *Journal of Design History* 27 (2014), pp. 115–31.

Nica, Elvira and Ana-Madalina Potcovaru. 'Labor Management and Dress Culture in the Victorian Textile Industry'. *Economics, Management and Financial Markets* 10, no. 2 (June 2015), pp. 96–101.

International Influences and Echoes

Bhatia, Nandi. 'Fashioning Women in Colonial India'. *Fashion Theory* 7, no. 3–4 (September 2003), pp. 327–44. DOI: http://dx.doi.org/10.2752/136270403778052050

Jackson, Anna. 'Imagining Japan: The Victorian Perception and Acquisition of Japanese Culture'. *Journal of Design History* 5, no. 4 (1992), pp. 245–56.

Kramer, Elizabeth. '"Not so Japan-easy": The British Reception of Japanese Dress in the Late 19th Century'. *Textile History* 44 (May 2013), pp. 3–24.

Yokoyama, Toshio. *Japan in the Victorian Mind: A Study of Stereotyped Images of a Nation, 1850–80*. Basingstoke: Macmillan, 1987.

Zutshi, Chitralekha. 'Designed for Eternity: Kashmiri Shawls, Empire, and Cultures of Production and Consumption in Mid-Victorian Britain'. *Journal of British Studies* 48, no. 2 (2009), pp. 420–40.

Print Culture

Beetham, Margaret and Kay Boardman. *Victorian Women's Magazines: An Anthology*. Manchester: Manchester University Press, 2001.

Boardman, Kay. '"A Material Girl in a Material World": the Fashionable Female Body in Victorian Women's Magazines'. *Journal of Victorian Culture* 3, no. 1 (1998), pp. 93–110.

Brake, Laurel and Marysa Demoor. *Dictionary of Nineteenth-Century Journalism in Great Britain and Ireland*. Gent: Academia Press and the British Library, 2009.

Breward, Christopher. 'Femininity and Consumption: The Problem of the Late Nineteenth-Century Fashion Journal'. *Berg Fashion Library*. http://www.bergfashionlibrary.com/view/CMWF/chapter-FCPS0326.xml

Breward, Christopher. 'Patterns of Respectability: Publishing, Home Sewing and the Dynamics of Class and Gender 1870–1914'. *Berg Fashion Library*, 1999. DOI: http://dx.doi.org/10.2752/9781847888884/CULTSEW0006

Collins, Tracy. 'Athletic Fashion, "Punch", and the Creation of the New Woman'. *Victorian Periodicals Review* 43, no. 3 (2010), pp. 309–35.

De Ridder, Joan and Marianne Van Remoortel. 'From Fashion Colours to Spectrum Analysis: Negotiating Femininities in Mid-Victorian Women's Magazines'. *Women's History Review* 21 (2012), pp. 21–36.

Fraser, Hilary, Stephanie Green, and Judith Johnston. *Gender and the Victorian Periodical*. Cambridge: Cambridge University Press, 2003.

Korte, Barbara. 'Between Fashion and Feminism: History in Mid-Victorian Women's Magazines'. *English Studies* 96, no. 4 (2015), pp. 424–43.

Loeb, Lori Anne. *Consuming Angels: Advertising and Victorian Women*. New York: Oxford University Press, 1994.

Marcus, Sharon. 'Reflections on Victorian Fashion Plates'. *differences* 14 (2003), pp. 4–33.

Yan, Shu-Chuan. '(Ad)dressing Women: Fashion and Body Image in *Punch*, 1850s–1860s'. *Women's Studies* 43, no. 6 (2014), pp. 750–73.

Yan, Shu-Chuan. '"Politics and Petticoats": Fashioning the Nation in *Punch* Magazine 1840s-1880s'. *Fashion Theory* 15, no. 3 (September 2011), pp. 345–372. DOI: http://dx.doi.org/10.2752/17517411 1X13028583328883

INDEX

Note: Page locators in *italics* refer to figures.